The Image

JACQUES AUMONT

LONGWOOD LIBRARY

Longwood College, Farmville, Virginia 23909-1897

A center for learning. A window to the world.

The Image

The Image

Jacques Aumont

Translated by Claire Pajackowska

BRITISH FILM INSTITUTE

bfi

BFI PUBLISHING

First published in 1997 by the
BRITISH FILM INSTITUTE
21 Stephen Street, London W1P 2LN

Copyright © Jacques Aumont 1994
Copyright © Translation Claire Pajackowska
First published as *L'Image*, Editions Nathan, Paris 1990

The British Film Institute exists to promote appreciation, enjoyment,
protection and development of moving image culture in and
throughout the whole of the United Kingdom. Its activities include the
National Film and Television Archive; the National Film Theatre; the
Museum of the Moving Image; the London Film Festival; the
production and distribution of film and video; funding and support for
regional activities; Library and Information Services; Stills, Posters and
Designs; Research; Publishing and Education; and the monthly *Sight
and Sound* magazine.

Illustrations courtesy of Editions Nathan
British Library Cataloguing in Publication Data
A catalogue record for this book is available from the British Library

ISBN 0 85170 409 3
 0 81570 410 7 pbk
Cover design by Andrew Sutterby
Cover images: *The Draughtman's Contract* (Peter Greenaway, 1982)

Typesetting by Fakenham Photosetting Limited, Fakenham, Norfolk
Printed in Great Britain

Contents

Introduction

The Image: a title as succinct as it is ambitious, implying that the book aims to account for a vast and infinitely varied sphere of human activity. The image has innumerable potential manifestations, some of which are perceived through the senses, and others that are purely intellectual, as when we use metaphors of vision in abstract thought. We must therefore start by stating that the object of this book is one aspect of the image, and that, without ignoring the multiplicity of meanings which imagery may convey, we are limiting this study to images with a visible form, to *visual* images.

This book deals with visual images as one specific form of imagery, and yet the book also has a more general range since it is an attempt to discuss what all visual images have in common, whatever their nature, form, use and mode of production, and whatever their significant differences.

Written by someone who has worked for the most part with cinematographic images, such a project is not innocent. It has emerged essentially from two observations. First, it became increasingly clear to me while teaching the theory and aesthetics of film that film theory cannot develop in splendid isolation and that it is essential that it should be historically and theoretically articulated with other forms of concrete visual imagery, such as painting, photography and video (to name only some of the most important). It seemed almost absurd to discuss framing in cinema without relating it directly to the concept of the frame in painting, just as it seemed unhelpful to discuss the photogram without considering the snapshot, and so on.

This first thought, refined and reinforced over the years, emerged from an earlier, wider speculation about the nature of images in general in our society. It is banal to evoke the concept of a culture of the image, but this formulation accurately expresses the feeling that we all, to some extent, have experienced living in a world where images are not only proliferating but becoming increasingly varied and interchangeable. Today films are seen on television, just as, for some time now, paintings have been known through photographic reproduction. The crossovers, exchanges and the passage of images are becoming increasingly varied and it seemed to me that no single category of the image could be studied in isolation without taking into account all the others.

This idea is the basis of the book and accounts for its approach to the study of the image. It explains why the book remains at a general level of conceptualisation, without any attempt to theorise on the basis of any one particular form of imagery. At the same time, of course, space had to be given to specific examples of the textual analysis of particular types of imagery (e.g. cinematography, photography) and of specific individual images. It also explains the structure of the book: the discussion of the image is organised into chapters which deal with the major problems of the theory of the image.

These problems may be reduced to five essential areas:

1. As the book is about *visual* images, the question of vision must be understood. What is it to see an image, what kind of perception is entailed, and how is this type of perception related to perceptual phenomena in general?

2. Visual perception, or vision, is a complex activity which is imbricated in important psychic functions such as intellectual processes, cognition, memory and desire. Therefore, after describing the external process through which light enters the eye, we need to consider the subject which sees the image, the subject for whom the image is made, and whom we will call the *spectator* or the *viewer*.

3. Following the same line of thought, it is evident that the spectator along with the images seen, is never an abstract or pure entity, cut off from concrete reality. On the contrary, the perception of images always takes place within a context with many determinants: a social context, an institutional context, an ideological context. The situational factors which determine the spectator's relation to the image will be called the *apparatus*.

4. Having discussed the main elements of the relation between an actual image and an actual spectator, we can then discuss the properties of the image itself. What relation does it construct with external reality? In other words: how does the image *represent*? What are the forms and means of this representation, how does it negotiate the basic categories of our conception of reality, space and time? But, also, how does the image inscribe *meaning*?

5. Finally, we cannot discuss the image without referring to images that already exist. From the range of these real images, this book chooses to discuss *artistic* images, that is to say, images pertaining to the realm of the arts. The final chapter, therefore, is devoted to examining certain specificities of these images, their particular properties and values.

Such a project may seem ambitious, as potentially it covers the themes of several specialist discourses. I am especially aware that the first chapter, which covers more formal and even systematic theories, may seem to be more technical and hence more difficult for some people to read. Nevertheless, to make this the book's first chapter seems to me to be the most logical and thus the most useful solution, as it introduces some fundamental, and often misunderstood, concepts which will be

elaborated in the following chapters. In the first chapter, possibly to a greater extent than in the others, I have aimed for maximum clarity. I would like to ask those readers who nevertheless find this chapter confusing, to be patient and to take it on trust that a reading of the book in its entirety will resolve any difficulties.

I have adopted this structure, running the risk of summarising several theories in one slender volume, because this is not a treatise, but a simple exposition of the current state of thinking on various aspects of visual culture across a range of discourses. From this perspective, the book is simply an introduction to more specialist approaches. I have nevertheless found it essential to introduce the reader to the multiplicity of these approaches. Writing this book, I have borne in mind the students I have known over the twenty years in which I have been teaching cinema at the university; and, knowing the extent to which theoretical knowledge tends to be provided to them in small segments, I have not tried to be exhaustive (which would be impossible anyway), but to step back, to allow these students to situate their knowledge in relation to less contingent, less local and more inclusive considerations. It seems obvious to me that, for this book to be at all successful, it must also address those who are particularly knowledgable about some specific aspect of imagery. I hope the book will enable them to contextualise their own knowledge as well as to develop it.

I would like to thank Anne-Marie Faux, Jean-Louis Leutrat and Michel Marie who read the first draft and gave me much help in improving it. This book is dedicated to the man who, literally and in all other senses of the term, taught me how to learn: Christian Metz.

J.A.

Chapter One

The Role of the Eye

There are images because we have eyes; that much is obvious. Images, artifacts which are proliferating and becoming increasingly important in our society, are nevertheless, up to a point, visible objects like any other, and as such subject to the same laws of perception.

Visual perception is a relatively well-researched aspect of human beings' relationship to their external world. There is a vast literature of empirical observation, experiments and theories dating back to Classical antiquity. Euclid, the father of geometry, also founded the science of optics *c*. AD 300 and was one of the first theorists of vision. In the modern era artists and theorists (Alberti, Dürer, Leonardo da Vinci), philosophers (Descartes, Berkeley, Newton) and physicists have all extended this field of exploration.

The beginnings of the theory of visual perception really lie in the 19th century, with Helmholtz and Fechner. More recently (since the last world war), experiments in psycho-physiological laboratories have been set up and the quantity of observations and experimental data has become very large. At the same time, the need for theories of visual perception which are able to integrate and organise the experimental data has become more urgent. And these theories raise new questions and suggest new areas of research. In short, the study of visual perception has become more scientific (although we are still a long way from knowing all there is to know about this very complex phenomenon). We begin, in this chapter, by describing, as simply as possible, the main features of contemporary accounts of visual perception.

I. What the Eye Does

I.1 The Eye and the Visual System

Daily life, common sense and figures of speech all tell us that we see with our eyes. The eyes are an instrument of vision, but they are only one and by no means the most complex of these instruments. Vision is a process which uses several specialised organs. Roughly speaking, vision results from three distinct (and successive) processes: optical, chemical and nervous.

I.1.1 Optical Transformations

Figure 1 shows what happens when an image of an object is formed on

5

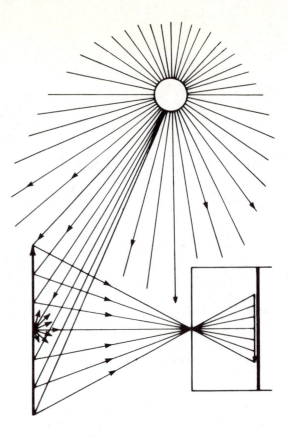

*Figure 1 The principle of
the camera obscura.*

the inner screen of a camera obscura. The light rays from a light source
(such as the sun), hit an object (here a white stick), which reflects part
of the rays in all directions; a number of the reflected rays pass through
the aperture of the camera and form an (inverted) image of the object
on the inner back wall, or screen. As the light is very diffuse only a small
quantity of rays reach this screen: the image is very pale, and if we
wanted to record it, for example on photographic paper, we would need
a very long exposure time. To increase its luminosity, we would have to
increase the amount of light entering the camera by widening the aper-
ture. Naturally, this would result in the edges of the image becoming
more blurred (in direct proportion to the widening of the aperture). It
was to counteract this effect that, from the 16th century onwards, con-
vergent lenses were used. These were pieces of glass especially ground
in order to collect light from all of their surface area and to concentrate
it in one point.

This principle of capturing a number of light rays on a surface and
then concentrating them on one point is the basis for many optical in-
struments, even though, today, most of them are complex, using a num-
ber of component lenses. The same principle is at work in the eye.

The eye is an approximately spherical globe, about two and a half
centimetres in diameter, covered with a layer that is partly opaque (the

sclera) and partly transparent. The transparent part is the *cornea* which secures most of the convergence of light rays entering the eye. Beneath the cornea is the *iris*, the sphincter muscle which is governed by reflex action, and at its centre is the aperture, the *pupil*, which enlarges from about two to about eight millimetres in diameter.

The pupil opens to allow in more light when the light is dim, and closes down when the light is bright. Contrary to what might be believed, the size of the pupil modifies perception not in relation to the amount of light that enters the eye, but because of the change in depth of field produced by the size of the aperture: the smaller the diameter of the pupil the greater the depth of field (which is why we see more clearly when there is more light, because the pupil is closed). This is easily tested; for example, when the pupil is artificially opened, such as in atropine treatment (where the back of the eye is examined or treated) one does not see more clearly but less sharply. Moreover, the size of the pupil may alter spontaneously with changes in emotional states: fear, anger and states induced by psychotropic drugs.

Finally, the light that has crossed the pupil must still cross the crystalline lens of the eye which increases or decreases its convergence. Optically speaking, the crystalline lens is a biconvex lens of variable convergence; this variability is called its accommodation. To accommodate is to vary the convergence of the crystalline lens to make it more or less convex, in relation to the distance of the source of light from the eye (to maintain a focused image on the receptive membrane, or retina, of the eye, the rays of light must be made more convergent in direct proportion to the proximity of the light source). This is a fairly slow reflex action as it takes almost one second for the crystalline lens to move from the closest accommodation to the most distant.

The eye has often been compared to a miniature photographic camera: this is accurate if it is understood that this description is limited only to the purely optical aspect of the way it processes light.

I.1.2 Chemical Transformations

The back of the eye is lined with a membrane known as the *retina*, containing innumerable light receptors. These receptors are of two types: the *rods* (about 120 million of them) and the *cones* (about 7 million). The latter are particularly grouped around the *fovea*, a sort of small hollow in the retina near the axis of the crystalline lens, especially rich in receptors.

Rods and cones carry the molecules of pigment (about 4 million molecules per rod) which contain a substance known as *rhodopsin* which absorbs light and, through chemical reaction, decomposes into two other substances. Once the chemical process of decomposition has taken place, the molecules can no longer absorb light; and conversely, if no more light is transmitted through the retina, the reaction is reversed and the rhodospin recomposes and the molecules can begin to function again (it takes about three-quarters of an hour without light for all the

molecules of rhodospin in the retina to be recomposed, but half are already recomposed after five minutes).

In other words, the retina is primarily a vast chemical laboratory. It is very important to understand that what we know as the *retinal image* is an optical projection received on the back of the eye through the system of cornea + pupil + crystalline lens, and that this still purely optical image is then transformed by the chemical system of the retina into information of a completely different type. It is especially important to understand that, contrary to what is sometimes suggested by the term 'image', we do not see our own retinal images. Only an ophthalmologist using special equipment can see those. The retinal image is only one stage of the process by which the visual system treats light, and is not an image in the sense that we speak of images either in this book or in everyday life. We will return to this later.

I.1.3 Transformations in the Nervous System

Each retinal receptor is linked to a nerve cell by means of a *synapse*; each of the cells is, by means of other synapses, linked to other cells which make up the fibres of the *optical nerve*. The communications between the cells are very complex: in addition to the two synaptic levels mentioned above, there are also a number of transversal links which connect the cells into networks (the consequences of this will be discussed below). The optical nerve connects the eye to a side region of the brain, the *geniculate body,* from which more neurological connections extend towards the back of the brain to reach the *striated cortex.*

Very schematically, it could be said that this dense and complex network constitutes a third and final stage of the processing of information already processed by optical and then by chemical systems. As a general rule, there never is a one-to-one correspondence, but only a multiplication of transversal correspondences: the visual system does not simply copy information but processes it at each stage. Thus, for example, the synapses are not simply points of connection, but play an active part, some exciting and others inhibiting stimuli.

This aspect of the perceptual system is the largest, but also the least understood, because its structure and function began to be researched only about thirty years ago. In particular, not much is known about how information passes from the chemical to the nervous stages (and the nature of the nervous message can only be metaphorically compared to an electrical signal, as not much is known about this aspect of the nervous system). What is important for the scope of this book is to remember that while the eye is, up to a certain point, like a photographic camera, with the retina comparable to a sensitised plate, the essential part of the process of visual perception takes place after this, through a system of processing information that, like all cerebral processes, more closely resembles cybernetic or computer systems than any mechanical or optical model ('more closely' obviously implies that these models are not really adequate representations).

I.2 The Elements of Perception: What Do We See?

Visual perception then is the processing, through successive stages, of information that reaches us through the intermediary of the light entering our eyes. Like any other information it is coded, but not quite in the way this term is used in semiology. In this case, the codes are natural laws of transformation (neither arbitrary, nor conventional) which determine the nervous activity in relation to the information contained in light. To speak of the coding of visual information refers to the fact that our system of sight is able to recognise and interpret certain regularities in the phenomena of light which reach our eyes. Essentially, these regularities concern three of the characteristics of light: its intensity, its wavelength, its distribution in space (we will discuss its distribution in time later).

I.2.1 The Intensity of Light: The Perception of Luminosity

What we experience as the greater or lesser luminosity of an object in fact corresponds to our interpretation, already inflected by psychological factors, of the actual quantity of light emitted by this object. The light source may be the sun, a flame, an electric light and so on, or it may be a reflection of such a source.

Basically, the eye reacts to a luminous *flux* (on the notion of flux see Table 1). A very weak flux (a 10^{-13}lm flux corresponds to about a dozen photons) may be enough to register a sense of light. When the flux increases, the number of retinal cells affected becomes larger, the chemical reaction of the decomposition of rhodospin is increased, and the nervous signal becomes more intense. Table 2 describes the scale of luminosity of everyday objects.

Excluding extremely dark objects (such as a dark object in a tunnel, night-time), which are not perceived, and extremely bright objects, which emit such intense light energy that they may cause burns and destroy the nervous system,[1] two types of luminosity are usually differentiated corresponding to two types of sight, themselves based on two types of retinal cell:

- *photopic sight*: this is the most common form of sight and covers the entire range of objects which we would think of as being normally lit up by daylight. The photopic world mainly activates the cones, which are principally responsible for the perception of colour. Photopic sight is chromatic. The cones are especially dense around the fovea, so it is a form of sight which largely uses the central area of the retina. For this reason, and because in this range of luminosity the pupil can be more closed down, it is characterised by its sharpness.
- *scotopic sight* or *night vision* (although even at night, bright lighting will activate daytime vision): the characteristics of this type are the inverse of photopic sight: it uses mainly rods and is an achromatic perception, unfocused and, especially in intense darkness, mostly uses the periphery of the retina.

9

Table 1 Flux, intensity, luminescence and illumination

Photometrics is the technique of measuring quantities of light by means of, for instance, photoelectric cells.

The luminous **flux** is the total quantity of luminous energy emitted or reflected by an object, expressed in *lumens* (abbreviated as lm).

The **intensity** of light is measured in terms of *candelas* (cd). A black body of 1cm^2 heated to 2042° Celsius emits 60 candelas. One candela is roughly equivalent to the amount of light emitted by one candle (made of white sperm whale wax and $\frac{7}{8}$ of an inch thick) viewed horizontally.

The **luminescence** is the luminous intensity of a unit of the apparent surface of a luminous object. It is expressed in cd/m^2. Note that the amount depends only on the source, not on the observer. The cinema screen has a certain luminescence and will appear equally shiny whether one sits in the front row or in the back. However, the screen's apparent surface, which governs the luminous flux it emits, will vary a lot. On the other hand, the screen's luminescence is strongly affected by any movement of the light source, i.e. the projector.

The three scales of flux, intensity and luminescence relate to the light-emitting object. The quantity of light which reaches a given surface is called its **illumination**, defined as the luminous flux per unit of the surface illuminated. It is measured in terms of *lux* (1 lux is the illumination produced by 1lm on to a surface of 1m^2.

Table 2 Values of luminescence (in cd/m^2) of everyday objects

10^{10}	sun	⎫ dangerous
10^9	electric arc light	⎬
10^8		⎭
10^7		
10^6	filament of a tungsten lamp	⎫
10^5	cinema screen	⎪
10^4	white paper in sunlight	⎬ photopical zone
10^3	moon (or the flame of a candle)	⎪
10^2	readable printed page	⎭
10		
1		
10^{-1}		
10^{-2}	white paper in moonlight	⎫
10^{-3}		⎬ scotopical zone
(...)		⎪
10^{-6}	absolute threshold of perception	⎭

Naturally, the presentation of these mechanisms of sight in relation to the flux of luminosity has been simplified here. We have omitted the variables that result from the localisation of the retina, the angle at which light may enter the eye, the phenomena of certain threshold perceptions (for example, with very small surfaces the size of the lit area is not registered by the senses). The point is that vision of images is predominantly voluntary and mainly uses the foveal zone. This vision mainly uses photopic sight. Although they are usually viewed in the dark, cinema and video activate similar mechanisms of sight, as the screen is brightly illuminated (usually several thousand cd/m²), so that, contrary to what one might assume, viewing cinema or television uses daytime vision even though it takes place in a nocturnal environment. It is very rare to find examples of scotopic vision of images although this may be found, for example, in certain art installations.

I.2.2 The Wavelength of Light Rays: Colour Vision
Just as the perception of luminosity is a product of the responses of the visual system to the luminosity of objects, the experience of colour is a product of its responses to the wavelength of the rays of light emitted or reflected by objects. Quite contrary to our common sense impressions, colour is not a property of objects any more than luminosity is, but lies 'within' our perception.

Everyone knows that white light (especially sunlight, which is by far the most common source of light) is in fact a mixture of colours, comprising all the wavelengths of the visible spectrum. This can easily be demonstrated by splitting sunlight with the help of a prism, or observed in the phenomenon of a rainbow.

The light which reaches us from objects is reflected by them. Most surfaces absorb some wavelengths while reflecting others. Surfaces which absorb all wavelengths equally appear grey: light grey, if they reflect a lot of light, dark grey, if they do not. Any surface which reflects less than 10 per cent of light appears black.

The empirical classification of colour is made in relation to three features:

- the wavelength, which determines the *colour* (blue, red, orange, cyan, magenta, yellow . . .);
- the *saturation*, or the purity of a colour (pink is a less saturated form of red, that is to say, a red to which white has been added) – the colours of the solar spectrum have the maximum saturation;
- the *luminosity*, linked to brightness. The greater the luminosity, the brighter and the closer to white a colour will appear. In the case of two reds of equal saturation, one may be brighter than the other depending on luminosity.

From Newton's work we know that colours may be combined. Traditionally, colours are classified according to the two different kinds of combination:

11

- *additive*: mixtures of light such as in video, or tiny beams of primary coloured light (red, green and blue), are mixed on the retina because each individual beam is too narrow to be perceived individually. The autochrome process of colour photography (*c.*1900) is based on a similar principle, as was the pointillist movement in painting which sought to represent colour by juxtaposing tiny dots of colour, fused by the eye into one colour by a process of addition;
- *subtractive*: in mixtures of pigments, each pigment added will absorb new wavelengths of light, which amounts to a subtraction from the wavelengths of light emitted by the reflective surface. This is usually the case in painting, as well as in all the modern forms of photography and colour cinema.

The general principle of mixing is the same in both cases: two colours mixed together make a third colour. If you have the three primary colours, every other colour can be produced by regulating their combination. For example, a yellow pigment absorbs blue and green–blue, a blue pigment reflects blue and green; the mixture of the two only allows green to be reflected, which is why a green pigment is obtained by mixing blue and yellow pigments.

The perception of colour is due to the activity of three types of retinal cone, each sensitive to a different wavelength (for a normal, non-colour-blind, person, the wavelengths are 0.440μ, 0.535μ and 0.565μ, corresponding, respectively, to blue–violet, green–blue and green–yellow). The coding of colour in the last stage of the visual process is a very complex process; here it suffices to know that certain combinations of cells, from the retina to the cortex, have specialist functions in the perception of colour, and that the latter is therefore one of the most fundamental dimensions of our visual world.

It should be noted that this dimension is absent from the many monochrome images that we generally refer to as black and white (in fact these images represent luminosity rather than colour, and thus use a scale of greys). The most ubiquitous type of such images today is probably the photographic image, but we should not forget that for a long time before the advent of photography, black-and-white images, notably engravings, were in circulation. Here we find an important example of the way in which the image represents reality conventionally, according to what is socially acceptable. For instance, none of the first spectators of Lumière's Cinématographe complained of the absence of colour.

I.2.3 The Spatial Distribution of Light: Visual Edges
Everyone knows, however vaguely, that the eye is made to perceive the luminosity and the colour of objects. It is less well known that it is also made to perceive the spatial limits of these objects, their edges.

The concept of a visual edge, or outline, refers to the border between two surfaces of different luminosity – whatever may be the cause of this difference of luminosity (different lighting, different properties of reflec-

tion, and so on), – from a given point of view (there is a visual edge be-
tween two surfaces when one is behind the other, for example, but if the
point of view changes, the edge will no longer be in the same place).

Up to *c.* 1950–55, visual perception was conceived in terms of suc-
cessive isomorphic replicas from the object to the brain, the retina being
conceived as a fairly simple relay which transmitted information rather
than interpreted it. Today we know that the coding process takes place
uninterrupted from the retina to the cortex, and that some cells on the
furthest layer of the retina are connected to many cells from the next
stage and thus represent several hundreds or thousands of receptors.
Therefore:

- every cell from the furthest layer of the retina and further (cerebral)
 stages is linked to a *retinal field*, that is to say, to a complex of recep-
 tors. As a rule, any one receptor is one part or link in hundreds of dif-
 ferent intersecting fields;
- neurones are linked by two different types of connections: if one
 group of receptors is associated to one cell by a stimulating connec-
 tion, the cell will be as excited as the receptors are, and so on through
 all the subsequent links between cells; on the other hand, if the link is
 inhibiting, the activity of the cell or receptor will inhibit or block the
 activity of the following cell.

For example, a frequent structure found in the field of cellular activity
in the optic nerve is the one represented in Figure 2. This field stimu-
lates the receptors located in the centre of the field and inhibits those in
the surrounding one. The final connections leading to the cortex com-
bine these fields in various ways, corresponding to a wide range of dif-
ferent specialist functions. Thus there are cortical cells which exist in a
field divided between two sub-regions, excitory and inhibitory respect-
ively: it is these cells which react to an edge. Figure 3 shows two other
possible field structures which specialise in the detection of light fissures
and lines respectively.

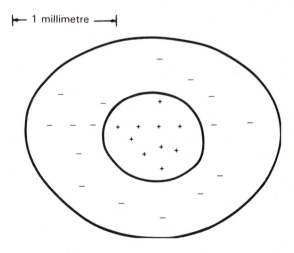

Figure 2

13

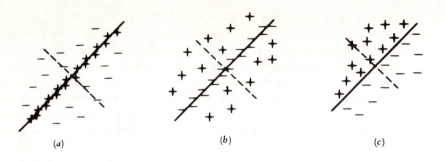

(a) (b) (c)

Figure 3 (a) split (b) line (c) edge

Crudely stated, the zone of the striated cortex – the seat of visual per-
ception – comprises cells organised in columns, approximately 120 cells
per column, each one corresponding to one region of the retina. These
columns are themselves clustered into hypercolumns, aggregates of hun-
dreds of columns (between 400 and 600 columns per hypercolumn,
measuring from between 0.5–1mm^2 and between 3–4mm in length,
containing about 100,000 to 200,000 cells). Each cell gives one unit of
information which is in itself ambiguous, and which must be combined
with the units of information from other cells in the same hypercolumn.
Although there is as yet no precise model for the mechanisms of dis-
tinction which this system implies, we know that the phenomena of ex-
citation and inhibition play a very important part. Each column is tuned
to a different spatial direction in slices of about 10°, that is to say, it is
specialised in the detection of stimuli of light within this particular 10°
angle; the hypercolumns contain cells with an even more specialist func-
tion, in fields of varying size, which are able to detect differences, for
example, between distinct and blurred stimuli, or enabling the recog-
nition of an angle or the length of a line. The significance of this is that
the mechanism of perception is constructed to enable the perception of
a visual edge and its orientation, a fissure, a line, an angle, a segment;
these percepts are the basic elements of our perception of objects and
space.

These very complex mechanisms give good results as we are capable
of distinguishing between visual edges on a very small scale. An optician
measures this visual acuity by using letters of the alphabet as visual stim-
uli, a complex form for which the performance of the eye is not perfect.
In this kind of test an acuity of 1 (usually noted as 10/10) corresponds
to a discrimination of an angle of 1°, and is usually thought to be good.
But if the given stimulus is not alphabetical letters but a black line on a
white background, acuity can go as high as 120, which corresponds to a
perception of differences between a half-minute of a degree of an angle.

I.2.4 Contrast: The Interaction of Luminosity and Edges
Our visual system is, in fact, equipped to perceive changes in lumin-
osity rather than luminosity itself; the (psychological) luminosity of a

14

Figure 4 The embedded triangles all have the same luminescence but their apparent luminosity varies a great deal. The triangles set against a dark background appear more luminous than those set against a light background.

surface is almost entirely determined by its relation to the environmental light; it is especially a function of its relationship to a background (see Figure 4). Two objects will appear to be of equal luminosity if their relationship to their background is similar, regardless of the absolute value of their luminosity; and inversely the same object (emitting the same level of luminosity) will appear to be brighter if placed on a darker background.

In addition, our visual system is capable of linking the perception of luminosity with the perception of visual edges. Thus a contrast between two visual surfaces is only perceived if these are perceived as being within the same visual plane. If, on the other hand, they are seen as being at different distances from the eye, their respective luminosities will be difficult to compare. Similarly, when a visual edge is perceived as being due to lighting (a transition from an illuminated zone to a zone in shadow) on the same surface, rather than being due to a change of surface, the difference in luminosity between each side of the edge will be systematically overlooked and the two zones will be judged to be equally bright.

What is important here is that the elements of perception – luminosity, edges and colours – are never produced in isolation, but are always produced simultaneously, and that the perception of each affects the perception of the others. The immediate consequence of this is that it is not possible to give even simplified models of this complex interaction. Indeed, some theories eschew any attempt to do so (*see* §II.3 below).

The perception of images is identical to the perception of any other object. Everything we have described applies equally to them. But

15

because they give indications of surface (*see* §III.2 below) and visual edges appear, almost systematically, as separating surfaces within the same plane, the contrast between these surfaces will be more intensely perceived in a figurative image than they would if they were perceived in a real scene resembling the scene figuratively depicted. The chiaroscuro painters, for example, made extensive use of this particularity: the contrast between light and shadow represented by, say, Rembrandt or Caravaggio is very much more intense than it would be in reality; it would be difficult to represent *The Nightwatch* as a tableau vivant. Godard's attempt to do so in *Passion* (1982) is closer to a painting than to real vision because he is still working with a single plane image, in this case, cinematography.

I.3 The Eye and Time

Vision is first and foremost a spatial sense. But temporal factors also play an important part in it for three main reasons:

- most visual stimuli vary across time, or are produced successively;
- our eyes are in constant motion, which means that the information received by the brain is constantly changing;
- perception itself is not an instantaneous process – certain stages of perception are rapid, others much slower, but the processing of information always takes place in time.

The following measurements of the duration of neurological processes can be given: light moves very rapidly, covering 3 metres in 10^{-8} of a second; retinal receptors react in less than 1 millisecond when they are rested; at least 50–150 milliseconds elapse between the stimulation of the receptor and the excitation of the cortex. It has been shown that most of the 'lost' time relates to the retina (about 100 to 150 milliseconds, or about one tenth of a second, which is, neurologically speaking, considerable).

I.3.1 Temporal Variations Light Phenomena

Here we will address only two of the most significant phenomena of temporal variation.

Adaptation. A very extensive area of the eye is particularly sensitive to luminosity (between 10^{-6} to 10^7 cd/m^2), but at any moment in real life, the range of luminosity which it may perceive rarely exceeds factor 100 (between 1 and 100 cd/m^2 in a lit room, between 10 and 100 outdoors, and between 0.01 and 1 at night). When it encounters a sudden change of luminosity, the eye goes 'blind' for a while.

Adaptation to light is more rapid than adaptation to darkness: it is sometimes painful to leave a cinema and walk into bright sunlight but normal vision soon returns, whereas when entering a cinema it takes quite a long time before anything at all is visible (apart from the screen which is usually fairly bright). In numerical terms, adaptation to light

16

takes a few seconds (according to the intensity of the adaptation which must be made), adaptation to darkness takes longer, up to 35 to 40 minutes (about 10 minutes for the cones to reach maximum sensitivity, and another 30 minutes for the rods to do so).

These phenomena of adaptation are theoretically explained only in terms of their chemical processes (the reconstitution of rhodospin). But they are well-known empirically and have given rise to a number of gadgets which aim to decrease the length of time required to adapt to darkness. For instance, red-tinted glasses can be used to read a map at night without losing visual adaptation to darkness. The reason for this is that red stimulates mainly the cones, allowing the rods to remain adapted to the darkness.

The eye's capacity for temporal separation. Numerous experiments have shown that the eye will perceive two luminous phenomena as non-synchronous only if they are separated enough in time: it takes at least 60–80 milliseconds to differentiate between them with any certainty, and this must be extended to 100 milliseconds (one-tenth of a second) if perception of temporal priority (which light was first) is to be achieved. In absolute terms, this duration may seem short. In fact, it is quite long if compared to other sensory processes such as the auditory system, which has a temporal resolution of only a few microseconds.

Similarly, the eye is not very good at differentiating between successive light stimuli. For example, above six to eight flashes per second, the eye no longer perceives differentiated events, but sees a continuum through a process of integration.

I.3.2 Eye Movement

Not only are our eyes in almost continual movement, but our heads and bodies are also in motion: the retina is thus perpetually in motion in relation to the perceived environment. This continual motion might easily be seen as a source of visual 'noise', the effects of which it would be necessary to mitigate. However, this is not the case. On the contrary, it seems that perception depends on these movements. By artificially and laboriously immobilising the retinal image, it has been shown that if this immobilisation is maintained for about one second (which corresponds roughly to the size of three receptors on the retina), there is a progressive loss of perception of colour and form, and a sort of fogginess gradually begins to cloud the image. Retinal movement is thus indispensable to perception (*see* §II.1 below).

Ocular movements are of several types:

- very rapid *jerky* movements (of about one-tenth of a second) which are sudden and either voluntary (as for example, during a search, like finding the beginning of the next line of a text or when looking at a picture) or involuntary (when the eye moves in order to explore a stimulus perceived at the periphery of the retina). Their latent time

(the time necessary for them to begin) is relatively long, of the order of two-tenths of a second;

- *tracking* movements, through which an object in (sufficiently slow) motion is followed; these are slower, smoother movements which are almost impossible to reproduce without the presence of a moving target;
- *compensatory* movements which aim to maintain fixation during the movement of the head or the body – these are entirely reflex actions;
- *drifting* without any identifiable object, which is evidence of the eye's inability to remain fixed; it is a movement of moderate speed, of no great amplitude, continuously corrected by 'micro-jerks' which rapidly bring the eye back to its fixed point.

Although we are not aware of it, such movements do entail to greater or lesser degrees a loss of sensitivity.

I.3.3 Temporal Factors in Perception

Time is fundamental to perception. We have come to know more about this since the discovery in 1974 of the existence of two types of cell in the optic nerve: one type specialises in reacting to permanent states of stimulation, the other one to transitory states.

The 'permanent' cells have a smaller receptor field, corresponding to the fovea, which operate when the image is sharp; the 'transitory' cells have a broader field and react to changing stimuli. The latter are associated with peripheral vision and are not particularly sensitive to unfocused images. Furthermore, the transitory cells can inhibit the permanent cells: the former are more of an alarm system, the latter an analytic tool.

Corresponding to these two types of cells, the visual system has two types of temporal response:

Slow response. This is the sum of the effects of temporal excitation or integration. Excitation takes place at the level of receptors, which, within specific limits, cannot differentiate between a weakish light sustained over some time, and a very brief but intense flash, if the quantity of energy emitted is the same. Integration is produced when several flashes are integrated in one single perception because they fire in rapid succession, faster than a specific critical length (this fusion takes place at post-retinal levels).

However, the best-known effect of this kind is what is called *retinal persistence*, which consists of a prolongation of the activity of the receptors a little while after the end of the stimulus. The length of persistence extends according to the eye's adaptation to the dark, that is to say, it is longer when the eye is most rested or fresh. After an intense flash, the retinal persistence can reach several seconds. When the eye is adapted to darkness, this may be longer by a fraction of a second.

This effect is almost always present in everyday life, even if it may only be perceived in fairly rare circumstances (such as on waking up). It

was a widespread belief that it was also at work in the cinema due to the intense luminosity of the projected images resulting in a length of persistence of something like a quarter of a second. This is no doubt why, for so long, it was believed that the representation of movement could be explained by retinal persistence. A little further on (§II.2) we shall see that this explanation is completely false, and that the movement effect uses completely different optical mechanisms.

Another example often cited is the phenomenon, known since antiquity, of the circle of fire: if a flaming torch held at arm's length is waved in a circle fast enough, the successive images of flames will merge into a circle of light. This effect is only partly due to retinal persistence. Besides, it is obviously completely different from cinematic images as it is a continuous movement, whereas cinema entails the merging of projected, discontinuous images.

Rapid response. This is the sum of the effects of reaction to rapidly varying stimuli. Of these effects, two are of particular importance because they are part of the perception of moving images:

- *flicker*: it is as if the visual system were having difficulty in following variations in an intermittent light, when the frequency although higher than a few cycles per second remains fairly low. The effect is that we seem to see a kind of wavering known as 'flicker'. When the frequency of the appearance of light increases beyond what is called the critical frequency (the value of which depends on the intensity of the light), this effect eventually disappears and then a continuous light is seen. For an average light the critical frequency is in the order of 10Hz, but it can be up to 1000Hz for greater intensities of light. Flickering is produced by all phenomena of intermittent light. They occur in cinema when the projection speed is too slow. Early projectors often produced a flickering image, which is one reason why the speed of projection (and therefore also the speed of shooting) gradually increased from about 12 to 16 and eventually to 24 images per second. When the intensity of projection bulbs increased (notably with arc-lamp projectors), the critical frequency rose to over 24Hz, and at 24 frames per second, the flicker effect reappeared. In order to eliminate it without further increasing the projection speed, which would have entailed serious mechanical problems, a gadget was invented which is still in current use. It consists of a means of doubling and even tripling the blades on the rotating shutter of the projector, thus cutting the projector's light beam two or even three times before the projector moves the film on to the following frame. Thus, with 24 different frames being projected per second, in fact 48 or 72 images are projected per second, which overcomes the 'critical frequency' barrier.
- *visual masking*: light stimuli which follow one another in rapid succession may interact, with the second one disturbing the perception of the first one; this is called the masking effect because it reduces sen-

sitivity to the first stimulus – less contrast is perceived and thus acuity is reduced. This phenomenon, frequently explored since 1975, seems to be linked directly to the different activities of the transitory and the permanent cells. One case often cited as particularly spectacular is that of metacontrast: two light stimuli succeed one another in a short space of time, the second being, moreover, complementary to the first in space. For example, a luminous disc and a luminous ring, the latter's hole corresponding to the size of the disc, follow each other at a 50-millisecond interval: the disc will become almost or totally invisible. Another important example of visual masking is by deploying visual 'noise' (a random structure of lines): this is by far the strongest form of masking.

In cinema, perception of movement may be masked by an 'empty' stimulus, such as a blank frame inserted between two photographic frames (a black frame or the absence of a stimulus will not achieve this effect). It may be the case that the masking of one photogram (frame) by a successive one is one of the conditions that facilitate the perception of movement through the elimination of retinal persistence, but this is far from being conclusively proven, as two successive photograms are generally too similar to effect any real masking. On the other hand, masking is effective every time there is an edit (cut); some experimental films make much use of this phenomenon with their frequent, abrupt editing.

II. From the Visible to the Visual
What we have described so far are the processes pertaining to the sphere of the visible: the main characteristics of the mechanisms of perception and their reaction to light.

However, even the simplest of everyday situations involving sight are much more complex than a simple reaction to isolated stimuli. Next we will give an outline of the way in which we organise what is visible through sight, that is to say, the human characteristics of the visual. The simplest way of doing this is to follow Kant's description of the fundamental 'categories of understanding' and to describe visual perception in terms of space and time.

II.1 The Perception of Space
The choice to exclude the term 'visual' from the heading of this section is deliberate: the visual system has, properly speaking, no organ which specialises in the perception of distance, and in everyday life the perception of space is almost never entirely visual. The idea of space is fundamentally linked to the body and its movement: verticality, especially, is a specific immediate given of our experience via the perception of gravity. We see objects fall vertically, but we also feel gravity through our body. The concept of space is as much derived from tactile and kinetic data as from the visible.

II.1.1 The Study of the Perception of Space

Unlike all the elementary phenomena described above, which can generally be studied using experimental methods in laboratory conditions, the perception of space is a complex phenomenon which can only partly be studied in the rather antiseptic conditions of the laboratory. There will always be some doubt as to the applicability of laboratory data to the perception used in 'normal', everyday perception. For example, the convergence of our two eyes is intrinsically a source of potential information about depth. The role of binocular, parallax vision in the perception of depth can be tested in the laboratory by asking a subject to estimate the distance of a point of light in complete darkness. However, in our ordinary uses of sight, this way of estimating depth is a very rare occurrence; moreover, in such circumstances it is only one source of information, and an uncertain one at that, among other, more powerful, criteria. So perhaps the convergence between the eyes should not be regarded as an indicator of depth at all.

In order to resolve this type of problem, one must decide which analytical model to adopt and how to conceive of the role of perception as a whole (*see* §II.3 below). Such a decision is more important here than it was when considering the elementary structures of perception. The perception of space is an area of study which has to be theory-based from the outset.

II.1.2 Perceptual Constancy

With the exception of phenomena involving elementary particles (since Heisenberg's formulation of the principle of uncertainty, we know that such phenomena are affected by the presence of the observer), the physical properties of the world do not depend on our observation of them. The world has, more or less, always the same appearance, or at least we expect to find within it, from one day to the next, a number of stable elements. It is the perception of these invariables in the world (size of objects, forms, location, orientation, qualities of surfaces and so on) that is described as *perceptual constancy*: despite the variety of perceptions, we locate ourselves through constants. This notion is related to an adjacent concept which could be called *perceptual stability*. Our perception is made up of continuous sampling (alternating eye movements and brief fixations). However, we have no consciousness of either the multiplicity of these successive points of view, nor of the constant blur of eye movements, but rather interpret our perception as being of a stable and continuous scene. There are other phenomena of this kind, for example: the optical image formed on the retina is very blurred and not very coloured at its periphery; the perception of a scene is always *panoramic*, with every point within it being potentially visible (and this potential kept constantly in mind). Furthermore, we see with two eyes and yet we usually have only one image of reality (from which we derive the notion of the 'cyclopean eye', a sort of ideal combination of both eyes (*see* §II.1.5 below)).

All in all, it is clear that the sight of space is far more complex a

process than a simple retinal 'photographic' perception (more about which later). Perceptual constancy and stability cannot be explained except by taking into account the fact that visual perception almost automatically activates *knowledge* about visible reality. We find this idea again at the heart of the main theories of perception (*see* §II.3 below).

II.1.3 Monocular Geometry

Within the terms of the human scale, physical space can be fairly accurately described in terms of a simple and venerable model: the Cartesian geometry of three axes of coordinates. This model, developed through successive refinements of Euclidean geometry, is characterised by the fact that it describes space as having three dimensions. These three dimensions may easily be conceived intuitively with reference to the human body and its position in space: the vertical axis is the direction of gravity and the standing gait; the horizontal dimension is constituted by the line of the shoulders parallel to the visual horizon before us; and, lastly, the third dimension is that of depth which corresponds to the body moving forward in space. (Note that this intuitive understanding should not be confused with geometry itself.)

The first (optical) stage of the processing of light in the system of vision consists of forming a two-dimensional image at the back of the eye. The (optical) retinal image is a projected representation of the diverse luminosities of the perceived scene, and the relation between an object and its retinal 'image' can be calculated through rules of optical geometry. The *projective* nature of the optical image formed in the eye has been known since antiquity. Euclid noted *c.* 300 BC that the image at the back of the eye is smaller if the object is seen from a greater distance. From the 16th century, when the camera obscura was very popular, an analogy has often been made between it and the eye (*see* Chapter 3, §III.2.3 and Chapter 4, §II.1.3). However, to be absolutely accurate it should be noted that the actual relationship between the object and the image is one of great geometrical complexity, because the image is projected on to a spherical surface. Therefore, the analogy with a camera obscura, which has a flat screen-wall, is a loose one. To facilitate visualisation of the retinal image, the process is often depicted as the projection of an object's contours and surfaces on to a plane perpendicular to the angle of vision, but this is only a useful convention.

Once again, we should note that the retinal 'image' is never perceived, but is only one stage of the treatment of light data. It is therefore not very important whether the image is flat or curved, regardless of what has been thought. To give only one example, taken from an author whose work is, in other respects, very important, Erwin Panofsky claims in his book *Perspective as Symbolic Form* that, since retinal images are projected on to concave spherical surfaces, horizontals perceived in front of us will be perceived according to spherical geometry and will appear to be slightly curved, seeming to converge on the periphery of the visual field. According to experimental testing, this is not the case, at least as

far as the useful zone of the visual field is concerned (the central zone up to about 30° or 40° from the fovea); beyond this zone our vision is too indistinct for this fact to have any effect on the way we perceive space.

Monocular geometric vision is enough to supply data which our visual system can then interpret in terms of space: what we call *indices of depth*. In fact, the problem of visual space is essentially that of the perception of depth, the two other dimensions being perceived in more straightforward and less ambiguous ways. The principal indices of monocular depth are as follows:

Gradient of texture. A visual scene consists of objects against a background, and the surfaces of these objects have various consistencies, a kind of 'grain', known as their *texture*. For instance, a brick wall has a double texture: a macro texture comprising the pattern of the bricks and a micro texture consisting of the surfaces of the bricks. An expanse of grass seen from a distance may appear to have a smooth texture, as may a pebbled area. Of course, man-made substances generally have more even textures, for instance textiles, the very term for which evokes the idea of texture.

As visible surfaces are usually at an angle to our axis of vision, the projection of textures on to the retina gives rise to a progressive variation in the texture-image. Technically this is known as their gradient. For some theorists, such as James J. Gibson, the *texture gradient* is the most important element in the perception of space. That is to say, these are the elements which give the most trustworthy data and are also the most important ones for the qualitative assessment of depth. It should be noted that images communicate two types of texture gradient: that of the image's surface itself (such as the textures of paper or canvas), and that of the surfaces represented in the image (*see* §III.2.1 below for the notion of a double reality).

Linear perspective. According to the laws of geometric optics, the light rays that go though the centre of the pupil generally give a real image with a central projection. Roughly speaking (but very close to the truth as far as vision in and around the foveal zone is concerned), this transformation can be described in geometrical terms as a projection emanating from one point onto a flat plane: this is known as centred or *linear perspective.*

Figure 5 shows, in linear perspective, the image of a landscape. We surmise that in the image the lines parallel to the axis of vision (perpendicular to the plane of projection) comprise a family of lines that converge on one point (the intersection of the optical axis and the retina); the size of the uprights parallel to the picture plane decreases with their distance; the elements furthest removed from the eye give an image located closer to the axis of vision, and so on.

The laws of linear perspective are, geometrically speaking, simple and well known. The optico-geometric transformation furnishes a great deal of data about the depth of the scene viewed: apparent diminishing size is interpreted as distance and so on. Of course, this information can be

Figure 5

ambiguous: a three-dimensional scene cannot be transformed into a two-dimensional image without the loss of some information. The proof is that it is impossible to reconstruct a three-dimensional object starting from its projection on to a flat surface. Figure 6 shows that the same figure may be projected as an infinite number of potential objects. That the eye interprets the retinal projections in the vast majority of cases correctly is because it adds independently acquired data to the information culled from perspective. These two types of information can corroborate or negate one another. All in all, perspective and texture gradients provide adequate criteria for resolving many ambiguities or doubts. For example, the combination of the two makes it easy to differentiate an angle or the corner of an object from the edge of a surface.

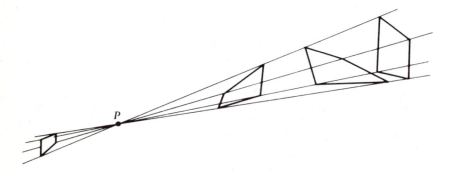

Figure 6 Different objects project on to the retina in the same way.

24

It is worth repeating that linear perspective is only a convenient geometrical model giving an adequate, but not absolute, equivalent of real visual phenomena. It should be added (although we will explore this in greater depth in Chapters 2 and 4) that great care should be taken not to confuse linear perspective, as a model of the way the eye works (hence the fact that it used to be called *perspectiva naturalis*), with the geometric perspective used in painting and later in photography, which derives from a representational convention which is partly arbitrary, and which must be artificially produced (hence the term *perspectiva artificialis*). Although each of these perspectives is based on a similar geometric model, they are not of the same type.

Variations of illumination. In this category we find a range of phenomena such as variations of luminosity and colour, direct and indirect shadows and atmospheric perspective. Atmospheric perspective refers to the fact that objects very far away are seen less clearly and with a bluish tinge due to the greater amount of interposed atmospheric factors (for instance, it may be misty) between the viewer and the distant object. All these variables provide important data about depth, although they may be erroneous: brighter objects appear to be closer and, inversely, objects of a colour similar to the background against which they appear tend to seem further away. One of the most important factors in these variations is the *illumination gradient*, or the progressive variation of lighting on a surface in relation to its curvature, linked to the presence of direct shadows which give objects the appearance of solidity.

Local criteria. These are the criteria linked to the most localised aspects of the retinal image. The main factor to be noted here is *interposition*: objects placed in front of a textured surface conceal part of that surface which will thus be perceived as a *ground* situated behind the object. This criterion is more important in the case of objects which partially conceal other objects and it often allows us to judge the relative distances between less textured objects.

All in all, there are quite a few elements of static monocular vision, but here we will briefly list only a few more.

II.1.4 The Dynamic Indices of Depth

As noted earlier (*see* §I.3 above), in general, the stimulation of the retina changes constantly, but we nevertheless do not lose sense of the continuity of perception (*see* §II.1.2 above). As far as depth and space are concerned, we can say, as a general rule, that static indices have dynamic equivalents. In other words, the indices of depth listed above also give information about depth when there is retinal movement. This information is obviously more complex, but it is an indispensible complement to the information described earlier. For instance, linear perspective is often present in our perception in the form of dynamic perspective: when we move forwards while travelling in a car, the constant transformation of the visual field creates a sort of flux on the retina, a continuous gradient of transformation. The speed of the flux is

inversely proportional to distance (objects close-by seem to move more quickly), and thus provide information about this distance. The direction of the flux depends on the direction of the gaze relative to the direction of movement: if we look straight ahead the flux is mainly directed downwards (that is, if there is nothing above the horizon). On the other hand, if we look behind us, the flux seems to move upwards; if we look to the right, it moves towards the right, and so on.

There are other types of information linked to movement: for example, the *parallax* of movement (the information produced by the relative movement of images on the retina when one moves sideways). As shown in Figure 7, an object situated further away than the focal point seems to move in the direction of the movement; on the other hand, an object in front of the focal point seems to move in the opposite direction. Naturally, if the focal point is changed, the resulting impression of movement is changed as well. For example, if we look out of a moving train's window at the horizon, all the objects in front of this focal point will seem to move in a direction opposite to the direction of the train.

Rotational and radial movement (when an object moves towards or

Figure 7 The retinal images corresponding to the eye's successive positions from positions 1 to 5

26

away from the eye) also provides information about space and the objects within it. In this respect, two things should be noted:

- These indices are simultaneously geometric and kinetic: they are perceived in the cortex rather than in the retina;
- The indices are completely absent from flat images; when we move in front of a picture in a museum, we perceive neither parallax movement nor dynamic perspective within the image; the image moves rigidly and is perceived as a single object.

This is also true of moving images: we must not confuse the *representation* of dynamic indices (as filmed by a moving camera, for example) and dynamic indices caused by our own movement as spectators. If, for example, we move about in front of a television set, there will be no dynamic perspective or parallax *caused by our own movement*. If one object is hidden behind another within the filmic plane, we can only hope to see the hidden object if the camera moves; no matter how much we crane our necks, our own movements will be to no avail.

II.1.5 Binocular Indices
Up to this point, we have considered perception as if it were a question of one single eye. Binocularity introduces some complications into the system. The essential problem of binocularity, recognised by Leonardo da Vinci, is the following: given that, for a fixed focus, our two retinal images are different, how come we perceive objects as single (and in three dimensions)?

The answer to this question, which in some respects is still a puzzle, rests on a concept and a theory:

The concept of corresponding points. For a given focal point, it can be (geometrically) demonstrated that there are a number of points in the binocular field of vision that are perceived as single. The geometrical locus of these points is known as the horoptera and the right and left hand retinal images of each of these points form pairs of *corresponding points*.

When we focus on an object which is fairly close, there is a discord between the two visual axes of our two eyes, neither of which is directed straight ahead. The object is, subjectively, seen in a single direction, located 'between' the *two* eyes: this is called 'subjective direction', linking the object to a single Cyclopean eye imaginarily located between the two eyes. Moreover, all objects located in both visual directions (those of the two optical axes) are perceived as being in the same subjective direction. It is as if the two points corresponding to the two retinas have the same directional value.

When one point in space stimulates two non-corresponding points on the two retinas (which, of course, implies that this point in space is not a focal point, nor that it is even within the horoptera), there will be a disparity between the two retinal images, known as the *retinal disparity*. If

27

this disparity is large, the point will be seen double (which is not a problem because it is necessarily some way away from the focal point); if it is a small disparity, it will be perceived as a single object but at a different distance in space from the focal point. This is the very important phenomenon of *stereoscopic depth*. It exists in all binocular fields of vision, with rods as well as cones, and generates information that can be used about depths of up to 100 or 120 metres from the eye. It also furnishes data about space: whatever is not seen 'in relief' is perceived as *flat*[2], such as a very smooth plastered wall.

Here again, images do not adhere to the rules of stereoscopy, except for those images that are specially constructed to create a stereoscopic effect. The principle of stereoscopic imagery dates from 1838, when Wheatstone invented he *stereoscope*, a gadget which allowed each eye to see a different image. By carefully calculating the differences between the two images, the effect of stereoscopic depth is produced analogous to the effect of real depth. The calculations become much easier, and effectively automatic, with photography: a double, synchronised camera, with two lenses spaced at about the same distance as the eyes, allowed the production of two photographic plates of slightly different views of the same scene. In order to produce a powerful sensation of depth, the two images were viewed through similarly spaced lenses. This gadget was very popular in the second half of the 19th century and again at the beginning of the 20th.

It should be noted that, despite the differences in technology, the principle of stereoscopic cinema is exactly the same: a double image is projected on the screen, representing two corresponding retinal projections, and special glasses enable the separation of the images aimed at each eye (either by red and green filters which give a monochrome image, or by the use of lenses polarised both horizontally and vertically, which enable images to be reproduced in colour). In other words, the special glasses mean that the image intended for the left eye is not read by the right eye, and vice versa.

Theory. There is no universally accepted theory, but the one most current today is that of fusion, suggesting that the interconnecting nerve pathways 'create' one single, 'merged' datum from the two different data provided by the two retinal images. Fusion is not necesarily complete: the theory accounts for a certain rivalry between the eyes, and if, in laboratory conditions, objects that are incompatible to the two eyes are set up to be viewed, what tends to happen is that one of the two eyes predominates and the image it creates is seen as singular, as if it were perceived by both eyes.

II.2 The Perception of Movement

There are many different aspects to the perception of movement. You can approach it in terms of how we perceive the movement of objects, or how we perceive a static world through our own movement, or in terms of the relation between perception and movement, orientation

and motor activity. Here we will deal mainly with the aspects bearing most directly on imagery.

II.2.1 Models of the Perception of Movement

There are many theories aiming to explain the perception of movement. The one most widely accepted these days relates it to two phenomena: on the one hand, the presence in the vision system of motion detectors capable of encoding the signals which affect neighbouring points on the retina, and, on the other hand, knowledge of our own movements which enables us to avoid attributing movement to objects when it is our own body or our eyes which are in fact moving.

The detection of movement. The principle by which these detectors work is simple enough: they seem to be specialised cells which react when retinal receptors close to each other within the field of the cell are activated in rapid succession. In 1962 such cells were discovered in the cortex of cats by Hubel and Wiesel. Some of these cells reacted to the direction of movement and others to its speed. Numerous subsequent experiments provided reasons to believe that human beings also have these kinds of cells.

The most familiar of these data relate to the group of movement-linked phenomena known as the *après-coup* effect, or the after-effect: if one looks for some time (say, one minute) at a regular movement – the classic example is that of a waterfall – and then moves the gaze to a static object, that static object will seem to be moving in the opposite direction. Another spectacular experiment shows that a disc with a spiral on a turntable produces the effect of dilation or contraction, depending on the direction in which the spiral turns: if, looking at it for a couple of minutes, you then look at something else, the new perception will also seem to contract or to dilate.

These effects indicate that cells that have been stimulated for a certain length of time continue to function for a short time after the stimulation has ceased, reading the lack of movement experienced as a movement in the opposite direction.

Knowledge of our own movements. In 1867 Helmholtz noted that we had to be informed constantly about the position of our eyes and our body in order to differentiate between the movements of the reality being observed and the movements of our perception. In fact, information about ocular movements is imprecise and cannot do this. Today, it is generally considered that Helmholtz was more or less right, but that information feedback comes not from ocular musculature, but rather from the 'efferent' brain signal.

The efferent signal is the name given to neuronic activity going from the brain to sensori-motor organs; afferent signals travel in the opposite direction, from the organs to the brain; reafferent data derive from sensory events produced by voluntary movements.

In the 1960s, when cybernetics was fashionable, models aiming to represent the stability of the visual world were constructed. These

models were based on a comparison between the efferent and the reafferent signal, and held that it is this comparison which takes place in the brain and produces the sense of visual stability. This has been corroborated in a number of scientific experiments: for example, if one of the eye muscles is temporarily paralysed and the subject is then asked to move the eye, an efferent signal will be sent even though the muscle does not move, and the subject, comparing this signal to a reafferent signal which does not correspond to any movement of the eye, 'sees' the world move. More simply, it can be supposed that the eye movements which are not ordered by the brain make us lose the stability of the visual world. For example, a finger applied to one eyeball will make it move without the intervention of cerebral nerve centres, resulting not only in the loss of stereoscopic vision, but also of the perception of verticality.

Thresholds of the perception of movement. As in all light phenomena, movement is only perceptible within certain limits. If the retinal projection of a visual edge moves too slowly, it is not perceived as moving (although it may later be perceived as having moved); if it moves too rapidly, it will simply seem blurred. The upper and lower thresholds are a function of a number of variables:

- the size of the object – a large object will need to move more in order to be seen as moving;
- lighting and contrast – the higher the level of these, the better movement can be perceived;
- the environment – the perception of movement is partly relational and is facilitated by the existence of fixed reference points.

It is difficult to perceive the movement of an object against an untextured background: a cloud high up in the middle of the sky, or a boat at sea on the horizon. Movement is more easily seen if it is seen through a window, the edge of which then becomes a fixed reference point. Another example is 'autokinetic' movement whereby a small light in the dark will be perceived as moving spontaneously, regardless of the movements of the eye, because of the lack of a referential context.

II.2.2 Real Movement, Apparent Movement

Up to now, we have assumed that there is real movement to be seen: the movement of a real object placed within our field of vision. However, for some time it has been thought that, in certain conditions, it is possible to perceive movement where no real movement exists. This is known as *apparent movement*.

The main experiment here is the one that gave rise to the concept (Wertheimer, 1912): a subject looks at two points of light, fairly close together in space, lighting up together but at variable times. When the interval between the timing of the two flashes is small, they are perceived as simultaneous. If, on the other hand, the interval between the two flashes is too long, they are perceived as separate and successive events.

It is within the intermediate zone of 30 to 200 milliseconds between the flashes that apparent movement is perceived. Diverse forms of perception have been categorised and labelled in terms of the Greek alphabet: an alpha movement is one of expansion or contraction (with two flashes emanating from the same point but consisting of different sizes); a beta movement refers to the movement described above (movement from one point to another), and so on. The name often given to such phenomena which, although quite different, are related, is the *phi effect*.

Wertheimer formulated the fundamental, still viable hypothesis about the phi effect: it relates to post-retinal processes. The details of the explanations have become more accurate since 1912, but a number of questions remain unresolved:

- *Do real movement and apparent movement have the same receptors?* After many experiments, it seems that complex (or very proximate) stimuli in apparent movement are often dealt with via the same processes as real movement, whereas stimuli that are more binary (such as the two light flashes described earlier) seem to be treated via another mechanism.
- *Which attributes of an object trigger the perception of movement?* Apparently the main criterion here is the brightness of light's impact on the colour and the form of the object: movement is 'first' seen as a phenomenon of light, and is only later attributed to a form and thus to an object.
- *What is the role of masking?* Generally speaking, apparent movement is very sensitive to masking. It is easily obscured if a light is interposed between the two stimuli that are supposed to trigger the perception of movement.
- *What is the relation between the perception of form and the perception of movement?* Experiments to test this question are complex and have yielded less information. Apparent movement has been created through recourse to successive stimulations of very different shapes: the subject then often receives the impression that these forms not only move but that they gradually change into one another, which is exactly the process used in animation films such as those of Robert Breer or Norman McLaren. However, these experiments are difficult to interpret. It has been suggested that there must be a double system in operation, one part decoding information regarding the location of the stimulus, the other informing us about the identity of the object, but this remains a hypothesis.

II.2.3 The Case of Cinema

Cinema consists of static images projected on to a screen at regular intervals. These images are separated by black spaces, produced by the intermittent obstruction of the projector's lens by a rotating shutter as the film moves from one photogram to the next. In other words, the film spectator receives a discontinuous stimulus of light which gives an

impression of continuity (if the flickering effect can be overcome, *see* §I.3.3 below), and, moreover, it gives the impression of movement within the image through various kinds of phi effect. Moreover, the apparent movement in film results from successive stimuli that are fairly similar, at least within one particular shot. It can, therefore, be suggested (following the first of the points made in §II.2.2 above), that it is based on *the same mechanism as the perception of real movement*. The consequences of this hypothesis (currently regarded as the most plausible one) are obvious: in cinema, apparent movement cannot easily be physiologically differentiated from real movement. There is a perfect illusion, based on the innate structure of our visual perception mechanism. Recent developments in the study of visual perception provide startling confirmation of the hypotheses formulated by the Filmology School (1947–50). At the time, these were more intuitive than scientific, but they were later taken up and systematised by, among others, Christian Metz in his early writings (1964–65).

Furthermore, as noted earlier, although the insertion of a white photogram blocks apparent movement by means of the masking effect, the insertion of a black frame seems to play a different role: that of masking the edge. Current opinion holds that detailed information about edges and outlines is temporarily suppressed with each black frame between successive photograms, and that it is this masking effect which accounts for the fact that there is no accumulation of persisting images caused by retinal persistence: at each moment, only the present screen image is perceived, the previous image having been erased by the masking.

As early as 1912, when Wertheimer published his experiments, the theory of apparent movement through the phi effect was cited by Frederick Talbot in his book *Moving Pictures: How They Are Made and Worked*, and in 1916 by Hugo Münsterberg in his book *The Photoplay: A Psychological Study*, where it receives a more detailed discussion. It is all the more surprising then to find that writers as important as André Bazin and Jean-Louis Comolli have continued to perpetuate the totally erroneous theory of retinal persistence in film. The perpetuation of this, inherently absurd, explanation is due to intellectual inertia. It cannot be stressed too much that, although retinal persistence does exist, it does not exist in the cinema's production of the impression of continuity. If it were to exist in the spectatorship of film, it would only cause a blur of images interfering with each other. Perception of film is only possible because of the phi effect and because of the effects of visual masking, which effectively rids us of persistence of vision.

II.3 The Main Approaches to Visual Perception

The questions raised in the second half of this chapter are among the most complicated issues in the study of visual perception. They refer to the two fundamental categories of space and of time, they call into question the very concepts of the visible, of vision and of the relation between the two, that is to say, perception. For three centuries the debates in this

field have been conducted in terms of two main approaches and their successive variations: an analytic approach and a synthetic approach.

II.3.1 The Analytic Approach

As the name implies, this approach consists of starting with an analysis of the stimulation of the mechanisms of vision by light and seeks to relate the scientifically isolated and identified elements to various aspects of real perceptual experience. This tendency has been strengthened by research into brain structure, which has uncovered the existence of specialist cells for the elementary functions of the perception of edges, lines, directional movement and so on.

The most typical examples of this approach are the 'systems' and 'algorithmic' theories which were much in evidence in the 60s, when the advent of computers made it possible to believe that sufficiently complex systems could account for all natural phenomena (we are more cautious nowadays). According to these theories, the perceptual system creates truthful percepts, that is to say, percepts which correspond to the reality of the surrounding world and which enable predictive accounts by combining variable elements according to specific rules.

In addition to being systematic, these theories also consider the information contained in retinal projection to be insufficient in itself to account for the precision of our perception of objects in space, and that the latter demands explanation in terms of other sources. Therefore, to the combinations and algorithms they add both *intrinsic* elements of retinal vision, identified analytically, and *extrinsic* variables linked to other processes (efferent signals controlling eye movements, memory and so on). These two characteristics were already at work in the earliest analytic theories, sometimes called 'empirical' theories, from Berkeley (1709) to Helmholtz (1850). These theories emphasised the connections and associations, learned from experience, between visual and non-visual data (which is why these theories are labelled *associationism*). These early theories emphasised *learning,* leading to the association and integration of heterogeneous data.

All analytic theories rest on what is known as the *invariance hypothesis*. For a given configuration of retinal projection there are, as noted above, an infinite number of possible objects that could produce this configuration. The invariance hypothesis consists of supposing that, from amidst this group of objects, the observer chooses to see one and only one alone. The empiricist model supposes that there is a repeated application of this hypothesis, on a trial-and-error basis: if an application proves wrong, the visual system 'revises' its invariance hypothesis and produces others in order to make all hypotheses correspond to a possible configuration (from learned experience or from associations). The invariance hypothesis is thus linked to the phenomenon of visual constancy mentioned earlier. For example, the *constancy of orientation,* which means that the orientation of static objects remains seen as such despite changes in the retinal image, results from an algorithm compris-

ing, among other things, recognition of the body's orientation in space. The *constancy of size* would then be the result of the algorithm relating retinal size to information about distance (sometimes called the 'law of the square of distances'), and so on.

Naturally, in these theories which combine visual and non-visual phenomena, the role of the observer is considered to be important.

- There are characteristic *tendencies*, more or less similar for everybody, such as the tendency to equidistance (when the indices of relative distance are not clear, objects tend to appear equidistant), or the tendency to specific distance (in the absence of sufficient data about absolute distance, objects tend to be seen as being at the same distance, of about two metres). In general terms, it could be said that if the visual system lacks some of the elements required to interpret what has been seen, it prefers to invent a response rather than not to give one at all.
- In addition, it seems that repeated encounters with the visual world produces habits of perception which become *expectations* about the predictable outcome of perceptual (and motor) acts. These expectations are largely the basis of the invariance hypotheses formulated about objects in the visual world. A common example of this is the notion of a 'hill'. Semantically, the term is rather vague and does not refer to any specific size of geographical protuberance; on the other hand, real hills do vary a great deal in shape and size and it is impossible to assess the actual size of a hill in a landscape without bringing to bear other visual reference points.

II.3.2 The Synthetic Approach

This consists of finding equivalents for the visual world in the stimuli alone. According to these accounts, the optical image on the retina, including, of course, the changes which it undergoes over time, contains all the information necessary for perceiving objects in space, because our perception mechanism is sophisticated enough to achieve this all by itself.

In the 19th century this approach was represented by the innatist accounts of perception (notably that of Ewald Herring), which, as the name implies, are defined in opposition to theories which define vision as an acquired process. At the beginning of the 20th century, emphasis was put by the theoreticians of form on the innate capacity of the brain to organise the visual according to universal and unchanging laws. This was the so-called Gestalt theory. From 1950 onwards, following the work of J. J. Gibson and others, this approach has once again entered circulation, first under the guise of *psychophysiology* and then as the *ecological* theory of visual perception.

The originality of Gibson's theory (1966) is that it considers transformations of retinal projections as an irreducible, unanalysable whole. According to him, the elements defined by analysis exist only in the

artificial world of the laboratory in which they are isolated and not in everyday 'normal' perception. Hence his proposition of an 'ecological' approach, eschewing experimental data and considering only 'natural' perception. According to this theory, every retinal image creates a unique total perception: the variables of this perception are more difficult to define in this type of theory than they are in analytic theories, and they are also more complexly structured. The notion of a *complex variable* is at the heart of Gibson's theory, and the textural gradients are one of the examples repeatedly taken up in this respect. Textural gradients are held to be correlates of the perception of inclined surfaces. In other words, the gradient of texture in the retinal image is a stimulus for the perception of a continuum of variation in distance. Therefore, according to this approach, the discontinuities of light in the retinal image only provide information about spatial relations. They are not *image*s of space, which would be the result of an interpretation. Moreover, retinal projection contains enough information about spatial relations for the viewing subject never (or rarely) to need to have recourse to sources of information such as those brought into play by associationism.

The logic inherent in this approach is unusual, especially in its ecological aspect. For example, one of its logical premises is the existence of a ground: a surface which stretches into the third dimension provides a base for motor activity and is almost always part of the visual field (as is the supposition that the upper part of the visual field is almost always the sky.[3] The retinal projection of an object is described in terms of the surfaces around this object; the perceptual constant is thus a direct consequence of the normal perception of textured objects on textured surfaces. It is not necessary to know an object's distance in order to know what the object is, nor is it necessary to have already seen it in order to perceive it as having a size and shape. Finally, in this approach, the retinal *flux* is imbued with a specific importance as every variety of movement, of the object or of the observer, produces a specific, unique pattern of transformations of the retina. For example, the movement of an object in relation to other objects is perceived when the retinal projection contains a perspectival transformation associated with a cinematic optical occlusion (a moving object progressively covers and uncovers the texture of the surface behind it).

Two significant aspects of this approach should be noted:

- It presupposes that we notice the variations within the structures of retinal images by referring them to a continuum (of surfaces) and to a constant (of objects): objects momentarily outside the sphere of vision continue to be thought of as objects. We should note, in passing, the similarity between this idea and the analogous suspension of disbelief involved in the plausibility of 'off-screen' space which is at the heart of cinematic representation and even, to some extent, of painting.
- It rests on the idea that complex and densely coded retinal stimu-

lation gives access to the *invariants* of the visual world, to its most basic and intrinsic qualities. For Gibson, the goal of perception is to furnish some sort of *scale* of evaluation of the *visible world* (which, of course, is not to be confused with the momentary *visual field*). Movement and sequentiality, and thus time, are essential to the construction of this spatial scale which underpins the perceived world. Here again we should note the cinematic analogy; when discussing the cinematic image, Gibson tends to confuse it too readily with the direct perception of the world – he too often forgets the conventional aspects of cinematography.

For Gibson, perception is to perceive the characteristics of the environment in relation to the creatures that live in it. Light gives us all the data necessary for this, within genres of dynamic perspective (the relation *between* subject and environment) and invariable structures (events and objects *in* the environment). The role of the system of vision is, according to him, neither to decode inputs, nor to construct percepts, but to *extract information*. Perception is a *direct* activity.

II.3.3 Which Is Better?
This is a deliberately naive question. Each of the theories is based on a great amount of experimental data which confirm their hypotheses. The theories, in any case, are not completely contradictory because they do not have identical objects. To take up the points made by Irving Rock (1977), they study two different forms of perception: the *form of constancy*, which is dominant in everyday life and which is, because aimed at the physical world, objective, and the *form of proximity*, which is not geared towards everyday behaviour, but plays an important part in total perception (even if it is difficult to describe).

It is difficult to compare the two theories because any experiment aiming to study a complex variable (in Gibson's sense of the term) in laboratory conditions will be refuted by Gibsonians since they claim that it is meaningless to isolate any variable, even a complex one. Many experiments have shown that the textural gradient, isolated under laboratory conditions is less effective as an index of space than perspective. This fact is not a problem for Gibson's followers, as they claim that textural gradients do not exist in isolation but only as an attribute of an object's surface against a background in a context which provides a spatial scale.

At the same time, the most recent accounts of the two main approaches (Hochberg's 'constructivism' and Gibson's 'ecological theory') are less mutually contradictory than their earlier versions. Two issues that were deemed crucial at the start of the century are no longer significant today:

- The opposition between innate and acquired vision is no longer current; Gibson does not necessarily suppose that the mechanisms linked

to his complex variables are innate, and the latter are probably acquired through normal learning (which fits in very well with the notion of an ecology of perception). Inversely, the algorithms of the constructivists do not need the notion that specific learning processes are required for these constructions. Briefly, it is generally believed that we have an innate capacity to learn, that perception is innate in the newborn infant and is learned by adults.

- As a corollary to this, the opposition between what might be exclusively visual information and the combination of visual and non-visual information is much less acute than it was with the conflict between Gestalt theory and associationism earlier this century. Here, too, we find links between, if not syntheses of, the two theories (for example, between the concepts of gradient and indices of depth).

The basic problem which remains, and which differentiates the two approaches, is the following: is there, or is there not, a new characteristic (such as Gibson's hypothesis of a 'total visual scale') which manifests itself when visual information is present in a coherent way over the entire retinal surface? Or are we dealing with the perception of a collection of separate, isolated events?

Of course, this debate cannot be settled once and for all. The most one can do is to take new opinions into account: almost all recent advances in the understanding of brain functions indicate that the latter work not only through the co-operation of very many specialised functions, but through certain general, delocalised or 'total' processes, which imply either parallelism or bilateral connections. For example, a few years ago it was discovered that some birds, such as owls, have a map of auditory space, different from all projection of sensory information, located at the level of cerebral neurones. It is possible that Gibson's complex variables work in a similar way.

While awaiting verification or falsification, each of the two theories has its advantages and usefulness, and we will refer to one or the other whenever it seems appropriate, as if they were, in terms of contemporary science, equally likely to be correct.

III. From the Visual to the Imaginary
The move from the question of the visible to that of the visual opens up the problem of the place of the viewing subject, an issue which needs further exploration at least in two directions:

- First, it must be made clear that the eye is not the same as the look. To discuss visual information or algorithms is very interesting, but it leaves aside the question of who constructs these algorithms, who uses this information and why they do so.
- Then, we have to return, briefly, to the main aspects of what has been discussed so far, applying it very specifically to the question of the perception of images.

37

III.1 The Eye and the Look

Naturally, with the notion of the *look*, we already leave the sphere of the visual strictly speaking. Before examining the notion of the look in a psychoanalytic framework in Chapter 2, a preliminary, more limited definition can be proposed: the look is what defines the intentionality and the aim of sight. It is, in a way, the specifically human dimension of vision.

The psychology of visual perception has contributed important work to the study of some forms of the look. It has addressed those forms of the look which are closest to consciousness, that is to say, those furthest from the unconscious, since psychological studies are almost all cognitive in orientation (*see* Chapter 2, §I.2.4). The selectivity of the look in particular has been addressed in this way, with an examination of the issues of 'attention' and 'visual search'.

III.1.1 Visual Attention

Attention is always given a central role, but it is never precisely defined. There are many experiments on this topic, but they nearly all fail to produce results that can be reliably interpreted, due to their almost tautological structure: in order to define attention and to test it experimentally, there must already be a definition of it, which then runs the risk of being the common-sense definition.

One distinction is fairly common, although it appears under various names: that between *central* and *peripheral* attention.

- Central attention, conceived as a kind of focalisation on important aspects of the visual field, is distinguished through what has been called a process of pre-attention. Ulrich Neisser, one of the founders of cognitive psychology, describes this as a sort of division of the visual field into object and ground, allowing attention to fix itself to either of these according to necessity.
- Peripheral attention is a vaguer concept and mostly concerns the attention given to new phenomena on the periphery of the visual field.

This distinction supports the notion of a useful visual field, the zone around the point of fixation in which the subject may register information at any given moment. The size of the useful field is constituted by an angle of just a few degrees around the fovea and depends largely on the type of visual task that is being performed. The useful field is greater when the stimulus to be detected or registered is a simple one. Moreover, it has been demonstrated that the entire surface of the visual field, up to around 30° of the fovea, can be explored without moving the eyes, simply by directing one's attention successively to all the zones of this surface.

III.1.2 Visual Search

The term 'search' is used to refer to the process linking several fixations

on one and the same visual scene in order to explore it in greater detail. Obviously, this process is closely linked to attention and information, as each successive fixation point is determined by the object of the search, the nature of the currently fixated point and the type of visual field involved. If the visual scene is a landscape being observed from a hilltop, the points of visual search will be different (different rhythms, different sequence of fixation points) according to whether the spectator is a geologist, an agriculturalist or an art historian. This is a simplistic example, but it serves to underscore the fact that visual searching exists only in the context of a more or less conscious research project (this is the case even in the apparent absence of such a project as when we glean interesting information without any prejudgment as to its nature).

This notion of the search is particularly interesting in the case of images. It has long been noted, at least since the 1930s, that we do not look at images in one go, but through successive fixations. All experimental findings more or less agree that where there is an image being looked at without any specific aim, the successive fixation points last a few tenths of a second each and are limited to those parts of the image that are most intensively informative (this can be defined fairly rigorously as those parts of the image which, when remembered, enable the viewer to recognise the image when it appears again).

What is especially striking about these experiments is the complete absence of any regularity in the sequence of fixation points. There is no systematic reading of the image from top to bottom or from left to right, there is no general visual plan. On the contrary, there are several fixation points very close together in each intensively informative zone, and a complex route between these zones (see Figure 8). Predictions about the way the eye scans an image have been attempted, but in the absence of specific instructions to the viewer, the movements form a random latticework of broken lines. The only repeatedly obtained result is that these movements are influenced by the introduction of specific instructions to the viewer, which confirms that an informed gaze moves differently within the field of exploration.

The important thing to remember in the context of this book is that the image, like any visual scene observed over time, is seen not only in time, but through a form of exploration that is rarely innocent, and that it is the *integration* of these many successive fixation points which creates what we call our vision of an image.

III.2 The Perception of Images
Our concern here is with the most prevalent type of images in our culture, that is to say, with flat visual images such as paintings, engravings, drawings, photographs, films, television and even synthetic images. More problematically, we are also limiting our study to the somewhat arbitrarily selected sphere of the perception of these images, bracketing the interpretation of images. Subsequent chapters address the use of images within subjective and social contexts.

Figure 8 Eye movements during the visual exploration of the image

III.2.1 The Double Reality of Images

The image in Figure 9, a production still of *Riso amaro*, aka *Bitter Rice* (1949), by Giuseppe De Santis, is a reproduction of a flat image in which we can easily recognise a spatial arrangement similar to what we might encounter in a real scene. In other words, we perceive the image simultaneously as a fragment of a flat surface and as a fragment of a three-dimensional space. It is this fundamental psychological phenomenon that we call the *double perceptual reality of images*, or, more briefly, the double reality of images.

The abbreviated term 'double reality' has become so widely used that it is difficult to avoid using it. Nevertheless, it should be noted that it is potentially misleading: the two 'realities' of the image are not at all similar. The image as a fragment of a flat surface is an object that can be touched, moved and seen, whereas the image as a fragment of the three-dimensional world exists exclusively through sight. It is important to remember that the term implies the unspoken concept of a 'perceptual' double reality, without which the phrase would be meaningless.

Information about the two-dimensional reality of images. For a single eye in a fixed position, the flat image contains three potential sources of information: the frame and the support of the image; the (textured) surface of the image itself; the flaws of analogical representation, especially the fact that in the picture, the colours are often less saturated and the contrasts less bold than they would be in reality. In binocular and/or mobile vision, information on the flatness of the image is much more plentiful: every movement of the eye confirms that the perspective within the image does not change, and there is no disparity between the two retinal images. Each of these factors confirms that we are dealing with a flat

40

Figure 9 Production still from Bitter Rice *(1949)*

41

surface. Therefore, in normal vision (for instance, a viewer looking at paintings with both eyes while moving through a museum), images appear to be flat.

Information about the three-dimensional reality of images. Unlike the omnipresent two-dimensional information, images can only be perceived as having a three-dimensional reality if this has carefully been constructed. In order to do this, it is necessary to imitate as closely as possible certain characteristics of natural sight (and the list of these characteristics would be as long as the list of the characteristics of vision itself).

Such a list, drawn up for the use of painters, was made by Leonardo da Vinci in his *Treatise on Painting*. This list is sometimes referred to as Leonardo's rules. He observes, for instance, that objects close to the picture plane should be painted in more saturated colours, with clearer outlines and a rougher texture; objects further away should be painted higher up on the picture plane, smaller, paler and more finely textured; lines that are parallel in reality should converge in the image, and so on. These rules enable the spatial scale of the painted surface to reproduce on the retina discontinuities of light and colour comparable to those produced by a real (not a painted) scene, with the exception of the blurred edges.

It should be noted that such blurred edges constitute one of the most significant differences between an artificial image and a retinal (optical) image: the retinal image is only focused at the centre whereas an artificial image, which is made to be explored all over by a moving eye, is uniformly focused. As far as the edges of images are concerned, the camera, like the camera obscura, follows Leonardo's rules. At various stages in the history of painting, further conventions were added to these rules, all designed to make paintings resemble retinal imagery, such as the rule of 'local' colour, which aims to reproduce the effect found in natural vision when two different colours in close proximity mutually 'influence' each other.

The compensation for point of view hypothesis. This is one of the most striking corollaries of the notion of double reality. In 1970 Maurice Pirenne put forward the following hypothesis: to the extent that one can register both the two-dimensional and the three-dimensional realities of an image, first, the correct point of view of the image can be determined (the view which corresponds to the perspectival construction), and secondly, the retinal distortions created by an incorrect point of view can be compensated for. In other words, it is because the image is seen as a flat surface that the picture's imaginary third dimension can be more readily perceived.

This hypothesis may seem surprising, as it appears to contradict current opinion, which holds that we will believe more in the reality represented in the image if we forget that it is, precisely, an image. In fact, there is no real contradiction. Pirenne's hypothesis does not take into account the spectator's *knowledge*, nor the effects of *belief* that may be induced by the image. It applies to a level that precedes these psycho-

logical phenomena. And at this level, it has often been experimentally proven, and the existence of a compensatory mechanism has been demonstrated, without, however, being entirely explained.

Compensation is all the more effective when the spectator can move and use both eyes, that is to say, when the spectator can confirm by every means possible the existence and the nature of the image's surface. We need not stress the importance of this hypothesis for our perception of images: in museums, at the cinema or when watching television, we rarely occupy the exact position constructed for the spectator by the image's perspective. Without a compensatory mechanism we would see only distorted images.

Double reality and learning. If the perception of depth in images at least partly mobilises the same mechanisms used in the perception of real depth, then the perception of images develops, as does retinal perception, with age and experience, although both aspects do not necessarily develop at the same rythm. It seems that childen up to the age of about three cannot see the two-dimensionality of images very well and tend to treat the retinal images from such pictures as if they were created by real objects. A specific but interesting example is that of the direction of light. An adult used to images always supposes that light emanates from the top of a painting, even when the picture is turned upside down. For instance, when looking at an upside-down photograph of lunar craters, these will be perceived not as hollows, but as a kind of blistered surface.

Figure 10 A frame still from Alain Resnais' Hiroshima mon amour *(1959). If one looks at the still from a tangent, the represented scene will be correctly perceived, but no matter how much we crane our necks, we will never be able to compensate for the deformation of the photographs exhibited on the central panels, photographs themselves shot at a tangent.*

43

The ability to see an image as a flat object generally comes later than the ability to see depth, and everything would seem to indicate that this is the reason why young children, who only see depth, read images wrongly.

III.2.2 The Principle of Highest Probability

Images are very paradoxical visual objects: they are two-dimensional and yet enable objects to be seen in three dimensions. This paradoxical characteristic is linked, of course, to the fact that images depict absent objects, which makes them a type of symbol. The capacity to respond to images is one step toward the symbolic.

As projections of three-dimensional reality on to two dimensions, they imply a loss of information by 'compression'. It should be remembered that, geometrically speaking, an image in perspective can be the image of an infinite number of objects having the same projection: there will always be ambiguities about the perception of depth. That represented objects are almost invariably recognised, at least by form, is remarkable: it must be the case that the brain chooses the most probable image from all the possible geometric configurations available to it. The image will present problems only if it presents contradictory characteristics, or if the representation is insufficiently informative, as is the case with ambiguous, paradoxical, uncertain figures such as the one in Figure 11.

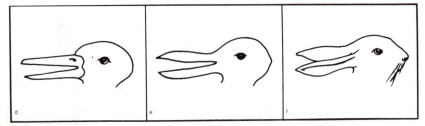

Figure 11. Duck or rabbit? The central figure is ambiguous.

Here, despite the formal similarity between the principle of highest probability and the hypothesis of invariance which underlies perceptual constancy, we begin to leave the sphere of simple perception in order and we enter the sphere of cognition: the selection of the most probable object uses the same processes as real vision, but refers, beyond this, to a range of symbolic representations of objects, already known and recognised, in the visual cortex.

III.2.3 Elementary Illusions

An image is said to produce an illusion when the viewer describes a perception which does not match any physical attribute of the stimulus. Here, we will only discuss illusions about the judgment of size and distance, and not, for example, the illusions linked to the persistence of

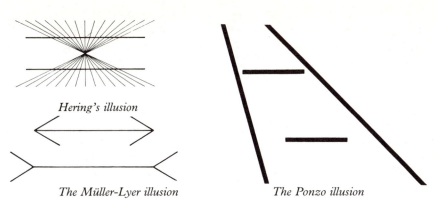

Hering's illusion

The Müller-Lyer illusion　　　　*The Ponzo illusion*

Figure 12

vision, such as the illusion of the waterfall referred to earlier. Figure 12 gives some classic examples of size and distance illusions.

These elementary illusions are drawings which are not intended as depictions of real scenes and they contain many indices of two-dimensionality. According to a hypothesis formulated by R. L. Gregory, the illusion generated by these images derives from the interpretation of the drawings in three dimensions, that is to say, from the introduction of a displaced perceptual constant, despite the fact that these images are rarely consciously interpreted in terms of depth. For example, in Ponzo's illusion, the upper horzontal is seen as further away because of the perspectival effect produced by the convergence of the diagonal lines. Consequently, because it is seen as further away, and since it is also seen as having a projection which is as large as that of the 'nearer' line, it is 'seen' as, in fact, being larger. Similarly, in the Müller-Lyer illusion, the lower horizontal is seen as an internal angle and it is 'enlarged' in order to compensate for it supposedly being further away.

These and many other illusions were intensively studied in the 60s and 70s, especially by the British school following R. L. Gregory and Béla Julesz, as objects likely to throw light on certain mechanisms of perception. These researchers were struck by the capacity of the visual system to attribute to (in this case very simplified) images non-visual characteristics, notably spatial characteristics. This is the conclusion that we too will emphasise: the image is almost automatically perceived in relation to spatial and three-dimensional terms. Such elementary illusions are simply spectacular manifestations of the perceptual system's tendency to use this capacity.

III.2.4 The Perception of Form

The notion of form is an old one and is rendered exceedingly complex by its use in a great number of different contexts. We use it here in the sense of a 'total form', the 'collective form' characteristic of an object represented in an image, or of a symbol without phenomenal existence

45

in the real world. It is a question of the perception of form as an entity in itself and as a configuration implying the existence of a whole which rationally structures the parts. For example, a human form will be recognised in an image not only if it can be identified by face, neck, torso, arms and so on (each of these elements having its own characteristic form), but if certain spatial relations between these elements are maintained.

If considered in this way, the notion of form is relatively abstract and relatively independent of the physical characteristics of the material in which it is realised. A form can, for example, change its size, its place, even some of its constituent elements (e.g. dots instead of a continuous line), without being really altered as a form. This aspect has been established most clearly by Gestalt theory, which defines form as a system of unvarying relations between specific elements.

Form, visual edges, objects. All experiments confirm the (common-sense) idea that it is the visual edges present in the stimulus which furnish the information necessary for the perception of form. Many devices which aim to produce homogeneous light, without edges, demonstrate that one is then not only unable to perceive form but, very rapidly, unable to perceive at all. The second common-sense idea to be proven by experimental methods is that the perception of form takes time. Even if a very simple visual form (a circle, triangle or square) is shown to a spectator in a weak light and for a short length of time, the subject will only have a dim recollection of having been shown something and will not really know what was shown. In this type of experiment the results seem to indicate that the visual system helps to construct a form: an increase in the length of viewing time makes the form recognisable.

With figurative images, the perception of the form is inseparable not only from the perception of edges, but from that of the objects represented: in these images, especially in the vast majority of photographic and videographic images, the problem of the perception of form is the problem of the perception of visual objects. The perception of form becomes more difficult, or less habitual, when the image is abstract, more symbolic (or when depth is depicted incorrectly). In all cases where information about depth is absent or inadequate, other principles of formal organisation can be activated.

The separation of figure and ground. This double notion of figure and ground, which has now become part of ordinary language, was first introduced by psychologists of perception to designate a division of the visual field into two zones, separated by a outline. The figure is located inside the outline (a closed visual edge), it has a form and is more or less like an object, even if not a recognisable object; it is perceived as being nearer and as having a more visible colour. In experiments it is more easily identified amd named, more easily linked to semantic, aesthetic and emotional values. The ground, on the contrary, is more or less formless, more or less homogeneous and is perceived as extending behind the figure.

This distinction originates in the kind of everyday perception described by the ecological concept of sight: we perceive figures (collections of textured surfaces constituting objects) on grounds (surfaces, whether textured or not, belonging to objects or not). It is even one of the constants of all real perceptual scenes. The practical importance of the distinction between figure and ground is well demonstrated by techniques developed to undermine it, such as *camouflage* which aims to incorporate the figure into the ground, using one or several of the characteristics of the figure listed above. Gestalt theory suggested that the separation of figure and ground is a spontaneous organising structure of the visual system: all form is perceived in its context, in its surrounding, and the figure/ground relation is the abstract structure of this contextualising interaction.

This Gestaltist concept has been criticised by analytic theories which have shown that: first, the separation of figure from ground is not instantaneous, but takes time; second, that it is not even a primary process in relation to other processes such as visual exploration, peripheral vision or spectatorial expectations; and, lastly, that the local criteria of depth are insufficient or ambiguous (see Figure 11 above). According to constructivists, the perception of figure/ground in reality corresponds to the extent of the real distance between the two visual structures when one goes beyond the object's outline. On the other hand, as far as visual surfaces are concerned, and hence images, this is a wholly learned, cultural phenomenon.

On this point there is a stark opposition between the innatist Gestalt theory and the theory of learned information, constructivism. In the rest of this book, we will implicitly use constructivist concepts and we will suppose that, *as far as images are concerned*, the distinction between figure

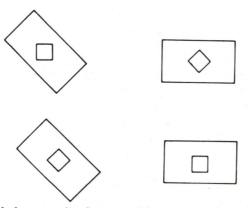

Figure 13 An example demonstrating the power of the context on the perception of form: a very simple form such as a square, shown at an angle of 45°, will be seen as a rhombus. On the other hand, if it is put into a rectangular context, it appears to be a figure on a ground that is limited and framed in its own right, and this ground has an effect.

and ground is learned. However, to avoid any misunderstanding, let us emphasise that this does not imply that the distinction between the theories is arbitrary: if the real world is visually structured in terms of figures on a ground, as the majority of theories of perception suppose, then the transposition of this notion on to images does not require us to establish an additional convention to those which govern figurative images in general. On the contrary, it forms part of the very notion of figuration itself. The vocabulary is coherent here: the *figurative* image is that which produces or reproduces *figures* and their ground.

Regular structures of form. This refers to the general principles of the perception of form (figurative or abstract, although more clearly in the latter), which have also been proposed by Gestalt theory. The Gestaltist explanation is no longer valid (it consisted of attributing the perceived organisation to the impact of the elements of the stimulus on force fields of the nervous system, conceived rather like an electrical field), but the observations which gave rise to the explanation remain relevant.

Some of the popularity of these principles can be attributed to the legislative vocabulary of Gestaltists, who also gave striking names to their 'laws'. The better known of these laws are (see Figure 14):

- *the law of proximity*: elements close together are more easily perceived as belonging to a common form than elements further apart in space;
- *the law of similarity*: elements of similar form or of similar size are more readily seen as belonging to a similar collective form;
- *the law of continuity*: when a form is incomplete, there is a 'natural' tendency to see it as completed;
- *the law of common aim*: this relates to moving forms and confirms that elements which move at the same time are perceived as a unity and tend to be seen as a single form.

All these 'laws', mainly elaborated between the 20s and the 40s, rest on a central concept of Form (*Gestalt*), implying that there exists a relationship between the elements of a figure which is stronger than the elements themselves and which is not destroyed by transformations of these elements. These laws were widely used (for instance, Eisenstein knew of them and referred to them often in his writings in the 30s and 40s). However, when their neurological explanation was eventually superseded, they became rather discredited. In fact, these laws are semi-empirical, semi-intuitive combinations which, within these limits, are more or less accurate, with the proviso that they are undermined as soon as any information about depth-perception enters the field. They are therefore quite interesting for non-figurative images, for many simple and abstract forms (and they can thus be compared to certain theories of abstract art, from Kandinsky to Vasarely, which rediscover similar principles of composition, structure and form; *see* Chapter 5, §I.2).

Form and information. For several decades, attempts to move beyond the theory of form have largely centred on the concept of information,

Figure 14 a) the law of proximity b) the law of similarity c) the law of continuity d) the law of closure

in the technical sense of the term as used in the well-known theories of Claude E. Shannon and Warren Weaver (1949). The main idea is that, in a given figure, there are some parts which supply a great deal of information, and others which supply little. The latter are those which 'say' little more than their surroundings already 'say'; they are entirely predictable and can be said to be *redundant*.

In a visual figure, redundancies are found in areas of unbroken, homogeneous colour or light, in a more or less constant, unidirectional outline, and so on. Other redundancies are created by regularities of structure, such as symmetry, and adherence to the Gestaltist 'laws' (and generally in all manifestations of *invariance*). The non-redundant parts are the uncertain, unpredictable ones, generally clustered along contours, especially in areas where direction changes very rapidly. It is on these points that the spectator focuses when asked an informational question (for example, if the spectator is asked to memorise or to copy a figure).

The notion of information enables Gestaltist principles to be rewritten in a more general way, incorporating them into the *minimum principle*: among two possible informational organisations of a given figure, it is the simplest that will be perceived, the one which contains the most redundancy or, which amounts to the same thing, the one which mobilises the least information. This generalisation is interesting in itself, although it does not yet meet the hopes it raises for information technology (note that the 'minimum principle' is very visibly at work in synthetic images). On the other hand, it has given rise to a number of developments within the context of constructivist approaches to perception, in which the perception of objects and figures is based on an accumulation of predictions and 'tests' about the meaning of edges – predictions which are, in turn, founded on the unequal distribution of

49

information and redundancy in a figure and on the spectator's expectations.

IV. Conclusion: The Eye and the Image

What conclusion can be drawn from this analysis of the relation between the eye, the most universal of structures, and the image, the most cultural and historical of objects, in its thousands of different forms?

First, something we stated as a truism at the outset: there is no image that is not the perception of an image, and the study, even a cursory one, of the main characteristics of this perception enables us to avoid mistakes, some of which have become absolute clichés in our understanding of the image. Because even though the image is arbitrary, constructed and fully cultural, the perception of an image remains a more or less unmediated process. The intercultural study of visual perception has provided us with ample evidence that subjects who have never seen an image have an innate capacity to see the objects represented in an image along with their compositional organisation, provided that they are given the means of putting this capacity into play by explaining to them that it is an image. These studies have become all the more extensive since ethnologists have, on the one hand, developed an awareness of their own position as external enquirers, and, on the other hand, have had access to the means of producing instant images with Polaroid and video cameras. Studies of the perception of images have often been accused of ethnocentrism, of claiming universal validity for experiments carried out in the laboratories of industrial societies. These accusations are sometimes appropriate, but it is worth remembering that, in principle, the *perception* of images, insofar as this can be separated from their *interpretation* (which is not always easy), is a process which is characteristic of the human species and which has simply become more cultivated in some societies than in others. The part played by the eye is common to everyone and should not be underestimated.

Notes

1. The Belgian scientist Joseph Plateau, for example, who insisted on observing the sun, eventually went blind.
2. The French term '*plan*' means both 'flat' and 'shot', a happy coincidence for this phrase [Ed.].
3. Gibson's 'ecology' is emphatically related to the open air: the sky plays a particularly significant role, perhaps because Gibson began his work on perception by studying the visual perception of airplane pilots.

V. Bibliography

The two main introductory books which may help the reader to pursue in greater depth some of the issues addressed in this chapter are:

Delorme, André, *Psychologie de la perception visuelle* (Montreal and Paris: Etudes vivantes, 1982).

Haber, Ralph N. and Maurice Herschenson, *The Psychology of Visual Perception*, 2nd edn (New York: Rinehart and Winston, 1980).

In addition, the following anthologies provide survey essays covering approximately the same area:

Carterette, E. C., and H. Friedman (eds), *Handbook of Perception*, vols 5 and 10 (New York: Academic Press, 1975 and 1978 respectively).

What the Eye Does

Frisby, John P., *De l'oeil à la vision* [1980] (Paris: Nathan 1982).

Le Grand, Yves, 'History of Research on Seeing', in Carterette and Friedman, *Handbook of Perception*, vol. 5, pp. 3–23.

Nichols, Bill, and Susan J. Lederman, 'Flicker and Motion in Film', in Teresa de Lauretis and Stephen Heath (eds), *The Cinematic Apparatus* (London: Macmillan, 1980), pp. 96–105.

From the Visible to the Visual

Anderson, Joseph, and Barbara Anderson, 'Motion Perception in Motion Pictures', in de Lauretis and Heath, *The Cinematic Apparatus* pp. 76–95.

Bailbé, Claude, 'Programming the Look' [1977], *Screen Education* 32/33, (1979–80), pp. 99–131.

Fraisse, Claude, and Jean Piaget, *Traité de psychologie expérimentale*, vol. 6 (Paris: P.U.F., 1975).

Frisby, John P., *De l'oeil à la vision* [1980] (Paris: Nathan, 1982).

Gibson, James J., *The Senses Considered as Perceptual Systems* (Boston: Houghton-Mifflin, 1966).

————, *The Ecological Approach to Visual Perception* (Boston: Houghton-Mifflin, 1979).

Gregory, R. L., *The Intelligent Eye* (London: Weidenfeld and Nicolson, 1970).

Hochberg, Julian, *Perception*, 2nd edn (Englewood Cliffs, NJ: Prentice-Hall, 1978).

Kanisza, Gaetano, *Organisation in Vision: Essays on Gestalt Perception* (New York: Praeger, 1979).

Metz, Christian, 'On the Impression of Reality in the Cinema' [1965], in *Film Language: A Semiotics of the Cinema* (New York: Oxford University Press, 1974), pp. 3–15.

Michotte, André, 'Le Caractère de réalité des projections cinématographiques', in *Revue internationale de filmologie*, 3/4 (October 1948), pp. 249–61.

Münsterberg, Hugo, *The Photoplay: A Psychological Study* [1916], republished as *The Film: A Psychological Study* (New York: Dover, 1970).

Oldfield, R. C., 'La Perception visuelle des images du cinéma, de la télévision et du radar', in *Revue internationale de filmologie* nos. 3/4 (October 1948), pp. 263–79.

Panofsky, Erwin, 'Die Perspektive als "Symbolischen Form"', in *Vorträge der Bibliothek Warburg*, vol. 4 (1924–5), pp. 258–331.

Richards, Whitman, 'Visual Space Perception', in Carterette and Friedman, *Handbook of Perception*, vol. 5.

Rock, Irving, *An Introduction to Perception* (New York: Macmillan, 1975).

Sekuler, Robert, 'Visual Motion Perception', in Carterette and Friedman, *Handbook of Perception*, vol. 5, pp. 387–430.

From the Visual to the Imaginary

Cohen, G., *The Psychology of Cognition* (New York: Academic Press, 1983).

Gregory, R. L., *The Intelligent Eye* (London: Weidenfeld and Nicholson, 1970).

Guillaume, Paul, *La Psychologie de la forme* (n.d. [1937)] Paris: Flammarion, 1979).

Koffka, K., *Principles of Gestalt Psychology* (New York: Harcourt Brace, 1935).

Pirenne, Maurice, 'Vision and Art', in Carterette and Friedman, *Handbook of Perception*, vol. 5, pp. 434–90.

———, *Optics, Painting and Photography* (Cambridge: Cambridge University Press, 1970).

Shannon, Claude E., and Warren Weaver, *The Mathematical Theory of Communication* (Urbana: University of Illinois Press, 1949.

Finally, one should mention the important anthology of essays on the perception of images:

Hagen, Margaret A. (ed.), *The Perception of Pictures*, vols 1 and 2 (New York: Academic Press, 1980).

Chapter Two

The Role of the Spectator

Images are made to be seen, and we should begin by emphasising the part played by the organ of perception. Our investigation of the characteristics of sight have led to the conclusion that this organ is not a neutral instrument, simply and faithfully transmitting data, that, on the contrary, it is one of the frontlines between the brain and the world. The eye leads us automatically to consider the subject which uses it in order to look at an image, and which we call, slightly extending the common sense usage of the term, the *spectator*.

This subject cannot be defined in simple terms, and many, often contradictory, determinants play a part in the subject's relation to an image: beyond the mere capacity to perceive it, there is knowledge, affects and beliefs, each of them substantially grounded in a specific historical moment, in a social class, or in an era or a culture. Nevertheless, despite the tremendous differences that can to be found in a subject's relation to a particular image, there are transhistorical and intercultural constants in the human relation to the image in general. It is on this basis that we will consider the spectator, emphasising the psychological models that have been developed to study and understand this relation.

I. The Image and Its Spectator

Let us begin with a clarification: we are not suggesting that the relation of spectator with the image can only or entirely be understood in psychological terms, nor that there is a universal model of the psychology of the spectator. We shall simply review some of the more significant answers to the following questions: What do images mean to us? How is it that they have existed in almost all human societies? How are they seen?

I.1 Why Do We Look at Images?

The production of images is never completely gratuitous, and images have always been produced for specific individual or collective uses. One of the first answers to our question therefore raises a further question: What use are images (that is, what are they used for?). It is obvious that in all societies most images have been produced for very specific purposes (propaganda, information, religion, ideologies in general), and we will return to this issue later. But, to begin, and to focus on the question

of the spectator, we will examine only one of the main reasons for the production of images: the fact that images are generally in the domain of the symbolic, which means that they are points of mediation between the spectator and reality.

I.1.1 The Relation of the Image to the Real

Rudolf Arnheim (1969) usefully and conveniently distinguished three kinds of values in the way the image relates to the real:

Representational value. A representational image is one which represents concrete objects (from a level of abstraction inferior to that of the images themselves). We will return to this crucial notion of *representation*.

Symbolic value. The symbolic image is one which represents abstract things (from a level of abstraction superior to that of the images themselves). Two brief points need to be made before returning to the concept of the symbol which also has a complex history: first, in these two first definitions, Arnheim supposes that we understand what is meant by 'a level of abstraction', which is not always a straightforward matter. Is a circle an object in the world or a mathematical abstraction? Next, and more importantly, the symbolic value of an image is, to a greater extent than any other symbolic form, defined pragmatically by the social acceptability of the symbols represented.

Sign value. According to Arnheim, an image is a sign when it represents a content which is not represented by its visible characteristics. The most common example of this is roadsigns (at least some roadsigns) such as the sign for the end of a speed limit zone, where the visual signifier has a completely arbitrary relation to its signified.

In fact, sign-images are barely images in the common-sense acceptance of the term, which corresponds roughly to Arnheim's first two categories. The reality of images is much more complex and there are few images that embody exclusively one or other of these three functions. The great majority of images possess to varying degrees characteristics of all three functions simultaneously. To take a simple example, a religious painting in a church, let's say Titian's *Assumption of the Virgin Mary* (1516–18) in the church of Santa Maria dei Frari in Venice, possesses a triple value: it signifies, rather redundantly in this example, the religious nature of the place by its position above the altar (note that, strictly speaking, it is not so much the image but its position that signifies the religious nature of the place); it also *represents* people arranged in a scene which, like all biblical scenes, is largely *symbolic*. Moreover, there are also partially symbolic aspects in the painting such as colour.

I.1.2 The Functions of the Image

What is an image used for? Here, unlike Arnheim, we cannot make such decisive distinctions. The functions of the image are those that have, throughout history, been the functions of all human production: they aim to establish a relation to the world. Without claiming

54

exhaustiveness, three main categories of this relation need to be distinguished:

The symbolic. Images orginally functioned mainly as symbols or, more precisely, as religious symbols believed to give access to the sphere of the sacred through the representation of a divine presence. Without going all the way back to prehistoric culture, even the first ancient Greek sculptures were idols produced and worshipped as material manifestations of a divinity (even though this manifestation was only partial and was incommensurable with the divinity itself). In fact, the number of possible examples is virtually endless because of the proliferation throughout history and into the present day of religious imagery, both figurative and non-figurative. Some images depict divinities such as Zeus, Buddha or Christ, while others have a purely symbolic value, such as the Christian cross or the Hindu swastika. Symbols are not only religious, and the symbolic function of images is still fully evident in spite of the secularisation of Western societies, if only to embody the different values of modern political systems, such as democracy, progress, liberty, and so on. There are a great many other symbolisms of lesser significance.

The epistemic. The image conveys (visual) information about the world which facilitates knowledge of that world, including its non-visual aspects. The nature of this information varies: a road-map, a postcard, a playing card, a bank card are all images but their informational value is not the same. This general function of knowledge has been assigned to images from the outset. For example, it can be found in the vast majority of medieval illuminated manuscripts, whether they illustrate the *Aeneid*, the New Testament or whether they are collections of botanical engravings or a navigator's manual. This function has been considerably developed and enlarged since the beginning of the modern age with the emergence of 'documentary' genres such as landscape or portraiture.

The aesthetic. Images are intended to please the spectator, to produce in the spectator specific sensations (*aesthesis*). This aspect of imagery is also very ancient, although it is almost impossible to identify what might have been the aesthetics of societies far removed from our own (were the bison in the Lascaux caves meant to be beautiful, or were they simply magical?). Whatever may have been the case, it is now a function of the image that is inseparable from the notion of *art*, so much so that the two are often confused and that an image aiming to produce an aesthetic effect can easily pass for an artistic image (an example of this is advertising where this confusion is at its most extreme).

I.1.3 Recognition and Recall

In all its relations to the real and in all its functions, the image pertains ultimately to the sphere of the symbolic (the domain of social productions made viable by the conventions that govern relations between individuals). However, our initial question, why and how do we look at an image, remains unanswered, although the answer is largely contained in

our previous remarks: all we need to do is to reformulate them in more psychological terms. Following E. H. Gombrich, let us propose the following hypothesis: the primary function of the image is to reassure, to comfort, to consolidate and to refine our relation to the visual world. The image functions as a *discovery of the visual*. In the first chapter we saw that this relation is essential to our intellectual activity: the role of the image is to facilitate and to improve mastery of our intellectual activity. Discussing art images, Gombrich (1965) compares two main forms of psychological cathexis of the image: *recognition* and *recall*, the second being more profound and more essential. We will return to these two terms, but it is worth noting straightaway that this dichotomy largely repeats the distinction between the representational function and the symbolic function, to some extent reformulating that distinction in psychological terms, pulling one towards memory and hence the intellect, that is to say, to the rational functions, and the other towards the experience of the visible and the more directly sensory functions.

I.2 The Spectator Constructs the Image, The Image Constructs the Spectator

The most important thing about this approach is that it regards the spectator as an active partner of the image, both emotionally and cognitively. This also implies that the spectator is a psychic organism on which the image acts.

I.2.1 Recognition

To recognise something in an image is, at least in part, to identify what is seen in that image with what has been seen or could be seen in reality. It is therefore a form of work which puts into play the characteristics of the mechanism of sight.

The work of recognition. In Chapter 1 (§III.2) we noted that a fair number of the real world's visual characteristics can also be found in images and that a spectator can see what is, up to a point, the same thing: visual edges, colours, gradients of size and texture, and so on. Moreover, it could be said that the notion of perceptual constancy, which underpins our encounter with the visual world by enabling us to attribute constant qualities to objects and to space, is also at the base of our perception of images. Gombrich also states that because the work of recognition, in so far as it is a recognising, depends on memory or, more precisely, on a store of remembered object-forms and spatial compositions, perceptual constancy is founded on perpetual comparisons between what we see and what we have already seen:

> The name [constancies] covers the totality of those stabilising tendencies that prevent us from getting giddy in a world of fluctuating appearances. As a man comes to greet us in the street, his image will double in size if he approaches from twenty yards to ten. If he stretches out his hand to greet us, it becomes enormous. We do not register the degree of these changes; his image remains

relatively constant and so does the colour of his hair, despite the changes of light and reflection. (Gombrich, 1965)

Perceptual constancy is thus the result of complex psycho-physiological work. But this stability of recognition extends even further, because we are able not only to recognise but also to identify objects despite the distortions that result from being reproduced as images. The most striking example of this is the face: our ability easily to recognise the model of a photographic portrait or of a painted portrait, if it is figurative enough, is due to perceptual constancy. However, if we also recognise the model of a caricature, it follows that we must also be using other criteria, since nobody looks exactly like their caricature. To return to Gombrich, the caricature takes those constancies of the face which we might not have noticed, but which are capable of functioning as indices of recognition (the same idea, though stated in different terms, can be found in the semiological work of Umberto Eco). Moreover, when we meet someone who we have not seen for a long time, we recognise them by virtue of similar invariants. These are, however, difficult to identify for the purposes of analysis. In other words, the work of recognition uses not just the elementary properties of the system of vision, but also the capacities for coding which are already quite abstract. Recognition is not a question of comparing similarities point by point, but of finding visual constancies which for some people are already structured, like a kind of macro-form.

The pleasure of recognition. To recognise the world in an image can be useful. It can also produce a specific pleasure. It is doubtless true that one of the main reasons for the development of figurative, more or less naturalistic art is the psychological satisfaction derived from refinding a visual experience in an image, in a form that is simultaneously repeatable, condensed and capable of being mastered. From this perspective, recognition is not a one-way process. Figurative art imitates nature and that imitation gives us pleasure. On the other hand, and almost dialectically, it also reacts on nature, or at least on our way of seeing it. Many have remarked on the fact that landscape was never the same after the genre of landscape painting had been established. Similarly, the movements of Pop art or hyperrealism make us 'see' everyday life and its objects differently. Gombrich makes a similar point in relation to Robert Rauschenberg's collages, noting that they come to mind when looking at real advertising billboards with their collages and tears. The recognition facilitated by the art image belongs to the sphere of cognition, but it also addresses the spectator's expectations in order to modify them or to create different ones. All this is linked, at least in part, to the function of recall.

I.2.2 Recall

Image and coding. The image has, among others, two psychological functions: beyond its mimetic relation to the real, it conveys knowledge

about the real in a necessarily coded form (taking the term 'coded' in its semiological and linguistic sense). The mechanism of recall through imagery could be called, very loosely, the *schema*: a fairly simple, easily memorised structure which exists beyond its diverse manifestations. Remaining in the field of art, there are many examples of styles using a schema, often repetitively and systematically. Indeed, the schema could be said to be at the centre of the notion of style. One well-known example is that of the pharaohs in ancient Egyptian art, where an image is only a collection of partial images reproduced as literally as possible from typical shemata (seated scribe, crouched scribe, divinities, the pharaoh, and so on) which are in turn linked through convention to their actual referents.

Schema and cognition. In so far as it is a mechanism of recall, a schema is 'economical': it is the simplest, most legible version of what is schematised. It therefore necessarily has a cognitive, even a didactic, aspect. Consequently, a schema is not an absolute: the schematic forms correspond to certain uses to which they are adapted, but they evolve and sometimes disappear when these uses change. Similarly, the production of new knowledge renders it unsuitable. In short, there is an experimental aspect to schemata in that they are constantly corrected.

The presence of a schema is most readily visible in art that is furthest away from naturalism. For example, pre-Renaissance Christian art employed the same iconographic formulas, not only to depict sacred characters, but to represent canonical scenes (see Figure 15). However, within this long tradition, especially from the 12th century onwards, schemata have become progressively adapted to an increasingly overt dramatic *mise en scène*. To take but one (tiny) example of this evolution, the halo placed behind the heads of certain people to indicate their saintliness (an iconographic schema derived from an earlier symbolism of the aura) was first represented by a circle (or more rarely a square) without any perspectival effect; eventually this halo came to be represented as if it were a real object and thus subject to the rules of perspective, hence its elliptical form in the 14th and 15th centuries.

Lastly, the cognitive aspect of the schema can also be found within figurative art. Witness, for instance, the importance of the schema (in the literal sense of a diagram) in so many methods of teaching naturalistic drawing, as if beneath the finished drawing with its shading, its modelling and its textures, there was a skeleton or an armature representing the draughtsman's structural knowledge of the object drawn. This is the case in some treatises on painting, such as Leonardo's, which strongly emphasise the need to know anatomy in order to paint the body, an idea which survived for a long time, at least until Ingres and his school.

I.2.3 The 'Beholder's Share'
In his famous book *Art and Illusion* (1956), Gombrich suggested the term 'the beholder's share' to designate the collection of perceptual and

Figure 15 Image and schema: The Deluge depicted in an eleventh-century manuscript

psychic acts through which the spectator brings an image into existence by perceiving and understanding it. This notion is, basically, the direct extension and summation of what we have been describing.

There is no innocent look. Gombrich adopts a kind of constructivist position on visual perception. For him, visual perception is a sort of experimental process, implying a system of expectations on the basis of which hypotheses are made which are then proved or disproved. This system of expectations is itself very much influenced by our prior knowl-

edge of the world and of images. In our experience of an image, we anticipate by overlaying ideas on to our perceptions. The idea of an innocent look is thus a myth, and Gombrich begins his work precisely by reminding us that seeing is a matter of comparing our expectations with the message received by our perceptual system.

This idea may seem trivial, but the almost didactic emphasis that Gombrich lays on this concept is aimed at the theories of spontaneity emanating from the art world. In the 19th century, Courbet's Realism and, more obviously, Impressionism wanted to defend the idea that painters should paint 'what they see' or 'as they see' (Figure 16). Influenced by the theory of the diffusion of light and the discovery of the 'law of colour contrast', the Impressionists overdid it, rejecting clear outlines in favour of little daubs of paint intended to reproduce the way in which light is refracted in the atmosphere, and painting shadows systematically, using violet in excess. Obviously, this way of painting does not achieve a closer approximation to actual sight than any other, and in some respects it may even be further removed from that goal.

The 'etcetera law'. The spectator, by virtue of his or her prior knowledge, makes up for what is lacking, that is to say, he or she supplies what is not represented, in the image. This tendency towards completion operates at all levels, from the simplest to the most complex, and is an example of Gombrich's basic principle, given that an image can never represent everything.

There are innumerable examples of this 'etcetera law' (adapting a phrase of John F. Kennedy's; see Figure 17). It is in operation when we see a realist scene in a monochrome engraving and we complete the perception by adding at least some of what is missing between the lines of the engraving, and sometimes an idea of the missing colours; also when we add missing or obscured parts of objects represented (especially people). In other words, the role of the spectator is projective. Rather like in the somewhat extreme, but familiar, example of the Rorschach personality tests (the interpretation of unstructured ink blots), we tend to identify anything in an image, provided it has a form which bears some minimal resemblance to something. On the one hand, this tendency to project may become excessive and may result in an erroneous or distorting interpretation of an image by a spectator who projects incongruous things into it. This is one of the problems with interpretations of images that have a rather fragile objective basis and contain a large degree of projection.

A well-known example is Freud's reading of Leonardo da Vinci's painting of *Saint Anne, the Virgin and the Infant Jesus.* Basing his interpretation on observations others made before him, Freud thought he could see the outline of a bird of prey in the shape of Saint Anne's garment, an 'observation' which was undoubtedly projective and which he related to his theory of the psychological case study of Leonardo, especially to the part supposedly played by a kite in Leonardo's childhood. Ultimately, a spectator can go so far as to 'invent', completely or in part,

Figure 16 Does optico-geometric precision come closer to the ideal of painting 'as one sees' than the quest for 'atmospheric' effect? Above: 'The Pilon du Roi' by François Marius Granet (1848; Aix-en-Provence, Musée Granet); Below: The Estacade Bridge in Paris by J.-B. Jongking (1853).

a painting. Gombrich reminds us that some painters have deliberately used this projective faculty to invent images, 'discovering' them in aleatory forms such as ink blots. So the image, from the point of view of

Figure 17 The 'etcetera law': Nero's Suicide, *drawing by S. M. Eisenstein (1942).*

its spectator as well as its author, is a phenomenon also linked to the imagination.

Perceptual schemata. The spectator's faculty of projection is based on perceptual *schemata*: in exactly the same way as in everyday perception, the spectator of an image uses the full scope of the visual system, especially its capacity for organising reality and its ability to match up percepts with icons that have been previously encountered and are stored in schematic form in the memory (*see* Chapter 1).

In other words, according to this approach exemplified by Gombrich, the role of the spectator is constantly to combine recognition and recall, in the sense described earlier in §II.2.1 and 2. Gombrich does not doubt that perspective has a quasi-scientific value. Not that he thinks that a perspectival painting is like reality (which would be patently absurd, and, anyway, he denies the possibility of an absolute resemblance between representation and reality), but for him, what is conventional is not perspective but the fact of painting on a flat surface. Perspective, in effect, is within the faculty of sight, while the flatness of the image is completely outside of the visual system.

Gombrich is perfectly aware of the theoretical ambiguities of perspective in terms of geometry, but for him these ambiguities are similar in the image and in reality. What they have in common is the way in which the eye overcomes them, in both everyday life and in the image, by interposing other indices and other forms of knowledge, and, above all, by interposing the schemata that have already been more or less symbolised (those which are used by the recall capacity). In short, according to Gombrich the role of the spectator is an extremely active one: the visual construction of recognition, the activation of the schemata of recall, and the combination of both in order to construct a coherent vision of the overall image. It is understandable that the role of the spectator is so central to all of Gombrich's theories: it is the spectator that makes the image.

I.2.4 The Image Acts on the Spectator
Gombrich is not alone in holding the view outlined above. Others, often starting from very different premises, have developed similarly constructivist analytical approaches to the spectator's relation to the image. Most of these other approaches place great emphasis on the intellectual processes which operate in the perception of the image and are formed by the image, even though they may not give so much importance to the purely perceptual stage.

The cognitive approach. Cognitive psychology is one branch of psychology which had a spectacularly rapid development in the 1980s. As its name indicates, it aims to describe the intellectual processes of knowledge, understood in the widest sense, including, for example, language, but also, more recently, including the production and consumption of images.

Cognitive theory, in almost all of its current varieties, presupposes constructivism. Every perception, every judgment, all knowledge is said to be a construction on the model of hypothesis-testing (and hypotheses are also based on mental schemata, some innate and some derived from experience) on the basis of data supplied by the sense organs. There is now, almost exclusively in English, a vast literature of cognitive psychology addressing the image, and particularly the image in art. This literature tends to present itself as 'developments' in the field of cognitive psychology, but it has not yet added anything really new to our

understanding of spectatorship. It is basically a matter of taking each individual element of an image and of explaining it in terms of very general functions of cognition (inferences, problem solving, and so on) which is, of course, important and will no doubt in time produce an alteration of the constructivist approach exemplified by Gombrich.

The pragmatic approach. This approach lies at the interface of psychology and sociology. It is especially concerned with the conditons of the spectator's reception of the image and with all the factors, be they sociological or semiological, which affect the comprehension or the interpretation, in short, the reception of the image. We will return to this recently developed approach later, but it is worth mentioning it here to underline the image's capacity to include signals that are aimed at the spectator and which enable him or her to take up an appropriate reading position. The work of Francesco Casetti on film and spectatorship (1986) can be cited here. For Casetti, film includes certain formal processes which enable it to communicate to the spectator how it should be read.

The influence of the image. Here we are broaching the vast problem of the psychological effect of the image on its spectator, for good or ill. This question has been the focus of interminable debates, especially about cinema, which from the outset was suspected of ideologically corrupting spectatorial minds. Approaches to this issue are generally beset by enormous methodological chaos, full of untheorised statistics and gratuitous assertions. The only endeavours that might be of intellectual interest are those that aim to specify the supposed effect of the image, usually by breaking it up into elements and by examining the potential effect of each element.

There appears to be, in a very embryonic state, a vague apprehension of the possible effects of colours, of certain forms, and so on. This is an area which pure or applied experimental psychology has sought to address for some time. The results of this research are still too uncertain to be described here. However, it is worth mentioning Eisenstein's work in this respect, not because it is more scientific, but because its degree of theoretical development makes it more conclusive. Having conceived of the cinematographic image in a fairly basic way as a combination of elementary stimuli (themselves definable as forms, intensities, lengths of time), and basing his method on Pavlovian reflexology, Eisenstein supposed that every stimulus involves a calculable response, and that, consequently, through a long, complex and probably impossible calculation the spectator's emotional and intellectual reaction to a specific piece of film could be predicted and controlled. Naturally, Eisenstein was the first to notice that this was much too simplistic an account. Having carefully calculated the final scene of *Stachka* aka *Strike* (1925), the scene of the parallel montage of the massacre of the workers by the Tzarist police and the slaughtering of cattle, he had to face up to the fact that, although the scene was very successful in conveying its intended meaning to urban working-class spectators, it was totally ineffective for rural audi-

ences, who were not at all frightened by images of cattle being slaughtered. Eisenstein did not completely abandon the idea of affecting the spectator, but he gave up his initial, very mechanistic concept of the influence of the film image.

I.3 The Image and the Spectator Resemble Each Other

The question of the influence of the image raises a new issue: that of the relation between the spectator and producer of an image. This question is implicit in all the more radical approaches to the problem of the spectator, regardless of their other differences. All of them imply a sort of equivalence between the work of the spectator and the work of the producer of the image. It is difficult to subsume all these approaches under one general methodology. Here we will limit our remarks to the more significant examples.

I.3.1 Gestaltist Theories: Arnheim

All the Gestalt-influenced literature on the image contains the theme of the spectator's discovery of the image as a discovery of deep structures in the image which are also deep structures of the mind. This notion is quite compatible with Gestalt theory in general, according to which the perception of the world is a process of organisation, of ordering given sensory data to make them conform to a certain number of basic categories and innate 'laws' of the brain's functioning (*see* Chapter 1, §III.2.4). A first, historical example of this concept is offered by Hugo Münsterberg in his book on cinema, which posits that the major aspects of film form are in fact so many versions of the major functions of the human mind (attention, memory, imagination, and so on). However, it is Rudolf Arnheim who, being trained in both psychology and art history, developed this theme most systematically through several books. Two concepts, especially, exist in suggestive form in Arnheim's work.

Visual thinking. Next to verbally expressed thought, shaped by and manifested in the form of that man-made mediating agent called language, there is a place for a more immediate form of thinking which is not, or at least not entirely, formed through language, but is organised directly from the percepts of our sense organs, a kind of sensory thinking, within which *visual thinking* occupies a privileged place. Of all our senses, sight is the most intellectual, the closest to thought (a thesis consistent with what we said in Chapter 1 about vision being the first stage of intellectual process). Indeed, it may even be the only one of our senses which genuinely functions like thinking.

This concept of visual thinking has been much used by many writers, especially in the interwar years. Although it has not been completely abandoned, it has now come to be questioned seriously since the experiments which were supposed to prove this hypothesis often yielded ambiguous results. It is almost never possible to prove that language has not been used where visual thinking was supposed to have been taking place. So, any reference to the term visual thinking is more an approximate use

of language pointing to processes within which the operation of language can be isolated as a discrete element or within which it cannot be precisely located. Visual thinking is not a scientifically proven and universally accepted concept.

Subjective centering. Many of Arnheim's thoughts on the image are based on the idea that the spectator has a subjectively centred concept of the surrounding space. Arnheim often set out descriptions of the space of representation, not only through objective, Cartesian geometry, but through subjective geometry (defined by a centre, a perceiving subject, two angled co-ordinates horizontally and vertically locating the direction of the look in relation to the centre, and a third co-ordinate which is the distance of the object from the centre). We will return to the implications of this approach for the concept of the frame. For now, it is enough to note that this idea is based on a similarly inductive notion of the spectator's relation to the image.

I.3.2 Pre-logical Thinking; The Organic and the Ecstatic: Eisenstein

The metaphor of the organic (a structure comparable to the organisms of living beings) refers, ultimately, to the organism par excellence, the human body, where each part has meaning only in relation to the whole. A work of art, which is usually a product of the mind, can be said to be organic when the relation between the parts is as important as the parts themselves, that is to say, when it resembles a natural organism. It was Eisenstein who developed this idea most systematically, trying to articulate and confirm it by way of theories of general psychology.

The image is structured like inner speech. The most important human characteristic, in terms of signifying practice, is language. Hence Eisenstein's idea, expressed in a number of ways, that the work of art should be seen in terms of a kind of language, and that cinematographic language in particular can be understood more or less as a manifestation of inner speech, which is but another name for thought itself. In the 30s, inspired by the work of the psychologists Leonid Vygotsky and A. R. Luria, Eisenstein looked to what were called primitive, pre-logical modes of thought (infantile and psychotic thought, and that of people believed primitive by anthropology) for a model for his notion of inner speech. These forms of thinking apparently all function with a kind of short-circuit pattern between their various elements, creating a freer form of association of ideas, which, in Eisenstein's view, was closer to the structure common to all imagery (especially but not exclusively cinematographic imagery), that is to say, the structure of montage.

Spectatorial ecstasy, ecstasy of the image. A few years later, Eisenstein used a different model to express the same idea, that of ecstasy. The ecstatic construction of a work, be it filmic, pictorial or literary, rests on a sort of process of gradual build-up and sudden release. Eisenstein uses a number of metaphors for this phenomenon in his essay 'Non-Indifferent Nature': igniting a rocket, triggering religious ecstasy

through spiritual practice, and so on. This new phase of consciousness is called ecstatic because it is like an explosion, a being taken out of and beyond oneself (ek-stasis) by the work. Naturally, the theoretical question is to find an equivalent psychic process being triggered in the spectator. The ecstatic work can then be said to trigger an ek-stasis, the spectator being taken beyond him or herself and transported onto a new emotional level propitious for the reception of the work of art. Obviously, as a theory of spectatorship, this theory is not based on scientific principles. On the other hand, it is of interest as an aesthetic theory of the spectator's relation to the work of art. The works analysed as ecstatic by Eisenstein are all emotionally very powerful and reveal a sophisticated mastery of the art of composition. In his own work, the theory of ecstasy accompanied the making of *Ivan Groznyi* (*Ivan the Terrible;* 1945), which undoubtedly owes part of its power to such a quest for ecstatic moments.

I.3.3 Generative Theories of the Image
Another type of analogy has been drawn between the functioning of the image and the way in which the spectator understands it. In other words, the setting up of a homology between image and language. However, this time using the term language in its usual sense, and not with reference to the hypothesis of an inner speech.

Following the theories of Chomsky, Michel Colin (1985) pursued the hypothesis that filmic competence and linguistic competence are homologous, which develops the notion that in order to understand a number of filmic configurations, the spectator has recourse to mechanisms which have been internalised through language. Colin has only applied this hypothesis to sequential images (cinema, cartoons) and his work aims to take account of the way in which a diegesis is understood and integrated. The hypothetical nature of Colin's work makes it difficult, at this stage, to judge the extent to which this theory could actually be applied. Consequently, I shall limit myself to noting that it rests on a presupposition which is totally opposed to Arnheim's, namely, that all thinking, even visual thinking, entails using the mechanisms of language.

I.4 A Very Provisional Conclusion
The overview of these more or less coherent and more or less theorised approaches to the relation between spectator and image would seem to suggest the following: the spectatorial model alters according to whether the emphasis is placed on the reception or on the production of an image. In the first case, there is a tendency to develop analytic, constructivist theories which emphasise the intellectual work of the spectator. In the second case, the approach is both more inclusive and more heuristic, with a greater tendency to use anthropological models which take account of the image within an overall way of conceiving the world. We do not have to choose between these two approaches, as they are neither mutually exclusive nor even contradictory.

II. The Representational Illusion

Strictly speaking an illusion is a mistaken perception, a total and erroneous confusion between an image and something other than the image. Our everyday experience and the history of images are testimony to the fact that this is not the usual mode of our perception of images, but an exception, whether it is deliberately constructed or a chance occurrence (*see* Chapter 1, §III.2.3). Meanwhile, in our perception of any image, especially if it is a very figurative one, there is an element of conscious and voluntary illusion, even if it is only a case of the spectator's acceptance of the double perceptive reality of images. In different historical periods illusionism has been variously the aim of representation or, alternatively, criticised as the wrong, misleading or useless goal of representation. Without expanding on these value judgments, we will try to unravel some of the issues at play in the relation between image and illusion.

II.1 The Conditions of Illusion

II.1.1 The Psycho-Physiological Base

The main aspects of this issue were discussed earlier in the chapter on perception, so we can be brief. The possibility of illusion is largely determined by the capacities of the perceptual system, in the inclusive definition that we have given it. Illusion can only take place under two conditions:

A perceptual condition. The visual system must be in a position where it cannot differentiate between two or more percepts. For example, at the cinema, under normal conditions of projection, the eye is unable to differentiate between the apparent movement produced by the phi effect (*see* Chaper 1, §II.2.2) and real movement. As the visual system is so constructed that it almost always spontaneously searches for extra indices whenever there is ambiguity in perception, chances are that there will be an illusion only when the viewing conditions are restrictive or in some way inhibit the visual system's 'natural' tendency to search.

A psychological condition. When facing a somewhat complex spatial scene, the visual system will attempt a kind of interpretation of what it perceives. Then there will only be 'illusion' when there is also an effect of verisimilitude; in other words, if the illusion offers a plausible interpretation (more plausible than others) of the scene viewed. The very terms verisimilitude and plausibility emphasise that it is a matter of judgment and that, consequently, the illusion depends largely on the psychological conditions of the spectator, particularly of the spectator's expectations. As a general rule, illusion works best when it is expected. Recall the well-known (although probably mythical) anecdote (Pliny the Elder, *Natural History* 35.65) about the two painters in Athens, Zeuxis and Parrhasios. Zeuxis was famous for having painted grapes so lifelike that birds would come and try to pick them. Parrhasios then wagered that he could outdo and deceive his rival. One day he invited Zeuxis to his studio and showed him various paintings, until Zeuxis noticed, in a

corner of the studio, a cloth-covered painting leaning against the wall. Curious about the painting that his rival seemed to be concealing from him, Zeuxis went to the painting, tried to remove the cloth, and then realised he was dealing with a *trompe l'oeil* effect and that the painting and the cloth were both painted on to the wall itself. Parrhasios won his wager with the painter who could only deceive birds. For us, his victory illustrates the importance of the expectation of deception, for if Zeuxis had seen the *trompe l'oeil* as such, who knows whether the illusion would have been as effective? The *mise en scène* to which he was subjected predisposed him to accept the plausibility of a false perception.

II.1.2 The Socio-Cultural Base

There are all sorts of 'natural' illusions which have not been manufactured artificially. For example, the well-known example of certain insects endowed with extraordinary mimetic capacities: spiders that look like ants, butterflies with a second 'head', stick insects that are indistinguishable from their environment, and so on. These illusions are not really central to our discussion here, except to reiterate that the amazing perfection of a purely visual imitation is almost always accompanied by the perfect context for that illusion-inducing imitation. However, what is of interest here is, of course, the illusion which an image deliberately induces. Over and above the perceptual and the psychological conditions of its reception, this illusion will to some extent be influenced by the social and cultural conditions in which it is used. As a general rule, the illusion will be all the more effective for being found in socially accepted or desirable types of imagery, that is to say, when the aim of the illusion is clearly socially coded. In any case, the exact aim of the illusion is not very important; it is often simply a matter of trying to make the image more believable as a reflection of reality. This is the case with the cinematic image, which derives most of its power of documentary plausibility from the perfect illusion of apparent movement. For the contemporaries of the invention of cinematography, this illusion was interpreted mostly as a guarantee of the film image's naturalism. In other cases, illusion is used in order to create a specific imaginary state, to solicit admiration rather than belief and so on. Finally, although the aims of an illusion may vary widely, it is always more powerful when its aim is *endoxal*, that is to say, when it seeks to repeat meanings already fixed by a dominant ideology.

II.1.3 Partial Illusion and Total Illusion

The illusion described above is a case of a 'total' illusion being produced by an image, with all of its elements contributing to the deception of the spectator. Clearly, most images only contain elements which, taken individually, use some form of illusion. At a micro-analytic level, this is true of the 'elementary illusions' (*see* Chapter 1) deployed in images. More generally, it has been argued that all the figurative arts in our culture are based on the induction of a *partial illusion* of reality, relative to

the technological and physical conditions of each art form. This is the main argument in Rudolf Arnheim's essay on cinema (1932), where he differentiates between cinema and the other figurative arts, arguing that cinema's use of temporality produces a powerful illusion of reality whereas its use of space produces only an acceptable equivalent of real space through the illusion of depth. Arnheim locates this filmic illusion between theatrical illusionism (which he suggests is also very powerful) and photographic illusionism (much less powerful).

However, the notion of partial illusion is a dubious one. As Christian Metz has pointed out in one of his seminars, it can be seen as contradicting itself: an illusion either is or is not, one is duped or one is not, there are no halfway measures. On the other hand, this objection sounds excessive, since there is 'in cinema' a pure illusion of apparent movement, which is indeed only a partial aspect of the total perception of the filmic image. In fact, the main objection to this notion of partial illusion, which nevertheless remains a suggestive concept, is that it reduces film to only those aspects of its perceptual dimension which are available to analysis, ignoring the way that film creates phenomena of belief, especially through the fiction-effect. In other words, the main problem with Arnheim's thesis is that it is not sufficiently historical, because it takes into account neither the variability of illusionist aims nor the variations in spectatorial expectations.

II.1.4 An Example: The Vault of San Ignazio

An example may clarify some of these aspects of illusionism. In the church of San Ignazio in Rome there is an interesting painting which covers the entire ceiling of the vault over the central nave (Figure 18). The painting represents allegories of the missionary work of the Jesuits, who commissioned the work in 1691–94. The vault has one of the best-known examples of *trompe l'oeil* of the period, not because it could be mistaken for anything other than a painting, but because the allegory is placed within a painting of a sky beyond (painted) architecture, columns and arcades which appear to continue and extend, very accurately, the church's actual, solid and tangible architecture. It is a partial illusion from all points of view. No spectator could imagine that he or she was really looking at the divinities portrayed in this painting (no more than one could believe in the reality of the allegorical characters representing the Continents). On the other hand, the average spectator, even today, has trouble deciding where the stone building ends and where the painted building begins. The partial illusion of the painting is one of deep space.

However, this illusion is not without its preconditions. The cultural conditions include the fact that the spectator must have some idea, even if only vaguely, of what is meant by a stone building structured like a church with columns and capitals. Among the more specific conditions is the fact that while the *trompe l'oeil* effect in San Ignazio is for us a magnificent example of pictorial virtuosity, for its seventeenth-century spec-

70

Figure 18 Detail of the vault of San Ignazio, painted by P. Andrea Pozzo (1642): the 'architecture' towards the top as well as towards the bottom of the photograph is painted. The photograph, taken from a decentered position, shows up the trompe l'oeil *effect, betraying that the two parts do not seamlessly connect with each other.*

tators it was a visible sign of the communication between the terrestrial world and the 'other', celestial world. Psychological conditions may replicate these cultural conditions: the illusion is all the stronger for those who believe in that 'other' world and who are ready to accept its reality. The perceptual conditions also play a part: the striking impact of this famous *trompe l'oeil* comes from the fact that it is painted on a vaulted ceiling and is, therefore, out of reach. Moreover, the height of the church's ceiling means that the painting is quite far away, and that there are few indices of surface available to us to suggest that it is a painting. Of these two perceptual realities, the three-dimensionality is unusually emphasised, at least when one stands in the correct viewing position marked by a small circle on the church's floor. When one does not occupy this spot, perspectival distortions become very visible and are all the stronger for the fact that the absence of indices of surface do not enable the eye to compensate for the 'inappropriate' point of view (*see* Chapter 1, §III.2).

II.2 Illusion and Representation

II.2.1 Illusion, Copy, Simulacrum

An image can create at least a partial illusion without being the exact replica of an object, without being its copy. Generally speaking, there is

no such thing as a perfect copy in the real world, not even in our age of widespread mechanical reproduction. Hence, perhaps, the importance of the theme of the double in fantasy, myth and literature. There are always differences, though they may be very small, between two photocopies of the same document. A photograph of a painting could never be confused with the painting itself, nor could a painting be confused with reality. The problem with illusion is of a quite different order: it is not a matter of creating an object that copies another, but of creating an object, that is to say, an image, that copies the appearance of the former.

In a famous essay entitled 'The Ontology of the Photographic Image' (1945), André Bazin seems to have somewhat underestimated the difference between the problematic of the copy and that of illusion. For example, he writes that 'Painting became divided between two aspirations: one aesthetic – expressing spiritual realities where the model is transcended by the symbolism of forms – and the other being nothing but a psychological desire to replace the outside world with a copy. This need for illusion, the satisfaction of which resulted in the demand for yet more illusion, grew rapidly and gradually consumed the plastic arts.' Other than the final sentence, which is highly contestable because the 'need' for illusion did not, in the history of Western art, simply grow in an unambiguous way, Bazin gives too great a determinacy to illusion, believing that it enables the world to be replaced by a duplicate, a copy.

The difference between the illusionistic image and the simulacrum also needs to be pointed out. The simulacrum does not, usually, create a total illusion, but is based on a partial illusion that is strong enough to be functional. The simulacrum is an artificial object which is intended to be mistaken for another object within a specific usage, without necessarily resembling it completely. The model of a simulacrum can be found in animals and their illusions (for example, in the mating or war dances of certain birds or fish, as when in certain fighting fish the sight of their own reflection triggers an aggressive response identical to that triggered by the sight of another male). In the sphere of human behaviour, the simulacrum is closer to phenomena such as masking or travesty, as Jacques Lacan (1973) has noted. This question is becoming current once again with the widespread use of simulation technology, especially since the development of simulated images. A flight simulator designed to train jet pilots, for example, is a sort of closed cabin where the trainee sits in front of controls similar to those of a plane and he or she has to react to events that are generated by computer on a screen in front of him or her. The image seen is not illusionistic, since nobody would mistake it for reality, but it is perfectly functional in that it imitates selected aspects (in terms of distance and speed) which adequately represent reality in order to learn the controls of an airplane.

II.2.2 The Notion of Representation: Illusion Within Representation

Illusion is not the goal of imagery, but in some way the practice of im-

ages has always kept this goal a virtual if not always a desirable horizon. It is, basically, one of the problems central to the notion of *representation*: to what extent does representation aim to be confused with what it represents?

What is representation? Despite its rather rhetorical character, this question must be addressed. The notion of representation, and the term itself, are so loaded with historical layers of meaning that it is difficult to give them a single universal and eternal meaning. There are enormous differences between political, theatrical, photographic and pictorial representations. However, in one respect they are similar: representation is a process by which, within a limited context, a representative is made to *stand in* for what it represents. Kenneth Branagh takes the place of Hamlet in Andrew Noble's RSC production of Shakespeare's play in 1993. This doesn't mean that he is Hamlet, but that for a few hours in a specific space and in a highly ritualised way, I could consider that Branagh by his voice, body, gestures and words enables me to see and understand a certain number of actions and states of mind attributable to an imaginary person. This particular representation can also be compared to other representations of the same subject, such as Nicol Williamson's performance of the play at the Round House in London in 1969, Laurence Olivier's film, my mental image of Hamlet when I reread Shakespeare's text, or, in a more limited way, of a painting figuring Hamlet in the gravedigger scene.

Representation is arbitrary. In the very process of representation, the institution of 'standing in for', there is an enormous amount of arbitrariness in the use of socialised conventions. Some theorists have gone so far as to suggest that all representations are equally arbitrary. They suppose that, for example, the representation of a landscape is neither more nor less conventional than a traditional Chinese painting, an ancient Egyptian drawing, a seventeenth-century Dutch painting or an Ansel Adams photograph. They argue that the differences that we note between these various representations, by judging some to be more adequate because more 'lifelike' than others, is totally contingent on our twentieth-century Western cultural assumptions.

One of these theorists, the American philosopher Nelson Goodman, takes a fairly extreme position. In his book *Languages of Art* (1968), he states that literally anything (for example, any image) can represent any referent, as long as we have agreed that it shall be so. Therefore, the question of resemblance between the object and its representation is a side issue, since no such resemblance is a *priori* required for such an agreement. Goodman also thinks that the question of representation itself is not crucial, but that it is simply a subcategory of the main and vast problem of denotation.

Other less extreme, but comparable, positions have been taken by various critics and art historians. In terms of film theory, there is a series of articles by Jean-Louis Comolli on technique and ideology, published in *Cahiers du cinéma* no. 216 (1969) and translated in *Screen* vol. 12 no.

1 (1971), which suggests that the evolution of cinematographic language owes nothing to the desire for greater realism or verisimilitude, and can be accounted for only by general ideological considerations, cinematographic styles being strictly determined by the social order. Arnold Hauser's *Social History of Art* (1938) proposes an analogous theory.

Representation is motivated. Many theorists, on the other hand, have emphasised the fact that certain techniques of representation are more 'natural' than others, notably in relation to pictorial reality. The argument most often proposed emphasises that certain conventions are learned very easily by every human individual, to the extent that they do not really have to be learned at all. Earlier we referred to the debates around perspective (discussed more systematically in Chapter 3 below); and this is also one of the nodal points of this kind of theory. When Gombrich suggests that perspectiva artificialis reproduces a number of the characteristics of natural perspective, he draws the conclusion that although it is a question of a decidedly conventional form of representation (Gombrich is very 'relativist' in terms of styles), its usage is nonetheless more justified than other conventions. Similarly, Bazin suggested that the sequence shot was such a realistic kind of representation that it could be described as a very special kind of representation of the real, with a more absolute vocation than other aspects of film language.

The question of realism. Up to a point, the above-mentioned positions are obviously irreconcilable. One cannot sustain within one framework that representation is totally arbitrary, that it is wholly learned, that all forms of representation are equivalent, and that some forms are more natural than others. A number of these discussions are based on a – often deliberate – confusion between two levels of the problem:

- the *psycho-perceptual*: on this level all human beings' responses to the image are largely similar. Concepts such as 'resemblance', the 'double reality of images' or 'visual outlines' are common to all able-bodied human beings, even if only in a latent form;
- the *socio-historical*: some societies attach great importance to verisimilitudinous images, and are consequently driven to make rigorous definitions of the appropriate criteria of realism, which can vary and which set up a hierarchy in the acceptability of various images. For a European art lover in the 19th century, a Polynesian hut painting was only a primitive daub of no artistic value; on the other hand, the first Papuans of New Guinea to be shown photographs found them strange, difficult to understand and aesthetically unpleasing, because they were not schematic enough.

Consequently, it is very important not to confuse the concepts of illusion, representation and realism, even if they are often highly interconnected. *Representation* is the most general of these phenomena, allowing a spectator to see an absent reality 'by proxy', presented to him

74

or her by something that takes its place, that stands in for it. *Illusion* is a perceptual and a psychological phenomenon, which is sometimes triggered, in certain specific psychological and cultural conditions, by representation. Lastly, *realism* is a collection of social rules which aim to regulate the relation of the representation to the real in a way that is satisfactory *to the society that creates those rules*. In addition, it is important to remember that realism and illusion are not necessarily mutually inclusive – one does not imply the other.

II.2.3 Time in Representation

We have, implicitly, only taken into account the image in its spatial dimensions. However, time obviously is also an essential dimension of the image, of the apparatus in which it is presented and, therefore, of the image's relation to the spectator. It is the latter relation which we shall discuss briefly here.

The spectator's time. For all animals, human beings included, there is a body clock which governs the great natural rhythms, especially the circadian rhythm (from the Latin *circa diem*, one day long). We notice this most when the body clock is in some way upset, such as after an airplane journey when there is time change. However, when we refer to the time of the spectator, we are referring neither to this body time nor to the mechanical time measured by clocks. The time of the spectator refers not to some 'objective' time, but to our temporal experience. Traditional psychology differentiates between several modes of this kind of experience:

- the sense of the *present*, based on short-term, even immediate memory. In reality, the present does not exist as a point in time, but as a short duration (a few seconds for many bio-psychological functions such as the perception of rhythm);
- the sense of *duration*, which is what we normally mean by 'time'. Duration is felt (I obviously do not use the term 'perceived'), with the help of the long-term memory, as a sort of combination of the objective duration which passes, the changes which affect our perceptions during this time, and the psychological intensity with which we register both aspects.
- the sense of a *future*, linked to the expectations that we may have and determined in a more straightforwardly social way than the two senses of the passage of time described above. The sense of the future may be linked, for example, to the more or less precise definition and measurement of the objective passage of time: the expectation of a Western spectator, who is constantly surrounded by chronometric technology, is certainly different from that of an Amazonian Indian. The domain of the future is also the domain of interpretation (personal, social, intellectual);
- The sense of *synchrony* and *asynchrony*. What is 'the same time'? When two phenomena do not take place at the same time, which of them happens first? And so on.

75

So, there is no such thing as absolute time, but rather a 'general' time, in Jean Mitry's phrase, that refers all our temporal experiences to one inclusive system.

The notion of an event. The representation of our sensations in temporal form is the often complex result of work combining these different senses of time. The feeling of time does not flow from the objective duration of phenomena, but rather from changes in our sensation of time, which themselves stem from the permanent process of interpretation that we engage in.

It could thus be said that, if duration is the experience of time, time itself is always conceived as a more or less abstract *representation* of the content of sensations. In other words, time does not contain events, it is made up of events themselves in so far as we apprehend them. Time, or at least psychological time, which is the only kind of time we are considering here, is not a continuous, regular flux outside of ourselves. According to a formulation of Merleau Ponty, the notion of time presupposes 'a point of view on time', a *temporal perspective*. This is confirmed especially by Jean Piaget's work on child psychology: for the child there is no time in itself, but only 'a time incarnated in changes and assimilated to individual actions', with temporal concepts flowing from more fundamental concepts, reflecting factual phenomena.

Represented time. The representation of time in images, which changes according to the type of image involved (*see* Chapter 3, §II and Chapter 4, §III) takes place in reference to the categories of duration, of the present, of an event or occurrence and of succession. Theatrical representation is obviously the closest imitation of our normal temporal experience, certainly in its conventional form, since events are condensed or expanded according to the needs of scenes and of the narrative. Within the sphere of imagery, there is an enormous difference between the temporalised image (film, video) and the non-temporalised image (painting, engraving, photograph). Only the former is likely to give a convincing temporal illusion.

Note that this illusion is far from total. The development of 'invisible' editing in classic cinema is entirely based on a symbolic, conventional representation of factual time, omitting a number of moments which are judged to be insignificant, while extending others. As Albert Laffay (1964) has noted, cinema uses many forms of symbolisation that are very different from time, such as dissolves, superimpositions or acceleration, all of which are far from being transparent. Filmic time is mostly time reworked in the direction of expressivity, even within the temporal unity of the shot, which is not always an altogether homogeneous element (*see* Chapter 4, §III.2).

The non-temporalised image does not provide any illusion of time, but this does not necessarily mean that it is has no methods of representing it, sometimes in a suggestive way, as we will see in Chapter 4, §III.

II.3 Psychic Distance and Belief

II.3.1 Psychic Distance

The organisation of space, as we have seen, can be generically linked to a mathematical structure (*see* Chapter 1, §II.1.3). But a given representation in an image is more accurately described, in psychological terms, as the organisation of 'existential relations experienced with their instinctual force, with a predominantly affective sensorial register (tactile or visual) and a defensive intellectual organisation', according to Jean-Pierre Charpy (1976). The 'existential' relation between the spectator and the image has a spatiality which can be linked to spatial structures in general. It also has a temporality linked to the events represented and the temporal structure that flows from these. These relations to the structures qualify what we call a certain psychic distance. Pierre Francastel (1983) defines *psychic distance* as: 'The typical imaginary distance that regulates the relation between, on the one hand, objects of representation and, on the other, the relation between the object of representation and the spectator.' This concept is a little vague. Psychic distance is not measured; there is no technology for quantifying it. But despite the vagueness with which it is used, it has the advantage of indicating that illusion and the symbol, if these are really the two poles of our relation to the figurative image, are not the only possible forms of this relation, but rather its extremes, between which all sorts of intermediary psychic distances are possible.

The metaphor of psychic distance has sometimes been taken literally. An interesting antecedent can be found in the theory proposed in 1893 by the German art historian and sculptor Adolf Hildebrand. He differentiated between two forms of vision of an object in space:

- the nearby image (*Nahbild*), corresponding to the everyday vision of a form in lived space;
- the distant image (*Fernbild*), corresponding to the vision of this form in terms of the specific rules of art.

Hildebrand linked two tendencies in figurative art to these forms of vision (Figure 19): the *optical* pole of distant vision, in which perspective plays an important part and which corresponds to those arts that prioritise appearance (Hellenistic art, for example); and, at the other extreme, the *haptic* (tactile) pole of close vision, in which the presence of objects is more strongly emphasised, their surface qualities more in evidence, and so on, in what becomes an increasingly stylised manner (such as in Egyptian art). Between the two, there is a form of tactile-optical vision corresponding to an entire series of schools and periods of art history linking close and distant vision (as in classical Greek art). At the time, this theory was very successful and its effects can be traced through an entire generation of art historians of the early 20th century up to and including Panofsky. The division between optical vision and haptic vision (or visual touch) is found again in several more current authors, notably

Figure 19 Far/Near. In these two contemporaneous paintings, one is either held at a distance (G. Bellini's Holy Conversation, *1505) or projected straight into the action (G. Bellini's* Burial of Christ, c. *1500).*

Henri Maldiney, Gilles Deleuze (in his book on Francis Bacon) and Pascal Bonitzer (who applies the idea of visual touch to the film close-up). It should be noted that this theory also presages one of the great intuitions of the 'ecological' approach to perception, which also posits a difference between a normal mode of vision enabling one to move around and towards objects and, if desired, to 'touch' them with the look, and a less natural, perspectival mode which is a mode of representation. Although not scientific, the idea of a double mode of perception, and of a double 'psychic distance' in vision, is solidly based in our spontaneous experience of the visible.

This is what Raymond Bellour (1990) writes about the film made by Thierry Kuntzel and Philippe Grandrieux, *La Peinture Cubiste* (1981): 'It would seem that touch is prioritised over sight, tactile space over visual space. It is as if our gaze was simply an extension of our fingers, an antenna on our forehead.' In the same vein, consider the description of the 'Paluche', the miniature video camera invented by Jean-Pierre Beauviala, as 'an eye at one's fingertips', as Jean-André Fieschi put it when discussing the *Nouveaux mystères de New York*, and Paul Willemen's discussion of pornography in his essay 'Letter to John' in the book *Looks and Frictions* (1994).

II.3.2 The Impression of Reality in Cinema

A significant example of an image apparatus's ability to regulate psychic

distance is what has classically been called *the impression of reality*. From the outset, films have always been recognised as being particularly credible, whatever their subject matter and no matter how fantastic. The theorists known collectively as the Filmology School devoted special attention to this psychological phenomenon. Henri Wallon and André Michotte, among others, first emphasised a number of 'negative' factors: the film spectator, sitting in a darkened auditorium, is in principle not particularly disturbed or aggressed by the image apparatus, and he or she is thus more likely to respond psychologically to what he or she sees and imagines. This is a negative explanation of the impression of reality. However, there are also positive factors, as Christian Metz (1965) has shown. There are two main types:

• perceptual and psychological indices of reality, inherent in the medium of photography, to which is added the essential factor of apparent movement;
• phenomena of emotional participation, facilitated, paradoxically, by the relative unreality (or rather immateriality) of the filmic image.

The position of the film spectator therefore exemplifies a very specific kind of psychic distance: for reasons that are simultaneously quantitative and qualitative, as mentioned earlier, this is one of the weakest kinds of distance generated by imagery. It should be noted (and this is central to the concept of psychic distance) that this does not mean that cinema is an illusionist art, nor that it generates phenomena of belief that are necessarily stronger than others. It simply means that the film spectator is more psychologically invested in the image.

II.3.3 Reality Effect, Effect of the Real

By this play on words, Jean-Pierre Oudart, who suggested this distinction in an article written in 1971, sought to identify the essential link uniting two characteristic phenomena of the figurative image and its spectator. On the one hand, analogy, and, on the other, the spectator's belief.

The *reality effect* designates the effect produced on the spectator, through a figurative image (in principle, it does not matter whether this is a painting, a photograph or a film), by the ensemble of analogical indices. It is basically a spectator-centred variant of the idea that there could be a catalogue of representational rules which, by evoking natural perception, would enable its imitation. The reality effect would be all the more complete and effective in so far as the image uses these natural conventions, which are obviously fully historical (Oudart uses the term 'coded'). But it is already a matter of an 'effect', that is to say, an effect of a spectator's psychological reaction to what he or she sees. This notion is in essence no different from the theories of, for example, Gombrich.

The second 'level' of this theoretical construction, the *effect of the real*,

is more original. By this, Oudart means that, on the basis of a reality effect which is supposedly strong enough, the spectator infers a 'judgment of existence' on the represented figures and assigns them a referent in the real. In other words, the spectator believes, not because what he or she sees is the real itself (Oudart is not constructing a theory of illusion), but that what he sees indeed *has or could have existed in the real*. For Oudart, the effect of the real is characteristic of Western post-Renaissance representation which has always sought to subjugate analogical representation to a realist project. This concept is therefore part of a critique of ideology, as much as it pertains to psychology. It is cited here to help describe the notion of psychic distance, although the reality effect can also be interpreted as a way of regulating the spectator's investment in the image.

II.3.4 Knowledge and Belief

The notion of the impression of reality, the notion of the effect of the real, give a good idea of the complexity of the problem. The awkward vocabulary alone bears witness to this. In both cases, it is a matter of underlining the fact that, in his or her relation to the image, the spectator believes, up to a point, in the reality of the imaginary world represented in the image. In the 1950s and 60s this phenomenon of belief was often seen as monolithic, dominant and, in the last instance, deceptive. According to the ideological criticism of the end of the 60s, the effect of the real is deliberately used by bourgeois ideology to efface the work of the form; in favour of an investment in fictional reality. But the problematic of the impression of reality, which was not originally developed in this type of criticism, overestimates the role of 'deception' created by this impression.

Recently, the tendency seems to have largely subsided, with the arrival of cognitive theories of the spectator. Although these theories are still highly speculative, they seem to indicate a growing interest in what the spectator knows rather than believes. The generative approach of, for instance, Michel Colin broaches the question of the spectator's knowledge only indirectly, through the issue of the competence necessary for the comprehension of the image. In the United States, there is the systematic and extensive research of, for instance, David Bordwell. Bordwell and his colleagues have mainly described the spectator's 'functioning' within filmic narrative. This is undoubtedly easier to analyse in terms of cognitive processes. But when trying to understand the way in which images are seen, there are aspects of the 'constructivist' processes which still remain valid. Elsewhere, Bordwell has argued for what he calls neo-formalism, referring to a method for interpreting artistic texts by way of detailed descriptions of their precise formal and stylistic functioning. For Bordwell, the film spectator (but by implication the spectator of any image) is the locus of a double rational and cognitive activity: on the one hand, he or she activates general cognitive and perceptual processes which enable him or her to understand the image; on

the other hand, he or she uses forms of knowledge that, to some extent, inhere within the text itself. Bordwell has never claimed that this describes the entire activity of spectatorship, but he has continuously emphasised the importance of these cognitive moments, at the expense of emotional or subjective (in the psychoanalytic sense) ones, considering the latter to be difficult and even impossible to study scientifically.

The seemingly irreconcilable difference between theories of knowledge and theories of belief demonstrates that the psychology of the image-spectator is an inextricable mixture of knowledge and belief. It is in this sense that, in Europe, a less direct and more implicit form of research about spectatorship is being developed. With regard to the photographic image, Jean-Marie Schaeffer (1987) has clearly shown that a photograph's power to convince, often regarded as the power to portray a fragment of reality itself, rests on the implicit or explicit knowledge that the spectator has about the genesis of that image, which Schaeffer calls its 'arche'. Because we *know* that the photographic image is a print, a trace, a mechanically and physico-chemically produced version of the appearance of light at a given moment, we *believe* that it is an adequate representation and we are ready to believe that it 'tells the truth' about this reality (*see* chapter 3, §II.2.1). Similarly, in paying attention to 'figurations of absence', Marc Vernet (1988) underlines an aspect of cinema that demonstrates, to a more striking degree than the most obvious narrative conventions of the fictional film, the fact that, in watching a film, the spectator is simultaneously 'conscious of the unbridgeable gap between him- or herself in the auditorium and the fictional space where the story is taking place'. These 'figurations' – for example superimposition, and what Vernet calls 'this-side-ness' (*'l'en deça'*; the off-screen space) – require the spectator to accept an entire sytem of representational conventions that are themselves based on a knowledge of the cinematographic apparatus. In other words, when confronted with such features which are used widely in fictional film, the spectator, in order to continue his/her belief in the film, must intermittently suspend that belief in favour of an acknowledgment of the rules of the game.

The above are only two, albeit important, examples of work that has returned to and clarified old problems. Both are symptomatic of the fact that, while it is impossible to theorise spectatorship today without taking into account the spectator's knowledge, it is not enough to remain at the level of that knowledge – the image is also produced to be believed in and to be taken seriously.

III. The Spectator as Desiring Subject

III.1 Psychoanalysis and the Image

Up to now, we have concentrated on those aspects of spectatorship that are a product of cognition, consciousness, seeing and knowledge. Even when talking about those aspects of image viewing of which a spectator may not consciously be aware, we have implicitly privileged the rational cognitive dimensions of this activity. However, the spectator is, of

course, also a subject, affected by feelings, drives and emotions which intervene extensively in his or her relation to the image.

Over the last twenty years this question, especially as it exists in film theory, has been largely dominated by Freudian and Lacanian psycho-analytic perspectives. As we know, Freudian psychoanalysis differentiates between two levels of psychic activity: the primary processes of unconscious structures (neurotic symptoms, dreams) and the secondary processes which are those addressed by traditional psychology (conscious thinking). According to Freud, the secondary processes relate to the control, mastery and, if necessary, the repression of the psychic energy inherent in the primary processes, subject to the law of the reality principle; they are concerned with social organisation, civilisation and expression through language with its institutional constraints, producing rational discourse and representation. The primary processes, on the other hand, relate to the 'free' flow of psychic energy that moves from one form to another, one representation to another, without any constraints other than those of the play of desire; the primary processes relate to subjective, neurotic expression, based on the 'language' of the unconscious and its processes of condensation and displacement.

The image has been broached by psychoanalysis in two ways: the role it plays in the unconscious, and, in terms of art, as a symptom.

III.1.1 Art as Symptom

The founders of psychoanalysis, led by Freud, often discussed artistic production in terms of its subjective aspect, that is, in terms of its relation to the producer, the artist. The work of art was therefore studied as a secondary discourse (since it has a social existence, can be communicated, circulated and possibly understood by someone other than its creator), but one which nevertheless contained symptomatic traces of the primary, unconscious discourse. In fact, the work of art was one of the privileged objects of applied psychoanalysis.

The prototypes of these studies were, obviously, Freud's own texts on Leonardo da Vinci and Michelangelo's *Moses*. The essay on Leonardo is a typical case history. From all the available documents (paintings, drawings and notebooks), Freud analyses Leonardo in the same way that he would analyse a patient. The analysis, quasi-classically, centres on the unearthing of a 'childhood memory' considered to be the key to Leonardo's neurosis: he is a repressed or rather sublimated homosexual, emotionally fixated on his mother. Freud traces the famous childhood memory step by step through Leonardo's adult, conscious production, tracking the signifiers of its presence (such as the *Mona Lisa*'s smile). The study of Michelangelo's sculpture is somewhat different, consisting of an interpretation of this enigmatic work that attempts to understand the psychological state depicted in its subject, Moses returning from Mount Sinai (and including Freud's attempt to understand why Michelangelo was driven to express this psychological state rather than any other).

However, apart from these two well-known texts which opened up the areas of, first, psychobiography and, second, psychoanalytic reading of art, the work of the first generation of psychoanalysts on art was largely determined by the artists that they encountered in treatment. The development of psychoanalysis in German-speaking countries after the First World War coincided with the birth of a number of art movements, including many types of abstraction and expressionism, which partly aimed to set aside such secondary processes as rationalisation in order to allow the effects of the primary processes to emerge. It is significant that many of these artists were psychoanalysed by Freud and his disciples, and that the latter found in the work of contemporary artists material more ripe for analysis than that in the Renaissance work studied by Freud. We will cite only one example, discussed in a publication (1922) in which a follower of Freud working in Zürich, Oskar Pfister, wrote about his analysis of an (anonymous) expressionist painter. In his book, Pfister adopts a method which is itself both interesting and debatable, moving from an exposition of elements of the analysis to a discussion of the psychological and the 'biological' (*sic*) background of the patient's paintings, and concluding with a discussion of the psychological and biological basis of expressionism in general. Pfister's gloomy conclusions remain thoroughly enmeshed in the dominant art ideologies of the 1920s: expressionism 'leads to introversion, which then develops into autism which destroys all rational and volitional relations to empirical reality, limiting the artist to an intellectually and ethically sterile position'.

Many other writers have characterised art as a symptom. Here we will only discuss one comparatively individual and original study, Anton Ehrenzweig's *The Hidden Order of Art* (1967). As its title indicates, Ehrenzweig suggests that beyond the apparent order of the work of art – the order which is mainly concerned with figurative representation – there is also a deep structure based on a non-rational articulation of the primary processes. The task of the analyst before the work of art is less to do with interpreting the work's content than with finding the content of the repressed, not in the final product but through the traces of unconscious processes that the work bears. The main examples are obviously those taken from twentieth-century painting, which is more detached from the constraints of figurative representation, and from 'primitive' art and caricature. But his most interesting insights are perhaps those which show that his method can just as well be applied to the non-articulated aspects of classical paintings, such as its plastic values (*see also* Chapter 5 below). The corollary of this approach is that art should not be read in a linear way, but 'polyphonically', in the same way that, in music, we may hear a number of different melodies separately and simultaneously. The analyst should explore works by looking and thinking (Ehrenzweig talks of 'unconscious scanning') and should not try to flatten out their virtual depth. Ehrenzweig's book is very different from the more classical studies in applied psychoanalysis: he no longer

reads the art work as a symptom produced by a neurotic subject, the artist, but as a product organised according to structures which are those of the unconscious in general. It is because of this that Ehrenzweig's book foreshadows contemporary appropriations of psychoanalysis for textual analysis.

III.1.2 The Unconscious and Imagery

One of the basic ideas underpinning the psychoanalytic aproach to the question of image-spectatorship is that it recognises the close link between the unconscious and the image: the image 'contains' unconsciousness, primary processes that can be analysed, just as, conversely, the unconscious 'contains' imagery or representations.

In fact, it is impossible to specify the form in which imagery exists in the unconscious, because, almost by definition, the unconscious is inaccessible to direct investigation and can only be known indirectly, through the symptomatic productions that provide the evidence of its work. The fact that images play an important part in these symptomatic productions does not necessarily tell us anything about their existence 'in' the unconscious, and this question remains one of the most speculative in Freudian theory. We cannot go any further along this path. However, we shall, briefly, suggest a possible connection between the concept of unconscious imagery and other concepts of 'internal', 'mental' imagery. Earlier we mentioned the notion of visual thinking, but here it is a question of what is currently known as mental images. This link may seem scandalous to some, since it was one of the strongholds of cognitive psychology (and hence of anti-psychoanalysis), the Massachusetts Institute of Technology, which in the late 20th century pioneered the study of mental images. In the context of this book, which aims only to describe the current state of research rather than to side with one or other theoretical method, it seems possible and even useful to make a link between visual thinking and mental images.

The debate on mental images goes more or less as follows: given that countless experiments as well as ordinary self-conscious instrospection bear witness to the existence of 'internal' images in our thinking, how should these images be conceptualised? Are they real images in the sense that at least some of them, even if only partly, represent reality in an iconic way? This is the *pictorialist* position. Or are they mediating representations, similar to representation in language? This is the *descriptionist* position. The debate is more subtle than the words 'image' and 'language' would lead us to suppose, as it is generally agreed that these are not images in the common, phenomenal sense of the word. Perhaps one of the most lucid explanations is this: the 'mental image' is one which, in our mental processes, could not be imitated by a computer using binary data. The mental image is therefore not a sort of internal 'photograph' of reality, but a coded repsentation of reality, even if these codes are not the same as the codes of verbal language. However, there are also experiments in which subjects have confused mental imagery

with perception, which would seem to indicate that there is a certain functional similarity between the two. Many existing hypotheses about mental images are based on the possibility of a coding system that is neither verbal nor iconic, but of an intermediary kind. Without being tested experimentally, it seems possible if not probable that unconscious imagery is of that intermediary type. We cannot go any further along this path: nobody, not even the proponents of the cognitive approach, knows how real images inform and 'encounter' our mental or unconscious images.

III.1.3 The Image and the Imaginary
The concept of the imaginary clearly demonstrates the encounter between the two notions of mental imagery. In the current sense of the word, the imaginary is the domain of the imagination understood as a creative faculty, producing internal imagery which may possibly be externalised. In practical terms, it is synonymous with 'fiction' and 'invention', and it is the opposite of the real (sometimes of the realistic). In this ordinary sense, the representational image depicts an imaginary world, a *diegesis*. The concept has been given a more precise meaning in Lacanian theory, which has inspired a number of essays about representation, especially cinematic representation. For Lacan, the subject is an effect of the Symbolic, itself conceived as a network of signifiers which have meaning only through their mutual interrelations; but the relation of the subject to the Symbolic is not direct: the Symbolic is completely inaccessible to the subject in so far as it constitutes the subject. It is through the intermediary of Imaginary formations that the subject realises this relation to the Symbolic:

- through 'the figures of the Imaginary other in the relation of erotic aggression in which they are realised', in other words, through the subject's objects of desire;
- through identifications, 'from the specular *Urbild* [primal image] to the paternal identification of the ego ideal'.

The notion of the Imaginary, for Lacanian theory, reprises 'first, the subject's relation to its founding identifications [...] and, second, the subject's relation to the Real, which is characterised by its illusory nature'. Lacan always emphasised the fact that the word 'Imaginary' is closely linked to the word 'image': the Imaginary formations of the subject are images, not only in the sense that they are intermediary or a 'stopgap', but also in the sense that they may be manifested in material images. The first canonical Imaginary formation, which takes place at the mirror stage when the infant forms an image of its own body for the first time, is directly based on the production of an effective image, the specular image. But the images that the subject encounters later on come dialectically to supply his Imaginary: because of these images, the subject activates the register of identification and of objects, but can only

encounter them on the basis of identifications that have already been made.

What is surprising is that, reduced to its basic principles in this over-simplified account, this approach is not very different from some models proposed by theories close to cognitive psychology. When Arnheim speaks of subjective centring as a founding phenomenon of the perception of images, we could easily translate this statement into the terms of Lacan's mirror phase. Naturally, what will always divide the two approaches is the touchstone of the unconscious, which the cognitivists do not take into account either because they think it is always unknowable or because they simply refuse to recognise its existence.

The notion of the Imaginary has been very much enlarged and extended in psychoanalytic film theory, especially through the work of Christian Metz (1977). Since cinema offers no real presence, it is made up of imaginary signifiers (imaginary in the double, technical and colloquial senses of the word): 'Cinema activates all perception but then undermines it again through absence, which is nevertheless its only actual signifier.' Within the context of Lacanian theory, which establishes close links between the imaginary and identification, Metz has developed a theory of spectatorship and identification at two levels: the 'primary' identification of a spectator with his or her own gaze, and 'secondary' identifications with elements in the image.

The cinematographic image offers a great engagement of the imaginary, which is one of the reasons why the theory of the imaginary has been so prominent. But by rights, every image distributed socially through a specific apparatus derives from the same approach, since, by definition, the figurative image uses the double register ('double reality') of presence and absence. Every image encounters the imaginary, instituting identificatory networks and activating the specator's identification with him- or herself as observing spectator. But, of course, the secondary identifications are very different in different types of image. They are far less numerous and less intense in a painting and even in a photograph than in film.

III.2 The Image as Source of Affects

III.2.1 The Concept of Affect

With the concept of *affect* we are moving away from psychoanalysis in its strictest sense, since the term goes back at least as far as Kant, who used it to describe 'the feeling of pleasure or displeasure ... that prevents the subject from being able to think'. Today, it is defined as 'the emotional component of an experience, either linked or not linked to a representation. Its manifestations can be many: love, hate, anger and so on' (Alain Dhote, 1989). The subject-spectator is thus considered subjectively, but not analytically, without returning to the deep structures of his or her psyche, but remaining at the surface manifestations of emotion. We will briefly summarise two examples of work

86

in this field; there is, to date, no general theory of emotions in specta-
torship.

III.2.2 An Example of Affective Participation: Einfühlung (Identification)

Our first example is taken from the great tradition of early-twentieth-
century German art history. In 1913 Wilhelm Worringer published his
book *Abstraktion und Einfühlung* (1913; translated as *Abstraction and
Empathy*, the latter concept now more readily understood as 'identifi-
cation'), subtitled *A Contribution to a Psychology of Style*. He sought to
develop a psychological aesthetic in opposition to the then dominant,
normative aesthetic: the desire for a 'scientific' analysis of art conceived
as prescriptive, relating the art object to an absolute, eternal and uni-
versal ideal. To achieve this, Worringer borrowed two concepts from his
immediate predecessors:

- the concept of *abstraction* borrowed from Alois Riegl; Riegl conceived
 of art production as stemming from an anonymous and general 'will
 to art' (*Kunstwollen*), linked to the notion of 'the people'; he divided
 the entire history of art into, on the one hand, realist styles based on
 the optical imitation of reality and, on the other, artistic forms con-
 ceived on the basis of geometric stylisation, based on a more tactile,
 less optical relationship to reality; he associated this second type of art
 with the principles of abstraction;
- the concept of *Einfühlung*, which had already been in existence for
 some time in what was then (the 1870s) the new discipline of psy-
 chology. *Einfühlung* is sometimes translated as empathy and denotes
 an 'objectified pleasure in oneself' (Theodore Lipps), on the basis of
 a 'pantheistic tendency, characteristic of human nature, to be at one
 with the world' (Robert Vischer). *Einfühlung* corresponds to a happy
 relationship to the outside world (which, for a psychoanalyst, would
 be of an identificatory nature).

Worringer's art history uses this dichotomy to produce a general
theory of history in the form of a more or less regular oscillation between
two poles: the pole of *abstraction*, characterised by a clear, inorganic style
based on straight lines and flat surfaces, embodying collective values;
and the pole of *Einfühlung*, characterised by a naturalistic, organic style
based on the curvilinear and the three-dimensional, embodying individ-
ual tendencies and aspirations. Egypt is the paradigm of the former,
Greece of the latter. Certain periods such as the Gothic forge links be-
tween the two poles. This vision of history was not, when Worringer
proposed it, very original: it reprises the basic principles of Riegl and at
the same time restates the great divide between optic and haptic vision
proposed by Hildebrand in 1893 (*see* §II.3.1). It is of interest here be-
cause Worringer wanted to found it entirely on psychological determi-
nations of an affective nature: imitative, naturalist art is based on this

empathic relation to the world of *Einfühlung*, while abstract, geometric art is based on other affects, such as a profound psychological need for order, to compensate for the fact that contact with the outside world can cause anxiety. This idea that art can 'compensate' for existential anxiety has been made much of in many relatively recent forms of therapy.

III.2.3 Emotions

The concept of emotion, which in colloquial usage is often used as a synonym for 'feeling' or 'passion', should nevertheless be clearly differentiated from these. Feeling and passion are secondary forms of an affect already linked to a series of representations, whereas emotion maintains a more 'primary' character and is often experienced as being without signification. For Francis Vanoye (1989), one of the rare researchers to broach this question, 'there is a division between the neutral approaches to emotion, considered as regulating the transition from emotion to action, and the more negative approaches which consider emotion to be a dysfunctional sign related to a drop in the subject's ability to perform'.

Another approach tends to see emotion as a momentary regression and is dominant in all the literature on the *spectacular* image, that kind of image which is produced for collective mass-spectatorship. From fairground spectacle to television, there is a similar theoretical contempt for the emotions they generate, all the more so when these are claimed to be 'strong' emotions (most often due to a confusion between emotion and sensation).

More interesting are the rare theories attempting to elaborate a positive approach to emotion. In the majority of cases, images create frustrating emotional processes because there is no transition from emotion to action available to the viewer, nor is there any real communication between the spectator and the image. Vanoye, limiting his study to cinema, proposes a preliminary, rather schematic, account of the viewer's emotional situation, identifying two sorts of emotions induced in the cinema spectator:

- 'strong' emotions linked to survival, sometimes similar to stress, activating 'behaviour of alarm and regression into magical belief', such as fear, surprise, physical speed. In this case, there is an emotional blockage because the spectator cannot really react (he or she can only compulsively repeat the experience by going to see another film);
- other emotions that are more closely linked to reproduction and sociality, such as sadness, affection, desire, rejection. In this case, films activate well-known registers of identification and expressivity. These emotions come up against three obstacles. First, excessive coding, which is nevertheless necessary if the film is to be understood. Second, the inhibition of communication and action; and finally, the feeling of having experienced an incomplete or falsely complete emotional cycle.

Vanoye identifies two conditions which enable emotional experience in the cinema to be more satisfying:

- some films 'manage' the emotional cycle better by 'allowing the spectator access to the integration or elaboration of his or her emotional experience' through the mastery of a narrative configuration (for example, by varying the identificatory points of view);
- some subjective situations facilitate emotional cathexis more than others.

While Vanoye's study is illuminating, it should be noted that it mostly relates the production of emotion at the cinema to narrative-diegetic structures, and thus only indirectly to the image itself. What triggers emotion is the imaginary and momentary participation in a *fictional world*, the relation to the characters, the confrontation with situations. The emotional value of images themselves is still very rarely studied, and when it is, it is almost always within the sphere of aesthetics (we will return to this in Chapter 5).

III.3 Spectatorship: Its Drives and the Image

III.3.1 Drives

The notion of the *drive* is basic to Freudian psychoanalysis, where it constitutes a reworking of the older notion of 'instinct'. For Freud, the drive is 'the psychic representation of excitations issuing from inside the body and reaching the psyche'. In the psychic mechanism which aims to master this excitation, the drive is located between physical excitation and its expression. Freud's emphasis is on the *pressure* exerted by the drive. But beyond this pressure, which is its primary aspect, the drive is defined by its *aim*, which is always the satisfaction of the drive by its *object*, that is to say, the object through which a drive can reach its aim. Lastly, the drive is also defined by its source, which is the point where the drive is anchored in the body. Initially, the drives are 'partial, that is to say, they are linked to individual sources (oral, anal, phallic, and so on) and are aimed at individual pleasures connected with specific source-organs. In Freudian theory, partial drives become subordinated to a psychic organisation which Freud calls 'genitality'. The drives never disappear and can sometimes return to the foreground (the return of the repressed) when repression is blocked.

The drives are the most mysterious part of the model of the psyche elaborated by Freud. As with all aspects of the human psyche, they can intervene in our relation to images, even if this intervention is problematic and misunderstood.

III.3.2 The Scopic Drive and the Look

What we call the *scopic drive*, which activates the need to see, is only one example of such a drive, and not even the most fundamental one, linked

to organ pleasure. More basic, for instance, is the oral drive which springs from the biological need for food. On the other hand, the scopic drive is characteristic of the human psyche in so far as it transforms instincts into drives.

As the general schema implies, this drive comprises an aim (to see), a source (the vision system) and, ultimately, an object. The latter, which is the means by which the source fulfils its aim, has been identified by Jaques Lacan with the *look*. It is now obvious why the concept of a scopic drive, implying the need to see and the desire to look, is usefully applied in the sphere of imagery. But as is the case with psychoanalytic concepts in general, it is film theory (and then photographic theory) which has most used and developed this application. No doubt this is because film theory is more recent than art history and therefore has not met as much resistance and unwillingness to use new and demanding concepts. But another reason is that cinema, which articulates imagery and narrativity, is a cultural form in which desire and drives are very much in evidence. (All the same, it was specifically in relation to painting that Lacan introduced the concept of the look as *object a*, particularly noting that the painting, by offering something for the eye to consume, by being an object of the look, partly satisfies the scopic drive, even in those styles of painting such as expressionism where looking is so 'excessively' stimulated that Lacan calls it perverse because the drive is cultivated for its own sake. However, as far as I know, Lacan's analyses of paintings have not yet been followed up systematically by theorists of the pictorial image.)

In all the current uses of the word, the look is differentiated from simple sight, because it arises from a deliberately and actively perceiving subject. In Chapter 1 we discussed how psychologies of perception define the look as a voluntary and conscious sensorial-informational activity through which the subject organises knowledge and behaviour in its particular environment. Obviously, the Lacanian approach implies another conception of the subject altogether. In an often cited series of seminars, Lacan suggested that the look is an *object a* (a more or less part-object of desire, or an object of the drive). If the desire of the viewer is to look, he or she is caught in a complex, intersubjective game which is played out on three levels: first, on the subjective apparatus of spectatorship, a mechanism which simultaneously facilitates and prohibits the drive; second, on the exchange of looks within the diegesis, a play in which the viewer may, imaginarily, become trapped; third, the look directed, still imaginarily, from the screen towards the auditorium.

All these modalities of the look have each given rise to a great deal of literature: the play of looks within the image is central, for instance, to Nick Browne's analysis of a fragment of John Ford's *Stagecoach* and to Raymond Bellour's analysis of a fragment of Howard Hawks's *The Big Sleep*; the spectator's look at the screen is the object of the concept of suture as proposed by Jean-Pierre Oudart (1970), Stephen Heath and, more recently, of a study by Marc Vernet (1988), who suggests that it

represents one of the 'forms of absence' which punctuate cinematic discourse, thus enabling the unrepresentable to surface. Laura Mulvey's celebrated essay (1975) on visual pleasure discusses the interplay between the looks within the diegesis and those at the screen, while Paul Willemen (1976) discusses the (imaginary) look at the viewer while he or she is gratifying his or her scopic drive by looking at the screen.

III.3.3 Scopophilia and Sexual Difference

The psychoanalytic approach to film and photography has, in general, tended to study this aspect of the look in two ways. Psychoanalytic film and photography theory has studied

- the looks represented within the image and how the viewer is implicated in them;
- the viewer's look as a partial satisfaction of his or her fundamental voyeurism.

On both scores, studies centering on sexual difference (mostly from a feminist perspective, as, for instance, in Laura Mulvey's work) have made a very valuable contribution by pointing out the dissymmetry between male characters endowed with the power of looking and female characters constructed as objects of the gaze, or the essential difference, in the play of the look, between a masculine subject structured as voyeur and a feminine subject split between voyeurism and 'to-be-looked-at-ness', between the woman as image and man as bearer of the look (including, by proxy, that of the viewer, and thus neutralising the potential danger that emanates from the image of the woman as spectacle which tends to halt the flow of the action in order to become an erotic object). For Mulvey, this, in classical narrative film, gives rise to a fundamental contradiction between the boundless game of scopophilia (the perversion linked to the exacerbation of the scopic drive) and the play of identifications. In psychoanalytic terms, woman signifies the absence of a penis, castration: her image always threatens the spectator with anxiety, hence the escape mechanisms often used by classical cinema, such as the compulsive repetition of the primal trauma (in sadistic form in film noir) or the fetishisation of the image of the woman (which is a way of disavowing the castration that she represents).

These theses have been widely used by mainly anglophone and feminist theorists and critics of representation in general and of film in particular. It may also be worth mentioning in this context the less rigorously psychoanalytic, but equally feminist, book by John Berger, *Ways of Seeing*, which offers a radical criticism of the dominant imagery of 'woman' in Western culture, especially in painting and in advertising photography, and of the exploitation of the female body as an object of masculine voyeurism. Since then, there have been numerous studies of looking by art historians such as Norman Bryson, Lisa Tickner, Beatriz Colomina and Rosemary Betterton.

III.3.4 The Joy of Images

If an image is made to be seen (partly) to satisfy the scopic drive, it should give rise to a particular pleasure. This insight generated Roland Barthes' important text *Camera Lucida* (1980), which theorises the relation of the spectator to the photographic image.

Extending concepts developed in his theoretical work on literature, Barthes contrasts two ways of broaching the same photograph, distinguishing what he calls the photographer's photo and the spectator's photo. The former activates the information in the photograph, the objective signs of an intentionally coded field, the ensemble emanating from what he calls the *studium*. The latter activates chance, subjective associations, and discovers within the photo a part-object of desire, uncoded, unintentional, which he calls the *punctum*.

It is certainly not by chance that Barthes uses the photographic image as the basis for this important theoretical advance (in relation to his more semiological work on the image of the 60s such as 'The Rhetoric of the Image'). The photographic image, as a trace of the real, creates forms of belief that were not known prior to its invention. But Barthes goes further than this: not only do we believe in photographs, in the reality that the photograph represents, but the photograph actually produces a real revelation of the object represented. The photographer's photo implies a signifying *mise en scène* which it is up to the spectator to decode cognitively; on the other hand, the spectator's photo adds a fully subjective relation to the former, each spectator being able to project him or herself in their own way by appropriating certain elements of the photo which are, for him or her, like small fragments taken from reality. In that way, the photograph particularly satisfies the scopic drive because it provides not only something to be seen (a reality that has been, literally, placed on the scene), but also something to be looked at (something purely photographic which provokes *me*, the viewer, through the punctum, through what specifically targets *me* as viewer and engages *me* to derive joy from the photograph). In the book, Barthes analyses a number of photographs, some of them well-known, and identifies the locus of the punctum, *for him*, in each one. It is easy to see that this point is neither universal nor objective, that it belongs to the author, and that if the punctum exists in a photograph (which it does not necessarily), it is a function of a specific subject-spectator.

This theory, which is controversial because it starts from subjective experience, remains interesting even if one does not completely accept Barthes' descriptions of the photographs and all aspects of his argument. There are good reasons for being sceptical of a distinction based on the thorny criterion of the intentionality inherent in the work. In fact, by its very excess, Barthes' argument makes a useful distinction between the activity of the photographer and that of the spectator, showing in passing that, in the case of the photographic image, there is no pure spectatorship since the spectatorial is always defined in relation to 'creativity', that is to say, the activity of producing and the apparatus through which it is produced.

III.3.5 The Image as Fetish

Barthes' notion that there is a particular characteristic of the photograph which causes specific subjective effects was taken up by Christian Metz (1985) in order to demonstrate that photography is partly linked to *fetishism*.

In Freudian theory, fetishism is a perversion which results from the fact that the child traumatically discovers the mother's lack of a phallus. The child may refuse to give up believing in this phallus, putting a substitute, a fetish, in its place (usually an object that happened to be within view at the moment when feminine castration was acknowledged). This theory has been widely criticised from several points of view (specifically from feminist positions because in classic psychoanalysis it applies almost exclusively to masculine development). However, as Metz pointed out, whatever the value of the concept in its original context, 'there are many great similarities between what we call a photo, this piece of paper that is so easy to handle, overflowing with tenderness, the past and imaginary afterlife, and the Freudian concept of a part-object, of fear, of severance, of faith undermined'. Metz lists the many characteristics of a photograph which enables its fetishisation:

- its size: even a large size photograph has something 'small' about it (this point seems rather debatable: in exhibitions, photographs often are very big, more like paintings than passport-sized pictures);
- its ability to arrest the look, recalling the similarly halted gaze which gave rise to the fetish;
- the fact that, socially, the photograph has mainly had a documentary role and that, above all, it is principally an *indexical* sign which 'points at what once was, and no longer is', rather like the fetish;
- the fact that a photograph uses neither movement nor sound and that this double absence turns back on it in order to endow it with 'the power of silence and stillness', that is to say, it visibly and symbolically reaffirms the connection between photography and death;
- lastly, the fact that photography, unlike cinema, has only a very weak sense of off-screen space, but nevertheless produces a specific extra-diegetic effect, 'undocumented, immaterial, inviting projection, and all the more attractive for that', exactly like Barthes' punctum, which is the 'metonymic expansion' of off-screen photographic space. Given that off-screen space is a place which the look can never find, and that the photographic field is 'haunted by the feeling of what lies outside it, beyond its edges', this relation between a field and its 'outside' evokes that other relation between the space from which all looks are averted, the space of castration, and that space adjacent to it which is the place of the fetish.

In all these aspects, the photographic image lends itself very well to fetishisation. More precisely, since everything can be fetishised, including images, Metz demonstrates what can, in photographic practice itself,

operate a synthesis between the exercise of the look and fetishisation (which is based on a *denial* of the real).

IV. Conclusion: The Anthropology of the Spectator

What emerges from this overview of some of the main approaches to image spectatorship is thus a veritable anthropology of the image, that is to say, a study of the image in its relation to human beings in general. Rather than trying to reach a definitive conclusion, which would be difficult given the heterogeneity and diversity of the theories described here, we will end this chapter by mentioning that this project of an anthropology of the image has already been started, and by citing the most noteworthy proponents of this movement, Sol Worth and John Adair. In their most important work, *Through Navajo Eyes* (1972), they discuss the extensive field work which led them to explore the question of the universality of the image – a project previously conducted only with Western or Europeanised subjects – with Navajo Indians. They did so with a concern for honesty and mutual respect that is quite remarkable. They concentrated on six Navajo Indians, aged between 17 and 25, and a seventh, 55-year-old monolingual man. All seven lived on an Indian reservation in Arizona, and the research project was put to them by Worth and Adair only after a long period of getting to know one another. The seven agreed to take part in the research. The two anthropologists simply gave them technical instructions about the camera equipment so that they could make and edit a 16mm film about whatever subject they wanted.

The interpretation of the resulting films revolved mainly around the cinematographic language the Navajo used in their films, and was influenced by Whorf's famous hypothesis that various semantic and syntactic categories found in natural languages reflect different cultures' conceptual categories about the natural world. In other words, Worth and Adair supposed that the way in which the Navajo spontaneously filmed would be likely to indicate something about the representations of the world inherent in their culture (beyond what is already known about their language).

Consequently, they analysed both the form (the film language) and the content (the symbolic and mythic aspects) of the films. The formal analysis was informed by Worth's previous film semiological work on the structure of the development of film form. This work differed from most other forms of film analysis because it took into account the production processes of film. Worth distinguished two different semiological entities; the view taken through the camera during shooting, which he calls the *cademe*, and the view in the film after editing, which he calls the *edeme*. The questions they asked, among others, were: which cademes are used in editing and which are rejected? Where are cademes cut in order to transform them into edemes? Which edemes are used to qualify or modify other edemes? In all, are there any structures common to all the films made by the Navajo?

94

Their conclusions remained cautious and one cannot but respect their concern not to overinterpret the material. One of the central points that they bring out is the importance in Navajo culture of concepts linked to physical movement (especially to circular movement), and to the very notion of movement itself, manifested in various forms in the films. Although space prevents a detailed discussion of Worth and Adair's work, the experiment did show that, if there is a far-ranging universality to the moving image, it is at the level of the symbols that are firmly anchored within a culture and are thus least present to consciousness. In this way, film images are appropriated differently in different cultures, differences which can be tracked in the deep structures of the image rather than in its contents.

However one interprets these data (and the work of David MacDougall stands as a powerful extension and correction of Worth and Adair's pioneering efforts), they cannot but confirm the basic idea that the image is always formed by deep structures linked to language as well as to a symbolic organisation of a culture or a society; and that nevertheless the image is also a means of communication and representation of the world which can be found in all human societies. The image is universal, but it is always specific.

V. Bibliography

The Image and Its Spectator
Andrew, Dudley (ed.), 'Cinema and Cognitive Psychology', *Iris* no. 9, 1989.
Ang, Ien, *Desperately Seeking the Audience* (London: Routledge, 1991).
Arnheim, Rudolf, *The Power of the Center* (Berkeley: University of California Press, 1981).
———, *Towards a Psychology of Art* (Berkeley: University of California Press, 1966).
Casetti, Francesco, *D'un regard l'autre* [1986] (Lyon: Presses Universitaires de Lyon, 1990).
Colin, Michel, *Langue, film, discours* (Paris: Klincksieck, 1985).
———, 'Dossier Michel Colin', *Iris* no. 9, 1989, pp. 131-76.
Eisenstein, S. M., 'The Montage of Film Attractions' [1924], in Richard Taylor (ed.), *S. M. Eisenstein Selected Works, Volume One: Writings, 1922–34* (London: BFI, 1988), pp. 39–58.
———, 'Speeches to the Film Workers' Conference', in Richard Taylor (ed.), *S. M. Eisenstein Selected Works, Volume Three: Writings, 1934-48* (London: BFI, 1994).
———, *Non-Indifferent Nature* [1938-45] (Cambridge: Cambridge University Press, 1987).
Freud, Sigmund, 'Leonardo da Vinci and a Memory of His Childhood' [1910], *Standard Edition of the Complete Psychological Works of Sigmund Freud*, vol. xi (London: Hogarth Press, 1957).
Gombrich, Ernst H., *Art and Illusion: A Study in the Psychology of Pictorial Representation* [1959] (Princeton, NJ: Princeton University Press, 1961).
———, 'Visual Discovery through Art' [1965] and 'The Mask and the Face'

[1970], in *The Image and the Eye: Further Studies in the Psychology of Pictorial Representation* (Oxford: Phaidon, 1982).

Guillaume, Paul, *La Psychologie de la forme* [1937] (Paris: Flammarion, 1979).

Jay, Martin, *Downcast Eyes: The Denigration of Vision in Twentieth-century French Thought* (Berkeley: University of California Press, 1993).

Kennedy, John M., *A Psychology of Picture Perception* (San Francisco: Jossey-Bass, 1974).

The Representational Illusion

Arnheim, Rudolf, *Film as Art* [1932] (London: Faber, 1958).

Bazin, André, 'The Ontology of the Photographic Image' [1945], in *What is Cinema?* (Berkeley: University of California Press, 1967).

Bellour, Raymond, 'D'entre les corps', in *L'Entre-image* (Paris: La Différence, 1990).

Bordwell, David, *Narration in the Fiction Film* (London: Methuen, 1985).

Charpy, Jean-Pierre, *L'Objet pictural de Matisse à Duchamp* (Paris: CNRS, 1976).

Comolli, Jean-Louis, 'Technique and Ideology' [1969], *Screen* vol. 12 no. 1; reprinted in Bill Nichols (ed.), *Movies and Methods*, vol. 1 (Berkeley: University of California Press, 1976).

Deregowski, Jan B., *Illusions, Patterns and Pictures: A Cross-cultural Perspective* (New York: Academic Press, 1980).

Francastel, Pierre, *L'Image, la vision et l'imaginaire* (Paris: Denoël-Gonthier, 1983).

Gombrich, Ernst H., *Art and Illusion: A study in the Psychology of Pictorial Representation* [1959] (Princeton, NJ: Princeton University Press, 1961).

Goodman, Nelson, *Languages of Art* [1968] (Oxford: Oxford University Press, 1969).

Gregory, R. L., and Ernst H. Gombrich (eds), *Illusion in Nature and Art* (London: Duckworth, 1973).

Hauser, Arnold, *The Social History of Art* [1938] (New York: Arnold A. Knopf, 1951).

Hildebrand, Adolf, *The Problem of Form in Painting and Sculpture* [1893] (New York: Stechert, 1907).

Lacan, Jacques, *The Four Fundamental Concepts of Psycho-analysis* [1973] (London: Hogarth Press, 1977).

Laffay, Albert, *Logique de cinéma* (Paris: Masson, 1964).

Metz, Christian, 'On the Impression of Reality in Cinema' [1965], in *Film Language: A Semiotics of the Cinema* (New York: Oxford University Press, 1974).

——, *Psychoanalysis and Cinema: The Imaginary Signifier* [1973–76] (London: Macmillan, 1982).

Michotte, André, 'Le Caractère de "réalité" des projections ciné-matographiques', *Revue internationale de filmologie*, nos. 3–4, 1948, pp. 249-61.

Mitry, Jean, 'Temps, espace et réel perçu', in *Esthétique et psychologie du cinéma*, vol. 2 (Paris: Editions Universitaires, 1965), pp. 179-278.

Oudart, Jean-Pierre, 'L'Effet de réel', *Cahiers du cinéma* no. 228, 1971, pp. 19–28.

Piaget, Jean, *Mes idées* [1973] (Paris: Denoël-Gonthier, 1977).

Pirenne, Maurice, *Optics, Painting and Photography* (Cambridge: Cambridge University Press, 1970).

Schaeffer, Jean-Marie, *L'Image précaire* (Paris: Le Seuil, 1987).

Vernet, Marc, *Figures de l'absence* (Paris: Editions de l'Etoile, 1988).

Wallon, Henri, 'L'Acte perceptif et le cinéma', *Revue internationale de filmologie* no. 13, 1953.

The Spectator as Desiring Subject

Barthes, Roland, *Camera Lucida* (New York: Hill and Wang, 1980).

Baudry, Jean-Louis, *L'Effet cinéma* (Paris: Albatros, 1978).

——, 'Ideological Effects of the Basic Cinematographic Apparatus' [1970], reprinted in Bill Nichols (ed.), *Movies and Methods*, vol. 2 (Berkeley: University of California Press, 1985).

——, 'The Apparatus: Metapsychological Approaches to the Impression of Reality in Cinema' [1975], in *Camera Obscura* no. 1, 1976 and in Phil Rosen (ed.), *Narrative, Apparatus, Ideology* (New York: Columbia University Press, 1986).

——, 'Author and Analyzable Subject', in Theresa Hak Kyung Cha (ed.), *Apparatus: Cinematographic Apparatus – Selected Writings* (New York: Tanam Press, 1980).

Bellour, Raymond, *L'Analyse du film* (Paris: Albatros, 1978).

Berger, John, *Ways of Seeing* (Harmondsworth: Penguin, 1972).

Betterton, Rosemary (ed.), *Looking On: Images of Femininity in the Visual Arts and Media* (London: Pandora, 1987).

Block, Ned (ed.), *Imagery* (Cambridge, MA: MIT Press, 1981).

Bryson, Norman, *Vision and Painting: The Logic of the Gaze* (London: Macmillan, 1983).

Colomina, Beatriz (ed.), *Sexuality and Space* (Princeton, NJ: Princeton University School of Architecture, 1992).

Denis, Michel, *Les Images Mentales* (Paris: PUF, 1979).

Dhote, Alain (ed.), 'Cinéma et psychanalyse', *CinémAction* no. 50 (Paris: Collet, 1989).

Doane, Mary Ann, *The Desire to Desire* (Bloomington: Indiana University Press, 1987).

——, *Femmes Fatales: Feminism Film Theory Psychoanalysis* (New York: Routledge, 1991).

Ehrenzweig, Anton, *The Hidden Order in Art: A Study in the Psychology of Artistic Imagination* (London: Weidenfeld and Nicolson, 1967).

Flitterman, Sandy, 'Women, Desire and the Look: Feminism and the Enunciative Apparatus in Cinema', *Cine-tracts* vol. 2, no. 1, 1978.

Freud, Sigmund, 'Leonardo da Vinci and a Memory of His Childhood' [1910], *Standard Edition of the Complete Psychological Works of Sigmund Freud*, vol. xi (London, Hogarth Press, 1957).

——, 'The *Moses* of Michaelangelo' [1914], *Standard Edition of the Complete Psychological Works of Sigmund Freud*, vol. xiii (London: Hogarth Press, 1955).

Johnston, Claire, 'The Subject of Feminist Film Theory/Practice', *Screen* vol. 21 no. 2, 1980, pp. 27–34.

Kaplan, E. Ann, *Women and Film: Both Sides of the Camera* (London: Methuen, 1983).

Kosslyn, M. Stephen, *Ghosts in the Mind's Machine* (New York: Norton, 1983).

Metz, Christian, *Psychoanalysis and Cinema, The Imaginary Signifier* [1973–76] (London: Macmillan, 1982).

——, 'Photography and Fetish', *October* no. 34, 1985; also in Carol Squiers

(ed.), *The Critical Image: Essays on Contemporary Photography* (Seattle, WA: Bay Press, 1990).

Mulvey, Laura, 'Visual Pleasure and Narrative Cinema', *Screen*, vol. 16, no. 3, 1975, pp. 6–18; reprinted in Laura Mulvey, *Visual and Other Pleasures* (London: Macmillan, 1989).

Oudart, Jean-Pierre, 'La Suture', *Cahiers du cinéma* nos. 211–12, 1969; reprinted in *Screen* vol. 18 no. 4, 1977–8.

Penley, Constance, *The Future of an Illusion: Film, Feminism and Psychoanalysis*, (Minneapolis, MN: University of Minnesota Press, 1989).

Pfister, Oskar, *Expression in Art: Its Psychological and Biological Basis* (London: Kegan Paul, Trench and Trubner, 1922).

Rose, Jacqueline, *Sexuality in the Field of Vision* (London: Verso, 1986).

Vanoye, Francis, 'L'Emotion: Esquisse d'une réflexion', in Alain Dhote, op. cit., pp. 183-91.

Vernet, Marc, *Figures de l'absence*, (Paris: Editions de l'Etoile. 1988).

Willemen, Paul, 'The Fourth Look' [1976], in *Looks and Frictions* (London: BFI, 1994), pp. 99-110.

Worringer, Wilhelm R., *Abstraction and Empathy* [1913] (London: Routledge and Kegan Paul, 1953).

The Anthropology of the Spectator

Ang, Ien, *Desperately Seeking the Audience*, op. cit.

Langton, Marcia, *Well, I heard It on the Radio and I Saw It on the Television* ... (Sydney: Australian Film Commission, 1993).

Michaels, Eric, 'Bad Aboriginal Art', in Art and Text no. 28, 1988, pp. 59-73.

———, *For a Cultural Future: Francis Jupurrurla Makes TV at Yuendumu* (Melbourne: Artspace, 1987).

Taylor, Lucien (ed.), *Visualizing Theory: Selected Essays from V. A. R., 1990-1994* (New York: Routledge, 1994).

Worth, Sol, and John Adair, *Through Navajo Eyes* (Bloomington, IN: Indiana University Press, 1972).

Chapter Three

The Role of the Apparatus

Having discussed the relationship between the spectator and the image in terms of its physiological and psychological determinants, it is time to turn our attention towards another series of determinations: the social determinants, including the methods and technologies of image production, the modes of their circulation and possible reproduction, the places in which they are accessible and the media that broadcast and distribute them. It is the sum of these organisational and material structures which we call the apparatus, following while displacing the meaning given to this term in the important studies of cinema in the early 1970s discussed towards the end of this chapter.

I. The Spatial Dimension of the Apparatus

I.1 Plastic Space, the Spectator's Space

In the preceding chapters we emphasised the fact that to look at an image is to make contact with a spatial reality, the reality of the image, which is quite different from the reality of our everyday world. The first function of the apparatus is to offer concrete solutions to the management of this unnatural contact between the spectator's space and the space of the image, which we will call plastic space (for a justification of this term, *see* Chapter 5, §I.2).

The elements in the image which can be called 'plastic' (be it a figurative image or not) are those which characterise it as an ensemble of visual forms, and which allow these forms to be distinguished:

- the *surface* of the image, and its organisation, traditionally called its composition. In other words, the pattern of geometric relationships between the different parts of the surface;
- the range of *values*, linked to the degree of luminosity or brightness of each area of the image, and the contrasts that this range generates;
- the range of *colours*, and its range of contrasts;
- the *graphic* elements, especially important in all 'abstract' images;
- the *materiality* of the image itself in so far as this affects perception (for instance, the painterly brush strokes in certain kinds of art or the grain of a photographic image).

These are the basic plastic elements of the image, and they are the ones the spectator first encounters.

I.1.1 Concrete Space, Abstract Space

The primary function of any apparatus of the image is to regulate the psychic space between the spectator and an image composed of the interaction between the plastic values outlined above, taking into account the fundamental fact that they do not share the same space and that there is, to use a term derived from André Michotte's remarks (1948) about film, a segregation of spaces, a distinction between plastic and spectatorial spaces.

As noted earlier, one of the most important components of this relationship is the spectator's perception of a representational space, that is to say, a three-dimensional, imaginary and fictional space that nevertheless, through indices of analogy, can be referred to real space. However, there is a further link in this chain: the spectator not only perceives the representational, figurative space of the image, he or she also perceives the plastic space of the image in itself. Up to a point, that is what was implied by the notion of a 'double reality' described in Chapter 1, but only up to a point, since this notion claims that, in the perception of represented space, the perception of surface is taken into account. Here we have to add that, regardless of whether a space is represented in the image or not, the spectator has to deal with plastic space. In order better to understand the spatial aspects of the apparatus (and especially the frame), we need to address the issue of the subject's capacity to enter into a direct relation with plastic space. This is what the art historian and sociologist Pierre Francastel has attempted to deal with in a number of books.

Francastel (1965) has analysed those aspects of our relationship to the image based on the active construction of imaginary space. There is no need to dwell on those aspects here. His originality, however, lies in the fact that he also emphasises another aspect of that relationship: that of the construction of a material, 'concrete' space which relates directly to the plastic values of the image. For Francastel, imaginary space rests on a particular, abstract conception of space: that of the average Western adult. However, there are other, less abstract ways of relating to space, prior even to any encounter with images, ways less rigidly constructed by perspectival geometry. Francastel sums up the range of these ways of relating to space under the term topology. In fact, in mathematics, topology is merely the study of spatial relations and includes, among other things, the study of perspective. However, Francastel uses the term in the specialist sense, developed in the 40s by psychologists such as Henri Wallon, to describe a child's conception of space. According to Wallon, a child learns about space gradually and before acquiring a point of view liable to be 'perspectivised', a child apprehends space in terms of close proximities, relying on relations such as 'next to', 'around' and 'inside', rather than through concepts of 'near', 'far', 'in front of' and 'behind'. For Francastel, these first relations to the actual space that surrounds us never entirely disappear and are never completely erased by the subsequent acquisition of a more total and abstract

sense of space. In our relation to the image (artistic, pictorial, filmic), this original experience of space based on the body is reactivated, and to our perspectival organisation of social space is added, at times in contradictory manner, the genetic space of our 'topological' organisation.

I.1.2 Ways of Seeing

Francastel's thesis proposes that every spectator has two distinct and simultaneous, at times partly opposed, ways of perceiving space. In this respect, Francastel reprises, symptomatically, the German art historian Heinrich Wölfflin's famous thesis formulated in his *Fundamental Principles of the History of Art* (1915) that art (meaning Western art, of course) has developed in relation to two ways of seeing which range from the 'tactile' to the 'visual'. Wölfflin developed this thesis, which is reminiscent of Hildebrand's intuition (*see* Chapter 2, §II.3.1), into an explanatory principle of the history of art, and did so more rigorously than his colleagues Worringer or Riegl. For Wölfflin, the tactile form of vision is also a plastic form linked to the sensation of objects seen in close-up, organising the visual field according to a hierarchy which is close to Francastel's notion of topology. On the other hand, what he calls the visual form of seeing is the properly pictorial form linked to a distant and subjective vision of space, a unified vision of space and light which organises the totality of spatial relationships between the whole and the parts on geometric principles.

This idea seduced a number of art historians and critics because of its explanatory power and relatively elegant appearance. José Ortega y Gasset, the great Spanish critic, adhered strictly to Wölfflin's theory and set out to apply it to the history of figurative art from Giotto, who concentrated on the figuration of people, through Velasquez's ability to achieve a figurative representation of space by 'stepping back' from the canvas, through to the Impressionists, who 'stepped back' as far as it is possible to go in order to achieve the figuration of the sensation of light and, finally, to early-twentieth-century Expressionism and Cubism, in which an even greater distance leads the artist to represent ideas (and which, paradoxically, thus return to tactile values, closing the circle of the history of art).

Around the same time in the 40s, Eisenstein also took up this thesis, notably in his essay, Rodin and Rilke and the Problem of Space in Figurative Arts' (1945), in which he extended Wölfflin's thesis to suggest that not only the history of art, but the entire history of people's relation to space moves from the concave to the convex, from interior to exterior (that is to say, from the tactile to the visual), from a 'hollow' psychological situation to an understanding of 'plenitude'. Nevertheless, it is difficult to accept the *explanatory* dimension of this thesis, if only beacuse it places too much faith in its metaphor of the two different kinds of vision, near and far, which are ultimately reduced to functions of the seeing subject conceived as a completely ahistorical being. However, it remains an important intuition and, in combination

101

with Francastel's work, it helpfully identifies the nature of the problem, reminding us that our relationship to the image is not due simply to our adaptation to the century-long dominance and ubiquity of photographic imagery. On the contrary, that relationship is based on an accumulation of prior experiences which go back to childhood, as well as to the 'childhood of art', and which emerge through photographic ways of seeing.

I.1.3 The Size of the Image

To repeat, the image is first and foremost an object in the world, with physical characteristics, just like any other object, that make it perceptible. Among these characteristics is one that is especially important for the apparatus: the size of the image.

Michelangelo's *Last Judgement*, the *Mona Lisa*, a daguerrotype, a film frame, all can these days be found side by side in the form of reproductions of identical size in an illustrated book, even though Michelangelo's fresco takes up an entire wall of the Sistine Chapel, Leonardo's painting is about one metre high and a daguerrotype is less than ten centimetres square. As for a film frame, it measures about 20x35mm on a celluloid reel, but can become huge when projected on to a screen. Our main sources of images, such as books, magazines and television screens, dramatically reduce the variety of an image's dimensions and habituate us to a spatial relationship with them based on average distances.

It is therefore very important to realise that every image has been made to occupy a specific place in the environment, which determines the way it is seen. The frescoes by Masaccio and Masolino in the Brancacci Chapel in Florence are not only much larger than their commonly available reproductions, but they are also painted one above the other on the walls of a fairly narrow chapel. *In situ*, they give an impression (to those who have only encountered them in art history books) of being heaped up and crammed in, which, among other things, greatly reduces their power of illusionism and emphasises their status as texts *to be read*. One of the great innovations of the Renaissance was the production of work that could be detached from the walls, *tableaux* (canvas paintings), and which were generally much smaller than the frescoes in the churches. The relationship of the spectator to the painting thus becomes not only more intimate, it also becomes more purely visual. It is remarkable that when frescoes were once again painted on walls and ceilings in the 17th and 18th centuries, they were influenced by the ideology of '*tableau*' painting and tried to reproduce that kind of visual relationship rather than the kind of relationship characteristic of the pre-Renaissance fresco tradition. Examples are the vault ceiling of San Ignazio (*see* Chapter 2, §II.1.4) or the walls and ceilings of the Venetian palazzos decorated by Tiepolo.

The size of the image is thus one of the fundamental elements which determine the relationship that a spectator can establish between his or her own space and the plastic space of the image. In fact, the spectator's

spatial relationship to the image is even more fundamental: in every era artists have been conscious of, for example, the power that a large image can exert when a specator is forced to be close to it, forcing him or her not only to see its surface, but also to be dominated, even crushed, by it. This spatial fact is used as a central component in a number of contemporary works, including installations. In the exhibition *Passages de l'image* (Centre Pompidou, 1990), a piece by Thierry Kuntzel juxtaposed a gigantic and a tiny image, one static, the other moving. Moreover, the smaller image presented an extreme close-up whereas the larger image presented a more inclusive perspective. The juxtaposition produced a perturbation of the spectator's spatial reference points. On the other hand, the small scale of certain images such as most photographic images enables the subject to enter into a relation of proximity, possession, even fetishisation with the image (*see* Chapter 2, §II.3.5).

I.1.4 The Example of the Close-up

The success of the Lumière brothers' Cinématograph was largely due to the size of the projected image, which was significantly larger than the image size achieved by Edison's kinetoscope. However, the image size felt to be appropriate to represent expansive outdoor scenes became quite disturbing when film began to show human bodies in close-up. The first shots framing only a person's torso or head were rejected, not only because they were deemed unrealistic, but because these enlargements were experienced as monstrous. Critics referred to 'big heads' and 'dumb giants', and film-makers were accused of 'not knowing that a head cannot move by itself, without the help of a body and legs'. In short, the close-up seemed to be against nature. However, a few years later, in the 20s, Jean Epstein could say that the close-up was 'the soul of cinema'. What had originally been an eccentric characteristic of the cinematic apparatus had by then been transformed into a specific aesthetic element.

The close-up is a constantly repeated example of the power of the apparatus:

- It produces effects of 'Gulliverisation' or 'Lilliputisation', to quote Philippe Dubois, playing on the relative sizes of the image and the object represented in it (in early cinema, the close-up was often thought to represent an object seen through a magnifying glass or a telescope); however, the great directors of silent films knew how to use cinema's ability to make these strange enlargements, turning a telephone into a sort of monument (Epstein), a cockroach into a monster larger than an elephant (Eisenstein);
- It transforms the sense of distance, leading the spectator to extreme psychic proximity or intimacy (Epstein), as in the series of close-ups of Falconetti in Dreyer's *La Passion de Jeanne d'Arc* (1927). This intimacy can sometimes become excessive, as in Williamson's famous short film *The Big Swallow* (1901), in which the character filmed in

103

Figure 20 Cinema's close-ups

close-up opens his mouth and, continuing to move towards the camera, ends up by swallowing it;

- It materialises, almost literally, the metaphor of visual touch, accentuating simultaneously, and contradictorially, the surface of the image (because its graininess becomes more perceptible) and the imaginary volume of the filmed object (detaching it from the surrounding space, the depth of which seems to have been abolished).

The close-up very soon became one of the most widely and consistently discussed aspects of film theory. Not only Epstein but also Eisenstein (who wrote a number of texts on it up to the 40s) and Béla Balázs were preoccupied with theorising the close-up at an early stage, recognising that it could become one of the major assets of cinema if the cinema was to become something more than a simple reproduction of reality. The theory of the close-up as a technique for heightening expressiveness has been extended more recently by Pascal Bonitzer (1982, 1985) and Philippe Dubois (1984–85). For Bonitzer, the close-up is a supplement of 'the drama, cutting into the primitive integrity of the cinematic scene', 're-marking the discontinuity of the cinematic space, and sweeping vision, the image, along in the substitutive movement of (cinematic) writing'. In such a notion of cinema, the close-up becomes an emblem of the heterogeneity of the film text, 'wrecking' the linear conception of montage and celebrating the fragmentary nature of the shot found in Eisensteinian concepts. Dubois emphasises the instinctual

effects the close-up can produce, its ability to focus in its vertigo-effect ('a stone splits open and reveals a precipice'), its Medusa-effect which fascinates and repulses at the same time.

In all these cases, the close-up is seen as the image par excellence that produces a psychic distance specific to cinema, encompassing a sense of staggering proximity and irreducible remoteness.

I.2 The Frame

The image is a finite object with measurable dimensions: it has a size. The vast majority of images are objects that can be isolated perceptually, if not always materially, from their environment. The limited, often detachable, even portable nature of the image is also one of the essential characteristics that defines the image-apparatus. There is no concept that incarnates these characteristics better than the *frame*.

I.2.1 Concrete Frame, Abstract Frame

All images have a material base. They are all objects. The frame is first and foremost the *edge* of this object, its material, tangible boundary. Very often, this edge is strengthened by the addition of another object to the object-image, which we will call an *object-frame*. For paintings exhibited in museums, an object-frame, whether sculpted, ornately decorated, gilded, and so on, is almost mandatory. Even snapshots displayed on the mantlepiece, posters on an adolescent's bedroom wall, the projected cinema image, and even the television image, all have their object-frame, even though its significance varies enormously, as does its materiality, its thickness, size and form. For instance, the object-frame of television was much more present in the early television sets. Their obtrusive oval-shaped window-frame almost overwhelmed the image within, whereas the current sets with square corners and flat screen aim to render the frame as invisible as possible.

The frame is also, and more fundamentally, that which demarcates the closure of the image, its finiteness. It is the edge of an image in another, intangible sense: it is its perceptible limit. In that sense, it is a *limit-frame*. The limit-frame is where the image ends, defining its field by separating it from what it is not; in this way, it constitutes an *out-of-frame*. Object-frame and limit-frame usually go together, but it is important to realise that this is not necessarily so. Many pictorial works, especially those of the 20th century, have never been framed. On a more mundane level, the amateur photos developed and printed by machine are produced, not only without a frame, but also without a border. In these cases, the image only has a limit-frame and no object-frame. Inversely, some images with an object-frame barely have a limit-frame. For instance, the many Chinese paintings on horizontal or vertical scrolls, which provides a kind of frame since the scrolls containing the images have edges, but the limits of the painted area are not marked in any way and so there is no particular signifier of a perceptible limit to the separate images themselves.

The frame, in both its phenomenal forms, is what gives form, or rather, a *format* to the image. A format can be defined by two parameters: the absolute size of the image, and the relative size of its main dimensions. Frames come in all shapes and sizes, even highly improbable ones, but with the notable exception of a widespread vogue for round frames in classic Italian painting, the immense majority of frames have been rectangular. In such cases, the format is defined by the relation of the vertical to the horizontal edges. There are no precise statistics on the predominant formats at different periods, but we can safely say that while cinema has familiarised us with horizontal images (from its use of the standard format of the 1:1.33 ratio, through to the widescreen format of the 1:2.5 ratio), all portrait photography of the 19th century, informed by a well-established tradition in painting, used a vertical format. As for the proportions of the image, they are most frequently similar to a slightly elongated rectangle (some old statistic confirms that a ratio of 1:1.6 between the two dimensions is not only the most common, but is 'preferred' by the majority of spectators. This ratio is very close to the so-called 'golden-section' (*see* Chapter 5, §I.2.3)).

I.2.2 The Functions of the Frame

The gilded cornice frame seen frequently around paintings in our museums has been widely used since the 16th century. Previously, from ancient Greek painting onwards, other types of objects were used. Many mural paintings and mosaics of the Hellenistic era also had painted or sculpted frames. In other words, the frame, in both its aspects, has existed in our culture for a very long time. The durability of such a convention over a period of more than 2000 years can only be explained if it fulfils useful or important *functions*. The functions of the frame are potentially numerous:

- *Visual functions*. The frame is what separates the image from its perceptual environment. The effects of this perceptual function are multiple: the object-frame, by isolating a segment of the visual field, singles out and enhances its perception; it plays the part of a visual transition, an intermediary, between the interior and the exterior of the image, facilitating a smoother passage from inside to outside. (Classical painters were very sensitive to this transitional function, particularly to the way that the gilded frame enabled the canvas to be bathed in a soft, golden light, considered to be favourable to the vision of the painting.)

 Object-frame and limit-frame, together, ensure the perceptual isolation of the image. They contribute to its double perceptual reality (*see* Chapter 1, §III.2.1) by creating a special zone in the visual field, producing indices of analogy (*see* Chapter 4) while organising the image into a visual 'force field', that is to say, it contributes to the organisation of the image's plastic aspects, traditionally called 'composition' (*see* §I.2.3 below).

- *Economic functions.* Framing, in the form that we know it, appeared at more or less the same time as the modern concept of a painting as a detachable, exchangeable object able to circulate as merchandise within economic circuits.[1] The frame, therefore, soon turned into a visible signifier of the painting's market value. It is no accident, from this point of view, that the frame has for some time been a precious object in its own right, skilfully made and at times using precious materials such as gold, or embedded with precious stone.

- *Symbolic functions.* Simultaneously extending its visual function of separating and isolating the image, and its economic function of conferring value on the painting, the frame is also a kind of *index* which 'tells' the spectator that he or she is looking at an image which, because it is framed in a certain way, should be viewed in relation to certain conventions, and possibly has a certain value.

 Like all symbolic functions, this one is diverse, changing according to the reigning symbolic regime. For a long time, the framing of the image had a fairly straightforward value, signifying that it was art, and that it should be viewed accordingly. This idea has not altogether disappeared, and we find a faint echo of it in the proliferation of framed images in contemporary petit-bourgeois interiors or, until about 1960, in the way photographers (in France) 'framed' amateur photographs with a narrow white border, sometimes with patterns in relief. Other values have appeared with 'new' images: the television set which frames the televisual image (by locating it within the interior design of a room) gives this image a specific status, as far from art as possible, desanctifying it and giving it a status more like that of a 'conversation', an uninterrupted 'flow'. The televisual image seems to be addressed to me personally and, potentially, it goes on forever.

- *Representational and narrative functions.* As an index of vision designating a discrete world, the frame is intensified when the image is figurative or narrative, or when the image has a particularly *imaginary* value. The frame then becomes like an opening which gives access to the imaginary world, to the diegesis figured by the image. The famous metaphor of a frame as a 'window on the world', often repeated with variations, goes back at least as far as Leon Battista Alberti, the fifteenth-century Renaissance mathematician and painter who was one of the codifiers of perspective.

 In this instance, we are dealing primarily with a limit-frame, although some paintings have cleverly used their object-frames to extend the diegetic world of the painting through illusionism. Throughout the figurative tradition, from the Renaissance onwards and still today, the edges of an image are what limits the image, but also what builds a connection between the interior of an image, its 'field' with its imaginary extensions 'off-screen' (literally, in French, 'out-of-field' – *hors-champ*) (*see* Chapter 4, §II.2).

- *Rhetorical functions.* In many contexts the frame can be understood as 'making a statement' in a more or less autonomous way, although this

may sometimes be difficult to distinguish from the symbolic values of the frame. In certain periods one can notice a veritable 'rhetoric of the frame', with recurrent and fixed motifs.

This rhetoric is perhaps most evident where the painter has supplied his painting with a false frame painted in *trompe l'oeil*, deliberately playing with all the meanings of a frame. But it can also be seen at work in many other ways, especially when the frame is particularly expressive in relation to the representaional content of the image within it. For instance, in many Japanese CinemaScope films of the 60s (for example the work of Shohei Imamura) the frame is sometimes animated by autonomous movements such as a rotation on its axis or a vigorous trembling, which cannot be justified by the diegetic content, but which 'express' in a directly visible form an emotion that the director wanted to associate with that diegetic content: trembling to signify a character's sense of profound disturbance; rotation to signify a disorienting, strange atmosphere, and so on.

I.2.3 Centring and decentring

Several of these functions of the frame (economic, symbolic, rhetorical) are relatively abstract and relate to the social conventions that regulate the production and consumption of images. On the other hand, the visual and representational functions are more directly aimed at the subject-spectator as discussed in Chapter 2.

In his book *The Power of the Center* (1981), Rudolf Arnheim studied the relationship between the spectator conceived as an imaginary 'centre' of the world and images in which centring phenomena come to play a major part. Arnheim's thesis is interesting in its generality; there are several centres of various types in an image: a geometric centre, a visual centre of gravity, centres that are secondary to the composition, and diegetic and narrative centres. To view images (art images as it happens) means to order these different centres in relation to the 'absolute' centre of the subject-spectator.

Arnheim's thesis is important in spite of its psychologically dubious premises, because under the generic notion of centring it offers a unified theory of, on the one hand, phenomena otherwise left to the mercies of crude empiricism, such as the conventional understanding of 'composition' and, on the other, the relation between composition at the level of the image's plastic aspects and the organisation of the figurative image 'in depth'. The *dynamic* nature of Arnheim's theory adds to its seductiveness, conceiving the image as a force field and viewing as an active process creating often unstable relations. Arnheim's analyses are most convincing when he is considering *ex-centred* or *decentred* images in which there is a strong competition between centres, which increases the importance of the spectator's role. It could almost be said that more than a theory of centring, he develops an aesthetics of permanent de-centring: an image is only interesting, and only functions well, if some-

Figure 21 Centring representation: spectacularly excessive centring in Guardi's The Doge of St Marc, *c. 1770; more discretely in Manet's* Le Déjeuner sur l'herbe *(1863): a doubling of the frame's vertical edges, perspectival effects, play of looks.*

thing in it is decentred and can therefore be imaginarily confronted with the absolute but unstable centre where we, the viewers, are.

I.3 Framing and Point of View

I.3.1. *The Visual Pyramid*

The figurative image, in the form most familiar to us, has often been conceived as representing a fragment of a larger, potentially unlimited space (see the notion of visual field mentioned earlier and the notion of 'representative field' discussed below). It has often been compared to 'natural' sight, in so far as the latter already consciously, or unconsciously, segments visual space. From the Renaissance onwards this analogy becomes more ubiquitous with the metaphor of the visual pyramid, which is itself derived from the notion of a ray of light. For Alberti, the eye's look is thought of as a kind of searchlight sweeping through space (even though light emanates from a searchlight whereas it enters the eye), making the eye the apex of a cone consisting of an infinite number of light rays. This cone extends sideways very widely and is in fact relatively formless. The notion of a *visual pyramid* thus corresponds to an abstraction of one part of the solid angle formed by this cone, the part having an object of vision as its base and the observer's eye as its apex.

This notion is obviously not very scientific. It also echoes an ancient concept of vision, prevalent in the Middle Ages, which held that light rays emanated from the eye and were reflected back by objects. As the understanding of spatial geometry improved, this notion was superseded in the 16th and 17th centuries by a number of constructions which facilitated the perfection of the technique of perspective. Later, the notion of the visual pyramid continued to function implicitly in painting, then as an implicit or explicit fantasy informing concepts of photography.

I.3.2 Framing [2]

Although it had been present in painting for centuries, the camera, especially when it became portable towards the middle of the 19th century, made visible the idea that the centring of an image is in some way the materialisation of a particular visual pyramid (it is, in a slightly different form, the same metaphor as that of 'the window on the world'; *see* §I.2.2 above). It is worth noting that, as Peter Galassi has shown (1981), this identification of the frame with the visual pyramid, and especially the imaginary mobility of this pyramid and its associated frame, had been around since well before the invention of photography. Obvious traces of it can be found in many paintings, especially landscapes, towards the end of the 18th century in work which deployed the 'visual pyramid' to produce a pictorial description of space thought to be in line with the freedom and arbitrariness of spontaneous, 'natural' vision.

Framing (*cadrage*) and 'centring' within the frame are terms often used interchangeably in film to designate the mental and material process which guides subject-spectators to a particular field of vision, seen from a certain angle within specific limits.[3] Framing is therefore

111

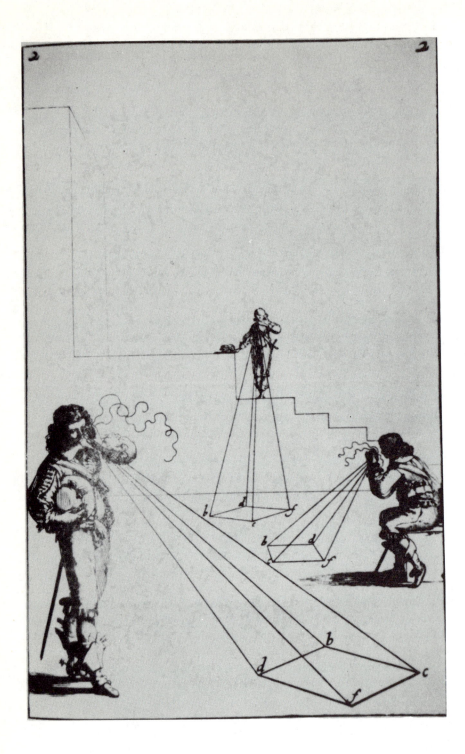

Figure 22 The Visual Pyramid. Opposite, Abraham Bosse represents it demonstratively in 1648 with 'Perspectiveurs'; above, its mobility manifests itself at the beginning of the 19th century in this 'documentary' painting by Delacroix.

what the frame does, implying its potential mobility, the unending motion of the 'window' to which the frame is equated. Framing works like this in all figurative images which imply a reference to a look, even a 'generic', totally anonymous and disembodied look of which the image would then be the trace.

In the earliest films, the distance between the camera and the filmed object was almost always the same, and centring within the frame enabled characters to be represented full figure. However, the idea of moving the camera closer or further away caught on very soon, resulting in people becoming 'lost' in much larger settings or becoming much too large so that only a part of them can be seen. In order to come to terms with these possible variations in the relationship between camera-distance and the apparent size of the filmed object, a fairly empirical and crude typology of image-scales was developed. In English, this scale is measured in terms of distance, going from extreme long shot to extreme close up.

By a natural slippage of meaning, framing rapidly came to signify certain specific positions of the frame vis-à-vis the scene represented. Here again, it is cinema that has most influenced the vocabulary for this relationship. Because the film image exists in time, its framing is eminently suited to be regarded as the visible embodiment of the virtual or actual mobility of the frame in general.

Framing, or centring, is thus the scanning (and sometimes the fixing)

113

of the visual world by an imaginary visual pyramid. All framing establishes a relation between a fictional eye (of the painter, of the camera, and so on) and a group of objects organised into a scene. In Arnheim's

Figure 23 Frames within frames: in painting (C.-D. Friedrich's Woman at the Window, *1822) and in cinema (E. Rohmer's* La Collectionneuse, *1967); in both examples, the device is 'motivated' by means of a window or a mirror.*

terms, framing is thus part of a permanent process of centring and de-centring, of creating visual centres, of balancing a variety of different centres in reference to an 'absolute centre', the apex of the pyramid, the Eye.

The question of framing also impinges onto the question of *composition*. This issue is particularly pronounced in photography which has tried for a long time to establish itself as an art, trying to establish a perfect balance between a notion of documentary framing and the achievement of a geometrically interesting composition. The relationship between framing and centring is just as evident in cinema. In the vast majority of so-called classical films, the image is constructed around one or two visual centres, often people, to such an extent that 'classic realism' is often synonymous with an essentially 'centred' style.

In this context, it is worth noting the frequent use in cinema of 'frames within frames' (or 'over-framing'), for instance through the inclusion of a mirror or a window. Equally important is the device of re-framing, that small movement of the frame which is made in order to keep a chosen subject in the centre of the image. Of course, this kind of centring is a hangover from an academic concept of pictorial composition and is not ubiquitous in cinema. There are a number of styles, such as those of Antonioni, Dreyer or Straub, which are based on a rejection of centring, on a deliberate and active decentring, usually aiming to emphasise certain expressive values of the frame.

I.3.3 Point of View

The notion of framing, by way of the fantasy of the visual pyramid, invites us to establish an equivalence between the eye of the image-maker and that of the spectator. It is this assimilation of one to the other that also informs the many forms of the concept of point of view. Contemporary language uses this term in three different senses. Point of view can designate:

- a real or imaginary place from which a scene is viewed;
- the different ways in which a question can be considered;
- an opinion or a feeling about a phenomenon or event.

The first of these meanings corresponds to the embodiment of the look within framing. The question then arises as to whose look is being represented: that of the image-maker, that of the apparatus or, in the narrative forms of the image (which may already be an imaginary construct), a character within the diegesis. The two other meanings of point of view entail different connotative values of framing. They suggest that, in a narrative context, the notion of point of view refers to all those aspects of the image which convey 'subjective', 'focused' vision and, more generally, to all those aspects which imply that framing implies a judgment about what is being represented, valuing or devaluing it, drawing attention to a detail in the foreground, and so on.

115

Figure 24 Decentring in cinema: in cinema (J.-M. Straub and D. Huillet's Nicht versöhnt, *1965) and in painting (J. Clausen Dahl's* Two Steeples in Copenhagen at Sunset, *1825).*

Framing is one of the main tools for the construction of this third sense of point of view, but it is not the only one. Other expressive means can also convey this, for example the contrast between values and colours, soft focus, and so on. The French cinema of the 20s known as the impressionist school extensively deployed such effects. In Marcel L'Herbier's *El Dorado* (1921), a shot of the heroine, lost in thought, shows her in soft focus surrounded by her friends who are seen in sharp focus. This image offers a synthesis of a visually centred point of view and a connotative, qualifying one.

I.3.4 The Decentred Frame (décadrage)

So far, we have emphasised the tendency to equate framing with the materialisation of a point of view, more or less centred and capable of being altered or recentred. However, in the twentieth-century figurative tradition, this equation has often been experienced as mistaken and ideologically pernicious (*see* §III.3 below). A whole section of contemporary image history is characterised by the will to avoid centring, to displace or subvert it. The most spectacular example is what Pascal Bonitzer (1985) has called *décadrage* (literally, deframing), decentered or deviant framing, marked as such and aiming to disturb the automatic equation between framing and point of view.

'Deframing' and centring. The traditional concept of composition is based on what occupies the centre of an image. Deframing, in Bonitzer's definition, consists of removing signifying objects from the centre, which thus becomes a relatively insignificant aspect of the representation. Deframing is a decentring in Arnheim's sense, introducing a strong visual tension, since the spectator almost automatically tries to fill the vacant centre.

Deframing and the edges of the image. Compositional decentring operates simultaneously in relation to both the window-frame and the limit-frame. Deframing is a more abstract process, more concerned with the limit-frame: by removing the signifying zones from the image's centre (often occupied by characters), attention is drawn to the edges of the image. The deliberate, visibly arbitrary aspect of these edges emphasises the fact that they are what separates the image from its visual environment 'beyond the frame'. In other words, deframing operates in a theoretical manner, implicitly marking the discursive value of the frame. As Louis Marin (1972) has said, 'The frame tells us that the painting is a discourse.'

Deframing makes the edges of the frame appear to slice into the representation, emphasising their power to 'cut off'. In this respect, deframing is an echo of the fantasy of the visual pyramid in paintings of the late 18th century and early 19th. Deframing means that an imaginary movement of the visual pyramid has enabled a deliberate 'centring elsewhere'. When Dégas, a master of deframing, decided to depict the Paris stock exchange by means of a fragment of a column and a group of men in suits and top hats exiled right of centre and cut-through by the right

edge of the canvas, he was making a clear statement about his desire to frame it in this way, that he wanted to place his attention a bit 'to one side' of the scene's real centre of interest. Deframing is always an explicit 'framing otherwise'.

Deframing and sequentiality. The 'normal' tendency of the viewer, who is used to centred images which mimic the 'usual' way of looking, is to want to cancel the deframing which is felt to be a potentially irritating anomaly. A fixed image such as a painting or photograph, of course, cannot be cancelled or altered. Deframing derives aesthetic value from this fact. It becomes accepted as a sign of a style and, after a while, the spectator stops wanting to reframe it, accepts and possibly even enjoys the composition. The same is not true of moving and time-based images such as film and video, nor of multiple images such as comic strips. In their case, the desire to 'normalise' may be satisfied by transformations internal to the image (such as a slight reframing action by the camera) or through the sequentiality of images (in a comic strip, a later image may reframe what an earlier image deframed). Consequently, decentring has an even stronger impact in those kinds of images because it must be deliberately maintained against a much greater possibility of re-centring. This is one of the reasons why decentring in cinema is, still today, perceived as stranger and even more scandalous than in painting or in photography.

The viewer's question really comes down to: 'Why keep the character on the edge of the frame, cut in half, when it would be so simple to move the camera slightly?' It hardly needs to be pointed out that, in cinema, decentring is always a sign of a deliberate intention, stylistic or ideological, to escape the centring characteristic of 'classical' representational styles. In the films of Jean-Marie Straub and Danielle Huillet, where there is a lot of decentring, deframing aims to establish a strong relationship between the character and the place by breaking with the more conventional, expected relationship between this character and other characters, or even by removing a character from the frame altogether, thus making the relation to off-screen space more ambiguous.

By displaying the frame as the site and the material of the relation between the image and its spectator, decentring draws attention to the apparatus. This is why it was initially described as an ideological, denaturalising process. Although it has somewhat lost its power in this sense, deframing remains a factor that calls into question the spectator's relation to the image and its frame in an immediately perceptible manner.

II. The Temporal Dimension of the Apparatus

II.1 The Image in Time, Time in the Image

We live in and with time, and it is within that temporal dimension that our ways of seeing are established (*see* Chapter 1). Furthermore, images

exist in time in various ways. The temporal aspect of the apparatus thus marks the encounter between both these determinants and the various configurations to which this encounter gives rise.

II.1.1 A Brief Classification of Images

In psychological terms (see Chapter 2, §II.2.3), time is first and foremost the experience of duration. Therefore, the chief distinction to be made here will be between those image-apparatuses which constitutively include time and those which do not, thus defining two image categories.

- *Non-temporal images.* These are images of which the configuration remains identical over time. This definition disregards very slow modifications not visible to the spectator: as, for example when a painting's pigments change with age, as happened with the tar-based black pigments used in the 19th century, causing the irreparable deterioration of famous paintings such as Courbet's *Burial at Ornans*; or when the colours of a photograph change, which in fact happens fairly quickly especially when exposed to bright light (this is particularly true of the very fragile prints made in the 19th century).
- *Temporal images.* The configuration of these images changes in time without the spectator's intervention, through the effect of their apparatus of production and presentation. Cinema and video are the most common forms of this category nowadays, although there used to be other, less complex temporal images, such as the variations in the temporality of Daguerre's Diorama which came about by varying the lighting on a large painted background. Such changes were fairly small compared to even the most elementary documentary of today. On the other hand, much more variable images such as those of the shadow theatre were very rudimentary at a figurative level.

However, this neat division is too simplistic. In practice, this division relates to several other, not time-related, aspects of the image-apparatus's temporal dimension:

- *Fixed versus mobile image.* The fixed image is easy to define, but the mobile image can have many forms; the dominant example is that of the moving image (cinematographic or videographic), but there are others, such as computerised images or when a performance artist moves a slide projector to produce mobile, although not moving, images.
- *Single versus multiple images.* Single and multiple are defined in terms of space (the multiple image occupies several areas of space, or the same area of space successively), but they nevertheless have some bearing on the spectator's temporal relation to the image. There is a difference between looking at one slide for an hour and looking at fifty different slides over the same period. To take a less trivial example, Roy Lichtenstein sometimes enlarged comic-strip images, turning a

multiple image into a single image, which entails altering the temporal instructions given to the viewer.

- *Autonomous versus sequential images.* The criterion here is more semantic, a sequence being a series of images linked by their signification. This dichotomy can be thought of as a variant of the previous category, with similarly different temporal effects. If we combine all these different parameters, the possible effects of the temporal dimension of the image-apparatus are very varied. The museum or gallery of contemporary art demonstrates this very well, where 'works' deliberately mix all the image-categories: video screens, slides, the hyper-multiplied image and the single image, and so on. In the course of one year at the Pompidou Centre in Paris, it was possible to see a giant photograph exhibited for months on the facade, a 'wall of images' (made of a number of video monitors piled up) on the French Revolution, a piece consisting of 5000 amateur photographs spread out on the floor, installations mixing video monitors with all sorts of other images, as well as more conventional exhibitions of paintings and films.

II.1.2 Spectator Time and Image Time

The temporal dimension of the apparatus is the relation between the image, variously defined in time, and a subject-spectator who also exists in time. Earlier in this book, we mentioned the encounter between image and subjective time. For example, the static single image gives rise to a visual exploration through *scanning* (*see* Chapter 1, §III.1 and Chapter 2, §II.2.3), demonstrating the inescapable temporal dimension of perception, the time necessary to apprehend an image. The image in a sequence adds to, and superimposes on to, this scanning of the single image another form of exploration which also unfolds in time. For example, a page of comic strips is read image by image, but also and simultaneously (including, at times, in mutually contradictory ways), in a total, inclusive way. The same thing goes for the wall of television images, which is an ordered juxtaposition of moving images, to be read both at once, as a collective image, and as a series of discrete but conjoined images requiring not only a more rapid, more agile, visual exploration, but also a more acute cognition.

The point is never to confuse the time of the image with the time of the spectator. The spectator has the freedom to view a photograph for three seconds or three hours, but in cinema the spectator can view only as long as the projector is running. That is the first aspect of the temporality of the image and it is experienced as a constraint. Moreover, when viewing either of these types of image, our eye and our attention can be variably directed in time. That is the second aspect, which is linked to desire and expectation or, in other words, to the spectator's pragmatic situation. This second aspect is always experienced in a less constraining way. Nevertheless, the spectator is never completely free when viewing an image, as his or her way of viewing an image is almost always

guided by implicit or explicit reading instructions. A spectator will not have the same expectations when viewing a multiple video-screen installation by Nam June Paik, an educational display of images in a museum or a multi-screen wall of advertising imagery. In the last case, for example, the gaze might be more distracted and only the visually compelling areas would attract the eye, whereas with the installation piece, from which a viewer might expect more subtlety, the viewer might also be inclined to greater subtlety and concentration.

II.2 Implicit Time

In our classification, only those images that are presented in time, whether or not they are moving images, have an intrinsically temporal existence. However, almost all images 'contain' a time which they are likely to communicate to the spectator if the presentation apparatus is capable of doing so.

II.2.1 Arche *and What the Spectator Is Supposed to Know*

If an image not in itself temporal can nevertheless create a feeling of time, this is because the spectator superimposes his or her own temporality on to it, adding something to the image. Our hypothesis is that this 'something' is *knowledge of the genesis of the image*, of its mode of production, or of what Jean-Marie Schaeffer (1987) calls the *arche* of the photograph (although the application of the concept can be extended to include all images). This hypothesis, if followed to its logical conclusion, is based on a broader hypothesis about the spectator, the image and the relationship between the two as regulated by the apparatus. In so far as an image is conventional, social and coded rather than simply a visible object, the image has a meaning that its consumer, the spectator, is 'supposed to know'. Like any social artefact, the image works by virtue of the spectator's implicit knowledge. Cross-cultural studies, and especially ethnographic studies, can be useful here. When someone who has never seen or heard talk of photographs is shown one for the first time, he or she may begin by making what may seem to us to be a strange use of what to him or her may seem a strange object. The reason is that he or she lacks a number of knowledges: what a photograph is *used* for (in our societies it is used as an effective representation of reality), how it is *made* (at first sight it is not very different from any other piece of paper cloth). Serious ethnographic studies (those which, for the last decade or two, have tried to be less projective and ethnocentric) suggest that the second of these two forms of knowledge is the key to the others: if the origin of the photograph, its manufacture, can be explained, if its arche can be explained and shown, he or she will *simultaneously* understand what its use may be. This has been demonstrated several times, using 'instant' cameras of the Polaroid type, whose 'magic' (including for us) rests on the fact that they permanently exhibit the genesis of a photo.

This is a very general hypothesis, to which we will return later. For the time being, it is sufficient simply to conclude that time is included in

non-temporal images in so far as the spectator correctly uses an apparatus which implies a knowledge of the *creation* of the image, of the image's production process. It is not the image itself that includes time, but the image as part of its *apparatus*. Let us look at two significant examples of this.

II.2.2 Photograph, Trace, Index

Predictably, the first example is photography. Photography is a process which begins well before the image is formed and goes back to Classical antiquity. It is the action of light on certain substances in which it causes a chemical reaction, called *photosensitive* substances. A photosensitive surface exposed to light will be transformed, either permanently or temporarily. The surface keeps a *trace* of the action of light. The photograph begins when this trace is more or less permanently fixed in view of a certain social use. Histories of photography all mention that photography evolved in two main directions since its invention: the Niepce–Daguerre direction of 'photo-graphein' properly speaking, of a 'writing with light' to fix the reproduction of appearances; and the Fox Talbot direction of 'photogenic drawings' created by placing objects between a photosensitive surface and a light source. Up to a point, both refer to the same invention. But only up to a point: the social use of these two types of photograph is not at all the same. The first type was immediately used to make portraits and landscapes, supporting and then replacing painting's function of providing a 'realistic representation'. The second, far less developed, type gave rise to more original practices such as the photogram[4] or Man Ray's '*rayogramme*' (in 1989 photographers again made 'light sculptures' on Ray's principle of directly exposing light-sensitive paper, without the use of lenses).

Before being a reproduction of reality (which is certainly its most widespread social use), the photograph is a *recording* of a particular light at a particular time, and every spectator knows this, whether or not he or she knows about the invention and history of photography. As far as the issue of time is concerned, this knowledge of a photograph's genesis is essential. An important current in recent theoretical thinking on photography (as in the work of Henri Vanlier, Philippe Dubois, Jean-Marie Schaeffer, Victor Burgin and a great many many others) holds that the relation between the photograph and the reality from which it is born is *indexical* – in the sense proposed by Charles Sanders Peirce – arising, that is, because of a natural relation between a sign and its referent or object. For these theorists a photograph is also an index on the temporal level: time is included, enclosed in a photo, the photo embalms the past 'like a fly in amber', to use Peter Wollen's phrase (1982). It 'continues to point (with the index finger) to what once was and is no longer', as Christian Metz (1982) has put it.

The photographic apparatus, in whichever of its innumerable forms (from the family snapshot to a slide show), is always based on the fact, known to the viewer, that the photograph has captured a moment in

122

time in order to give it back to me. This restitution is conventional. It is coded. It is also variable, especially in so far as the photo records a *duration* of greater or lesser extent, that is to say, of an *instant* (*see* Chapter 4, §III.1). However, the knowledge is always there. The two photographs reproduced here are of comparable subjects: a human figure in motion. But in one, the clarity of the outline, associated with the impossibility of the movement in suspended animation, tells me that it is of an 'instant', which I could never have seen 'naturally' and which only a photograph could enable me to see; in the other, the blurred outline of the figure tells me that the exposure was of a longer duration and enables me to see something in a way I could not see it in reality. In both cases, *I see time*. My knowledge of the photographic *arche*, acquired and confirmed for long enough to have become implicit, enables me to read the times of these images, to experience their emotional connotations and even, with certain very expressive photos, to re-experience them. Photography transmits to the viewer the time of a 'light-event' of which it is the trace. The apparatus is what guarantees this transmission.

Many photographic styles are based on this implicit inclusion of time in the photo. Henri Cartier-Bresson's famous definition of (good) photography as the 'meeting of an instant and geometry' can be extended to include all documentary photography, and Robert Doisneau echoes this perfectly by calling one of his collections of photographs *Trois secondes d'éternité* (*Three Seconds of Eternity*), because with an exposure of 1/50 of a second per photograph, three seconds is the total time 'contained' in the photos he selected for exhibition. Recently, one movement in 'art' photography has specialised in working with the temporal power of photography, either by aiming to capture particularly revealing moments (see the photographs and films of Robert Frank) or, on the contrary, by recording random moments in order to encounter time in a pure state (see Denis Roche's *Conversation avec le temps*)in order then to turn these random moments into particular moments, labelled with a precise date and time, like memories. This inclusion of a temporal trace in the photograph is especially characteristic of one particular type of photograph, the Polaroid, and one could even argue that this type of photograph is the product of a different kind of apparatus altogether. The particular mode of production of this type of photo, linked to other traces (notably the white mask border, which is produced automatically), mean that they are images that are more immediately linked to a *hic et nunc*, a specific time and place. This produces, among other things, the tendency of these photographs to induce fiction.

II.2.3 Cinema, Sequence, Montage

The second, less predictable example, is from cinema. It is less predictable because cinema is founded on a temporalised image which represents an inextricable 'space-time unit' (according to Gilles Deleuze – we shall discuss this in §II.3). But cinema, or rather film, is also a

123

*Figure 25 Photography's parallel paths: the Daguerrotype (shells and fossils) and . . .
Talbot's photogenic drawing (both 1839).*

Figure 26 Publicity stills of J.-L. Godard's Pierrot le Fou *(1965) and Leos Carax's* Boy Meets Girl *(1984).*

compound of several of these units (shots), 'within certain structures of order and duration', a definition in which we can recognise the process of *montage* and which contains a representation of time which is much more implicit.

Almost all films are edited, even though some films have very few shots, and even though the function of editing may differ in each film. Leaving aside all narrative and expressive functions of editing, it is first and foremost the ordering of units of time, units between which there are implicit temporal connections. All 'classical' editing, sometimes known as continuity editing or the aesthetics of transparency, presupposes that the spectator is capable of 'reassembling' the fragments of film, that is to say, of mentally restoring the diegetic relations, including the temporal ones, between successive units. This can only be done by virtue of a knowledge, however minimal, of editing, or rather of the varieties of shots one encounters in films. In order to understand a film (in the way that the cinematic apparatus structures it to be understood), one must know that a change of shot represents a temporal discontinuity during shooting – that the camera filming the scene was not suddenly moved to another place, but that between the filming and the projection this other process called editing has taken place. These days, every film viewer knows this, but this was not always the case. Spectators of the first films which changed the point of view from one shot to another often complained about the visual and intellectual violence resulting from such changes. Yuri Tsivian quotes a spectator who remembers the early years of the cinematograph, where 'on a piece of white cloth I saw in quick succession the heads of the King of Spain and the King of

England, a dozen Moroccan landscapes flashing by, Italian cavalry on parade, the launch of a rumbling German dreadnought'.

However, there are sequences of static narrative images (in painting and in comic strips) which can, up to a point, be compared with a cinematic sequence, in terms of their narrative content. Nevertheless, the temporal relation between successive images is obviously less intense, not only because each individual image contains time only in a very indirect and coded way, but because the apparatus within which they appear is much less constraining. Only the photographic sequence, because of the photographic *arche*'s ability to induce belief, may be compared to the cinematic sequence.

In cinema, montage (editing, sequential ordering) constructs a completely artificial, synthetic temporal relation between units of time which in reality may be dicontinuous. This synthetic time (which a photograph cannot so easily or so 'naturally' achieve) is without doubt one of the factors that pushed cinema towards narrativity and fiction.

On the other hand, it is also possible to see this sequential ordering of units of time as an original documentary-type production. In the 50s, influenced by a then dominant realist aesthetic, many critics including Eric Rohmer circulated the idea that a film is also and always 'a documentary about its own production'. In other words, whatever a film's fictional story may be, it always links together the pieces that were filmed separately and thus it necessarily must give an image or a representation of that production process, although this image may have an odd temporality of its own. Of course, it requires some intellectual effort to see this, and fiction film is not immediately perceived as this kind of document. However, the 'documentary' aspect of older films can more easily be noticed as these films become documents of a by-gone time as well as telling a story (which gives old film series with non-studio locations a certain charm or interest). Films from other genres have best illustrated the difference between shooting time and projection time. For example, Michael Snow's well-known *La Région centrale* (1971), a montage of long units of time shot by a camera rotating around a fixed point, thus depicting the same 'region' continuously. In the course of the long duration of its projection time (around three hours), the spectator has to think about the temporal relations between the units, without being given any index of the order in which they were filmed.

II.3 The Temporalised Image

II.3.1 Film Image, Video Image

Temporal images, which include time in their very existence, are of two types: *filmed* images and *videographic* images. There are many radical differences between the two forms and technologies of production and display of these images:

- The filmed image is a photographic image; the video image is recorded on a magnetic tape;

126

- The filmed image is recorded in a single moment; the video image is recorded through an electronic scanning which moves across the series of horizontal lines making up the screen-image (the term scanning, used to describe this electronic process, is the same that is used to describe the eye's exploration of an image) (*see* Chapter 1);
- The projection process of the filmed image consists of a rapid succession of photograms separated by black spaces (*see* Chapter 1, II.2.2); the video image consists of a luminous spot scanning the screen of the monitor.

These differences are very real, but the difference in effect on our perception has often been overstated. Much has been made of the fact that the video apparatus has no black intervals between successive images, and that it is not produced by projecting discontinuous images. In fact, the video image is not perceived as identical to the film image, but the difference between them is not so much a matter of black spacing between successive photograms, nor of the scanning of the video screen, but with the frequency with which the successive images appear. In cinema this frequency is generally sufficiently rapid to avoid flickering; in video the frequency of the image is subject to the electric current used to run the machine (50 Hz in Europe), and images cannot be made to appear at a more rapid rythm.[5] The brightness of the screen is generally strong enough to result in a flickering which is specific to video because, due to the scanning movement, it does not reach all parts of the screen simultaneously.

This difference is the main one between film and video images from the perceptual point of view, at least if one excludes the often significant differences stemming from the vicissitudes of television transmission (jumping images, visual 'interference', 'snow', and so on), as well as the graininess and softer focus of the video image in general. It is important to emphasise that if the masking effect generated by changes from one shot to another is slightly less in video, that is because of the interweaving of the two half-images. Apart from that, there is no perceptible difference of apparent movement in video and cinema (retinal persistence affects neither image). In fact, it seems that many theorists have grossly overemphasised the difference between film and video (in the understandable wish to differentiate the video image from the film image), leading to the overvaluation of video's perceptual effects.

In the work of some artists in film or video, the spectator's knowledge of the apparatus becomes a practical, technical knowledge that is sometimes of significant importance in the conception and realisation of a work, and which therefore must be taken into account. The electronic image consists of a surface being scanned, which lends itself to many reworking effects specific to this sweeping (the whole range of video effects, today popularised on television, stems from this) and, inversely, the fact that the film image is made up of physically tangible photograms lends itself to other forms of manipulation such as cutting, scratching,

painting, and so on; 'experimental' cinema differs more from 'experimental' video than fiction film from fiction video, at least in their intellectual and formal respects, no doubt because it is often difficult to differentatiate between a film image and a video image by sight alone.

Henceforth, we shall treat film and video images as two variations (often difficult to distinguish phenomenally) of a same type of image, the moving image or, better, the temporal image, overlooking what is often the most visible difference between them: flicker.

II.3.2 The Cinematographic Situation

The 'cinematographic situation', to use the term proposed by A. Michotte van den Berck (1948), designates the conjunction between the spectator and the apparatus of the temporal image. This conjunction obviously contains elements that are not, in themselves temporal, the main one being the psychological phenomenon of the segregation of spaces, separating the space perceived on the screen from the space of proprioception (self-perception).

In Chapter 1, §II.2 and in Chapter 2, §II.2–3, the temporal aspects of the apparatus were described in terms of the production of apparent movement, at least as far as the perceptive and psychological aspects of apparent movement are concerned. The main function of the apparatus is to regulate the very basis of the cinematographic and videographic image by ensuring the perception of apparent movement. In addition to the technical aspect of this function (the elimination of flicker, absence of undue masking), there is also a socio-symbolic aspect, as the apparatus is also what legitimates the very fact of going to see moving images on a screen. This former aspect ensures that the cinematographic (or videographic) apparatus *authorises* the perception of a moving image. The latter aspect cannot be summed up so succinctly. The cinematic image is an *apparition*. More precisely, it is an object the perception of which is subject to a jerky alternation of appearance and disappearance, whereas other visual objects tend to appear progressively through a gradual unveiling. In his 1948 essay, Michotte argues that, as a general rule, objects appear to us through the movement of another object in front of them which has screened our perception. Hence the expression '*screen effect*' to designate the process by which an object is gradually unveiled and offered to our perception. This effect is absent from the cinematic image. As the term 'screen-effect' is likely to be understood, falsely, as a reference to the cinema screen, it is best to avoid using it altogether. Here the term will be used only when referring to Michotte's historically important essay. In any case, one of the fundamental perceptual characteristics of the cinematic image, created by its apparatus, is the fact that it appears suddenly, which has an important consequence: the outline of the image, its edge (which is only[6] demarcated by the darkness around the screen) is seen as being a constituent part of the image, whereas the image itself is seen as flattened against the screen.

Two things are worth noting in this respect:

- This is not only a spatial characteristic but also a temporal one, since this oscillation of appearance/disappearance implies a succession of states which may be coded as 'no image', 'image 1', 'no image', 'image 2', and so on up to 'no more image';
- This way of understanding the image, which makes the limit-frame into an absolute, impenetrable cut-off limit, seems to run counter to Bazin's famous thesis of the 'centrifugal' effect of the film image (*see* Chapter 4, §II). Bazin, unlike Michotte, takes the diegesis into consideration as well as the powerful readiness to believe that it induces in the spectator, while rather underestimating the spectator's knowledge which may partly contradict this effect of belief constructed by the apparatus. Of course, one could criticise Michotte for assuming the opposite, as he seems to acknowledge when he points out that this 'all at once' appearance of the film image is forgotten, during the projection, in favour of a perception of the objects represented. These then appear to us in a way rather like the actual 'screen effect', that is to say, through a progressive veiling and unveiling.

Nevertheless, this characteristic of the apparatus remains important, especially in films which have frequent and sudden shot-changes, forcing the spectator to become aware of this process, even if only subliminally, or at any rate to perceive such shot-changes as a kind of jump, a sort of 'sudden appearance', or at times as a kind of visual masking.

II.3.3 Movement-image, Time-image
The cinematic image was originally seen as radically new because it moved, not only because it represented motion. It was this idea of an image fundamentally different from other images because of its different quality (it does not simply add movement to an image) which inspired the first theoretical thinking on cinema, the work of Hugo Münsterberg, and then the phenomenological approach of Michotte and his followers (up to the first writings by Christian Metz in 1964). Returning to this starting point which sees the film image as capable of 'automotion', Gilles Deleuze proposes the *movement-image* as one of the two great modalities of cinema. The movement-image is embodied in the shot which he defines as a 'mobile segment of duration'. Deleuze differentiates between three forms of movement-image, which he calls perception-image, action-image and affect-image, and because of which a particular process will predominate, the perceptual process, the narrative process or the expressive process. According to him, these three types are to be found, to varying extents, in all the types of classic cinema.

In the second stage of his philosophy of cinema, Deleuze follows this line of thought by suggesting the more original notion of the *time-image* to designate the post-classical film image. According to him, this new image expresses both a crisis, a 'breaking of sensori-motor connections', and at the same time a concern to explore time directly, beyond motion

alone, which had originally defined the film image. Deleuze's classification here is less clear than that of the forms of movement-image. The classification he proposes juxtaposes a number of points of view, some of which overlap, without giving a clear overall picture.

In the next chapter we will return to this approach, but at this point it is important to emphasise Deleuze's basic innovatory idea: the cinematic apparatus implies not only the passage of time, a chronology into which we would slip as if into a perpetual present, but also a complex, stratified time in which we move through different levels simultaneously, present, past(s), future(s) – and not only because we use our memory and expectations, but also because, when it emphasises the time in which things take place, their duration, cinema almost allows us to *perceive* time.

III. Apparatus, Technology and Ideology

While the apparatus may be defined as the regulation of the conjunction between spectator and image, it is also more than simply the regulation of this conjunction's spatio-temporal aspects. We will now turn to examine the *symbolic* aspect of the apparatus, beginning with a discussion of some effects of the technology that underpin the apparatus before going on to try to locate the notion of the apparatus within the symbolic sphere.

III.1 The Medium of the Image: Impression versus Projection

III.1.1 Two Apparatuses?

When considering a wide variety of images, from the earliest cave drawings to video art and interactive imagery, a clear division can be made between printed images obtained by putting coloured pigments on a surface, and projected images made by the action of a light beam on a screen:

- The printed image is imagined as being more manipulable: a photograph can be cut out (to make a collage, for example), the parts of a painting that are considered unsatisfactory can be repainted and so on. On the other hand, the projected image is experienced as an unchangeable entity. We have to take it or leave it. Strictly speaking, this is not true. One could place a filter between the projector and part of the screen, or superimpose two images – but this kind of manipulation is not anything like as effective as the things that can be done with the first type of image, which itself remains inert and may be recovered after a manipulation.
- Correspondingly, the printed image is regarded as being more mobile or portable, as an object we can pick up and carry away. The contemporary tendency in painting to produce large format works does not mean these cannot be moved from studio to gallery or to museums. On the other hand, the projected image exists only where there

is a machine to project it, and even though many of these machines are now portable, they are rarely moved during projection (the only examples that come to mind are all in the context of museums of contemporary art, where a slide projector is sometimes turned on its axis and so on).

- Printed images need light in order to be seen because, perceptually speaking, they only have a reflecting surface. Projected images require their own light source together with the extinction of other possible light sources, since these would diminish the brightness of the image.

One might argue that such differences imply that there are, in fact, two main image apparatuses. One would be based on the circulation of mostly relatively small-sized, manipulable, printed images viewed by a spectator who enjoys freedom of movement (a freedom which is itself variable, of course: from the exhibition space to the portable snapshot). The second apparatus would be based on projected images of varying sizes, often quite large, seen by a number of viewers at once, in a place that is specially selected for such an exhibition. Obviously, amateur photography and cinema are prime examples of each type of apparatus.

III.1.2 Opaque Image, Luminous Image

However, there are many aspects which contradict any simple notion of two image apparatuses. For instance, the exhibition of extremely large photographs in galleries or museums may stun, even paralyse viewers, almost rooting them to the spot, depriving them of their separate points of view as well as of the freedom to touch the images; or the projection of amateur films on a small screen in a domestic space, where the image distance and its size are reduced; or the perceptual 'tricks' set up as experiments in laboratories to test perception, such as the one which leads viewers to confuse a slide image with a cardboard model; and especially the obvious borderline case of the video image.

The video image is both printed and projected, but it is not printed like photography, nor is it projected like the cinematographic image. What we see is the direct result of a projection of light, but of a special kind. First, it comes from behind the image and from a place which must remain inaccessible (the cathode-ray tube must remain closed for there to be an image). Secondly, the light targets dots on the screen, which are reached in succession according to a specific rhythm (not by means of a general flow of light, not by a beam, but by a very slender, mobile pencil of light). It is this second trait which enables the video image to be imagined as akin to a printed image, an ephemeral and endlessly renewed print; though again we can see that this is inaccurate – at most we can say that it is the impression of an impression.

So, the video image seems to belong to a third type of apparatus, all the more so since it is based on a number of characteristics that we have contrasted with the first two apparatuses: generally speaking, the video image is small but immobile (the pocket television set, using liquid crys-

tals, is not widely used yet); it may be aimed, depending on the circumstances, at an individual viewer or a collective audience, sometimes in a domestic space, sometimes in a social space; it does not need to be viewed in the dark, but too much light on the screen does affect it. Even the criterion of manipulation places it in both categories, since the image may be modified during its production process as well as in its projected state (by means of electronic pointing devices which deform the image).

In fact, it does not really matter whether there are two, three, or more types of apparatus. Like all classifications, this one can be endlessly perfected. To sum up, the main thrust of these differentiations seems to point to a distinction between opaque images and luminous images. Opaque images can be touched and are made to be seen via the reflection of light; these images are formed on a material support from which they cannot be separated. Then there are the luminous images resulting from the presence of light on a surface of which they are an integral part; these images are often thought of as not definitive but temporary, and especially as having an identifiable source, whether visible or not. We should note that within these more general terms, the video image is undoubtedly a luminous image. The first symbolic dimension of the apparatus is then the luminous image, the image made of light, seen by the spectator as more immaterial than the opaque image, even though this is obviously a fantasy, since light is just as material a substance as any other. The luminous image is seen as instrinsically endowed with a temporal dimension, simply because it is almost impossible to conceive of light in any but temporal terms (as light is not a state but a process).

III.2 Technical Determinants

III.2.1 Technique and Technology
One of the liveliest and most important debates concerning the apparatus revolves around the evaluation of the influence of technical factors on the symbolic value of the apparatus. There is a well-established tradition which holds that technical factors have their own logic, their own autonomous development, and that revolutions in thinking or perception are caused by revolutions in technology. Underpinning this current of thought is a question about the forces of history, and thus about the causes of symbolic and social phenomena.

However, the first thing to do is to clarify the terms of the debate. In French the word *technique* is fairly ambiguous, because it can designate either a certain procedure for achieving a given action or the sphere of practical activity in general (whether or not this involves specialised tools). In discussions between French and anglophone researchers, this ambiguity has often caused difficulties, as the English term usually conveys only the former of these two meanings. Moreover, the English language makes a distinction between technique and technology, the latter meaning the totality of material instruments and knowledge used to perform a certain activity, the former referring to the application of tools

and knowledge in practice. French has no equivalent for this distinction (although, under the influence of English, the French word *technologie* has tended to take on the meaning of technology and to lose its sense of being 'a discourse on technique'), so it is hardly surprising that there have been misunderstandings.

Here, we shall distinguish three very different levels of meaning:

- the tools available for performing a given task, such as the different kinds of pigment necessary to make a painting (for instance, ready-made colours in tubes in the 19th century, acrylic paints in the 1950s);
- the technique involved in working with these tools; for instance, when the zoom lens was introduced into film-making, one technique that developed was to use it as a substitute for tracking shots, but it was also used for a new effect, 'zooming', which was not a substitute for anything, but, on the contrary, produced an original film form;
- lastly, the discourse on technique in general and its effects in particular cases. It is on this level that discussions about the technological determinants of the apparatus are located, although it is inextricable from the two previous levels.

III.2.2 The Automatic Image

Among the technological advances that have affected the history of images, there is one that has often been considered to have been revolutionary: the technology that made it possible, with the development of photography, to introduce 'automatic' images. Earlier in this chapter (§II.2), we discussed the *indexical* nature of the photograph, the fact that it is a sort of *recording* or *imprint* of visible reality. This notion has often been invoked when debating whether photography is 'art' or not, since an automatic rendering of the visible significantly reduces the impact of human agency.

Photography's capacity to override the intentionality of the photographer, or even to foil it altogether, was very soon felt by photographers. The work in which Fox Talbot described his invention is called *The Pencil of Nature*, but if photography is an image 'drawn' by nature, we obviously do not have much of a part in it. It is impossible to list all the authors who have put forward similar ideas, but their conclusions have tended to fall into two camps:

- In the first, photography is held to show us the world differently from the way the eye (including, and especially, the eye of the painter) has so far been able to; this argument is espoused by a number of avant-garde photographers of the 1920s, such as Laszlo Moholy-Nagy in his book *Malerei Fotografie Film* (1925), where he claims that photography works by analysing movement, showing the world through a microscope, finding original angles and viewpoints, and so on. All such aspects, he claims, distinguish it from painting. However, this pos-

ition is shared by a theoretician such as Siegfried Kracauer, for whom a photograph is essentially a way of showing 'things normally unseen';

- In the second, photography is the summit of representation, attaining and perfecting what the history of the figurative arts had been aiming for all along, that is to say, the imitation of appearances. In this argument, the camera becomes an off-shoot of the camera obscura, able to reproduce automatically a view in complete accord with the rules of optical perspective, and able, in addition, to fix and record this view. This is the 'realist' thesis espoused by numerous critics, such as André Bazin, who advanced a striking version of it cast in terms of religious metaphor: countering Kracauer, Bazin sees the photographic 'revelation' as the fulfilment of art's mimetic vocation (the first sign of which was the Renaissance's adoption of perspective), and as one of the most important manifestations of the wish, inherent in all acts of representation, to 'embalm reality'.

These discourses on the automatic image were extended to include cinema (for instance, by Kracauer whose thoughts on photography are included in a chapter of his *Theory of Film*, 1960). Nevertheless, despite the opposition between the 'perspectival' and the 'exploratory' positions, these two discourses overlap in two respects: first, they are both entirely positive about the effects of an invention that automatically records a perspectival construction; secondly, both are only indirectly interested in the viewer of the photograph as a subject presumed to know certain things (*see* Chapter 2, §II.3 and Chapter 3, §II.2). For more than a century, the documentary authority of the photographic image was never questioned (even though it took a long time before its artistic legitimacy was granted).

Photography's ability to legitimate what it depicted was hotly debated in film theory and criticism in the 1960s and 70s. Interviewed in 1969, the art historian Marcelin Pleynet put forward, apparently for the first time, a virulent critique of the photographic image's automatism. For Pleynet, the automatism, and the construction effected by the camera, derive from the wish to produce a perspective with all potential anomalies rectified, in order to reproduce *ad infinitum* 'the code of specular vision defined by Renaissance humanism'. The invention of photography by Niepce, according to Pleynet, happened 'at the very moment' when Hegel put a full stop to the history of art. So, no sooner did it begin to become apparent that perspective is related to a specific cultural structure, than photography came along to stifle this growing awareness with its ability to reproduce the perspectival ideology mechanically.

First, let us examine this theoretical position's implications. If photography reproduces an ideology, it can only be through its apparatus, and for its spectator. As an automatic recording of perspective, photography functions as a sort of ideological trap, since it implies a viewer who would be predisposed to accept perspective as a legitimate means of representation (whereas for Pleynet, perspective is just one code

among many, and a dangerously ideological one at that). Moreover, the viewer would not only have to be predisposed to accept perspective as legitimate, he or she would also have to believe that photography well and truly does record reality.

These positions are important and are the keystones of an entire era of image theory. It may now be easy to criticise a critique of perspective that confuses natural and artificial perspective (*see* Chapter 1, §II.2 and Chapter 4, §II.1); it seems easy, too, to distinguish between a photographic record (the photograph as trace) and the photographic form (the photograph as writing), and to transcend the fear that the automatic nature of the photographic image means that it cannot be 'worked upon'. Nevertheless, it is to the credit of this 'ideological' critique – and perhaps its very excesses – that it enabled such distinctions to be made in the first place. It was also the first discourse to relate the apparatus to the mode of production and consumption of images, and thus to the idea that the way that an image is produced necessarily impacts on the way viewers appropriate it.

III.2.3 Technique and Ideology

The most important texts rehearsing these questions remain Jean-Louis Comolli's series of essays, 'Technique et idéologie', published in 1971-2 in *Cahiers du cinéma* (and translated in the British journal *Screen* shortly afterwards). These texts, inseparable as they are from their context (Comolli 'responding' in an avowedly polemical mode to many other works or essays), present a systematic account of the way we conceive of the relations between the image (especially photographic image), its 'technique', its apparatus and the ideology that articulates the latter for the viewer. It does so by asking three specific questions:

- What is the relation between the photographic (and the cinematic) image and the pictorial image as defined in the Quattrocento?
- What is the relation between the invention of photography and the invention of cinema?
- How are we to understand the invention of the camera and its role as a pattern-setting model?

The camera as a metonymy for cinema. Of the entire cinematographic apparatus, the element most directly involved with the visible is the camera:

- The camera is a metonymy for the visible part of production and its technology (as opposed to the invisible aspects of production and technology, such as chemistry and laboratory processes);
- It deals directly with light and the visible;
- The camera has its own metonymy in the lens. The lens deals with light in terms of *geometry*, in terms of the perspectival rules it has been constructed to uphold and embody. Comolli dwells on the troubling

135

slippage between the French term for 'lens', *objectif*, and *objectivity* (found particularly in Bazin's writing), a slippage to which he ascribes the importance of the camera's ideological resonance.

All this leads Comolli to conclude that the film camera conveys an 'ideology of the visible' and that a materialist theory of film should carefully differentiate between what is ideological legacy and what is scientific investment. This thought is central, and it was crucial at the time of writing because of the then dominant notions of technological determinism, which tended to deny the ideological value of a technical instrument, however it was used. One of Comolli's targets was Jean-Patrick Lebel's *Cinéma et idéologie* (1970), in which Lebel claimed that the camera was no more ideological than a pencil or an aeroplane. Note that Comolli, carried away by his polemic, completely neglects the 'scientific investment' contained and concealed within cinema, reading everything in terms of ideology.

The invention of cinema. Comolli's position on the invention of cinema is also based on a critique of earlier texts. The main target is Bazin's argument which correctly refutes the notion that cinema was an invention prompted by science, but wrongly interprets cinema as an ideational process. Jean-Patrick Lebel is once again criticised for refusing to acknowledge that, as a signifying practice, cinema is directly related to ideology. For Comolli, the invention of cinema is completely independent from the discourse of science, which has always been slow to take up practical discoveries. For him, practical discoveries have had little or no direct bearing on the development of science. The invention of the camera obscura preceded Cartesian optics; the chemistry of photosensitive surfaces came a long time after Niepce's first experiments, while the perception of apparent movement (which Comolli unfortunately attributes to 'retinal persistence') was not yet understood when film was invented.

The reason why cinema is not a scientific invention is because it emerges from an *ideological imperative* issuing from the social context. Here again, Comolli radically simplifies the problems and even partly contradicts himself by claiming, rightly, that cinema was invented by artisans energised by ideological motivations, but also by scientists interested in the analysis of movement and the study of perception. However, his thesis is important. Interestingly, it has been strengthened by recent work in the history of photography (for instance, Peter Galassi (1981) claims that it was neither scientific nor technological discoveries that led to the invention of photography, but the changes wrought in pictorial representation towards the end of the 18th century; *see* Chapter 4, §II).

Deep focus. Comolli deals mainly with depth of field in film because of its relation to perspective, and because Bazin argued that deep focus and perspective can be used to create a greater degree of realism in the image. For Comolli, these arguments, and all the ways in which the

filmic image have been conceptualised (as, for instance, by Jean Mitry), tend to autonomise film space, supporting the fundamental illusion that filmic representation is based on 'Renaissance' representational idiom. In other words, representation exists within and is always part of a historically determined ideology.

This seemingly minor issue of deep focus rapidly took on major dimensions in Comolli's work, no doubt in reaction to Bazin's texts which proclaimed deep focus to be the key to an 'evolutionist' notion of film history. It is on this point that Comolli most systematically illustrates his claim to be writing a *materialist history* of cinema based on notions of *signifying practice* (as Julia Kristeva defined it) and '*differential historical time*' (proposed by Louis Althusser).

Provisional conclusion. Comolli's essays began by arguing for the primacy of ideology over technology, a point which he soon proved; he then went on to try to redefine the conditions of a history of cinema in order to demonstrate the crucial part played by ideology, and the role of over-determination (in Althusser's sense of the word). For Comolli, the key point of departure for thinking about depth of field is the ideology of realism (which he tends to identify with the ideology of the visible).

The debate on history, although it characterised the critical and theoretical debates of an entire era, is not our main concern. We mention it here only because it provided precise and clearly argued answers to the question of the techn(olog)ical determination of the apparatus. For Comolli, as for Pascal Bonitzer, Jean-Louis Baudry and later Stephen Heath, the cinematographic apparatus can only be understood if it is analysed as an articulation, a linking of the spheres of technology and aesthetics (that is to say, the shaping of film forms) in terms of the prior demands of ideology. These demands determine both the technical inventions and the spectator's acceptance of the apparatus. The histories of representation and images are thus, in the main, the history of these ideological demands. In particular, it is only because of this history, including, for example, the formation of the style of 'classical realism' based on the assumed transparency of the image, the advent of sound, colour and large screen formats, that in the 70s critics characterised cinema as 'imbued through and through with bourgeois ideology'.

Although these debates dominated film theory for a whole decade, they are no longer so central nowadays, mainly because their Althusserian and Marxist frames of reference have been, wrongly, forgotten or marginalised. The debate on history may still be very contemporary, but the concept of ideology as defined fairly precisely by Marxist criticism has fallen into disuse. Despite the flaws in all definitions of ideology, there are good reasons to regret this marginalisation: the theoretical void it left has been rapidly filled by a smug empiricism based on statistics, quantitative studies and crude 'common sense'. The result has been decidedly regressive, even when based on factually correct research, as for instance in the work of Barry Salt (1983).

137

III.3 The Apparatus as a Psychological and Social Machine

There is still no general theory of the apparatus's function within the social sphere. It would be fruitless to try to cobble one together from the many existing approaches based on incompatible presuppositions. Here we will confine ourselves to asking some questions with reference to the more useful aspects of these approaches.

III.3.1 Sociological Effects

The sociology of images is not the most advanced aspect of this discipline. There are sociological studies of the reception of media products, as there are on the reception of works of art. However, these are mostly analyses of the overt content of the products in order, for example, to measure the effects of certain television messages on young viewers. Some of these studies are better than others, but they are almost all studies of the content of representations and, as a rule, avoid the question of the image apparatus, which is considered to be self-evident: the image apparatus is there to provide analogical representations of reality. As such, the only questions allowed are those concerning subjectivity and distortion in the uses of the apparatus.

The main exception is Pierre Bourdieu's classic study of photography (1966) – the way it is used by amateurs; the way photographs are received, slightly differently from the way art is received, by a public which, intimidated by painting, finds in photography 'an average art', in the sense that one might speak of 'the man in the street' as 'an average person', likely to reassure him or her. Bourdieu studies photography as a social practice located half-way between between entertainment and art, defining its public as basically the moderately educated petit-bourgeois. His research was done in the 60s and would no doubt yield different results if done today, because of the rapid growth of photography in our society and a correlative growth of its public. Now, photography is becoming a fully legitimated art form, at least in terms of its market. In the market-place, the tendency is towards single prints (or very limited editions) signed by the artists, exhibited and sold in galleries. The model is clearly that of the circulation and marketing of paintings through the gallery system. However, Bourdieu's methodology remains exemplary because of its rigorous yet constantly self-critical way of proceeding.

Few sociologists have been as sensitive as Bourdieu to the influence exerted by the apparatus on the reception of images. The most important work in this area has been done more often by historians than by sociologists. For instance, the tendency known as the 'social history of art', a generic term for a number of at times very diverse historical studies that share the aim of departing from traditional art history (the chronicle of period styles) in order to elaborate a historical approach to the problems of the production and the reception of particular works of art. Within the social history of art, there is a wide variety of different kinds of work, such as the study of social representations (Francis

138

Klingender's remarkable study (1968) of the iconography of the first industrial revolution in certain art practices in England), or studies with more theoretical, totalising and generalising aims such as Arnold Hauser's *The Social History of Art* (1938), a sort of overview of the history of Western art from a rather unsophisticated Marxist perspective (a variant of the 'reflection theory' of culture, which claims that the production and reception of art literally reflects society's class structure).

It is impossible to list every single tendency within the social history of art, and the two examples have been selected simply to demonstrate its interest and usefulness for understanding the social effects of the (art) image.

'Painting and Experience in Fifteenth-century Italy'. The central thesis of Michael Baxandall's classic study (1972; translated into French with the more evocative title of *l'Oeil du Quattrocento*) is that since the meaning of painting is determined, above all, by social and ideological factors, we can only understand the way fifteenth-century people viewed contemporary paintings by grasping which of these factors determined their perception, and how they did so. Baxandall lists several of them, which he then goes on to relate to the then reigning notion of painting:

- courtly conventions, giving a specific and coded meaning to certain gestures represented in the paintings;
- the rhetoric of the sermon, which is an implicit reference in the many works illustrating some supposedly widely known and recognised motif;
- the Bible, of course;
- sacred dance and drama, found, like courtly gestures, in the positions of the painted figures (for example, in Botticelli's famous *Spring*);
- colour symbolism, which was a residue from the middle ages and antiquity (for example, the ultramarine blue of the Virgin's dress was supposed to symbolise the heavenly sky);
- the fascination with mathematics as bankers developed double-entry book-keeping and merchants applied geometry to the trade in goods; both being examples, according to Baxandall, of the taste of fifteenth-century Tuscan society for mathematical models, a taste also found in the many experiments painters conducted with perspectival systems, sometimes with great virtuosity;
- a taste for virtuosity in general, noticeable in music as well as in poetry;
- the symbolism of the five senses.

Baxandall goes on to add a list of inherently pictorial values (those used by painters in the practice of their craft), the very variety of which has a theoretical interest of its own: sociologically speaking, the apparatus functions simultaneously at a number of levels, which implies the deployment of different types of specialist knowledge and a reliance on strongly coded symbols.

Absorption. This term, used by Michael Fried (1980), designates the psychological state of many people depicted in paintings; they seem to be concentrating, absorbed in activity (such as Chardin's *L'Enfant au tonton*), in their thoughts or in conversation (with an invisible interlocutor, such as Fragonard's portrait of Diderot). Fried's study becomes socio-historical when he formulates the hypothesis that this state of absorption is characteristic of very many French paintings of the 18th century, and that this can only be explained in relation to a system of implicit values which is understood simultaneously by the painters and by the painting's implied viewer.

Fried's book is of interest to us for two main reasons. Like Baxandall, Fried connects pictorial values with ideological and social phenomena (for example, the value of different genres of painting, the theory of passions and their expression), but Fried does this in terms of a pictorial figure which directly involves the presence of a spectator viewing the painting. In fact, the many eighteenth-century French paintings that depict absorbed people do so by virtue of a 'supreme fiction': the forgetting of the spectator. In the ostentatious *mise en scène* of the segregation of spaces, Fried sees the wish to reaffirm painting as a specific art, an autonomous apparatus, independent of the model of the art apparatus which was predominant at the time, that is to say, the theatre. By pointing to mutually reinforcing elements in paintings and contemporaneous texts, Fried produces an analysis of the pictorial apparatus of the 18th century. Among other interesting examples of such an approach is the work of Michel Thévoz on academicism in nineteenth-century French painting (1980), Timothy J. Clarke's books on Courbet and on realism (both 1973) and so on. It is important to emphasise that these works represent an approach which deploys historical research in order to arrive at an understanding of the apparatus's social effects, and that it would be important to extend them into studies of similar quality on the contemporary effects of, for example, the moving image in film and video.

III.3.2 Subjective Effects
Since the apparatus regulates the spectator's relation to the work, it necessarily has effects on the spectator as an individual. For example, in Fried's study, the spectator whose presence is 'refused' by the fictional scene painted on the canvas, is thereby positioned at a specific psychic distance, which strengthens, in this case, the pole of knowledge (without necessarily weakening that of belief, as it happens).

But on this issue, it is film theory, once again, that has most systematically studied these effects, mostly deploying theories inspired by psychoanalysis. The very term 'apparatus' was introduced in 1975 by Jean-Louis Baudry in the title of a famous essay on the theory of the film spectator. In his metapsychology (we will return to this in the next section), Baudry discusses the impression of reality and its roots. He argues that the cinematographic apparatus creates an artificially regressive

state, alongside what he calls 'an enveloping relation to reality' (an absence of body boundaries, which seems to melt into the diegetic world, into the image): 'The simulation apparatus consists of transforming a perception into a virtual hallucination, giving an effect of the real far more powerful than can be created by mere perception.' Consequently, Baudry stresses the apparatus's charateristic propensity towards nostalgia. This nostalgia can take many forms: narcissistic regression, assimilation into the dream, but also a return to a mythic past, in this case to the Platonic myth of the cavern. Baudry draws a long parallel between the situation of the cinema spectator and the situation of the slaves in Plato's parable, who are condemned to see only the projected shadows of reality on the wall in front of them.

In *Psychoanalysis and Cinema: The Imaginary Signifier* (1973–6), Christian Metz developed the most systematic and direct approach yet to the question of the subjective effects of the cinematic apparatus: why do we want to go to the cinema in the first place, regardless of which film is playing? How does the apparatus induce a specific type of spectator? How does the spectatorial subject behave during projection?[7] This very rich perspective has been extended by a number of specific studies (as in several recent contributions to the collection *Cinéma et psychanalyse* (1989) edited by Alain Dhote). The study of other apparatuses such as video, photography or painting, is far less developed on this question of the spectatorial subject. However, worthwhile contributions include:

- studies extending film theory into other areas, for instance by using the concept of the apparatus to think about photography (several articles published in *Screen* in the 70s);
- the entire cognitivist tendency mentioned in Chapter 2, which in its future developments will inevitably have to confront the effects of the cinematic apparatus on its spectator, although it will elect to do so without having recourse to Freudian theory.

III.3.3 Ideological Effects
Finally, on the interface between the subjective and the social, the apparatus defines itself in terms of its *ideological* effects. These effects were the first to be studied, not necessarily because they are the most important or the most easily understood, but because the very notion of the apparatus was conceived at the same time that a large number of essays were being devoted to a consideration of art practices as ideological phenomena (such as, for instance, the essays by Comolli we mentioned earlier). This work sought to affirm that in art, ideology is not simply to be found at the level of content, but that it exists also on the formal and technical levels. The notion of ideology itself has never been so fully discussed, examined and excavated as in the 70s. Althusser's essay 'Ideology and the Ideological State Apparatuses' (1970) provided the contextual frame for a plethora of studies addressing the ideological effects of cinema.

Some of the more significant contributions of the early 70s came from Marcelin Pleynet and Baudry in *Cahiers du cinéma* and *Cinéthique*. In terms of the apparatus itself, these texts, despite significant disgreements, converge on several theses: the dominant form of cinema is driven by a wish for continuity and centering; both of these characteristics are seen as constitutive of the subject; and the ideological function of cinema consists mainly of constituting an individual as a subject by placing him or her imaginarily in a central position. The apparatus plays an essential role in all this: it is that which, although invisible, enables us to see. In this concept of 'the apparatus', its optical instruments were often singled out for special attention: the camera is said to reproduce the centred subject of bourgeois ideology, and the way in which it represents the world is said to be the goal of any history of 'bourgeois representation'; the projector is conceived as 'an eye behind the head' (André Green), which also embodies the generic eye which is the great metaphor for cinema. Such an apparatus is entirely based on sight: the spectator is 'all seeing' (Metz), that is to say, he or she is omnivoyant, but reduced to nothing but the act of seeing, which is moreover constantly centred according to the rules of perspectival optics and endlessly reproduced to suggest an illusory continuity. It is in this respect that the ideological effects play their part.

These notions have been developed particularly in relation to cinema, which does appear to be the principle vehicle of the ideology 'of the visible' (in Comolli's phrase), probably because of the powerful impression of reality that it can create. But we also have to recognise that these ideological effects ascribed to the cinematic apparatus did not drop from a clear blue sky. They have a long cultural history. For Jean-Louis Baudry, the way the cinematic apparatus creates a centred subject can be read as a continuation of the traditional notion of a transcendental subject as it has been elaborated from Descartes to existentialism, and of which cinema is a representation (a 'theatricalisation' says Baudry). More inclusively still, though more vaguely, Jean-Pierre Oudart (1971) considers the entire history of representation in Western art from the Renaissance onwards to be based on a specific concept of the subject:

> The characteristic of bourgeois representation is to reproduce its figures as real for a subject which is supposed to know nothing about the relations of production in which the pictorial product is inscribed just like all other products . . . Thus bourgeois ideology could be defined as a discourse in which a subject (the subject of the signifier, in other words, the subject of production to the extent that the signifier is, for example, an economic or linguistic product) has articulated the question of its own production, of its symbolic arrival, on the basis of repression, since, as Marx already noted, it is characteristic of the bourgeoisie that it conceives itself as ahistorical.

Despite its specific historical (and, more distantly, political) orientation, this train of thought rejoins other discourses on the cultural forms of the image and its reception. What comes to mind immediately is the

work of Pierre Francastel, who on the interdisciplinary axis of sociology, art history and the study of ideology had done a great deal of work on the idea that the moments of intensive transformation in the history of representation (the Renaissance, the beginning of the 20th century, and so on) correspond to transformations in ways of seeing within society in general. We could also mention the many philosophers who have written about the symbolic process in general and on imagery in particular. Ernst Cassirer's notion of symbolic form, which can be applied to all the main functions of the human mind (art, myth, religion, cognition), has been popularised by Panofsky's work on perspective and iconology (*see* Chapter 4, §II); and there is an entire current of analytic philosophy which develops Wittgenstein's notion of art as a *form of life* (*Lebensform*), the complex context of a given language, and so on.

IV. Conclusion: Apparatus and History

The apparatus is what regulates the relation of the spectator to his or her images in a certain symbolic context. However, what emerges at the conclusion of this overview of the studies of the image apparatus is that this symbolic context is also a social context, because neither symbols nor, more inclusively, the symbolic sphere in general exist in the abstract. The symbolic sphere is determined by the material characteristics of the social formation that gives rise to it.

Consequently, the study of the apparatus must also be a historical study: there is no apparatus outside of history. This comment may seem banal (can any human phenomenon be outside of history?), but it is useful to repeat it explicitly, since the concept of the apparatus itself was conceived in the very context of a theoretical approach which was often drawn to universalise its concepts, starting with the notions of ideology and the unconscious, which cannot necessarily account for the symbolic effects found in all human societies.

It is not a matter of writing a history, or even of making a list of possible image aparatuses. The reader will have noticed that the apparatuses that have been more intensively studied, perhaps being more striking than others, are cited repeatedly in this book. Simply note that the question of the apparatus may be the terrain on which the different theoretical and critical traditions in the study of images can most easily be brought together. The study of the cinematic apparatus is well advanced in terms of the development of concepts, but the study of the pictorial apparatus is much more advanced in terms of its history. Despite the fragmentation of research, there may be some useful interconnections emerging between these disciplines, especially around the newer forms of the image such as video.[8]

Notes

1. In Byzantium, the term '*ikonomia*' covered the normal, conventional functioning of images/icons according to the ideological (in this case, religious) rules which defined the image in that culture.

2. The French term '*cadrage*' can mean both 'framing' and 'centring'.
3. In France, the cinematographer's assistant who actually operates the camera and looks through its eyepiece is often called the '*cadreur*', the one who frames the image. Conventional practice dictates that such an image should be suitably 'centred'.
4. The term 'photogram' has two meanings which should not be confused. In photography (which is the way it is used here), it designates an image obtained through the direct action of light on a sensitive surface, without passing through a lens; while in cinema, it designates the image as printed onto the celluloid (and, by extension, a photograph taken from such an image, also called a frame-still).
5. In fact, for technical reasons, each video image is scanned in two phases: first, every second line (the uneven lines), then the remaining ones (the even lines); this means that there are twenty-five video images per second, each divided into two intertwined half-images.
6. Some cinema screens marketed to amateur film-makers have the border of the screen painted in black; an artificial framing which corporealises what is generally hardly an object-frame at all.
7. For further discussions of these questions, see J. Aumont and M. Marie, *The Aesthetics of Film* (1992) and part of their *L'Analyse des films* (1989).
8. For instance, in a recent collection entitled *La Video*, edited by Raymond Bellour and Anne-Marie Duguet, several contributions productively deploy such an interdisciplinary approach

V. Bibliography

The Spatial Dimension of the Apparatus
Alberti, Leon Baptista, *On Painting* [1435-6] (New Haven, CT: Yale University Press, 1956).

Arnheim, Rudolf, *The Power of the Center* (Berkeley: University of California Press, 1981).

Aumont, Jacques, 'Le Point de vue', in J. P. Simon and M. Vernet (eds), *Enonciation et cinéma,* special issue of *Communications* no. 38, 1983, pp. 3–29.

———, *L'Oeil interminable* (Paris: Librairie Séguier, 1989).

Balázs, Béla, *Der Geist des Films* [1930] (Frankfurt am Main: Makol Verlag, 1972).

Bonitzer, Pascal, *Le Champ aveugle* (Paris: *Cahiers du Cinéma*/Gallimard, 1982).

———, *Décadrages* (Paris: Editions de l'Etoile, 1985).

Dubois, Philippe (ed.), *Le Gros Plan,* special issue of *La Revue belge du cinéma* no. 10, Winter 1984–5.

Eisenstein, S. M., 'Rodin et Rilke: Le Problème de l'espace dans les arts représentatifs' [1945], in *Cinématisme* (Brussels: Complexe, 1980), pp. 249–82.

———, 'Dickens, Griffith, and Ourselves', in *Selected Writings, Volume 3,* ed. Richard Taylor (London: BFI, 1995).

———, 'The History of the Close-up' [1946], in *Selected Writings, Volume 4: Beyond the Stars* (London and Calcutta: BFI and Seagull, 1995), pp. 461–78.

Epstein, Jean, *Ecrits sur le cinéma,* 2 vols (Paris: Seghers, 1974–5).

Francastel, Pierre, 'Espace génétique, espace plastique', in *La Réalité figurative* (Paris: Denoël-Gonthier, 1965).

Galassi, Peter, *Before Photography: Painting and the Invention of Photography* (New York: Museum of Modern Art, 1981).

Jay, Martin, *Downcast Eyes: The Denigration of Vision in Twentieth-century French Thought* (Berkeley: University of California Press, 1993).

Jost, François, *L'Oeil-Caméra* (Lyon: Presses Universitaires de Lyon, 1987).

Lindsay, Vachel, *The Art of the Moving Picture* [1915] (New York: Liveright, 1970).

Marin, Louis, *Etudes sémiologiques: Ecritures, peintures* (Paris: Klincksieck, 1971).

———, *Opacité de la peinture* (Paris: Usher, 1989).

Ortega y Gasset, Jose, 'On Point of View in the Arts' [1949], in *The Dehumanization of Art* (Princeton, NJ: Princeton University Press, 1968).

Villain, Dominique, *L'Oeil à la caméra* (Paris: Ed. de l'Etoile, 1984).

Wölfflin, Heinrich, *Principles of the Art History: The Problems in the Development of Style in Later Art* [1915] (London: G. Bell and Sons, 1932).

The Temporal Dimension of the Apparatus

Bellour, Raymond, 'The Film Stilled', in *Camera Obscura* no. 24, 1990, pp. 99–123.

Bellour, Raymond and Anne Marie Duguet (eds), *Video*, special issue of *Communications* no. 48, 1988.

Chevrier, Jean François (ed.), 'Photographie et cinéma', special issue of *Photographies* no. 4, April 1984.

Deleuze, Gilles, *Cinema 1: The Movement Image* [1983] (London: Athlone Press, 1986).

———, *Cinema 2: The Time-Image* [1985] (London: Athlone Press, 1989).

Duve, Thierry de, 'Time Exposure and Snapshot: The Photograph as Paradox', in *October* no. 5, Summer 1978, pp. 113–25.

Doisneau, Robert, *Trois secondes d'éternité* (Paris: Contrejour, 1979).

Dubois, Philippe, *L'Acte photographique*, enlarged edition (Paris: Nathan, 1990).

Gauthier, Guy, *Vingt leçons (plus une) sur l'image et le sens*, enlarged edition (Paris: Edilig, 1989).

Michotte, André, 'Le Caractère de "réalité" des projections ciné-matographiques', in *Revue internationale de filmologie* nos. 3–4, 1948, pp. 249–61.

Münsterberg, Hugo, *The Photoplay: A Psychological Study*, reprinted as *The Film: A Psychological Study* [1916] (New York: Dover, 1970).

Roche, Denis, *La Disparition des lucioles (Réflexions sur l'acte photographique)* (Paris: Ed. de l'Etoile, 1982).

———, *Conversation avec le temps* (Paris: Le Castor Astral, 1985).

Schaeffer, Jean-Marie, *L'Image précaire* (Paris: Le Seuil, 1987).

Tsivian, Yuri, 'Notes historiques en marge de l'expérience de Koulechov', in *Iris* no. 6, 1986, pp. 49–59.

———, *Early Cinema in Russia and its Cultural Reception* [1991] (London: Routledge, 1994).

Vanlier, Henri, 'Philosophie de la photographie', special issue of *Cahiers de la photographie*, 1983.

Wollen, Peter, *Readings and Writings* (London: Verso, 1982).

Apparatus, Technology and Ideology

Althusser, Louis, 'Ideology and Ideological State Apparatuses' [1969], in *Lenin and Philosophy and Other Essays* (London: New Left Books, 1971), pp. 121–773.

Aumont, Jacques, et al., *Aesthetics of Film* [1983], trans. Richard Neupert (Austin, TX: University of Texas Press, 1992).

Aumont, Jacques, and Marie Michel, *L'Analyse des films* (Paris: Nathan, 1989).

Baudry, Jean-Louis, *L'Effet cinéma* (Paris: Albatros, 1978); 'Ideological Effects of the Basic Cinematographic Apparatus' [1970], reprinted in Bill Nichols (ed.), *Movies and Methods*, vol. 2 (Berkeley, CA: University of California Press, 1985).

———, 'The Apparatus: Metapsychological Approaches to the Impression of Reality in Cinema' [1975], in *Camera Obscura* no. 1, 1976, and in Phil Rosen (ed.), *Narrative, Apparatus, Ideology* (New York: Columbia University Press, 1986).

———, 'Author and Analyzable Subject', in Theresa Hak Kyung Cha (ed.), *Apparatus: Cinematographic Apparatus. Selected Writings* (New York: Tanam Press, 1980).

Baxandall, Michael, *Painting and Experience in Fifteenth-century Italy: A Primer in the Social History of Pictorial Style* (Oxford: Oxford University Press,1972).

Bazin, André, 'Ontology of the Photographic Image' [1945], in *What Is Cinema?* (Berkeley, CA: University of California Press, 1967).

Bellour, Raymond, and Anne Marie Duguet (eds), *Video*, special issue of *Communications* no. 48, 1988.

Bonitzer, Pascal, *Le Regard et la voix* (Paris: U.G.E., Collection 10/18, 1977).

Bourdieu, Pierre, *Un art moyen: Essai sur les usages sociaux de la photographie* (Paris: Ed. de Minuit, 1966).

Castelnuovo, Enrico, 'L'Histoire sociale de l'art: Un bilan provisoire', *Actes de la recherche en sciences sociales* no. 6, 1976, pp. 63–75.

Clarke, Timothy J., *Image of the People* (London: Thames and Hudson, 1973).

———, *The Absolute Bourgeois* (London: Thames and Hudson, 1973).

Comolli, Jean-Louis, 'Technique and Ideology' [1969], in *Screen* vol. 12 no. 1; reprinted in Bill Nichols (ed.), *Movies and Methods*, vol. 1 (Berkeley, CA: University of California Press 1976).

Dhote, Alain (ed), 'Cinéma et psychanalyse', *CinémAction* no. 50 (Paris: Collet, 1989).

Francastel, Pierre, *Peinture et société* [1950] (Paris: Gallimard, 1965).

Fried, Michael, *Absorption and Theatricality: Painting and Beholder in the Age of Diderot* (Berkeley, CA: University of California Press, 1980).

Galassi, Peter, *Before Photography: Painting and the Invention of Photography* (New York: Museum of Modern Art, 1981).

Green, André, 'L'Ecran bi-face, un oeil derrière la tête', *Psychanalyse et cinéma* no. 1, 1970, pp. 15–22.

Hauser, Arnold, *The Social History of Art* [1938] (New York: Arnold A. Knopf, 1951).

Heath, Stephen, *Questions of Cinema* (London: Macmillan, 1981).

Klingender, Francis, *Art and Industrial Revolution* [1947], revised edition (New York: Adams and Dart, 1968).

Kracauer, Siegfried, *Theory of Film* (Oxford: Oxford University Press, 1960).

Kristeva, Julia, *Desire in Language: A Semiotic Approach to Literature and Art* (New York: Columbia University Press, 1980).

———, *Revolution in Poetic Language* [1974] (New York: Columbia University Press, 1984).

Lebel, Jean-Patrick, *Cinéma et idéologie* (Paris: Ed. Sociales, 1970).

Metz, Christian, *Psychoanalysis and Cinema: The Imaginary Signifier* [1973–6] (London: Macmillan, 1982).

Moholy-Nagy, Laszlo, *Malerei, Fotografie, Film* (Dessay: Bauhaus-Bücher, 1925).

Oudart, Jean-Pierre, 'Notes pour une théorie de la représentation', *Cahiers du cinéma* no. 229, 1971, pp. 43–5.

Panofsky, Erwin, 'Die Perspektive als "Symbolischen Form"', in *Vorträge der Bibliothek Warburg*, vol. 4 (1924–5), pp. 258–331.

Thibaudeau, Jean, 'Economique, idéologique, formel', in *Cinéthique* no. 3, n.d. [1969], pp. 8–14.

Salt, Barry, *Film Style and Technology: History and Analysis* (London: Starword, 1983).

Sorlin, Pierre, *Sociologie et cinéma* (Paris: Aubier-Montaigne, 1977).

Thévoz, Michel, *L'Académisme et ses fantasmes* (Paris: Ed. de Minuit, 1980).

Willemen, Paul, 'Cinematic Discourse: The Problem of Inner Speech' [1975–81], in *Looks and Frictions* (London: BFI, 1994), pp. 27–55.

Chapter Four

The Role of the Image

Images exist only to be seen by a historically defined viewer, that is to say, by a viewer who deploys particular frameworks to process them. Even the most random of images created by machines, such as those taken by surveillance cameras, are created intentionally, with specific social aims in mind. The question does indeed arise whether, in all this, there is something specific about the image. Or is each stage of its existence – creation, production, reception – merely the outcome of one single intentional action, be it social, communicative, expressive, artistic or whatever?

Strictly speaking, the role of the image could indeed be entirely accounted for by one or other of the forces of social history. For convenience's sake we will, perhaps a little artificially, consider the role of the image in isolation, allowing us to summarise a number of theories of representation which have treated the image itself as endowed with immanent values.

For this chapter then, we will yield to the temptation of personifying the image, making it the source of a process, an impact, of meanings. But we will limit ourselves to only one key value of the image: its representational value, its relationship to perceptible reality. We will leave to the last chapter those expressive functions one might consider even more intrinsic to the image and which have been the focus of aesthetics and art theory.

I. Analogy

The notion of *analogy*, the problem of the similarity between image and reality, has been discussed in Chapter 1, §II.1, Chapter 2, §§I.1 and II.2, from the point of view of the spectator. There, the question was: how can we see in an image something which evokes an imaginary world? We will return to this question to stress the role of the image itself, or rather the relationship between the image and the reality it supposedly represents. In other words, we will approach representation not so much as the end-product to be evaluated by a viewer, but more as a process, a production, to be achieved by a creator.

I.1 The Limits of Analogy

I.1.1 Analogy: Convention or Reality?

Our deeply ingrained habit of looking mostly at strongly analogical images often detracts from our understanding of analogy as a phenomenon. We unconsciously refer our assessment of analogy to an ideal or absolute, that is to say, to a perfect resemblance between an image and its real-life model. This point of view, of ancient pedigree in theories of representation, can be found in a primitive form in any television viewer who mistakes what he or she sees for documentary reality; it is in every amateur photographer who mistakes his or her snapshots for slices of reality, and so on. Even the hundred-year-old upheavals in the artistic representation of reality have not yet been able to dislodge this way of thinking. Cubism, for example, although accepted by the public at large as a well-established artistic style, is still thought of as a *distorted* way of representing the world. It deviates from what is still considered to be the analogical norm embodied – more or less – in photography.

So let us begin by contextualising this absolutist notion of analogy without giving up on the concept altogether, as some theorists have done. This is the case, for instance, with E. H. Gombrich's outstanding and subtle *Art and Illusion* (1959). His main thesis is double. First, all forms of representation are bound by convention, even the most analogical ones. Even in photography, for example, one can alter optical settings such as lenses, light filters, and so on, or the chemical variants such as types of film stock. Secondly, despite this, some conventions – those which play with the properties of our visual system – are more natural than others: perspective, in particular. In other words, for Gombrich, the image's analogical role (or iconic[1] analogy in general) always has a double aspect:

- as *mirror* – analogy copies some parts of visual reality, and the technique of figurative imagery may even be an imitation of the kind of image we perceive in nature, for instance on a lake, through a window or on polished metal;
- as *map* – the imitation of nature is mediated through several cultural conventions, which are like mental maps linked to universals which aim to clarify representation through simplification, such as customs, artistic conventions arising from and fixed by tradition, and so on.

According to Gombrich (using these same terms in his 1974 essay 'Mirror and Map'), there is always some sort of map in the mirror; only in nature are mirrors purely mirrors. In contrast, when human beings wilfully imitate nature, a desire to create is always implied concomitant with the desire to reproduce (and often preceding it).[2] This imitation always has to pass through the relatively autonomous vocabulary of painting (and later of photography and cinema). This explains, for example, why 'the world never looks exactly like a painting, but a painting can look like the world'. In a painting this apparent similarity is

149

modelled upon and modulated by schemas which aim to make the viewer understand. Art is thus 'that which teaches us to see'.

Let us now turn to the theories which have stressed, rather unilaterally, either the mirror approach (mimesis) or the map approach (reference).

I.1.2 Analogy and Mimesis

Greek philosophers used the word *mimesis*, meaning imitation, in two somewhat different contexts:

- In the context of narrative, Plato in particular used it to refer to a kind of oral storytelling in which the narrator imitates the characters by mimicking their voices or their inner thoughts (*see* §IV.1.1 below);
- In the context of representation, especially for Aristotle and Philostratus, mimesis denotes the imitation of figures, which is the meaning we are interested in here.

 Mimesis is not a bad synonym for analogy. In our context, it denotes the ideal of 'perfect' resemblance between an image and its subject. If this is stretching the meaning of the word somewhat, so be it. Most theories of perfect resemblance assume that analogic images can induce a suspension of disbelief, partly because images are also diegetic in the contemporary sense, that is to say, thoroughly imbued with fiction. The most absolute embodiment of this view is André Bazin's essay 'The Ontology of the Photographic Image' (1945). His main points are:
- The history of art is that of a conflict between the need for illusion (reproducing the *world*) which is a survival of magical thinking, versus the need for expression (which Bazin understands as a 'concrete and essential' expression of the world). These two needs were not in conflict in pre-Renaissance art, but the invention of perspective, 'the original sin of Western painting', has pulled them apart by over-emphasising illusion;
- Photography has freed painting from mimesis insofar as it satisfies our hunger for illusion; the photograph is essentially, that is to say, *ontologically* objective, and thus more believable than painting. Photographs have 'an irrational power which sweeps our faith along with it'.

Bazin's thesis is remarkable in its consistency: if the photographic image is believable, it is because it is perfectly objective, but we only judge it to be so because of an art-ideology which assigns photography the function of representing and ultimately expressing the real and nothing else. Bazin allows that there is something of a map in the mirror: the objective neutrality of a geographical map. It can tell us about the terrain, but not about the map-maker. The closure of the theory is that Bazin reckons that if it is the real – and only the real – which

150

one can represent and express, it is because the real has meaning. This meaning is of necessity divine (since only God can give reality a meaning) and therefore hidden. What matters is to express what the real signifies. Although attainable, illusion is only a minor goal.

This is not the place for a detailed critique of Bazin's essay. It is marked by its philosophical context, in which he indirectly cites Sartre, Malraux and Teilhard de Chardin. The key concept is in its title: a photographic image has the essential quality of 'a true hallucination', it 'embalms' and 'reveals' reality in all its aspects, including its transience. As the embodiment of perfect resemblance, it is able to satisfy the need for illusion which is at the root of our desire for analogy.

I.1.3 Analogy and Reference

If Bazin reckons that the desire to achieve a perfect analogy answers a basic, timeless human need, other theorists have argued, on the contrary, that this desire is just an accident in the history of human production. In this view, analogy, which can never be perfect anyway, is just one modality among many in that larger process we can call *reference*. This term was elaborated in Nelson Goodman's *Languages of Art* (1968 and 1976), which aims to lay the foundations of 'a general theory of symbols', encompassing all means of human communication, including the alphabet, words, texts, pictures, diagrams, maps, models, and so on, as well as those 'symbolic systems' called languages.

In this project, which is carried out in the very abstract manner of Anglo-Saxon analytic philosophy, the problems of analogy and even of representation do not have a very high priority. They are discussed only because of the difficulties they present. For Goodman, the idea of imitation is almost irrelevant: one cannot copy the world 'as it is' because one does not know *how* it is. Imitation can only be described as copying one aspect of the world as normally or plainly as possible, as seen through an innocent eye. But neither an absolute standard of normality nor a completely innocent eye can exist: vision is always coupled with interpretation, even in everyday life. As we copy, we are making up the world.

Goodman's theory thus includes analogy as a subset, a particular type, of the semantic process of reference.

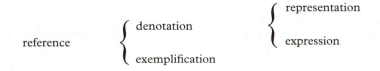

For him, there are two types of reference, exemplification and denotation, the latter having two modalities, expression and representation. In Goodman's terms, every step of the symbolic process involves the production of exchangeable artifacts within a society, which thus allows

references to be made to that society according to certain conventions. Denotation differs from exemplification in that the latter takes place when the referent is present, the former when it is absent. Goodman defines denotation as 'symbolizing without having'. The distinction between representation and expression lies in the type of referent. For representation, the referent is concrete, for expression it is abstract: one represents concrete objects, one expresses abstract values of objects.

In this view, analogy or resemblance is a secondary phenomenon which does not create a specific type of reference. It may occur in each category of reference, and if it has historically been associated with representation, that is mere coincidence. Goodman discusses resemblance at length (even though he doubts it could be achieved) as being neither a necessary nor a sufficient condition for representation. In logical terms, there is no link between resemblance and representation. Goodman's book largely bypasses the question of analogy. He studies types of images, such as 'collective' images (those which represent classes of objects rather than individual members of a class), 'fictive' images (those which have no real-world referent, such as a unicorn) and those he calls 'representations' (that is to say, something or someone depicted as something else, like a caricature of Mr Pickwick as Don Quixote). In all cases, analogy is present, but only in order to contrast two facets of the image: the denoted object on which it is modelled, and the denoted abstract quality which belongs to the referential process as a whole.

I.2 Indices and Degrees of Analogy

I.2.1 Analogy as Construction
Approaches as incompatible as Bazin's and Goodman's cannot easily be synthesised. However, we may conclude that:

- analogy has an empirical reality; it is discovered through perception; this discovery is said to produce the desire to create analogical representations;
- throughout history, analogy has been created artificially by different means, enabling closer and closer approximations of a 'perfect' resemblance;
- analogy has always been produced to be used in symbolic systems, which means that it is linked to language.

Analogical images have thus always been constructions, mixing in different proportions similarity to the natural world and the production of socially communicated signs. There are *degrees of analogy* corresponding to degrees of similarity, but analogy is present in any representational image.

That we are dealing with degrees is easily demonstrated by looking at images which have the same referent, but which have been produced in different social and historical circumstances. Even a tree can be represented in an almost infinite number of ways, based on a roughly

Figure 27 Degrees of analogy: three ways of seeing horses. The Horsemen of the Apocalypse, *an eleventh-century miniature;* King Philip II *by P. P. Rubens (17th century); and* The Derby at Epsom *by Géricault (1821).*

universal schema (distinguishing between trunk and boughs, between branches and foliage). Another revealing example can be found in the conventions adopted in different styles of art. Scenes such as the Annunciation, widely represented in European painting from the 12th century to the 17th, retain the same conventions for the most important elements (such as the red bed-canopy signifying the blood of childbirth, lilies and glass vessels referring to the purity of the Virgin, and so on). However, the depiction of the whole scene follows the dominant period-style, more naturalistic in the 15th century, more theatrical with use of chiaroscuro in the 17th century, and so on.

I.2.2 Indices of Analogy

For a long time, analogy was considered an all-or-nothing process. An image was either analogical or it was not. If it was, its meaning was exhausted, so to speak, by its resemblance to reality. It is against this idea (Christian Metz called it 'iconic purism') that most recent theorists of imagery have reacted. The semiological line of inquiry in particular, as developed in Europe during the 60s by Roland Barthes, Umberto Eco and Christian Metz, has done much to break with this concept of the image-as-analogy. Metz proposed the notion of degrees of analogy in his essay 'Au-delà de l'analogie: L'Image', which reads like a manifesto. He stressed the fact that the image certainly has elements of analogy, but it is not only analogical. Indeed, analogy may serve merely to convey a message which itself need be neither analogical nor even visual (such as an advertising, religious or narrative message). Around the same time, an article on photography by Barthes (1964), which begins with a study of an advertisement for a brand of pasta, took a similar position: there is no such thing as a naive image, one which innocently represents objective reality. On the contrary, any image conveys numerous connotations derived from social codes which are themselves subject to ideologies.

Metz went on to propose that *analogy itself is coded*. In other words, analogy is culturally determined through and through. Somewhat carried away by this insight, he even suggested that our visual system itself is culturally coded, falling into the pitfalls inherent in any approach that takes the image to have an immanent meaning, because, if our way of seeing is coded, it could not be coded in the same way that the connotations of images are coded. Metz's main point is to stress that any image, however perfectly analogical it seems, is *used* and *understood* by means of social conventions which always rely, in the last instance, on language (one of the basic postulates of semio-linguistics).

Barthes does not seem to share Metz's absolutist view of coding. For Barthes, a photograph is 'a message without a code'. There are no rules of analogy in photography because it has shown no historically variable codes. On the contrary, Barthes insists on the natural quality of photography as a recording, as a trace. Photography is a kind of evidence, it has a mechanical, 'objective' quality. The resulting believability of the photographic image creates a sense of things 'having-been-there'

(*l'avoir-été-là des choses*). This position might be somewhat extreme, since Barthes takes the side of photography against painting, where analogical coding is much more apparent. If a photograph is a kind of trace, an imprint of some sort, then this trace can be modulated, one may intervene in a 'coded' manner at various stages in its production process: the framing, the choice of focal length, lens, and aperture, of development and printing techniques, and so on.

To mark the notion that analogy is constructed, used in terms of degrees of approximation and altered by convention, and to demarcate it from the verbal sign, the image can be called an indexical sign. Indices of analogy designate all aspects of the image which combine to create the whole. Two comments are in order. First, there is an obvious parallel between these indices of analogy and what we called indices of perception such as depth of field (*see* Chapter 1, §II.1). It is not by chance that from the point of view of perception, indices of depth of field are an important part of the analogical indices. Secondly, the key difference between perceptual and analogical indices, if the latter are to be seen (and thus become the former), is that analogical indices must first be produced and manufactured. The discussion of depth of field in Chapter 1 referred to all modes of visual perception, regardless of whether it relates to the perception of an image or not. Analogical indices are those which have been intentionally put into an image.

It is well-nigh impossible to list all such indices, given that all indices of perception have corresponding analogical counterparts. One would find all the spatial indices, from static ones like perspective, to dynamic ones like parallax in moving images, but one would also find indices which refer to light, colour, texture, and so on – all the categories which have been coded in history, particularly in painting.

All histories of art devote a chapter to the revolution in the depiction of space during the Renaissance (*see* §II below). But that period was also rich in other innovations in analogical indexing. For example, Dürer's watercolours (of a bunch of violets, a tuft of grass, a rabbit) aim less at rendering depth of field than texture. He developed new conventions, both quantitative (thicker grass, more fur on the rabbit) and qualitative (more accurate colour, more lifelike depiction of lighting). However, lest one fall into the trap of assuming that there is a simple, linear historical 'progress' in these matters, we must not forget that this same artist at the same time produced his famous engravings of the rhinoceros perfectly 'unrealistically', faithfully reproducing visually the conventions of his age, particularly the legend that this creature was sheathed in reinforced plates like a suit of armour.

I.3 Realism Once More

I.3.1 Realism and Accuracy
Having considered *realism* from the spectator's point of view in Chapter 2, §II.2.2, it is necessary to return to the topic here because, in the his-

155

Figure 28 Inverted perspective: in this early eleventh-century Nativity, *the Virgin's bed and the manger with the ox and the ass are depicted in inverted perspective (the side nearest us is smaller than the one which is further away).*

tory of Western art during the past few centuries, realism has tended to be confused with analogy. Even today, in everyday language, a realistic image is one which represents reality analogically, approaching the ideal of perfect analogy, the nearest to which is supposed to be photography. The first thing to be done is to distinguish between realism and analogy. A realistic image is not necessarily one which produces the illusion of reality (which in any case would be very unlikely, as we saw in Chapter 2). Nor is a realistic image the most analogical image possible. A realistic image is an *image that provides the maximum information about reality*. In other words, if analogy concerns the visual, the domain of appearances, and visible reality, realism concerns the information conveyed by the image, it conveys understanding and thinking. In Gombrich's terms, analogy is linked to mirroring, realism to mapping.

Nevertheless, the above definition is not quite adequate, it is in one way even easily refutable. One could give the same amount of information using totally different conventions of representation, some of which might be experienced as unrealistic. A simple example of this – inverted perspective – is given by Nelson Goodman (1969). This was a common convention of late-medieval illuminated manuscripts by which the perpendicular lines in the plane of the image are not drawn to converge in a vanishing point (*see* §II.1 below), but instead diverge.

If a cube were drawn in this perspective, it would be represented in a way that would show not the inside of its side faces, but the outside. The twentieth-century Western viewer has a complex reaction to this kind of representation: it appears unrealistic because it is so unlike the photographic perspective which dominates our way of seeing; at the same time we recognise it as an acceptable convention, since we are more or less familiar with art history. Cubism (among other movements) has familiarised us with this sort of reversal. It is clear that, if one accepts the convention of inverted perspective, it can convey the exact same spatial information as does a vanishing-point model. So, since the realism of an image is not directly in proportion to the amount of information it conveys, the definition of realism needs to be modified. A realistic image must convey the maximum *relevant* information, making it easily available. This ease of access is *relative*: it depends on the amount of stereotyping in the conventions used in comparison with the predominant convention of representation. If according to Goodman almost any image can represent almost anything, then realism is only the measure of the ratio between the currently dominant representational standard and the system of representation used in a given image.

I.3.2 Realism, Style and Ideology
Realism is necessarily a relative concept: there is neither pure realism, nor realism *per se*. We always have to state explicitly what *sort* of realism we are talking about. Anyway, as the word and the -ism suffix already suggest, realism is a tendency, an attitude, a concept, in short a particular definition of representation embodied in a *style* or school. Historians

and art critics have listed several realisms (that is, several schools of realism).[3] There are few similarities between the realism championed by Courbet in the mid-19th century and, for example, the 'Socialist Realism' which ruled in the USSR for several decades; the 'Neo-realism' of the Italian cinema in 1945, and what is sometimes labelled the 'realism' of seventeenth- and eighteenth-century Dutch painting.

These different realist styles are themselves a product of social demand, and of ideology in particular. For instance, Socialist Realism, which has been the object of the most explicit and crude theories, obeys a certain number of canonical conventions as to what can be represented (in painting: 'socialist' work scenes, groups of party leaders, conferences,

Figure 29 Socialist Realism in cinema and in painting.

military scenes), but also, and especially, as to the human body (expressive gestures, stereotypes, clothing, poses). Instructions to artists in many speeches by the Commissar Andrei Zhdanov in the 30s specified that these human figures should be 'more exemplary, closer to the socialist ideal' (see Gorky et al., 1977). That alone is a clear admission that realism has less to do with the real than with the ideal, with convention.

However, the notion of realism itself is not relevant to all standards of representation. In certain periods of art history, representation did not even aim at realism and was not interested in representing the real world. There is the well-known example of ancient Egyptian art with its representations of the 'next' world. In more general terms, the same is true of all sacred art, from ancient Greece to Oceania, Africa, and elsewhere. André Malraux described sacred art as the art of the gods, anonymous, situated entirely in the realm of the sacred, of the occult. In the final analysis, it is the very notion of the real which is ideological, and the fact that we have lived with it for several hundreds of years does not make it universal. Realism can only exist in cultures which have a concept of the real and which regard this as important. As for modern forms of realism, let us say since the Renaissance, they are the result of an ideological link between what is real and what is apparent: this 'ideology of the visible' is what was at stake in the work of Jean-Louis Comolli discussed in Chapter 3, §III.2.

Nevertheless, it is worth noting that today the 'sacred' image has become far less common. No contemporary representational style totally escapes the ideology of realism (if not the ideology of the visible). In *Art and Illusion*, Gombrich does not hesitate to say that the only major change in the course of the entire history of art is the transition from primitive art, where an image is a substitute, a stand-in for something, like an idol, to illusion, in which the image refers to the visible. There is no need to go quite that far, since even the most thoroughly coded religious imagery (the stereotyped images of the Buddha, not to mention Christian icons, which supposedly are infused with a divine presence) is based on an at least partly realistic representation of what appears to the senses. Even if such images then go on to relegate such appearances to the realm of illusion, as is the case with the brahminical Hindus' Veil of Maya.

Michel Thévoz (1980) argues that this ideology of the visible in representation reached a high point in the academic painting of the 19th century, where we have both the apogee of the reign of the visible and its delusory rationalisation. This 'hegemony of the gaze', he added, is the result of a system of *generalised equivalences* based on general standards of value: gold in the economic sphere, monarchy in the political sphere, the phallus in the symbolic sphere. In the 19th century, the hegemony of the gaze is demonstrated concretely: experience is made visible; knowledge about the world places the world itself at a distance, replacing it with more and more abstract – and more and more mathematical – models, to the point where the concept of the real is reduced

to the describable. The distinguishing feature of the academic age is that this process of making visible produces negative, deceptive effects, as 'the effect of the real' becomes a neurotic substitute for, rather than an opening to, reality. The visible becomes a universalised trompe-l'oeil. To Thévoz, Academic Realism is a form of idealism.

Finally, let us remember that the drive to realism, although important within it, is not coextensive with Western art. There were also currents addressing the irrational, the non-real, the surreal or simply those which advocated a notion of art which would make realism obsolete. The late-nineteenth-century photographer Henry Peach Robinson felt so constricted by photography's enforced reproductive role that he claimed that the art of photography lies not in its accuracy; it only begins when accuracy has been achieved.

II. Represented Space

As noted in Chapter 1, §II.1, in the discussion of perception, space is a Kantian 'fundamental category of intuitive understanding' applied to our experience of the real world. From the point of view of perception, space is basic to visual perception and of 'haptic' perception (related to touch and bodily movement); it is this second aspect which gives us our 'sense of space'. Our sense of sight always reads space in terms of how the human body will move through it.

The representation of space in flat images (painting, photography, film) obviously can only reproduce some of the effects of movement in space, in particular those which concern *depth* (*see* Chapter 1, §III.2). Here we will always have to keep in mind that space is a much more complex category than its iconic representation.

II.1 Perspective

II.1.1 Geometric Perspective

Perspective is a geometric transformation which projects a three-dimensional space on to a two-dimensional one (a flat surface) according to certain rules so as to transmit reliable information about that projected space. Ideally, perspective projection should allow one to reconstitute projected volumes and their spatial arrangement in one's mind. The rules of this transformation may vary. In geometric terms, there are a great many different perspectival systems possible. In practice, two main systems have been used:

- centred perspectives, where parallel lines in a three-dimensional space become lines or curves which converge on a single point; the most important example is the vanishing-point perspective invented in the Renaissance under the name *perspectiva artificialis*; there are also advocates of curvilinear perspective.
- bird's-eye perspective, in which parallel lines remain parallel in the projection.

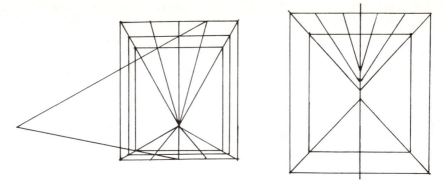

Figure 30 Perspective: on the left, a perspective with a central vanishing point; on the right, a fishbone perspective.

There are other systems, some of which have been used in the history of images. Examples are the so-called fishbone or vanishing-axis perspective in which lines perpendicular to the picture plane converge on an axis rather than on a point. Erwin Panofsky's book on perspective (1992) gives many examples of this in Roman and medieval painting, but this system is not as rigorous as the first two: the angle of convergence, particularly, is somewhat arbitrary, notably for those straight lines not perpendicular to the picture plane. So one might call it a pseudo- or a quasi-system.

II.1.2 Perspective as 'Symbolic Form'

Whichever system one chooses, the problems of perspective begin when one tries to use it. Some systems, such as the non-centred, true parallel axiometric projection used by architects and topographers, are meant to be used in a very formal manner. The systems used first in painting and later in photography are, of course, also formal and it does no harm to remember that one system could be substituted for another without the amount of information conveyed being substantially changed. Those systems which have been used have been so for reasons other than their simple capacity to convey information. Consciously or not, each system expresses a certain idea of the world and how it should be represented, that is to say, they express a certain concept of the visible.

In §I.3 above, we gave the example of so-called inverted perspective. Choosing such a system (or rather, such a pseudo-system) corresponds to the pre-eminence given to certain symbolic values over visual realism. According to Jean Wirth (1989), inverted perspective clearly *abolishes* space and distance, bringing the rear of the picture to the fore and depicting it on a larger scale than the foreground (consistent with the symbolically determined oversizing of figures in the background). In the same way, the non-centred parallel perspective of classical Japanese woodcuts (which has no vanishing point) corresponds to a refusal to make the near more important than the far, and so on.

161

In contrast, the system which has dominated our culture since the emergence of *perspectiva artificialis* in the 15th century has been an attempt to copy what is assumed to be the natural perspective at work in the human eye. However, this is not an innocent copy and it makes vision into the template for all forms of representation. Centred or photographic perspective is evidence that, even if we forget it most of the time, it is an ideological – or more loosely, a symbolic – choice which makes sight the measure of any and all representation. Panofsky (1924–5) said as much when he defined perspective as the 'symbolic form' of our relation to space. The notion of symbolic form (*see* Chapter 3, §III.3.3) comes from the German philosopher Ernest Cassirer (1953–7) and denotes those major intellectual and social constructs by means of which people relate to the world (for Cassirer, language is the symbolic form for verbal communication, artistic imagery for visual communication, myths – and later science – for understanding the natural world). Cassirer insisted on the relative autonomy of the symbolic sphere, which develops according to its own rules. For Panofsky, perspective was not just an arbitrary convention, rather each era has its own 'perspective', that is to say, a symbolic form for perceiving space geared to its particular concepts of the visible world. These different perspectives are not arbitrary, rather they correspond to the social, ideological and philosophical frames which engendered them. As for *perspectiva artificialis*, this was made possible (necessary) by the birth during the Renaissance of what he calls 'systematic space', mathematically ordered, infinite, homogeneous and isotropic, deriving from the spirit of exploration which was to lead to the great discoveries, but also linked to mathematical progress in other fields. The important thing is that this form of perspective appeared not in relation to an absolute visual reality, but as a way of plotting space in terms of a rational grid according to optical geometry. In other words, for Leon Battista Alberti and Filippo Brunelleschi, its inventors, perspective expresses *the way that God laid out the universe*. This form of perspective is thus a symbolic form because it fulfils a specific cultural need of the Renaissance, overdetermined politically (by republican government in Tuscany), scientifically (by the development of optics), technologically (by the invention of glazed windows, for example), stylistically, aesthetically and, of course, ideologically.

Obviously, this way of presenting Renaissance perspective as simply a product of an intellectual or cultural *Zeitgeist* is too sketchy – and does not do Panofsky justice. In his *Origins of Perspective* (1987), Hubert Damisch demonstrates that perspective, just like any other phenomenon, cannot be seen in terms of a history developing in a linear manner, from birth to death, but rather as a concatenation of many histories, through which it brings into play our perception of the world and our modes of thought. Alberti, Brunelleschi and others discovered, to put it anachronistically, that what is seen 'ecologically' in the 'visual world' cannot be reproduced geometrically without giving up the illusion of

depth of field. This discovery, which is of secondary importance in the Renaissance (since *perspectiva artificialis* sought to embody the look of God), allowed the system to be invested later with other symbolic values. For instance, as discussed in §II.3 below, perspective invaded the theatre, hierarchising the gazes of spectators around the king's gaze. In painting, centred perspective came more and more to 'represent' the proper human way of appropriating the visible.

II.1.3 The Perspective Debate

In its very construction, the perspectival image (here: images conforming to the laws of *perspectiva artificialis*) produces convergence on to one plane: straight lines at right angles to the picture plane converge on a *principal vanishing point* (this is sometimes also called the point of view). There is no better way to illustrate that perspective is a centred system, at the focus of which (automatically, in a sense) the human observer is located.

It is this issue of the location of the observer which has been at the heart of many twentieth-century debates on perspective. Around 1970 it was argued that perspective corresponded to the emergence of a 'centred subject' grounded in humanism (and entirely determined by this emergence). In Western art history there was a clash between making two positions. One put the human subject at the centre of the conceptual world, the other held to a perspective system which had been invented to account for the presence of God in the visible world (Alberti called the central line between the painter's eye and the main vanishing point, the 'divine ray'). This clash had productive effects, as did the notion of a human subject founded in humanism and developed by Descartes and his *cogito*, by Enlightenment philosophers and the Romantics. Thus, to a certain extent, the centralisation of representation and its assimilation into human perception became characteristic of painting *c.* 1800 and, later, of nascent photography.

Jean-Louis Comolli, Marcelin Pleynet and Jean-Louis Baudry (*see* Chapter 3, §III.2.3) argued that the camera, as a perspective-constructing machine, was a tool marked by the humanist and bourgeois ideologies that derive from perspective. Apart from the fact that the film camera as well as the still camera can distort perspective a great deal (with long or short focal lengths), it is worth remembering that there has been no such thing as one single bourgeois ideology that persisted, unique and unchanged, from the 15th century through to the 20th. What we do have in that period is a series of ideological formations and their manifestations. The view of history that tends to collapse all the different symbolic values ascribed to perspective (over several centuries) into one single ideology can hardly be called rigorous. Damisch (1987), who is very critical of these writers, notes that fifteenth-century humanism, whether Tuscan or any other variety, would not have accepted this so-called central perspective, any more than its corollary, the definition of the human subject as focal point.

On the other hand, the traditional academic position that held that centred perspective was the only legitimate scientific model has found new defenders against Panofsky's historical relativism. This academic position maintains that the scientific validity of this Renaissance invention is absolute and therefore timeless. Some of these theorists of perception fail to give due weight to the difference between our optic system and the way it is represented in images. They fail to notice that taking the eye as a model for vision is an ideology like any other, even though to us it seems more natural.

These debates should be related to the profound changes in representation we have witnessed in the 20th century. Pierre Francastel's *Peinture et société* (1950) showed that formal 'revolutions' inside painting were manifestations of a fundamental change in our visual sense and gave birth to a new concept of space. Marisa Dalai Emiliani (1974) has put it very well:

> The crisis of perspective in modern culture must be accounted for by new concepts of space introduced by non-Euclidean geometry and (in the scientific realm) by the theory of relativity. It also coincides with a crisis in the traditional mimetic function of art, now confronted by an idealist aesthetic which offers a new vision of art conceived as knowledge and language.

If these debates are the most visible part of recent thinking on perspective, they are also its most speculative part. We should also mention that at the same time there has been great progress in historical research in the Panofskyan tradition. For example, Miriam Schild Bunim (1940) has retraced the development of representations of space from early Christian art to the Renaissance, relating each 'stage' of development to its contemporary philosophical and mathematical theories, as well as to technological and cultural knowledge. John White (1957) has provided a detailed history not just of perspective until the Renaissance, but also of what he calls synthetic perspective, in other words, the curvilinear model, which is more empirical and less rigorous, and which is found in Fouquet, Uccello and even in some works by Leonardo da Vinci. Samuel Edgerton (1975) has related Renaissance perspective to social and historical factors such as developments in cartography. Michael Baxandall (1972) has related it to humanist rhetoric and mathematics, and so on. All these authors, and many more, agree that the invention of *perspectiva artificialis* is more like a *rediscovery*. It is less a breakthrough in geometric perfection than the endowment of that perfection with symbolic value – especially because Classical Greece and Rome knew it empirically without endowing it with such symbolic value. After these authors comes Damisch's book, integrating their work and summing up the complexity of current thinking on perspective. For Damisch (1987), *perspectiva artificialis* is certainly an invention worthy of its own history, as well as a history of its application in painting, but more importantly, it is the historical manifestation of a cluster of philosophical problems,

164

present since its invention and still current today: problems embedded in seeing and thinking.

II.2 Surface and Depth

II.2.1 Open and Closed Space

Neither perspective nor depth of field by themselves define space. First because space presents itself in an organised way to our visual and tactile senses; secondly because, even within the visual sense itself, the iconic representation of space mobilises factors other than perspective, particularly all the effects of light and colour.

Twentieth-century upheavals in pictorial representation have revealed, among other things, that the importance accorded to perspective has resulted in excessive attention being given to the perfection of the illusion of depth. Some theorists have reacted to what they see as the stifling predominance of geometry. In his *Peinture et société* (1950) and in essays in *La Réalité figurative* (1965), Pierre Francastel proposes to study the representation of space not just in terms of the visible point of view and geometry, but through a more complex inquiry based on Durkheim's concept of 'social space' and Piaget and Wallon's 'subjective genetic space'. For Francastel, the figuration of space is a synthesis of geometry and a society's myths: if Renaissance society gave pride of place to Euclidian geometry, modern painting would tend to reproduce a more 'topological' concept of space.

We have already, in our discussion of the viewer's fantasy (*see* Chapter 3, §I.1.2), encountered the idea that the representation of space could be more or less rationalised and represented visually. Francastel opposes purely visual art, which he says emerged in the Renaissance, to what he calls 'objective' art. The latter would be based on a realistic conception of the object (not on intellectual speculation about visual perception), including the evidence provided by other tactile senses. Objective art would define space 'polysensually and operationally' and 'practically and experimentally'. It can be found in medieval art, but also in Cubism, in Egyptian art and the drawings of children. It is an 'open space', unbounded, insofar as it is based on an idea of objects and the geometry of their proximity. Francastel contrasts this open space with the domination of 'closed space' during the last five centuries, in which the imagination is constrained by the frame of the image. The frame boundary of the perspectival cube concretely signifies the imposition of a geometrical grid on the real space of experience and objects.

Taking Francastel's line of inquiry further, Jean-François Lyotard's *Discours Figure* (1970) also stressed the negative quality of perspective. For him, sensory space is organised around *difference* rather than *opposition*: but the history of painting is a constant repression of difference to the benefit of a rationalist geometry. As evidence, Lyotard points to those positive occasions in history when reality is not seen through this geometric eye, but rather allows itself to be seen 'as one sees scenery

before really looking', as in the works of Cézanne, but also in Masaccio's Brancacci Chapel frescoes.

Lyotard's book defends a specifically figurative aesthetic in that the figure is linked to the birth of desire in representation (*see* §IV.2.3 below). His aesthetic is strongly influenced by the Freudian Marxism so fashionable in the 70s, and he went on to try to elaborate a theory of 'libidinal economy'. His reading of perspective as a form of repression is fascinating but incomplete. We will retain the simpler thesis that choosing any given system of perspective bears witness to a choice of symbolic system. Likewise, the closure of figurative space bears witness to the limiting of all that is visible by a single point of view, or gaze. We can call this limited view a field of vision, which also bears symbolic witness to the privilege accorded to a particular act of looking (as against the more passive 'seeing' which Lyotard praises, following Merleau-Ponty).

The word 'field', in this sense, comes from cinematography: it means that piece of a three-dimensional, imaginary space which is perceived in a film image. We know that this concept is empirically linked to the strong sensation of reality which the cinema produces, and which allows us to believe that the field is a deep space. It also allows us to believe that this space, the visible space, does not stop at the edge of the screen but extends indefinitely *off-screen*, beyond the visible field. The famous metaphor of the frame as 'a window on to the world' used by Bazin to describe the cinematic image was already used by Alberti to describe painting in perspective. As perspective imposes a centre on space, it also gives it boundaries. It organises space as a field seen by an act of looking, a gaze – just like a *veduta* (a 'view'; the name given to the earliest landscape paintings as well as some of the very first films projected in fairgrounds).

II.2.2 Field and Frame

This definition of the 'field', a notion created for and by the cinematic arts and then extended to all figurative images, extends our earlier comments about the apparatus and its spatial dimensions, defining the frame as an effect of the painter's imaginary visual pyramid (*see* Chapter 3, §I.3.2). The frame produces the field. This illustrates how hard it is to separate the role of the image from that of the apparatus and that of the viewer. If the figurative image provides a visual field, it is because we can see it in terms of a process of decoupage, a segmenting of space by a mobile gaze deploying a perspectival frame.

This process has become familiar in the cinema, where framing is essentially a matter of camera movement. The mobility of the camera goes back to the cinema's earliest days. First, cameras were placed on a moving object (a boat, a car); later, when equipment became lighter, cameras became portable. Since then, the industry has invented many pieces of equipment which have made mobility ever easier and more finely calculable, such as the dolly, the crane and, more recently, the steadycam or louma. So both the makers and the viewers of films

have been exploring the range of possible camera movement for a long time.

Newer types of equipment allow movement of great scope and fluidity. At the same time, they tend to underline the equation between the frame and the act of looking. This is particularly the case with the steadycam, which is worn on a harness by the cameraman and is designed to give the impression of the human eye in motion. In earlier times, when equipment was less sophisticated, camera movement was sometimes used to mimic the movement of the human eye, as in several European films of the 20s and soon afterwards in Hollywood. Fernand Léger, in *Ballet méchanique* (1924), attached a camera to a pendulum swinging to and from an object, so that the camera's movement could not possibly represent any diegetic eye. In some German films of the same period, this taste for camera movement gave birth to what was called the *'entfesselte Kamera'*, the unchained camera, as in a scene in Murnau's *Der letzte Mann* (1924) where a character's drunkenness is expressed by the camera spinning around him, and in several scenes of a film which explicitly played with this 'unchaining', Ewald-André Dupont's *Variété* (1925). Edward Branigan (1984) uses such examples to distinguish between, on the one hand, 'functional' camera movements, which build scenographic space, follow or precede a movement or a look, pick out a significant detail, or reveal a character trait, and other camera movements which he calls 'gratuitous'. The distinction may be useful for film analysis, but its theoretical merit is questionable.

Although camera movement has come a long way technologically speaking, the fact that there is still no coherent theory of it reveals the complex relationship between image, viewer and apparatus. The viewer of the finished film has no way of really knowing the movement of the camera which produces a particular shot. The viewer reconstructs it in an imaginative and haphazard way, but cannot avoid doing so since the movement of the frame in relation to the field is almost automatically referenced to and mediated by the imagination's visual pyramid. Some recent theorists have tried to define camera movement more rigorously, relying exclusively on what is seen on the screen. David Bordwell (1977) suggests such a model to create a description inspired by constructivist theories of perception. This attempt is interesting but unconvincing, since even if one could describe the movement of light-traces on the screen, we still would have to *ascribe* the movement to *something*: the viewer needs to know whether it is the camera or the filmed object which has moved. Even if on occasion any relative movement of the frame is difficult to decipher, this assigning process is a normal part of interpreting the filmed image.

This ambiguity of movement has frequently been addressed by film theorists. Jean Mitry discussed camera movement at length in cases where interpretation is unclear. A common shot in Westerns is one in which a driver and his sidekick are shown riding on a moving stage-

167

coach. Should this be considered a fixed shot of the two characters? As a tracking shot in relation to the background? Or neither? It does not make it any easier to reply that the shot can be filmed in a variety of technical ways: putting a camera on a real stagecoach moving in a real landscape; placing a camera on a mobile platform moving at the same speed in front of it; or even shooting the scene on a sound-stage with a filmed background.

The term camera movement then, is a term of convenience, too imprecise for a theoretical vocabulary. We have discussed it here because it shows unmistakably both the difference between field and frame, and also the strong, apparatus-induced link between the field and the frame in the viewer's imagination.

II.2.3 Depth of Field

The field is a deep space represented on a flat surface. In the process it is inevitably altered, since one cannot represent the roving, 'ecological' eye in terms of one single point of view. Among the tricks this alteration implies is one so common it goes unnoticed: the image is uniformly clear, while in the real world the eye only takes in clearly a smaller focal area, the outer area being more blurred (*see* Chapter 1, §III.2). This convention of clarity is found in almost all painting, with only a few exceptions (such as the soft-focus 'atmospheric perspective' in the background of landscapes). Impressionism reacted against this convention by intentionally cultivating blurriness. But this blurriness has been omnipresent in photography as an effect of the lens's so-called focal length, or depth (as in 'deep focus').

Film theory has influenced this discussion in a particular way by linking depth of field with realism. Bazin's article 'The Evolution of the Language of Cinema' (*c.* 1950) claimed that the use of deep focus in the works of Orson Welles and William Wyler, for example, produced a hyper-realism, a 'more-than-real' effect, because the viewer is freed to look at any part of the image, as in real life he or she is free to let the eye wander over any part of space. This view has been strongly opposed, notably by Jean-Louis Comolli, who denies that this resurgence of deep focus, which had also been prevalent in the early cinema, was pursued to promote realism. One could go further and separate completely the illusion of depth from the uniform clarity of the image. On the one hand, one can very well have one without the other (depth of field can be rendered through an out-of-focus background, and a clear image can be composed which gives no clear reading of depth) and, on the other hand, uniform clarity also makes a point of how the image fills the surface. In a photographic image, which need not be clearly focused, clarity is a consequence of a conscious, historically specific stylistic choice, which is surely not determined only by a wish for realism, but also, for example, by such factors as composition. It is worthwhile repeating the fact that deep focus is not the same as the depth of field.

168

II.3 From Field to Scene

II.3.1 Off-screen

The notion of the *field* we have been using here[4] only applies to certain types of historically defined images: those generated by the fantasy of the visual pyramid, be it fixed (as in Renaissance writings on perspective) or mobile (as is the case from the end of the 18th century, with the development of studies from nature). It owes its importance, then, only to the fact that, even today, this is by far the most widespread type of image. These are the kinds of images we will discuss here in our final comments on the representation of space.

It is cinema which has demonstrated most vividly the relationship between frame and field. Cinema has also shown that, if the field is a section of space cut out by an act of looking organised in terms of a point of view, it is of course only a section of that space – and therefore it is possible to move from the image (and the field it represents) to think of the global space out of which a given field has been cut. The familiar idea of the *off-screen* of course also has a cinematic origin. During shooting it was essential to know what the camera would see of the pro-filmic space and what it would not.

Because of the two-fold nature of its mobility (apparent movement and movement of the frame), the filmed image is able, at least potentially, to allow access to what is happening off-screen. That is the key concept in Bazin's 'Painting and Cinema' (1950) where he defines the filmed image as 'centrifugal' and its frame as a 'mobile mask' rather than a fixed, uncrossable limit. His observation has since been taken further by those examining the practical possibilities of moving from on-screen to off-screen. Nöel Burch's *Theory of Film Practice* (1969) has offered the most detailed typology of this kind, categorising six kinds of off-screen space according to their position in relation to the field (off-left, off-right, in front, and so on) and three main types of transition between them.

Bazin's essay compared filmed and painted images and suggested that while the off-screen was natural, even essential, to filmed images, it was all but forbidden in painting. However, the concept of off-screen can be usefully applied (retroactively, if you will) to all fixed images, regardless of whether they are painted or photographed. We discussed (*see* Chapter 3, §§I.2 and I.3) how 'decentred' or 'unframed' images produced by some painters and photographers can imply an awareness of what is happening outside the image, off-screen. If Dégas or Caillebotte so often cut off their subjects at the edge of the frame, they clearly intended that the viewer's imagination be extended beyond it.[5] Some authors have completely denied Bazin's suggestion. Jean Mitry (1963–5), for example, reckons that painting can reproduce the off-screen effect as easily as does cinema, especially if one looks at a canvas in the same physical context as one views a film, that is to say, in a darkened room.

Nevertheless, however usefully the notion of off-screen space can be

Figure 31 The 'off-screen' in cinema, J.-M. Straub and D. Huillet's Nicht versöhnt *(1965); and in painting, Caravaggio's* Abraham's Sacrifice *(c. 1600).*

applied to fixed images, there is still an important difference between fixed and moving images. In a still image, the off-screen is always unseen, it can only be imagined. In the motion picture, by contrast, it can be revealed at any time, either by moving the frame or by linking it to another image through editing (as in the cinema's shot–countershot sequences). This is what Noël Burch means when he distinguishes between the *concrete* off-screen (the temporarily off-screen which contains what we have already seen, and which we can therefore imagine as actual) and the *imaginary* off-screen (which includes everything we have not yet seen). Thus, 'localised' off-screen effects are more developed and more efficient in cinema. An actor looking out of frame is commonly used to invoke what lies off-screen, suggesting that someone or something is being looked at, whereas in painting such a look would invoke the viewer.

Jean Mitry's discussion of Bazin's article suggests that the cinematic use of off-screen space arises essentially from the fact that filmed images are never seen just one at a time. Therefore, he argues, a sequence of paintings, of multiple images, produces off-screen effects just as well as film does (he cites the example of the stations of the Cross, sequences of fourteen or so religious paintings which represent the Passion of Christ). His argument is only partly convincing, for this type of off-screen space is much less powerful and immediate than that seen in films.

II.3.2 *Stage and* mise en scène

If the notion of a cinematic off-screen recalls a moving visual pyramid (thus predating by far the history of cinema itself), it has its roots in another related activity, the theatre. In almost all its (Western) forms, the theatre has implied a bifurcated space: the playing field (or stage) where the actors play characters, and an area (off-stage) where they become actors again while waiting to resume their roles. This division between the physical spaces, as indeed the separation between the stage and the audience's space, came quite late (in France it was only in 1759 that on-stage seating reserved for honoured guests were at last removed). It took almost three hundred years, from the 16th to the 18th century, to produce the conventions, particularly those related to theatrical illusion, which in the 19th century came to be known as *théâtre à l'italienne*, theatre in the Italian style.

As for the representation of space, it is noteworthy that the great scenographers, particularly such Italians as Torelli, the Della Bellas and Servandoni, tried to reinforce theatrical illusion by using painterly conventions: one such was, of course, perspective, but also the convention of 'framing' the stage, often with a curtain materialising, as it were, that frame's surface. The huge machinery employed both in opera and the Baroque theatre was designed to make this frame 'move' from one tableau to the next.

It would be ridiculous to try to put the histories of painting, theatre and cinema all into the same bag. What we are trying to suggest here is

rather a convergence of these three histories between the Renaissance and the birth of cinema around one central concept: the scene (which in French denotes both stage and scene). The word is happily ambiguous. First it denotes both a real space, the stage, and by metonymy the space in the imagination where the action is played out. But it also came to designate a fragment of the drama which is played on the same set. Hence it came to designate a unit of the play, a scene, and then a unit of time. In its complex relation to the theatre, the traditions of which it inherited even while trying not to, cinema has taken on just about all these meanings, sometimes favouring one, then the other. As for painting, it has followed the history of theatre even more closely, since the idea of the scenic composition of space first emerged in the context of the invention of perspective. In the figurative arts, a scene in the sense of a stage is the archetype of the representation of space, embodying not only the notion of off-screen (in the wings, off-stage), but also the compromise between open and closed space which is common to all modern Western representational art. At the same time, it denotes that there is no representation of space without representation of action, without diegesis: it conveys, in painting and cinema just as much as in theatre, the very idea of dramatic unity which underpins representation.

Space is thus always represented as the space in which an *action* takes place, as the location of a *mise en scène* or production. In the theatre, the role of director (*metteur en scène*) came quite late, but is now regarded as just as creative and artistic as that of the author and the actors. In cinema, the equivalence between director and author of the work has been recognised since the famous *politique des auteurs* of the 50s. The increasing importance given to what used to be a technical job – arranging and managing the set – can only be explained in reference to a model of space as stage, the unitary nature of which suggests the concept of a single master-worker (the *metteur en scène*) as artist.

II.3.3 Scenography

The modern theatrical stage began as a space organised in perspective, and, like painting in perspective, it was first characterised by being centred. Jean-Jacques Roubine's *Histoire du théâtre en France*, talking about the manufacturing of illusion, quotes a text from 1699: 'Change seats as many times as you like at the opera; after trying them all you will have to admit that the best ones are right in the middle of the stalls.' Roubine concluded: 'This is because the honour of the full frontal perspective was to be given to the monarch, and to no one else.' Since the 18th century, the set-designer's art has been to reconcile this centred perspective with 'the multitude of ordinary sightlines dispersed throughout the auditorium'.

Similar problems beset Renaissance painting (first the subordination of representation to centred perspective and later the overcoming of this tyranny of the centre). The overt link between painting and theatre lies in *scenography*. As its etymology suggests, this technical term at first

denoted the art of painting (in perspective) stage decors in the Italian manner. Later it came to mean set design (placing objects on the stage) and then a way of representing place in general. Jean-Louis Schéfer's *Scènographie d'un tableau* (1970) goes against the historical grain to analyse a sixteenth-century painting as a theatrical staging event. He takes the notion of set design in its widest meaning, as representation of place, even including the relationship between characters and architecture. This approach was elaborated further by some film theorists (notably Alain Bergala (1980) and Pascal Bonitzer (1985)) who used the term scenography to refer to the spatial organisation of *mise en scène*, while reserving the term *mise en scène* itself to the more limited meaning of the direction of actors. These theoretical confusions are unfortunate, but one can at least note a high degree of kinship between theatrical staging and scenography on the one hand, and the *mise en scène* in painting on the other, both referring to the construction of a diegetic space obeying the dramatic unities.

The hybrid nature of cinematic space has long been recognised. Pierre Francastel (1965), for example, wrote a somewhat complex, even confusing essay on the topic. More recently, Eric Rohmer (1977) has tried to distinguish between three types of space in film:

- pictorial space, the cinematographic image as representation of a world;
- architectural space, denoting those parts of a natural or artificial world which are given an objective existence in pro-filmic space;
- filmic space, or 'that virtual space reconstituted in the (viewer's) mind with the fragmentary cues the film provides'.

Such distinctions (which match quite closely those between plastic space, pro-filmic space and diegetic space) are unfortunately harder to establish than it seems. As Rohmer's essay demonstrates, the distinction between architectural and 'filmic' space proves difficult to detect.

Scenography is the appropriation by theatre of painterly techniques for rendering space from a point of view using perspective. In film, which contains perspective from the outset, the rendering of space is a synthetic process in which scenography is constantly on the move and must be maintained in the continuity from one shot to the next. The whole history of painting's treatment of space (its decentring, its breaking open, its shattering) replicates the transition from classical theatre to cinema.

III. Represented Time

If space requires highly symbolic means of representation, what about time? All images occur in space, but only some have a temporal dimension as well. Images also always give (even if sometimes in an offhand way) information about the temporal nature of the events or situations they portray. This information has been coded and conventionalised in

ways too complex to discuss exhaustively here. Let us simply note the main ones at work in the history of the image.

III.1 The Notion of Moment

As we noted when discussing the viewer's perception of time, the most common apprehension of time is in terms of duration, however brief it may be. If one were to imagine shortening this duration to the limits of the perceivable, it would become, in a word which is difficult to define exactly though easy to grasp intuitively, a *moment*. Still images obviously had a privileged relation to the moment insofar as photography sought to capture such a single point – of no apparent duration – from the flux of time. A still image itself has no inherent temporal dimension.

III.1.1 The Pregnant Moment

With the appearance at the end of the Middle Ages of a largely naturalistic style, the majority of scenes depicted in painting came to refer to the real world; even religious scenes such as the Annunciation were depicted as if they had really happened, or rather as if they had been acted out by flesh-and-blood actors '*mises en scène*', put into a scene, on stage.

The impression steadily grew that a painting represented a frozen moment in an event that had really taken place – even if this event was itself only a representation in a theatrical style of something fantastic or surreal. The question arose, then, of the relation between the moment and the event. Just as techniques for the reproduction of reality advanced, painting found itself even more caught between two contradictory claims: showing *the entire event* to enhance its understanding versus showing only *one moment*, trying to be true to what could plausibly have been seen by a witness at a given moment. It was not until the 18th century that this dilemma received an adequate theoretical solution, which was that there was no contradiction between these two claims on painting. Both aspects could be expressed if the moment chosen was one which expressed the essence of the event. Gotthold Ephraim essing, in his treatise *Laocöon* (1760), called this the 'pregnant moment'.

The concept was highly useful in painting, especially since it had been practised well before it had been theoretically defined. It rests, however, on a barely tenable presupposition: there is no reason to suppose that any single moment of any real event encapsulates the significance of the entire event. As the invention of 'instantaneous' photography has proved, there are no isolable 'points' in time. Philosophers have often argued that if one supposes that one could extract a fractional moment in time so small that movement would effectively be frozen, it would make the idea of motion itself inexplicable. So, the pregnant moment is fully an aesthetic concept corresponding to no actual physiological reality. Showing an event by means of such a moment is only possible – even more so than Lessing realised – through a semantic coding of gestures and poses in the entire *mise en scène*. Concerning the paintings of the

Figure 32 The pregnant moment, or is it, in this case, the decisive moment?

Annunciation from the 15th century to the 16th, Michael Baxandall (1972) has shown that they choose a moment to represent the (fictional) event in question, but that the choice and the very definition of the moment are made in reference to a rhetorical code that traditionally distinguished five successive moments, said to correspond to the five states of the Virgin's soul. Some (Botticelli's, for example) are very dramatically rendered and seem to fix a single moment in the manner of photography, but they have nevertheless been made with reference to a meaning, determined by a *text*. It is highly improbable that flesh-and-blood models ever held these poses even for a few seconds.

III.1.2 The Ordinary Moment
This split between wanting to freeze a real moment and the requirements of meaning (which the pregnant moment doctrine sought to resolve) reappeared with a vengeance at the time of the invention of photography. Instant photographs from 1860 onwards finally allowed access to an authentic representation of a moment extracted from a real event. Photography's way of extracting an ordinary moment from the flux of time made it obvious that so-called 'ordinary', everyday moments fixed by painting had in fact been entirely manufactured.

What is at issue in this dyad – pregnant moment versus ordinary moment – is less the technological possibility of *freezing* the visible than an opposition between two aesthetics, two ideologies of the representation of time in a still image. A preference for the ordinary moment had

175

appeared even before the invention of photography in some styles of painting which affected to show that no particular moment had been specifically selected. Painters such as P. H. de Valenciennes, around 1780, specialised in rendering this impression by way of his small landscapes featuring aspects of the weather. In a pamphlet published in 1800 giving advice to painters, he stated that one should paint as quickly as possible to try, as it were, to keep up with time. It is an odd prefiguring of the snapshot. The same preference for weather effects (rain, thunder, clouds) can be found among many painters – Granet and Constable, for example. For all of them, the ordinary moment appealed to a wider taste for *authenticity*, which from the end of the 18th century acquired aesthetic value – minor at first, but increasingly important – to the detriment of the image's *meaning*.

The technically simple photographic process of freezing an ordinary moment did not solve the problem. On the contrary, the aesthetic of the pregnant moment – the meaningful moment – was in its turn pursued by art photography. One could easily catalogue a whole group of photographers characterised by such a preference for *expressive moments*: their work is made instantaneously – therefore *a priori* of ordinary moments – but it is also expressive, aiming to convey meaning, pregnancy. The art of these photographers (Cartier-Bresson, of course, but also Doisneau, Robert Frank and Kertesz) consisted of the way they captured this instant 'on the wing', as it were, knowing how to frame and shoot with confidence. Nevertheless, they did not capture fully the pregnant moment as understood by Lessing, and the meaning of their photographs remains more ambiguous than that of painted events; they even play on this ambiguity, often wittily.

III.1.3 The Movement-Image
If the movement-image deserves a mention here, it is because its invention upset notions of instantaneous representation in at least two ways:

- it allowed for the representation of an event's temporal dimension without having to resort to the somewhat arbitrary practice of conveying that time through one of its moments;
- by multiplying ordinary moments which, since filmed frames do fix instants (nowadays usually at about 1/50th of a second), are not determined by any particular semantic meaning, however unconscious.

A film, in the material sense of film stock, is a collection of still images, but its normal usage, that is, its projection, cancels out the stills (photograms), yielding one single, moving image. Cinema through its very apparatus denies the technique of instantaneousness, of the single representative moment. In cinema the moment exists only on the level of lived experience, embedded in an endless flux of moments (*see* Chapter 3, §II).

III.2 Synthesised Time

III.2.1 Montage and Collage

At root, the quest to represent an event by means of an image is utopian: apart from certain random images (taken by automatic cameras at regular intervals), the instant is always chosen in terms of a meaning to be conveyed. The instant is always fabricated. The doctrine of the pregnant moment, which insists that every part of the image has significance, demonstrates the manufactured, reconstituted, synthetic quality of the moment displayed – obtained through a more or less skilful collection of fragments from many different moments. This is the characteristic way of representing time in the painted image: in each important area of the canvas, one moment (the most favourable one) is highlighted. It then proceeds by way of a synthesis, a collage, a montage.

This synthesis is even more apparent in paintings which do not claim to capture a single instant, but aim instead to juxtapose many such moments within a single frame. The first works to do this at all systematically were those of Analytical Cubism (even if that was not Cubism's original goal). Following Cezanne's precept, the key principles of Cubism, as is well known, are that any natural form can be broken down into simple geometrical solids (cubes, spheres, and so on) and that the artist then presents multiple, different points of view of the subject within the same painting. This principle leads to the construction of a painting as an imaginary collage of fragments, each with its own spatial logic, and often its own temporal logic too.

Of course, it is cinema with its practice and theory of montage which first extended the concept of synthetic time to the moving image, later returning this theory of synthetic time to the still image in order to re-think its applications. This project was launched by S. M. Eisenstein in his treatise *Montage* (1937–40) and in several articles from the period 1938–46. Eisenstein analyses the portrait of the Russian actress Yermelova by Valentin Serov as a typical example of 'potential cinematography'. The portrait 'edits' together four different points of view on the central figure of the actress, represented visually by means of a multi-levelled '*mise en cadre*', that is to say, frames within the main frame which allow the viewer to define the different points of view. Each point of view corresponds to a different frame (to four different 'shots') and are thus incompatible. To make them co-exist within the same frame amounts to a major compositional *tour de force*. The juxtapositions deploy the same principle as cinematic montage – which for Eisenstein is a question more of *accumulation* than of a *sequence*. In one section of *Montage*, Eisenstein analyses in a similar way Daumier's engraving *Ratapoil offrant le bras à la République*, but in order to address more directly the montage of time: Ratapoil's body is anatomised limb by limb to show how its different parts represent successive moments of the same overall gesture.

Eisenstein's analyses seem at times somewhat forced. Their meaning

177

requires that one accepts his hypothesis that the history of representation includes and transcends both painting and cinema, that there are general, timeless iconic principles which apply to all types of image. Eisenstein is more coherent when he argues that general iconic principles underlie his complex and abstract theory of montage. For him, montage is a universal phenomenon (present in poetry as much as film or the plastic arts) resting in the last instance on a transfer of the nature of the human soul through analysis and synthesis. Eisenstein is a major exponent of the thesis that the image is understandable because it formally 'resembles' the viewer's psyche (*see* Chapter 2, §I.3).

This theory of cinematic montage has the drawback of conceiving montage exclusively as an expressive and semantic process, playing down its perceptual and representational aspects. As applied to the cinema, it led its author to relaunch, in a slightly different form, the quest for an 'intellectual cinema' in which montage would be entirely determined by the quest for meaning, almost as a word-game, a rebus or a charade. He overlooked at times the fact that film has not just meaning but *duration* as well. Ironically, Eisenstein's theory of montage could be applied more successfully to still images. Even without adhering strictly to Eisenstein's rules, many paintings of events reveal juxtapositions, invisible collages of distinctly different moments from the same event.

In our example of Annunciation paintings, the Virgin's pose does not in most instances coincide in time with that of the angel, leaving aside countless cases where the Virgin is depicted by a montage of hands, torso and head which are not strictly contemporaneous with each other. One of Einstein's favourite examples is Watteau's *Embarquement pour Cythère*, which, following a comment by Auguste Rodin, he reads as a cinematic sequence showing several successive stages in a generic love story: the couple sitting on the grass, getting up, then moving to the boat.

Temporal collage would thus appear to be the most common way of showing the passage of time in painting, even when it claims to portray a single moment, since the pregnant moment almost always amounts to a montage. But one can go further and ask whether photography itself (when a pose is extended, even if ever so briefly) does not function in the same way. The play of light on a photosensitive surface occurs throughout the time when the shutter is open. As soon as the shutter is open, let us say for a tenth of a second, photographic film shows traces of small changes: these include small movements, of course, but also continuous changes in light conditions. These do not appear as clearly as the collages and montages we were discussing above, since they come from a single flow of time, a single sitting. Yet, in a sense, such an image has acquired a temporal dimension by *unfolding time* spatially (*see* Chapter 3, §III.2.2). A general theory of how the image synthesises time might be stated thus: certain spatial points in the image correspond to certain points in time of the event shown.

III.2.2 Sequence and Interval

Beyond its *cumulative* aspect, cinematic montage has drawn attention to another type of temporal relationship in the still or moving, but in any case *multiple*, image. This is the concept of a *jump* between successive shots. What interests us here is not what unites two shots, but their interaction, in other words, the way they are separated, the *interval* between them.

In musicology, an interval is the distance between two notes measured in relation to their frequencies. Even a relatively untrained ear can appreciate such distances. Music concretely and positively plays on such intervals which, in themselves, are merely abstract relationships. This led Russian film-maker Dziga Vertov to adopt, metaphorically, the term 'interval' to denote the gap between any two filmed images. Naturally, this kind of gap cannot be measured. Nevertheless, Vertov suggested that it become the basis for a deliberately non-narrative, even non-fictional type of cinema. Meaning and emotion would be evoked by combinations of abstract relations between forms, lengths of time, and framing. Vertov barely outlined how such a 'theory of intervals' would work, but comparing his films with his writings makes it clear that he wished to stretch the metaphor a long way: he wanted to apply the concept of the interval not only to sequences of shots (corresponding to 'melodic' intervals in music) but also to simultaneous images ('harmonic' intervals) as in the famous superimposed images of *Man with a Movie Camera* (1929).

To its cinematic inventor, the interval is not something which takes place in time: the interval between two shots can even be completely achronological. But the idea can be usefully extended to the representation of time to denote all those cases in which two images, whether located in time or not, are separated by a hiatus, a sudden shift from one time frame to another, and where no continuity can be established. Cinematic examples are countless and are known in English as a 'jump-cut' (defined as a change of shot in which the point of view is maintained while a temporal ellipsis is produced). David Bordwell (1984) showed that the jump-cut is a stylistic device. How it is used in one film can be related to the historical norms in force. For example, in Jean-Luc Godard's *A bout de souffle* (1959), they are made to be visible, conforming to what Bordwell terms art cinema, whereas in the films of Georges Méliès they are, if not made invisible, at least obscured to create a dreamlike effect. Similarly, the jump-cuts in Pudovkin's silent films go unnoticed since they occur in the context of an overall montage strategy which operates by way of short and discontinuous pieces.

A jump-cut is thus rather like the perceivable aspect of the interval (which itself would be more of the order of cognition rather than perception). The 'jump' exists only in relation to the temporalised image, whereas the interval may occur in wider contexts. One might have a temporal interval between two still images belonging to the same series or same sequence. It is the instantaneous image, especially in

179

Figure 33 The Interval: between these two successive frames of A bout de souffle *(J.-L. Godard, 1959), there is a visual jump which nevertheless does not destroy the metonymic connection (the hand pointing a gun to just the gun), nor the metaphoric connection (the hand as a gun).*

photography, which lends itself best to the construction of series in which time is marked (and which may take the more rigid form of the sequence), but there are also examples in painting. One could even say that an interval becomes ever more interesting to contemplate – and more powerful aesthetically – the less the images on either side of it follow a narrative path. For example, in one of Duane Michals' photo sequences, which often tell a dreamlike or supernatural happening (hallucinations, psychic doubling, and so on), the temporal space between successive shots is related to a coherent diegetic time, allowing the viewer to fill in the gaps. In the same way, each image in some traditional painting sequences – of which the stations of the Cross remains the prototype – represents a semi-autonomous little episode. The gaps between the successive images are filled in by the viewer's own knowledge of the story being narrated. In such cases, it would be very difficult to experience the cut from one episode to the next as a jump in time.

On the other hand, a sequence of paintings or photographs of the same landscape, let us say at an interval of a few hours, produces works which carry little narrative charge, but they do stress the passage of time between images. This is often the case with open-air landscape painters such as Valenciennes, but the same is true, in a more intellectualised manner, of certain 60s and 70s conceptual artists who appropriately enough used photographic sequences to represent time.

This representation of time through intervals is thus always somewhat intellectual even though it rests on a sensation of the instant conveyed by single images separated by intervals. The concept of interval always requires keeping a distance, a gap, a visual difference between two images. Which is why it becomes even more perceptually disturbing in moving images. Besides Vertov's superimpositions, there is also the recent work of Jean-Luc Godard, especially his video productions such as *Puissance de la parole* (1988) or *Histoire(s) du cinéma* (1989). Godard's use of the interval is just what Vertov intended: tensions are maintained between two or more images in order to achieve greater expressivity. Even though it does not systematically denote time, the range of Godard's enquiry is vast and he often uses the interval as a marker of time.

III.2.3 The Time-Image

Strictly speaking, what we will call the time-image (*l'image-durée*), that is to say, the image as a registration of a moment in the flux of time, is not a piece of synthesised time. If a film shot lasts 22 seconds, it is usually because the event it recorded lasted 22 seconds. We can only repeat Bazin's wondrous phrase that cinema 'embalms time', presents it as it was. Time is barely *re*-presented in the time-image. Instead, it is presented, made into the present, cloned or twinned. This would be one of the rare cases in which one could conceive of a perfect copy of a bit of reality. This aspect has been strengthened by television's ability to

transmit live: the time in which the event unfolds coincides exactly – or with an infinitesimal delay of microseconds – with that of the image on the screen. But this ability to represent time perfectly has rarely been enough for the art of film, and even less so for video. Film- and video-makers have never stopped working to make the representation of time more expressive in at least three directions.

Event clusters. The viewer's time is not a neutral, uniform flow, a vessel in which actions are inscribed (*see* Chapter 2, §II.2.3). On the contrary, it is determined by these actions. The time-image cannot escape this law and its representation of time is modulated strictly by its diegetic content. The 'views' shot by Lumière's cameramen, lasting for about 50 seconds since that was the amount of film that could be exposed in one take, are an excellent demonstration of this modulation. Some Lumière films such as *La Place des Cordeliers in Lyon* or *L'Arrivée d'un train en gare de la Ciotat*, teeming with micro-events, will seem fast and relatively short. Others, like *Maréchal-ferrant* or *Brûleuses d'herbes*, in which a single action is carried out by one or two people, clearly feel slower and longer. In narrative cinema, everything happens as if time could cluster or aggregate around events, especially when the events are fictional. The greatest film-makers knew that one could modulate time in this manner, which has wrongly been referred to as 'playing on the rhythm of the image'.

An example can be found in the first shot of Paul Vecchiali's *Encore* (1988). As with every shot in the film, it is a long shot lasting about ten minutes, showing events 'in real time'. But towards the end of the shot, the camera lingers on a door behind which someone has just vanished. When that person reappears (we are still in the same shot), we are given to understand through the soundtrack and other clues that at least several hours have passed between his exit and re-entry. This sudden acceleration of diegetic time affects the viewer's sense of time: the twenty or so seconds which pass while the camera holds on the closed door feel like a long time, increasing our sense of surprise when we realise, very quickly, that through this narrative *coup* an even longer period of time has been conveyed.

Time distortion. So far we have assumed that the time-image faithfully reproduces time. This is, of course, false, and everyone knows that it is technically possible to speed up or slow down this replica, or more generally, to warp it. As with any distortion (*see* Chapter 5) this has usually been done for expressive purposes. The earliest theoreticians of silent cinema had already noted how such modifications could be put to use. Slow motion in particular was often used in European 'art' films of the 20s. Pudovkin and Vertov adopted the term given to this device by German film-makers: *Zeitlupe* (time-lens). Around the same time, French film-makers such as Jean Epstein and Marcel L'Herbier used it profusely. It is a device that can express different meanings in different contexts: in the sports scenes in Vertov's *Man with a Movie Camera* (which prefigure television's slow-motion replay) it is used to investigate

reality. In Epstein's *La Chute de la maison Usher* (1928), it becomes a way of scenographing facial expressions. Later, it came to be used often without a specific meaning, but always with connotations of 'art'. Speeded-up action has, ever since vaudeville, tended to signify the comic. Recently, especially in action films and advertisements, slow motion has tended to mean, ironically, speed combined with power.

It is worth mentioning that the often used device of 'the reversal of filmic time' consists of showing an event from the end to the beginning, with time running backwards. The Lumière brothers' famous *Démolition d'un mur* (1895) was exhibited first with time running forwards, then in reverse, showing the wall arising from the dust. More recently, Jean Cocteau used this device frequently for poetic, dreamlike effects, sometimes in combination with other special effects: we see a pearl necklace appear in Jean Marais' hand in *La Belle et la Bête*, for example.

The crystal-image. More radically still, cinema has been used to investigate the truly strange phenomenon of time lived in the present tense, 'now-time'. To say that time passes implies that we already feel the past in the present: the present does not exist, or rather, it does exist *all by itself*, since each moment ceaselessly slides into the past, the present consisting precisely of this endless slippage and the effects of memory and anticipation it produces. This is Gilles Deleuze's theme in *Cinema 2: The Time-Image* (1985): 'The past does not follow the present which it no longer is, it coexists with the present it was.' Deleuze offers the concept of the 'crystal-image' (*l'image-cristal*) as a metaphor for the coexistence of a real image and a virtual one, the first present, the other its contemporary in the past, the past-in-the-present:

> What the crystal reveals or makes visible is the hidden ground of time, that is, the differentiation into two flows, that of presents which pass and that of pasts which are preserved . . . There are, therefore, already two possible time-images, one grounded in the past, the other in the present. Each is complex and is valid for time as a whole.[6]

Deleuze sees important examples in 50s and 60s films by Orson Welles and Alain Resnais, which explore the theme of memory and give it cinematic form. He finds it too in Alain Robbe-Grillet, whose films refuse to mark past, present and future in order to produce each successive event as 'one and the same, single event'. He also sees it in Godard, who works with and on time as an agent of becoming, a way of provoking a sense of emergence or the process of something coming into view, and of metamorphosis.

Deleuze's work is a great deal more than a simple exploration of the representation of time. Among other things it is a meditation on time itself, showing how cinema has thoroughly changed our understanding of it. As to our theme here, the synthesis of time in the image, it throws an extra light on to our remarks about temporal collage: the crystal-image does not present itself, formally, as a collage or a montage. On the

contrary, it is split in two internally by the double action of time. This metaphor of the crystal, refracting reality as it multiplies it, is perhaps the richest way of looking at the representation of time in images: refracted, frozen, multiplied, fragmented, and always thrown back on to a present.

IV. Signification in the Image

IV.1 Image and Narrative

Since the representation of space and time in images is largely determined by the fact that images mostly represent events located in space and time, the representational image is thus often a narrative image, even if the story is short. So, in order to explore what images represent, let us turn to their relation to narrative in general.

IV.1.1 Narrative and Mimesis

Narrative is fairly strictly defined by recent narratological theory as the organised body of signifiers (or signs) of which the signifieds constitute a story. Moreover, this collection of signifiers that conveys a content, a story, presumed to occur in time, has its own duration (at least in the traditional conception of narrative), since the very telling of the story also takes time. Right away then, the key question arises: if narrative is a temporal act, how can it inscribe itself into an image which has no temporal dimension? And if the image does 'contain' time, what is the relationship between the time of the narrative and that of the image? Since our main topic is the image rather than narrative, it may be more useful to reformulate the question as: can the image contain a narrative, and if so, how? First we should recall that since Classical antiquity the very notion of narrative has been thought of in relation to the notion of representation, or better yet, *mimesis*. As André Gaudreault (1988) has shown, Plato distinguished three main types of narrative:

- the narrative which *excludes mimesis*: the expository telling of a story in which there is no attempt to imitate; more particularly, a character's own words are not rendered directly. Plato calls this the epic form;
- the narrative *consisting entirely of mimesis*: the acting out of a story through the words and actions of the characters, as in the theatre;
- the *mixed mode* of narration, incorporating both a verbal and a mimetic dimension. Today, this is the main form of literature, with its alternation of exposition and the characters' 'cited' dialogues.

This distinction between exposition and mimesis (or analogy) is basic to all narratology and is found in differing forms among almost all theoreticians from Percy Lubbock (1921) who opposes *showing* and *telling* in literature and written narrative, right up to Gaudreault, who reprises and expands these two terms for his account of early cinema. For Gaudreault, narrative, whether expressed in written, theatrical or cinematic form, restricts itself to *telling*, which he distinguishes strictly

from what he calls *monstration* (a literal translation of Lubbock's 'showing'). In cinema, Gaudreault finds *monstration* embodied in the single shot, the 'views' of early cinema, while narrative is played out in the montage of one scene with another. In this view, the shot is in the present (a past made present), always simultaneous and synchronous, and only montage allows an escape from this endless present.

However, Gaudreault does not maintain that there can be no narrative within a single shot. That would be absurd. For him, the shot has a relative narrative autonomy, produced through showing, which cannot become true narration. This latter occurs only in a continuous reading of shots which cancels out their autonomy. For Gaudreault, any shot, even the longest sequence-shot including complex camera movements, takes place in the 'monstrative' present, since there is a synchronicity between the act of showing and that which is shown.

Here we shall retain the proposition that there can be a narrative mode of a mimetic type (Gaudreault's *monstration*).

IV.1.2 Sequentiality and Simultaneity

The distinction between showing and telling signals that there are two potential levels of narrative available to the image. The first lies in the single image, the second in a sequence of images. This is indeed what we have established starting from different premises in our discussions of the representation of space and time, providing, of course, that we do not have too restrictive a concept of the single image.

An example may clarify the point. Frequently, images which can be perceived as 'single' depict many episodes of a particular story. In many biblical paintings of the 15th and 16th centuries, such as Memling's *Passion of Christ*, Jesus is shown many times over, in different areas of the canvas, just as in the stations of the Cross. Gentile da Fabriano's *Adoration of the Magi* (1423) shows in the upper part (below an arcade formed by the gilded frame) three scenes which precede the Adoration itself. Such works correspond to an image sequence, as Rudolf Arnheim (1954) pointed out, adding that one should not confuse sequentiality with movement: there are still images which represent sequentiality, just as there are moving images which do not.

This observation has led some authors to consider narrative techniques which are particular to the cinema (articulation of the two narrative levels, the concepts of the shot and of the sequence of shots) as merely a reprise of timeless techniques already widely used in the other arts. This observation is not false, but, unfortunately, it has often been expressed in a negative sense: that all other arts merely prefigure the cinema. The term 'pre-cinematic' was so fashionable around 1960 that a whole edition of the periodical *L'Age nouveau* was devoted to it, encompassing everything from the *Odyssey* to the Bayeux Tapestry. In this teleological form which makes cinema the capstone of the other arts, the proposition is unacceptable, even if it has tempted such distinguished authors as Eisenstein and Francastel.

185

To sum up, what Gaudreault and Arnheim suggest is that narrative (even in its embryonic form, the event) is encoded less in time than in sequentiality. While there is a temporal dimension to the telling of a story, it is also defined by the *sequential order* of its events. Nelson Goodman (1981) has gone further, asserting that when narratives are told in images, neither the text nor its enunciation is necessarily temporalised. What matters most is the ordering of the narrative. Changing this order can even transform the narrative into something other than a narrative: an étude or a symphony, for example. As for the image (and the still image in particular) this ordering will thus be the most powerful defining characteristic. The image narrates by ordering the events shown, whether in a snapshot or in the most elaborate and synthetic forms of representation (*see* §III.2 above).

IV.1.3 Narrative in Space

Arnheim also noted that if the event is the fundamental unit whereby our senses, including vision, perceive reality, that does not necessarily mean that we perceive events as located in time. There are 'events in space' even if our grasp of them requires time. Exploring a grotto or strolling through an architectural space needs time, but such experiences are perceived as 'spatial events'. More generally, for Arnheim, an event has a spatial dimension if perceiving it requires one to grasp it as an entity, as an ensemble. Some forms of film, for example, rely more on this spatial dimension than on temporality. One could go so far as to say that music, a temporal form *par excellence*, also sometimes has a spatial dimension. A classical symphony cannot be grasped by sequence alone: everything that has gone before is constantly changed by what is happening now. The idea of an ensemble which one gets in listening to a symphony is based not on sensations at a particular moment, but on the organisation of the whole, on its structure (for Arnheim, memory is more of a spatial than a temporal structure). Conversely, space is thus a potential vessel for events and the representation of space nearly always realises this potential, as several semiologists have remarked. Narrative writes itself as much in space as in time. Therefore, any narrative image, and indeed any representative image, is marked by narrative 'codes' even before this narrative power eventually manifests itself by the images being placed in sequence.

Alain Bergala (1977) analyses this narrative marking of space in a sequence of photographs. The marks used are coded: depth of field, framing, and the angle of the shot. Each photograph alone already tells an embryonic story and has been arranged to do so in its *mise en scène*. One can extend his observation to photography in general, since the photographer's art consists precisely of using the technical parameters of the shot to present a narrative. Likewise, Guy Gauthier devoted a chapter of his *Vingt leçons (plus une) sur l'image et le sens* (1989) to 'the organisation of space, the narrative element' in a corpus of illustrated covers of nineteenth-century popular magazines. He shows how these single, fixed

images always attempt to refer to a before and an after (an out-of-time, an off-screen of time) and how they condense, in a limited space, all the conventional signs of the scene, in particular playing on depth-of-field effects.

IV.2 Image and Meaning

IV. 2.1 The Perceived and the Named

The representation of time and space in the image is by and large determined by broader, narrative goals. What must be represented is a *diegetic* space and time. The work of representation itself is to transform a *diegesis*, or a fragment of it, into an image.

The diegesis is a construct of the imagination, a fictional world which has its own laws, akin to those of the real world, or at least to our changing conceptions of that world. Any diegetic construction is largely determined by its social acceptability, by the conventions, codes and symbols active in a given society. This is obvious, for instance, in the way antiquity is mostly represented: depictions of the ancient world tell us more about the age in which these representations were produced than about antiquity itself. If we look at cinematic depictions of the life of Christ, we can see how they change according to the styles, fashions and physiognomic preferences of the period. There is hardly any resemblance between the pious Christ figures of the Pathé *Passions* of the turn of the century, the Third World Christ of Pasolini's *Gospel According to St Matthew* (1964) and the decadent Christ of Scorsese's *Last Temptation of Christ* (1987).

All representations are interpreted by the viewers, or, rather, by successive viewers in history, in terms of their own ideological and cultural (or any rate symbolic) discursive network, without which representation is meaningless. These discourses may be left completely implicit and unspoken, but they are capable of being put into words. The problem of the meaning of the image is thus, first of all, that of the relationship between images and words, between image and language. This point has often been made and we shall only remind ourselves, as many others have done, that there are no 'pure' iconic images, since to fully understand an image requires the mastery of verbal language.

On this point all theorists agree. For semiologists, of course, language is the model and the foundation of all systems of communication and signification. Metz's illuminating essays (1970 and 1975) show not only that there are many non-iconic codes at work in images, but also that iconic codes themselves exist only in reference to verbal language. Emilio Garroni (1973) proposes even more bluntly that 'there is a definitive interdependence between an image and a verbal definition'. But the same point is true of those scholars of visual perception who are careful not to overlook the symbolic domain. The celebrated work by Julian Hochberg and Virginia Brooks (1962) asserts from empirical studies that in the young child the understanding of a visual image

begins at the same time as the acquisition of spoken language, and is related to it. Paul Willemen (1978) goes further and argues that images and verbal language cannot be regarded as two separate though interrelating signifying substances; instead, he proposes 'inner speech', which is rooted in verbal language, is part of the very fabric of the image, just like the lining of a jacket prevents the garment from falling apart.

The problem is thus to compare the ways in which the image and language convey the information that constitutes them both. Different semiological schools have given this question much thought:

- either to illustrate the fundamental differences between the signification of the image and that of words. Sol Worth (1975), for example, shows that grammatical syntax, prescriptive rules and truth-claims do not apply to images, which can be neither true nor false, at least in the sense those terms have for language. Images cannot express certain propositions, particularly negative ones (Worth's article is called 'Pictures Can't Say Ain't');
- or on the contrary to insist on the similarities, or necessary interrelation, between the two. We have already cited Garroni and Metz (whose 1975 essay 'The Perceived and the Named' is the clearest expression of the necessary interrelation between an image's visible dimension and its intelligible one in the concept of 'codes of iconic nomination'; see also Willemen's critique of Metz in this respect). One could add many other authors, from Umberto Eco and Roland Barthes to more recent attempts to found a generative semiology of the image based on a supposed kinship between the ways both images and language are 'mastered' by people (see, for instance, Michel Colin's work on the cinema).

For our purposes it will suffice to say that the image only has such an important symbolic dimension because it is able to signify, although always in relation to natural, that is to say, verbal language. There is an implicit opposition here to those philosophies of the image that hold it to be a 'direct' expression of the world, competing with and bypassing or short-circuiting verbal language. For Roger Munier, in *Contre l'image* (1963), 'the image replaces the written form with a global means of expression of great suggestive power', and 'inverts the traditional relations between people and things: the world is no longer named, it expresses itself in repetition pure and simple, it becomes its own statement.' Munier concluded that the image is dangerous, that it must be 'transcended by integrating it into a new, unprecedented higher order of expression which would translate into language the auto-articulate world that is the image'. One may understand what has provoked this naive position: a feeling of being invaded by increasingly arrogant and less controlled imagery. In particular, it overestimates an identity between the image and the real world, forgetting that we use different 'symbolic strategies' (see Worth and Gross, 1974) for dealing with each of them.

It also underestimates the 'in depth' presence of language in the image mentioned above. As for Munier's proposed 'language' which would bring the image under control, effective techniques already exist. One such form is the cinema. (Pasolini, starting from a similar point of view as Munier, sees in the cinema 'the written language of reality', a notion astutely discussed and explained by Sam Rohdie (1994).

IV.2.2 The Interpretation of the Image

If the image contains meaning, that meaning is to be 'read' by the recipient, by the viewer: that, in brief, is the problem of interpretation. Everybody knows from experience that images, which are supposed to be immediately visible, are not necessarily easily understandable, especially if they have been produced in a context remote from our own time and space (and images from the past are often those which require the most interpretation).

Semiology. The semiological project, with its distinctions between different levels of coding in the image, gives an initial answer to the problem: many codes are used in our relation to the image, from the almost universal ones (such as perception) to the more social (such as the analogic codes mentioned in §I above) to those most thoroughly determined by the social context. The mastery of these different codes would logically be unequal for different viewers and their historical situations, which would in turn give rise to differing interpretations.

This is demonstrated daily by advertising, which has made great use of semiology. Advertising images are by definition made to be easily interpreted (unless they are badly designed). They are also among the most overloaded with existing cultural codes. They are so overloaded, in fact, that these codes can readily overwhelm easy interpretation. The job of advertisers is to make images which can be read in spite of the different reading strategies, the differing quantities and kinds of codes different people will use. Their job is to smooth out these differences and make the inevitably wide range of reading strategies compatible with one another. Thus while the more cultured, or the more 'in', viewers will grasp the allusions, quotations and metaphors that escape the less refined, a common signifier must always be present if the advertisement is to succeed.

Iconology. The problem of interpretation is even more important when the image itself is regarded as valuable. In this respect, most attention has been paid to the interpretation of 'art' images, regarded as nobler, more worthy of interest and more consciously elaborated, therefore both more difficult and interesting to contemplate.

In this area, the most coherent and influential work has been that of Aby Warburg's German pupils, from Erwin Panofsky to E. H. Gombrich via Fritz Saxl, Rudolf Wittkower and others. Panofsky developed the most elaborated theoretical model for what has become known as 'iconology'. For him, any social phenomenon carries many levels of meaning (and can thus be read on different levels). An everyday gesture,

such as meeting someone who raises his hat, can bear many different meanings:

- a primary or *natural* meaning, divided into a factual, referential meaning (someone has removed an article of clothing called 'a hat') and an expressive meaning (whether the gesture was performed with a flourish, or more brusquely);
- a secondary or *conventional* meaning, in which we attribute a cultural meaning to the gesture (doffing one's hat is meaningful only in some societies and, nowadays, the convention is disappearing as people who wear hats keep them firmly stuck on their heads);
- an intrinsic or *essential* meaning, which we impute to the performer of the gesture and from which we infer his or her mood, good manners, and so forth.

The same distinctions apply to the reading of images:

- The primary or natural subject is what the image denotes: an image depicts a man, he is laughing, he is swinging his arms, and so on. Panofsky calls this the *pre-iconographic* stage;
- The secondary or conventional subject is the one which relates elements of the representation to specific themes or ideas. 'Realising that a man with a knife represents St Bartholomew, that a woman with a peach in her hand is a personification of Truth, that a particular arrangement of people at a dinner table represents the Last Supper, or that two figures in a particular fighting stance represent the Battle of Vice against Virtue' is the *iconographic* stage, which presupposes knowledge of conventional (and, Panofsky stresses, intentional) codes;
- Lastly, the intrinsic meaning is 'perceived by defining the underlying principles which point out the fundamental attitude of a nation, a period, a class, a religious faith or philosophy – specified by a specific artist and condensed into a work'. This is the level of *iconology* and Panofsky stresses that these meanings can be (and generally are) unintentional.

The iconological 'revolution' was to go against the grain of earlier approaches and to consider all aspects of an art work as symbolic in a wider sense, that is to say, they are all cultural symptoms of the spirit or essence of an age, a style, a school of art, and so on. This essentialism in Panofsky's approach has been widely criticised, and, more recently, it has been modified to avoid the pitfalls associated with the notion of a *Zeitgeist*. The interpretation of a work of art today seeks above all to read the work historically by putting it in its most likely philosophical and ideological contexts (but also its material and political contexts). In this way, almost all historians of art from Norman Bryson to Svetlana Alpers or Daniel Arasse practice iconology.[7]

This approach has since been applied well beyond the traditions which interested Panofsky, and in particular to the cinema. Panofsky himself (1934) suggested parallels between the cinema of 1910 and medieval art insofar as both sought to found a stable iconography which would facilitate interpretation. But much more recently, there have been interpretations of cinematic works which in rigour and learning match those of other works of art (see, for example, analyses by Michel Bouvier (1981) and Jean Louis Leutrat of Murnau's *Nosferatu*, or Leutrat's analysis of John Ford's *The Searchers*. One could add much of David Bordwell's work on Dreyer (1981) and Ozu, or Gérard Legrand's on Fritz Lang (1978)). Nowadays, the interpretation of artistic images of all kinds is iconological.

IV. 2.3 The Figure

So far we have considered the meaning of the image in terms of its representational contents, the imaginary objects which appear visibly in the image. But the implicit yet necessary reference of meaning to language, dicussed earlier, suggests that there must also be a secondary level of meaning in the image which would correspond to tropes or figures of speech. In spoken language, the *figure* is a specific turn of phrase which differs from normal discourse in that it aims to produce meaning in a more original or 'figurative' way. Figures of speech are often considered to be more interesting when they are innovative, more ingenious than everyday language; by contrast, well-worn phrases which become clichés or hackneyed speech lose their expressive value. The figurative and the word 'figure' itself show that, traditionally, the figure is a sort of contamination of the verbal by the iconic. Theorists of rhetoric have often sought to base the figurative process on the operation of a way of thinking different from that used in 'ordinary' speech. Arnheim and Francastel both have stressed the importance of 'visual thinking'. Lyotard (1970), who makes the figurative into a weapon to attack the primacy of language, sees in figuration the emergence of desire, of the primary processes in the Freudian sense. This same idea is applied to the cinema by Claudine Eyzikman. Paul Ricoeur (1975) sees in 'live' metaphor the very motor of poetry, a notion which his disciple Dudley Andrew (1984) has applied to the cinema, to name but a few instances.

In any case, if there is no shortage of theoreticians who consider the figurative as a prime force of signification from which new forms of expression continually emerge, there have been few analytic studies on how images produce figurative meanings. Indeed, most analyses literally borrow their definitions from the rhetoric of natural language (understandably so, given the strong tradition of rhetoric) and seek to dig out metaphors, metonymies, synecdoches, examples of litotes or emphasis in films. Some happily noteworthy exceptions include Dudley Andrew's analyses collected under the title *Film in the Aura of Art* (1984), Jean Louis Leutrat's *Kaleidoscope* (1988) and Marc Vernet's *Figures de l'absence* (1988). Their analyses try to locate, describe and make the viewer

aware of undiscovered tropes at all levels of the film from the purely visual to the most abstract (including, in Vernet's case, figures which refer to the cinematic apparatus itself).

Most of the time, then, it is the trope itself which, *as soon as it has been achieved*, becomes the focus, rather than the process of figuration (the way figures are created in the image). Paradoxically, everything happens as if this semantic process which is taken to be more figurative, to be closer to 'visual thought', can only be described by way of systematic references not just to language, but to literature. This is no doubt a sign that in our cultural tradition representational works of art have always been largely saturated with literature, philosophy and language in general. (It is clearly no accident that the long-dominant Christian tradition is a tradition of writing, of The Book.)

One rare attempt to escape from literary tradition is that of the Group Mu (Groupe μ) which tried to define a rhetoric of images based on specific categories, and in particular on a strict distinction between the iconic level, which is already invested with predetermined meanings attached to depicted elements, and the plastic level consisting of forms, colours, contrasts and elements which have no inherent meaning but which can acquire it in a system of combinations and permutations, in short, by their entry into a signifying system. This attempt is original, and we will return to it later on, but unfortunately it has not been accompanied by concrete analyses permitting the verification of its postulates.[8] The rhetoric of the image remains for the most part unwritten.

Notes

1. Most if not all terms derived from the word 'image', such as imaginary, have become attached to the semantic field dominated by the noun 'imagination'. Therefore, we have used derivations from the Greek term *ikon* to convey the relatively neutral meanings 'of the image', 'pertaining to the image' or 'specific to the image'.
2. Gombrich interprets Picasso's famous statement: 'I do not seek, I find' as meaning 'I do not seek to reproduce nature, but I find it', that is to say, I see objects, lines and so on come alive under my hands.
3. A recent exhibition in Paris at the Centre Georges Pompidou devoted to aspects of twentieth-century art was called 'Realisms'.
4. Other definitions are possible, for instance, by referring 'the field' not to some three-dimensional space represented in the image but to the two-dimensional space of the image's own surface, as Meyer Schapiro does with his concept of the image-field as a sign-field (see Meyer Schapiro, 'On Some Problems in the Semiotics of Visual Art: Field and Vehicle in Image-Signs', in A. J. Greimas, R. Jakobson et al. (eds), *Sign, Language, Culture*, The Hague: Mouton, 1970, pp. 487–502).
5. It is significant that such de-framings were virulently criticised at the time (in the last quarter of the 19th century) as an all too blatantly photographic contamination of the established and dominant convention of pictorial framing.
6. G. Deleuze, *Cinema 2: The Time-Image* (London: Athlone Press, 1989) p. 98.
7. An interesting contestation of the very foundations of the iconological approach (suspecting it of not being scientific and of finding only what one

puts into it in the first place) is provided in Jean Wirth's book, *L'Image médié-vale* (Paris: Klincksieck, 1989).

8. A group of Belgian academics specialising in the study of both verbal and non-verbal rhetoric. The group has a changing membership. When the essay mentioned here was produced, the group consisted of Jacques Dubois, Philippe Dubois, Francis Edeline, Jean-Marie Klinkenberg and Philippe Minguet.

V. Bibliography

Analogy

Barthes, Roland, 'Rhetoric of the Image' [1964], in Stephen Heath (ed.), *Image-Music-Text* (London: Fontana, 1977).

Bazin, André, 'Ontology of the Photographic Image' [1945] in *What Is Cinema?* (Berkeley, CA: University of California Press, 1967).

Damisch, Hubert, *Théorie du nuage: Pour une histoire de la peinture* (Paris: Le Seuil, 1972).

Eco, Umberto, *A Theory of Semiotics* [1968] (Bloomington, IN: Indiana University Press, 1976).

Gombrich, Ernst H., *Art and Illusion: A Study in the Psychology of Pictorial Representation* [1959] (Princeton, NJ: Princeton University Press, 1961).

————, 'Mirror and Map: Theories of Pictorial Representation', in *The Image and the Eye: Further Studies in the Psychology of Pictorial Representation* (London: Phaidon, 1982), pp. 172–214.

Goodman, Nelson, *Languages of Art* [1968] (London: Oxford University Press, 1969; 2nd edn, New York: Babbs and Merrill, 1973).

Klein, Robert, *La Forme et l'intelligible* (Paris: Gallimard, 1970).

Marin, Louis, *Etudes sémiologiques: Ecritures, Peintures* (Paris: Klincksieck, 1971).

Metz, Christian, 'Au-delà de l'analogie: L'Image', *Communications* no. 15, 1970.

Thévoz, Michel, *L'Academisme et ses fantasmes* (Paris: Ed. de Minuit, 1980).

Represented Space

Alberti, Leon Battista, *On Painting* [1435–6] (New Haven, CT: Yale University Press, 1966).

Aumont, Jacques, *L'Oeil interminable* (Paris: Librairie Séguier, 1989).

Baxandall, Michael, *Painting and Experience in Fifteenth-century Italy: A Primer in the Social History of Pictorial Style* (Oxford: Oxford University Press, 1972).

Bazin, André, 'The Evolution of the Language of Cinema' [1950–5], in *What Is Cinema?* (Berkeley, CA: University of California Press, 1967); reprinted in G. Mast and M. Cohen (eds), *Film Theory and Criticism: Introductory Readings,* 3rd edn (Oxford: Oxford University Press, 1985), pp. 124–38.

Bergala, Alain (ed.), 'Scénographie', special issue of *Cahiers du cinéma* no. 7, 1980.

Bonitser, Paslov, *Peinture et cinéma: D'écradages* (Paris: Editions de l'Etoile, 1985).

Bordwell, David, 'Camera Movement and Cinematic Space', *Cinetracts* vol. 1 no. 2 (1977).

Branigan, Edward, *Point of View in the Cinema* (The Hague: Mouton, 1984).

Burch, Noël, *Theory of Film Practice* [1969] (London: Secker and Warburg, 1973).

Cassirer, Ernst, *The Philosophy of Symbolic Forms* [1921–2], trans. Karl Mannheim (New Haven, CT: Yale University Press, 1953–7), 3 vols.

Damisch, Hubert, *The Origins of Perspective* [1987] (Boston, MA: MIT Press, 1994).

———, 'Five Notes for a Phenomenology of the Photographic Image', *October* no. 5, Summer 1978, pp. 70–72.

Doesschate, Gezenius ten, *Perspective, Fundamentals, Controversials, History* (Nieuwkoop: B. De Graaf, 1964).

Edgerton, Samuel Y., *The Renaissance Discovery of Linear Perspective* (New York: Harper and Row, 1975).

Emiliani, Marisa Dalai, 'La Question de la perspective', in Erwin Panofsky (ed.), *La Perspective comme 'forme symbolique'* (Paris: Ed. de Minuit, 1974).

Francastel, Pierre, *Peinture et société* [1950] (Paris: Gallimard, 1965).

———, *La Réalité figurative*.

Gorky, Maxim, et al., *Soviet Writers' Congress 1934: The Debate on Socialist Realism and Modernism in the Soviet Union* (London: Lawrence and Wishart, 1977).

Jay, Martin, 'Scopic Regimes of Modernity', in Hal Foster (ed.), *Vision and Visuality* (Seattle, WA: Bay Press, 1988).

———, *Downcast Eyes: The Denigration of Vision in Twentieth-century French Thought* (Berkeley, CA: University of California Press, 1993).

Jomaron, Jacqueline de, *Histoire du théâtre en France*, 2 vols (Paris: Armand Colin, 1989).

Lyotard, Jean-François, *Discours Figure* (Paris: Klincksieck, 1970).

Merleau-Ponty, Maurice, 'The Eye and the Mind', in *The Primacy of Perception* (Evanston, IL: University of Illinois Press, 1964).

Mitry, Jean, 'Caméra libre et profondeur de champ', 'Espace et peinture' and 'De la peinture filmée', all in *Esthétique et psychologie du cinéma*, 2 vols (Paris: Editions Universitaires, 1963–5).

Panofsky, Erwin, *Perspective as Symbolic Form* [1924–5] (New York: Zone Books, 1992).

Rohmer, Eric, *L'Organisation de l'espace dans le* Faust *de Murnau* (Paris: U. G. C., coll. 10/18, 1977).

Schefer, Jean-Louis, *Scénographie d'un tableau* (Paris: Le Seuil, 1970).

Schild Bunim, Miriam, *Space in Medieval Painting and the Forerunners of Perspective* [1940] (New York: AMS Press, 1970).

Schapiro, Meyer, 'On Some Problems in the Semiotics of Visual Art: Field and Vehicle in Image-Signs', in A. J. Greimas, R. Jakobson et al. (eds), *Sign, Language, Culture* (The Hague: Mouton, 1970), pp. 487–502.

Vernet, Marc, *Figures de l'absence* (Paris: Ed. de l'Etoile, 1988).

Willemen, Paul, 'Notes on Subjectivity' [1978], in *Looks and Frictions* (London: BFI, 1994), pp. 56–84.

Wirth, Jean, *L'Image médiévale* (Paris: Klincksieck, 1989).

Represented Time

Aumont, Jacques, *L'Oeil interminable* (Paris: Librairie Séguier, 1989).

Baxandall, Michael, *Painting and Experience in Fifteenth-century Italy: A Primer in the Social History of Pictorial Style* (Oxford: Oxford University Press, 1972).

Bordwell, David, 'Jump Cuts and Blind Spots', *Wide Angle* vol. 6 no. 1, 1984, pp. 4–11.

Deleuze, Gilles, *Cinema 2: The Time-Image* [1985] (London: Athlone Press, 1989).

Eisenstein, S. M., *Selected Writings, Volume 2: Towards a Theory of Montage*, ed. Michael Glenny and Richard Taylor (London: BFI, 1991).

Lessing, Gotthold Ephraim, *Lacöon* [1760] (New York: Dutton, 1961).

Vertov, Dziga, *Kino-Eye: The Writings of Dziga Vertov*, ed. Annette Michelson (Berkeley, CA: University of California Press, 1984).

Signification in the Image

Abel, Richard, *The Ciné Goes to Town: French Cinema, 1896-1914* (Berkeley, CA: University of California Press, 1994).

Andrew, Dudley, *Concepts of Film Theory* (Oxford: Oxford University Press, 1984).

Ang, Ien, *Desperately Seeking the Audience* (London: Routledge, 1991).

Arnheim, Rudolf, *Art and Visual Perception* (Berkeley, CA: University of California Press, 1954).

Bergala, Alain, *Initiation à la sémiologie de récit en images*, Cahiers de l'audiovision, (n.d. [1977]).

Bordwell, David, *The Films of Carl Theodor Dreyer* (Berkeley, CA: University of California Press, 1981).

———, *The Cinema of Eisenstein* (Cambridge, MA: Harvard University Press, 1993).

Bouvier, Michel, and Jean-Louis Leutrat, *Nosferatu* (Paris: Cahiers du cinéma and Gallimard, 1981).

Eyzikman, Claudine, *La Jouissance-cinéma* (Paris: U.G.C., coll. 10/18, 1976).

Garroni, Emilio, 'Immagine e linguaggio', in *Working Papers of the University of Urbino* (1973).

Gaudreault, André, *Du littéraire au filmique* (Paris: Méridiens-Klincksieck, 1988).

Gaudreault, André, and François Jost, *Le Récit cinématographique* (Paris: Nathan, 1990).

Gauthier, Guy, *Initiation à la sémiologie de l'image*, Cahiers de l'audiovisuel, 1979.

———, *Vingt leçons (plus une) sur l'image et le sens*, enlarged edn (Paris: Edilig, 1989).

Goodman, Nelson, 'Twisted Tales, or Story, Study and Symphony', in W. J. T. Mitchell (ed.), *On Narrative* (Chicago, MI: University of Chicago Press, 1981).

Groupe μ, 'Iconique et plastique sur un fondement de la rhétorique visuelle', *Revue d'esthétique* nos. 1 and 2 (Paris: U. G. C., coll. 10/18, 1979), pp. 173–92.

Hochberg Julian, and Virginia Brooks, 'Pictorial Recognition as an Unlearned Ability: A Study of One Child's Performance', *American Journal of Psychology* no. 75, 1962, pp. 624–8.

Legrand, Gérard, *Cinémanie* (Paris: Stock, 1978).

Leutrat, Jean-Louis, *L'Alliance brisée* (Lyon: Presses Universitaires de Lyon, 1985).

———, *Le Western: Archéologie d'un genre* (Lyon: Presses Universitaires de Lyon, 1987).

———, *Kaleidoscope* (Lyon: Presses Universitaires de Lyon, 1988).

Lubbcok, Percy, *The Cract of Fiction* (London: Jonathan Cape, 1921).

Lyotard, Jean-François, 'L'Acinéma', in Dominique Noguez (ed.), *Théorie, Lectures*, special issue of the *Revue d'esthétique* (Paris: Klincksieck, 1973).

Metz, Christian, 'Au-delà de l'analogie: L'Image', *Communications* no. 15 (1970).

——, 'The Perceived and the Named' [1975], in *Studies in Visual Communication*. vol. 6 no. 3, 1980, pp. 56–68.

Munier, Roger, *Contre l'image* [1963] (Paris: Gallimard, 1989).

Panovsky, Erwin, *Studies in Iconology: Humanistic Theories in the Art of the Renaissance* (Oxford: Oxford University Press, 1939).

Ricoeur, Paul, *La Métaphore vive* (Paris: Le Seuil, 1975).

Rohdie, Sam, *The Passion of Pier Paolo Pasolini* (London: BFI, 1994).

Vanoye, Francis, *Récit écrit, récit filmique* [1979] (Paris: Nathan, 1989).

Vernet, Marc, *Figures de l'absence* (Paris: Ed. de l'Etoile, 1988).

Willemen, Paul, 'Cinematic Discourse: The Problem of Inner Speech' [1975–81], in *Looks and Frictions* (London: BFI, 1994).

Worth, Sol, 'Pictures Can't Say Ain't' [1975], in *Studying Visual Communication* (University of Pennsylvania Press, 1981), pp. 162–84.

Worth, Sol, and Larry Gross, 'Symbolic Strategies' [1974], ibid., pp. 134–47.

Chapter Five

The Role of Art

As will have become obvious from the examples used in the preceding chapters, the study of the image has been undertaken largely with the artistic image in mind. It has become commonplace to complain that we have been invaded, even swamped by images of all kinds which now occupy our environment. There is no need to repeat that refrain. Let us just say that if we have given pride of place to images produced within the domain of art, it is because we consider that they are implicitly more interesting (more innovative and pleasing, stronger and longer-lasting). That is a preference we shall have to defend, at least in part (*see* §III below), but, for the time being, it is enough to grant the artistic image a quality of inventiveness clearly superior to all other images. If the limits of the domain of art have changed enormously in the last hundred years, even in the last thirty, it is still, at the very least, the domain of innovation and discovery, whereas most other images are merely kinds of plagiarism, conscious or unconscious repetitions, or decoration. We shall start by discussing some characteristics which link images with 'artistic quality', beginning with so-called 'pure' images.

I. The Abstract Image

I.1 Image and Image

I.1.1 The Dispute over Abstract Art
Thus far, we have insisted on the fact that art is an object produced by human hands by means of a particular apparatus. Its goal is always to create, in symbolic form, a dialogue with the viewer about the real world. In short, we have tried to consider all images as representations of reality or of an aspect of reality. One could argue, with some merit, that this is not completely consistent with the desire to grant a privileged place to artistic images. Indeed, nowadays images that bear a direct reference to the visible world, that document it, are primarily found outside the sphere of art. Anyone knows that the most salient change that has affected artistic images in the 20th century has been what quickly became known as *abstraction*.

What is abstraction? For a long time, the word denoted distance from reality: an abstract relationship to the world is the opposite of a concrete one. This lack of concreteness quickly came to signify the loss of a di-

rect referential relationship. This loss was felt to be prejudicial, as demonstrated by the clearly pejorative connotation that was attached to the word 'abstraction' in the 17th century. In seventeenth-century French, to be abstracted ('*être abstrait*') always connoted incomprehensibility, distraction; the abstract was always *too* abstract. As for painting, it was the enemies of abstract art who named it so as to stigmatise the loss of what had been constructed as a universal, timeless and indisputable value, that is to say, the reference to the real world and its representation. It was only after the Second World War, after several decades of abstract art, that the word could be used without pejorative associations, as in Abstract Expressionism even though in this case it had to be combined with the appreciative noun 'expressionism'.

Abstract art thus has only a negative definition: it is the art of non-representational, or put euphemistically, 'non-figurative', images, the art of the loss of representation. As with many artistic trends, it was subsequently rendered banal through its use in many of the applied arts, such as fabric design, the decorative arts and so on. Nevertheless, to the public at large it still has a somewhat malodorous strangeness, as with any activity associated with avant-garde practices.

I.1.2 The Historicity of Representation

The first consequence of the appearance of abstract art is historical. The issue has been settled for a long time now: artistic images can be stripped of representation because representation is not 'ontologically' linked to the image as such, but had been associated with it through a particular historical evolution. Even among authors with little interest in abstract art or those who still take exception to it, abstraction has at least some usefulness: that of forcing a more radical inquiry into the rationale of non-abstract art, that is to say, of representational art. Indeed, if abstract art is possible and acceptable, why was there such a prolonged elaboration of representation?. Thus, in the 20th century, art historians began to concern themselves with the genesis of art as something grounded in psychological need, rather than it simply being a matter of imitation or religious ritual. They singled out the need for expression (about which more in §II below) around the turn of the century with the concept of *Einfühlung* (*see* Chapter 2, §III.2.2). At the same time, abstract art tried to become aware of the relative autonomy of artistic forms (cf. Gombrich, 'Paintings feed off other paintings, paintings nourish paintings') and of the institutional power of what we call art. If a few artists were able to invent abstract art in opposition to dominant ideologies, it is because there was a place (an environment or institution producing its own ideological values) where this invention could be legitimised. Thereafter, representation could no longer retain the cachet, the absolute value, which academic art had tried to impart to it. Representation had to be related to its history and institutions. It has often been claimed that it was the invention of photography (and later of cinema) which diverted and removed the need for imitation which

had always been deemed to be at the root of artistic activity. By removing representation, painting was henceforth freed to attempt abstraction.

This theme occurs in diverse forms among many of the authors we have mentioned in relation to photography, from André Bazin (picking up from André Malraux) to Gombrich. There is, of course, some merit in their position. Painters' reactions to the daguerreotype, ranging from fascination to pretended distaste, bear witness to the fact that they recognised the arrival of a dangerous competitor into their private domain of imitation. Up to a point, it is logical to suppose that in order to sustain its claim to be art, painting clearly had to differentiate itself from photographic practice, to which artistic status was denied. Although there was no need for this differentiation to take the form of abstraction, a form of differentiation was institutionally inevitable.

I.1.3 The 'Pure' Image

The representative image, as it has been defined in the first four chapters of this book, is defined by its referential aim: it denotes, it shows reality. At the same time it always offers a discourse on that reality, at least implicitly so (*see* Chapter 4, §IV). The abstract image obviously calls this referential quality into question. As soon as the dissemination of abstract painting became socially accepted, it became possible, or at least tempting, to develop theories which minimised the connection between image and reality. Thus there was much contemporaneous theoretical polemicising, although in a less theatrical manner than the row over abstract art which achieved prominence in the media, on the status of the image vis-à-vis reality. Later we will come to some of the writers who took extreme positions in this debate, defending a so-called 'purity' of the image: absolute autonomy from visible reality. But this same idea of purity had an impact and exerted considerable influence even on authors who have no particular commitment to abstract imagery.

Pierre Francastel devoted the entire first chapter of *La Figure et le lieu* (1967) to the argument that figurative art is not equivalent to its translation into natural language and that the elements of representation arise from a completely unique system 'that owes nothing to the linguistic'. For Francastel, the arts as a whole play a specific role in society akin to those of other semiological systems. Consequently, when we study classical works of art which 'may have been obscure even to their contemporaries', we should not be misled into overestimating their representative aims.

These proposals are sometimes excessive, as if the discovery in abstract art of qualities intrinsic to the 'pure' image require one to deny that it also contains 'extrinsic' values that have long dominated imagery. Let us retain and build on the idea that each image has, in effect, a life of its own. Artists have no doubt been more sensitive to this idea than others, well before theorists asserted it, even if this is only in the tricks of their trade or their studio techniques (there are more similarities among the technical/theoretical writings of Leonardo da Vinci, Paul

Klee and André Lhote than their respective ways of painting might lead us to expect). Through the ages then, representational images have also been in some way abstract images.

I.2 Plastic Values

I.2.1 Plastic and Iconic

The Plastic Arts. At the same time that attention was being given to the 'pure' image detached from any reference to reality, there appeared the concept of its plasticity. In its current, non-artistic usage, this notion of plasticity signifies flexibility, variability, a quality of being 'mouldable', one might say. In this sense, an image would be considered 'plastic' if it is pliant, on the model of that most plastic of the arts, sculpture (and particularly in clay, which can be modulated ad infinitum). This primary sense of pliability has given way to a second sense which in loose usage has tended to be confused with the idea of abstraction. The plasticity of a painting (the photographic image being somewhat different in this regard) derives from the possibility of manipulating the raw materials of which it is made. If painting has been considered a plastic art comparable with a sculptor shaping a lump of clay, it is above all because of the painter's movements as he or she spreads pigment on the canvas, brushes it over, works it with different tools and, in the last resort, with his or her hands.

The type of image in which these processes appear most clearly in the finished work is undeniably abstract art, or, retrospectively, those pictures in which abstract values of the image, from colour to texture and 'touch', have been elaborated. The plastic qualities of paintings by Velasquez, Goya or Delacroix are more apparent than those of Dürer or Ingres. Nowadays, we speak of 'plastic arts' to include all non-photographic arts, arts 'made by hand'. The echo of the sculptural metaphor still faintly resounds in this usage, but the term has now become fixed. It evokes an institutional division: the traditional arts 'defending themselves' against photography, the latter being slighted for its mechanical nature, rather than the distinction being based on any categorical difference.

The case of the photographic or videographic image is complex and has been addressed inconsistently, according to the goals different writers sought to achieve. In general, both have been refused the status of 'plastic arts', which at root is to deny their artistic status altogether, and it is, of course, on this terrain of 'artistic quality' that most of the battles have been fought. One of the rare attempts to claim the cinema as one of the plastic arts, that of Elie Faure (1922), is based on an opposition between cinema as *cinémime* and as *cinéplastique*. *Cinémime* is cinema as drama, subordinated to narrative and essentially of limited scope, although of interest when done by skilled practitioners (Faure cites Chaplin as an example). Faure says that cinema could or even should be *cinéplastique,* that is to say, based on a more or less free play of visual forms and thus closer to art: 'The cinema is first of all plastic.

Figure 34 'Cinéplasticity': frame stills from Gold Diggers of 1935 *(Busby Berkeley, 1935) and* Faust *(F. W. Murnau, 1926)*

It is to some extent an architecture of movement which must be in constant harmony, in a dynamic equilibrium with the environment and the landscapes in which it rises and falls.' One hears the same theme sounded in articles written by plastic artists, such as this brief remark by Fernand Léger on the plastic values of Abel Gance's *La Roue:* 'The appearance of this film is all the more important in that it will determine a place in the plastic arts for an art which, with few exceptions, has so far remained descriptive, sentimental and documentary.'

Of course, the arrival of sound pushed these ideas into the background and favoured film's dramatic aspect, leading once more to a wave of lamentations that the 'art' of cinema had been lost or, at least, set back.

In Britain, the long-running debate about whether cinema could be considered as a genuine art form, not resolved even today, has taken different forms, invariably with grievous consequences. At first, the debate sought to locate human intervention, the defining characteristic of the artistic process, in the mechanical process of photography in editing, most notably in Ernest Lindgren's *The Art of the Film* (1948). One of the consequences was that a film-maker could be admitted to equal status with a literary creator on condition that he or she demonstrated, through editing, an ability to overcome the fact that cinema consisted of images. Later, when a more complex relationship to imaged discourse had gained broader acceptance, the old prejudices returned under the guise of an engagement with cinema as 'popular culture' rather than art. In that phase, characteristic of much British film theory from the 80s onwards, films began to be valued not on any aesthetic grounds but on their ability, demonstrated by the number of tickets sold at the box-office, to 'please' audiences. This subordination of aesthetic criteria to more easily quantifiable commercial ones demonstrated the tenacity in Britain (and in many sectors of the US media industries as well as among their academic apologists) of an ideology which insists on refusing the status of art to cinema on the grounds that it is essentially an industry, the success or failure of its products and practitioners having to be assessed in terms of market-share and customer satisfaction.

Plasticity in the Image. Although widely used, the term 'the plastic arts' adds little to what is already denoted by 'the art of the image'. When the image began to be addressed in terms of abstract art, it became necessary to find a theoretical definition of the notion of plasticity in images. For a long time this project was the fiefdom of teachers in art schools, who were mostly painters or aspirant painters. So it is not surprising that the earliest theoretical works devoted to the abstract image and to plastic values in general were published by the Bauhaus. That great interdisciplinary school in Germany of the 20s and early 30s collected a great many of the best avant-garde artists (painters, sculptors and architects). We will be returning later to the fascinating, ground-breaking writings of Paul Klee and Vassily Kandinsky; these writings by painters, however, are by no means genuine theories. Each system they proposed was

largely an idiosyncratic elaboration and rationalisation of their own personal practices, which cannot really be applied to other people's work. Outside of these writings, even today, there are few rational theories of the plastic dimension of the image able to claim universal validity. Groupe μ's 1979 essay (*see* Chapter 4, §IV.2.3) asserts that 'insofar as a semiotics of the image has been attempted, what has been achieved to date is, in fact, only an *iconic* semiotics', by which the authors meant a semiotics of the image as *mimesis*.

In the same essay Groupe μ goes on to distinguish between '*iconic signs*' and '*plastic signs*' in images. Plastic signs have a level of expression and a level of content (as all signs do) and carry denotational and connotational signifieds. The essay moves swiftly and their examples are not very convincing. To say that the plastic denotative signified of a circle is the idea of circularity is true (if tautological); on the other hand, to say that its plastic connotative signified is 'the meaning-effect/formal perfection/or/Apelles' is a little arbitrary. The name of the ancient Greek painter Apelles, of whom next to nothing is known, was indeed invoked as a symbol of perfection until the 19th century, but today he is no longer identified automatically with the idea of a perfect circle. Likewise, giving the colour yellow the denotative signified of 'galbanicity' (a coinage meaning 'the quality of being yellow') is jejune; giving it the connotative signified of 'warmth' refers back to a mistaken synaesthetic typology (see below).

Nevertheless, it is worth retaining the essay's main suggestion that the plastic sign has two 'dimensions': its 'grading' and its 'materiality', which suggest some interesting possible typologies. The concept of grade is important in that it aims to overcome one of the key difficulties of the theory of plasticity: the fact that it does not deal with systems made up of discrete, discontinuous elements, but with a continuum. Its elements vary in a gradual or scalar way. One cannot categorise all variants of the colour blue, but 'one can grade nuances of blue in a given work and ascribe to them values in relation to one another' (one could say the same, for example, of degrees of closeness of shot in cinema or photography). While 'materiality' allows one to distinguish works which have only one medium of expression, such as unretouched photographs, from those which have many, such as collage. So, we await with interest the continuation of Groupe μ's project.

I.2.2 The Grammar of Plasticity

Since there are no well-founded theories of plasticity in the image, let us summarise the more empirical approaches offered by artists themselves.

The Elements. From Bauhaus textbooks and later re-editions, one can draw an implicit list of plastic elements:

- the *surface* of the image and the more or less fine graduations of texture and definition in the way the surface is organised into different segments;

- the *colour*, also accorded a continuous scale (with the rainbow as its paradigm);
- the range of tonal *values*, from black via various shades of grey to white.

This brief list mirrors in a striking way the elements of visual perception: edge, colour and luminosity.

The Structures. The plastic artist works to create more complex forms out of these simple elements through combination and composition. Kandinsky devoted an entire Bauhaus pamphlet, *Point Line and Surface* (1926), to the problems associated with surface. He discussed the embodiment of this fundamental plastic value in the point, the line and the surface area, together with the interrelationship of all three. A simple example of the relationship between a point and the plane in which it appears allows Kandinsky to define the 'fundamental resonances' of any point, namely its concentric tension, its stability (the point has no spontaneous tendency to move) and its tendency to 'encrust itself into the surface'. Such fundamental resonances are modified by more contingent factors such as the size of the point, its shape and its location on the surface. These analyses are multiplied for all possible cases of interaction between point, line and surface, the goal being to link them to expression. What interests Kandinsky is the possibility of attributing an expressive value to each configuration he analyses. His text abounds in metaphors, primarily of warmth and cold, but also musical metaphors. He wants to place plastic values within a global system founded on a peculiarly idealist aesthetic, maintaining that forms have a life of their own, an internal 'pulsation', an intrinsic 'resonance', which must be discovered. This type of description and evaluation has had considerable influence on theoreticians. For instance, Arnheim, without endorsing Kandinsky's entire philosophy, follows in his footsteps by analysing plasticity in correlation to expression.

Around the same time, Klee's *Pedagogical Sketchbook* (1925) offered similar thoughts. Klee conceives of the relationship between line and surface in terms of their relative 'activity' and 'passivity', for example in the form of the moving vertical. Klee's briefer text also tackles two important themes: visual 'rhythm' (based on an opposition between divisible and indivisible structures) and the organic quality of form, evoking the classic theme that artistic form has 'natural' origins: plants, the human organism and especially its circulatory system are taken as 'deep' structural models of the artistic image in a way that Leonardo would not have disavowed.

Structuring. The enquiry into the realm of plastic values leads to the isolations of the active 'moment' at which a structure is built from the elements, the moment of the active structuring of the materials. Many painters' writings stress the role of the hand which outlines and places paint, that is to say, they stress the role of *touch*. However, here still more than elsewhere, reflection remains empirical, and mostly rather vague.

In sum, one can say that the realm of plasticity has been catalogued in some fashion, that some basic categories have been logged, but that there has been as yet no genuinely theoretical approach to the issue. The exploration of a possible grammar of plastic values through the empirical approach has been accentuated by, among others, Vasarely, but without getting us much further. Even René Passeron's (1962) synthetic approach, albeit more theoretical and much more precise, still treats plastic values as though they are largely ineffable.

I.2.3 Composition

The work of structuring we have invoked is known traditionally as *composition*. Earlier, in Chapter 3, §I.2, we attributed composition to the function of the frame, which organises and structures the surface, and that remains true. Now we must put a little more emphasis on the traditional idea of structuring.

Composition and Geometry. A widespread notion, often reinforced by analyses of classical painting, has it that composition is above all a question of a geometrically harmonious division of the canvas (or more generally, of its painted surface). In this view composition is 'the art of proportions', to invoke the title of a book by the painter and sculptor Matila Ghyka, *Esthétique des proportions dans la nature et les arts* (1927). Since the turn of the century, countless articles and books have been devoted to this theme. There have been analyses, some more convincing than others, which have tried to prove that such and such a painting is built around simple geometric forms. Some have gone as far as offering 'universal' models of dividing a rectangular frame according to 'harmonious' proportions.

While we are on the subject, we should at least mention the vast literature on the Euclidean relationship which in the 16th century was called the 'Divine Proportion' (by Luca Pacioli, 1509) and in the 19th century came to be called the 'Golden Section', that is to say, the relationship between dimensions in which 'the whole line is to the greater segment as the greater is to the less'. Another formulation has it that in the Golden Section, one dimension stands to another in the same way that it stands to the sum of both, mathematically expressed as $A/B=B/(A+B)$, yielding an easily computable value of 1.618, called the 'Golden Number', for the ratio of the two sides. The simplicity of the formula that defines this relationship, and certain striking mathematical properties which result from it, have spurred interest in the Golden Number since the Renaissance. The mathematician Leonardo of Pisa (1175–1230), also called Fibonacci, was the first to show that the Golden Number is the limiting value of his so-called 'harmonic sequence', nowadays known as the Fibonacci Series in which each number is the sum of the preceding pair (1-2-3-5-8-13-21 and so on), a sequence which rapidly approximates the Golden Section expressed mathematically as the ratios 5:8 or 13:21. These speculations were certainly known to some Renaissance painters, who did not disdain

geometrical investigations, but it is no less probable that frenzied searches for the Golden Section in the composition of all painting is inappropriate. Allusions to the Golden Section among informed theorists, from Eisenstein to Jean Mitry, should be understood in relation to this myth.

On this issue we join Passeron's position: he finds the Golden Section interesting because it is 'pulled between two strong forms, . . . the square and the elongated rectangle', but it 'must be pulled out of shape, distorted, never quite fixed in an annoying perfection'. More generally, this profusely discussed 'secret geometry' should not be overvalued. The multiplication of geometric constructions in a painting has, on rare occasions, been used as a preparatory 'architecture', but most of the time only the broadest structures are noticeable by the viewer and few canvases, under deeper analysis, display anything like such a complex and regular geometric structure. In short, mathematics is a mere aid to composition.

Composition and plasticity. If the idea of a geometry of composition seems a relatively recent one, academic treatises of the 19th century taught that it had a direct relation to the plastic materials of the painting, that is to say, to its iconic material. The art of composition was long understood to be the art of appropriately arranging painted figures (people, objects, decor) on the canvas, and it was only as painting distanced itself from imitation that composition began to encompass the arrangement of plastic elements: values, colours, lines and surfaces. This is the twofold definition of composition one finds as much in Passeron's historical overview as in Arnheim's studies of paintings. Brilliant analysts both, they give plasticity in visual works an inherent value which for them arises from perception, from 'sensory thought'. We noted above that it is doubtful that such thought really exists. Perhaps one should just see in such assertions a sign of a particular sensitivity (backed up by experience) to those plastic values which may appear to be more 'immediately' visible than others.

Composition across art forms. Composition, the visible organisation of plastic materials, can be at work in any image. The most noteworthy extension of this idea applies to the mechanically produced image, especially photography. Photography is indeed a trace, but the most striking thing about its invention was the notion of its lack of intentionality: that the photograph's 'innocent eye' merely recorded what was in front of the lens. In photography, therefore, composition was for a long time what took place *in front of* the lens, in the classic sense of composition as *mise en scène*. However, even such a tactful portrait photographer as Nadar always posed his models in an expressive way, sometimes placing them in a decor. Others, from Disdéri to Rejlander, would accord even more emphasis to decor. It was only at the turn of the century, with Pictorialism and its unnatural aim of copying the painter's brush-stroke, that photography affirmed a vocation of composing its own plastic elements. Here we touch on the Gordian knot of photography and the

Figure 35 Composition in photography: Ralph Gibson, Sardinia, 1980

photographic art. There have been endless discussions on defining it: is a photograph an imprint, a recording? Or is it a formulation (*mise en forme*): is it crafted? Even though photographers have long implicitly replied that they do make something take shape in the basis of a recording, and that this paradox is the essence of their art, these debates keep resurfacing, even in theoretical work.[1]

The question becomes even more complex when we consider the moving image, be it cinema or video. Composition (in the plastic sense) takes on another meaning, a resonance of its meaning in music. The temporal organisation of a film can be calculated in terms of regularity and rhythm. This has indeed been the case in some films, particularly in what has been mislabelled 'experimental film'. This form, of all cinematic institutions, is the one which is consciously most akin to the 'plastic arts' (to the point that today experimental films are exhibited in museums of modern art). Walter Ruttman's *Opus 1*, Viking Eggeling's *Diagonal Symphony,* the films of Hans Richter, American 'underground' films of the 50s and 60s, and of course much of so-called 'structural' film, all rest on calculations of duration, sometimes to the precise number of individual frames, something which could truly be compared to musical composition.

In any case we should remember that while the eye, particularly the well-trained eye of the film-maker or the critic, can discern plastic composition in space, it is by nature much less able to perceive the flow of time (*see* Chapter 1, §I.3 and Chapter 3, §II.1). This has been noted by many film theorists from Eisenstein (who derides 'metrical montage' as early as 1929) to Jean Mitry, who devotes a chapter to the question in *Esthétique et psychologie du cinéma* (1963–5). Thus the concept of rhythm, even more than composition, is troublesome when applied to film, where, at best it is metaphorical, at worst completely misplaced.

I.3 The Image and Presence

I.3.1 The Immediacy of the Visible

The emergence of abstract painting loosened the centuries-long connection between painting and representation. The new approach often took the form of valorising a *presence*, conceived as real, actual and effective in its own right, rather than as a representational, imaginary or virtual stand-in for the real. This idea is in fact only an extension of what we have just been discussing: as painters and theorists became more and more aware of the pictorial materials and their plastic organisation, they came to see the manipulation of these materials as the only reality of painting. Representation came to be seen as a by-product, and not always as a desirable one at that.

In a series of essays published between 1920 and 1960, the critic Georges Duthuit took perhaps the most uncompromising stance in this polemic. In Duthuit's opinion, the entire representational tradition that was spawned by the Italian Renaissance, in other words, all Western art

until Impressionism, is stigmatised as having forced all human encounters with the visible into the unacceptable, inhuman abstraction of geometry. His argument has often been taken up by those who defend abstract art: abstraction does not take place where one thinks it does; abstract art is in fact more concrete, since it works more directly, more tangibly with raw materials, whereas the representational tradition can only exist because of ideological (in the last resort mathematical) rules which separate us from real life, from spontaneous encounters with the world.

The ideology in which Duthuit's writings are steeped may appear naive. For him, the painter is guided by his or her own intuitions and immediate sense-impressions, but also his or her tastes, generosity, love of life, and so on. These are the values which the viewer is supposed to receive from the work. Discussing a Renaissance painting, he wrote: 'Here is a painting which, on the basis of fragments of perception, reconstitutes an appearance, whereas what matters is to give life.' As we have stressed time and again (see especially Chapters 1 and 2), visual perception is an intellectual process. Consequently, the notion that there could be such things as 'unmediated', 'spontaneous' encounters with the visible, prior to the always necessarily historical and intellectual act of looking, is a myth.

Nevertheless, this myth has its pedigree and one cannot deny its effectiveness altogether. One finds variations of it throughout the philosophical and critical offshoot of existentialism which holds that all our encounters with the visible can be founded on immediacy. Merleau-Ponty has been one of its most influential theorists. Referring in particular to Cézanne's paintings, he invokes the 'passive' aspect of perception. That is to say, he regards perception as a way of relating to the visible that consists of accepting what has been seen as a gift (donation), without trying to impose on it an organised conceptual framework. To Merleau-Ponty, Cézanne represents a turning point in the history of Western painting because he substitutes an impersonal, objective vision of the world 'as it is before one looks at it' for the first-person point of view implicit in perspective. Cezanne shifts painting from the first person pronoun to the indefinite, 'from I to One' ('du Je au On').

Jean-François Lyotard (1970) picks up and elaborates the theme, seeking in painting not just the emergence of this impersonal One, but a more radically impersonal It (Freud's id), the locus of desire. Henry Maldiney expresses a similar view: 'an excess of perspective' has made the real world too clear, too photographic, and has made the project of painting problematic. Maldiney states that modern 'man' lacks sensation because 'he' is overburdened by 'his' perceptions. The task of painting, fulfilled by abstract painting in particular, is to restore this indescribable contact with reality and bypass the symbolising intellect. Similar arguments can be found in Clement Greenberg's advocacy of abstract painting in the US and they remain an important element within various romantic-modernist ideologies such as, for

instance, the discourse advanced by Susan Sontag in her book *Against Interpretation*.

I.3.2 The Life of Forms

Another avatar of the ideology of 'presence' is the view that the art work conveys not the direct presence of the visible world but that of *form*. Form is an abstraction of the structure of visible elements that comprise a visible object (*see* Chapter 1, §III.2). One can go further into abstraction to argue that form is a more general principle which has nothing necessarily to do with objects, but only with the appearance of the work of art. This temptation, naturally influenced by the evolution of painting, is found not only among theorists of abstract art. The evocative metaphor of 'the life of forms' has been borrowed from an art historian specialising in medieval art, Henri Focillon. In *La Vie des formes* (1943), he personalises form and sees its incarnation not just in the painting's materials, but also in space and time. Form 'has a meaning of its own, a personal and particular value which must not be confused with the attributes imposed on it. It signifies and receives literal and figurative meanings . . . It has a physiognomic quality which can show striking similarities with those of nature, but stands apart from it.'

Numerous critics and painters have subscribed to a similar view. Either, like Focillon, they argue for the 'life' of forms in the history of art, or they claim the existence of form in the here-and-now, on the canvas. The canvas is a living surface, animated by its own life, that of its forms and its plastic values. This is the core of Kandinsky's teachings and he had the distinction of fearlessly asserting out loud the frankly idealist philosophical premises of his thesis. It is also at the heart of countless declarations by painters during the first half of this century, including Matisse, the Fauves, and abstract artists such as Manessier and Estève, among others: the image is the presence of living forms.

I.3.3 Representation and Presence

Lastly, the concept of presence has been argued in another context, that of the photographic image (and thus, in a way, *a priori* opposed to its meaning in painting). If photography can be said to bear a trace of reality, many critics have extended the idea, going so far as to argue that the photograph bears not just a fragment of reality but of the Real itself.

This line of thought has often been somewhat fluid and incomplete. To speak of the *presence* of an actor (or, sometimes, of a decor) in a film does not say a great deal more than that we recognise a major expressive effect placed front and centre, a presence-*effect*. More interesting, despite its somewhat unverified presuppositions, is the urge to see in photographs, and even more so in the cinema, a supernatural presence, founded on representation but going beyond it. This theme of 'a divine presence' has inspired several major film critics, from André Bazin to Amédée Ayfre and Henri Agel. But from a less metaphysical point of

view, we can also see that it is connected to photography's evocative power of presence, linked to photogeneity (*see* §III.3 below).

By their very construction, photographic and cinematographic apparatuses are made to create effigies of reality. Wanting to feel an actual presence out there, even if important critical insights accompany that wish, can only arise from religiosity, fantasy or social convention. Despite their powers, such as the power to teach us to see more clearly, neither cinema nor photography *reveal* anything of the world, regardless of whether the term 'revelation' is taken literally or esoterically.

II. The Expressive Image

II.1 The Problem of Expression

The abstract, 'pure' image has thus revived, rather crudely, a very old question, but one that had often been forgotten, in relation to the figurative image: the problem of *expression*. Few words in the critical lexicon have given rise to as many paraphrases and misunderstandings as the word 'expression', particularly in the last hundred years or so, when the term has come to be used more and more frequently. Its etymology, of course, derives from pressing, forcing something out, just as one presses out the juice from an orange, but the question is knowing what the thing is that is being forced out, where it comes from, and where it is going. So, let us treat the problem as a genuine question: what is expression?

II.1.1 Definitions

Theories of expression are many, but, aside from recent theoretical and critical points of view which aim to circumvent the issue, they are all incomplete. First, they all stress more or less exclusively only one single aspect of expression. Secondly, they have implicitly answered one and only one of the two vital questions: what and how. What exactly does an expressive work express? What does expressiveness express? And by what means does a work make itself expressive? What endows it with expression? And always lurking in the background lies an implicit problem: who is responsible for this quality, who legitimises it? Let us outline four basic definitions of expression.

The pragmatic or spectatorial definition. A work is expressive if it induces a particular emotional state in the viewer. The key example for this model is surely music, which is said to induce the most direct, the most intense feelings through rhythmic composition. Musical rhythm, to which we have become increasingly exposed, like it or not, certainly has a more physical, more unavoidable and more immediately experienced effect on us than any image. Even in cinema, music has always been the most emotive element and has been intentionally used to that end. So, theories of expression in terms of emotive power, once applied to images, are usually based, explicitly or implicitly, on the musical model (as in the example of colour below).

211

This definition in terms of the viewer's emotion rarely comes alone, but is usually accompanied by one of the other three models. By itself, it says next to nothing about *what* it is that produces emotion. Hence theories based on this model have tended to emphasise the expressiveness of the medium before its *mise en forme*. What is considered expressive in music is rhythm, or the timbre of instruments and voices (the broken or at least blurry vocal timbre preferred by blues singers is one example). Studying images in the same way, one would look for universal, simple elements, easy to describe, which would always move the viewer (colour, of course, but also contrast: chiaroscuro has always been used for a powerful emotional effect).

The realist definition. Expressiveness is what conveys reality. In this theory, the elements of expression are elements which allow us to sense reality. This recent view occurs in contexts which impute to reality a profound, or potential, importance. Combined with the first definition, that of *moving* the viewer, it forms the notion of painting that prevailed in the 18th century. Diderot, for example, argued that a painting must be visually stunning; it must 'attract, stop, fix' the viewer. But it can only do so if it depicts real passions, if it makes the viewer quiver with recognition at reality. In less spectacular styles, this definition is given to works which seem more transparent. These can only move the viewer if he or she accepts a transfer of emotion on to the reality the works represent. Hence the viewer of neo-realist films is said to be moved by the real misery of *The Bicycle Thieves* (1950); De Sica claims to 'express' the reality of unemployment in Italy at the time.

The subjective definition. Expressive is that which expresses a subject, usually the work's creator. This definition appeared relatively recently in history, since it assumes not only that one recognises the notion of a person as subjective, but also that this subject is endowed with a unique right of free expression. Gestures and mimicry, for example, have long been held to be expressive when they reproduce a *code* of conversation and manners, when they conform to a sort of universal catalogue of behaviours. The idea that one can 'express oneself', that is to say, that one can express one's 'self', has only existed since Romanticism. This point bears repetition in an era in which we consider the expression of our subjectivity as normal, even desirable, to the point of being integrated into the educational curriculum. As this notion has come to predominate, it has come to require less explanation, to the point that today we automatically assume that a work of art 'expresses' its author before we ask any other questions of it. While this may be true of Van Gogh or the Fauves (expressive by almost any definition) we also project this notion on to films, variety shows and advertisements, in other words, to all of everyday life. I leave readers to supply their own examples and to express themselves a little in doing so.

The formal definition. Expressive is work the form of which is expressive. This simple formulation obviously hides a major problem. How do we know whether or not a given form is expressive? In most cases one

could also refer to one of the definitions given above, but the formal definition is more interesting and demonstrative when it is undiluted, that is to say, among theorists who believe in the expressiveness of form itself. There are, or have been, two main varieties of this belief. On the one hand, one may refer the form of a work to a catalogue of forms and stipulate which are the more expressive forms and which less so. In this view, expression is regulated by society. One example might be ancient Egypt (although we do not yet know if the pharaohs' artists entertained notions of expressiveness). The epoch of Louis XIV was surely another such epoch, as was the Soviet Union in the age of Socialist Realism. On the other hand, one might consider form as 'living' or 'organic', and then its expressiveness would not be much different from that of any other living organism. This notion flourished in our century in the wake of abstract painting and its cult of 'pure' plastic values.

This last idea has often been taken up in twentieth-century aesthetics, which has been tempted to make the concept of 'the life of forms' more and more autonomous, perhaps too much so. In the 50s, for example, the American philosopher Suzanne Langer elaborated an approach defining art by its idealist and transhistorical goal: its 'expressive value'. Expressiveness is not only present, but present in the same way in all works of art, Langer asserts. What is expressed are *feelings*. Expression is thus the embodiment of an abstract form; it is what gives symbolic form to feeling. From this point of view, if non-imitative art, art which transforms reality, can be strongly expressive, so too can imitative art, providing it avoids the mere copying of apparent reality and devotes itself instead to 'anchoring naturally expressive forms'. Unsymbolised emotion escapes the representational process, so that genuine reality can only be transmitted through abstraction and symbolism. Thus art always implies a process of abstraction. There are, of course, many other possible definitions, and even those given here are often combined with one another. An art historian like Gombrich will insist that expression is played out on the formal level. If art has natural components (colours, graphic forms) which evoke reality, it is above all made of historical and contextual components which refer to a history of form, and thence to the historical locus of the viewer. For Gombrich, expression is extrinsic, not immanent in the work. Conversely, for a critic like Duthuit, expressiveness of form is inseparable from the desire of the painter as subject, and it is always evidence of a successful encounter with the real: it is intrinsic to the work and manifests its living nature.

II.1.2 Critiques

This overview of the main definitions allows us to understand why the notion of expression has posed such problems: its definitions shift according to a society's aesthetic values. As a symbolic function, expression always co-exists with (but is separate from) signification: it always appears more or less to complement some primary function

(usually representation). Expression lies at once within the work and outside it, unchanging and yet historically defined.

So there has been no shortage of critiques, from those which try to define expression rationally to those which throw it out altogether. Of the former, the most impressive example is the work of Richard Wollheim. Within a framework of rigorous analysis, Wollheim has undertaken a complete redefinition, not just of expression, but of art, from which it is inseparable. Opposed to the still dominant institutional theory of art that holds art to be whatever is socially recognised as art and nothing else, Wollheim tries to provide an intrinsic definition: art is a realm of human productive activity which, like language, has a symbolising function and its own 'life' (Wollheim takes up Wittgenstein's term *Lebensform*, life-form), whether considered from the point of view of the artist or of the viewer. He concludes that there are indeed artistic *intentions* and that art requires apprenticeship.

The idea of expression investigated by Wollheim is a prime example of art's particular properties, those which force one to go beyond any merely materialist 'presentational' idea of the art work. His line of argument is deliberately complex and defies a simple summary. On the one hand, he refutes those definitions we have called 'subjective' and 'spectatorial' because they place expression outside of the art work. On the other hand, he follows Gombrich in asserting that expression cannot be assumed as a given in the work. Just when he seems to be refuting all possible definitions, his solution emerges: a sort of dialectic between a 'natural' or 'immediate' component of expression (derived from the artist's ego) and a 'cultural' or 'arbitrary' component (derived from the history of forms). The whole would have meaning only in relation to his definition of art as a 'life-form'.

But the whole notion of expression in general, and those definitions which relate to human subjectivity in particular, were the target in the 60s of an even more radical philosophical critique presented by deconstructivists such as Jacques Derrida and Julia Kristeva. They primarily criticised the model of signification that implicitly underpins the notion of expression; indeed the very notion of expression assumes that one 'privileges' the thing which is signified at the expense of the 'work' of the signifier. Correspondingly, what is denied by this critique is the idea of a 'centred subject', self-aware and 'full', who meets the work in broad daylight. Derrida, Kristeva and many others besides go back to the Freudian concept (sometimes as it was reformulated by Lacan) according to which the subject exists only in a continuous process of construction by the play of all kinds of signifiers. It is a game of which the subject is never the master, and which is largely played out in the unconscious. To speak of an artist's 'expression' would, to these writers, be only a decoy, based on a faulty notion of the subject. Expression is once again reduced to a formal coding of expressiveness, denounced as a product of signifieds and dependent on conscious production. These critics were interested foremost in literature and the play of language (an important

aspect of Derrida's early works is his critique of the subordination of the oral tradition in the philosophy of language and the privilege accorded to writing, *écriture*). These theorists and philosophers have exerted a considerable influence on theories of the visual arts, particularly the cinema. Around 1970, for example, one finds in *Cahiers du cinéma* essays by Pascal Bonitzer, Jean Narboni and Jean-Pierre Oudart, unsubtle condemnations of the concept of expression in films as an obsolete, subject-centred and logocentric approach to art. Film-makers such as Bresson or Straub are praised for having created works which are not so much inexpressive as drained of any will to expression. More recently, and in a more systematic fashion, Marie-Claire Ropars has continued the critique of the 'logocentric' model, seeking to reveal in several film analyses these processes of *écriture* as Derrida defines it.

II.2 The Means of Expression

As our exposition of the contradictory definitions demonstrates, it would be utopian to try to provide a universal definition of expression. As a working definition, we shall say that expression is aimed at an individual or collective viewer, that it conveys meanings extrinsic to the work and uses specific techniques and means which affect the work's appearance, which will be examined below.

II.2.1 Materials and Form

All current definitions of expression argue for a sort of apparent autonomy, even an exaggeration of the formal aspects of the work. Either form itself is stressed, underlined, even distorted at times, or the process and work of transforming the raw materials is made apparent and insisted upon. The first means of producing an 'expressive' work then, often consists of using 'more' materials, or rather to make it appear as if it is 'material work', in both senses: the artist works the material, and tries to give the impression that in the finished work it is the materials which do the work. The prime examples of this technique, as one might expect, make distinctive use of the most basic plastic values.

The surface of the image. In the 60s and 70s we saw a great many very large paintings which yielded a very specific (expressive, if you will) effect due entirely to their size. Chuck Close's giant portraits, some of them over two metres high, are meticulous blow-ups of photographs which in themselves reveal little physiognomic expressiveness. Part of their attractive power is their disproportion, including the disproportion between the neutrality of the original photograph and the very large space they occupy on the canvas. But the surface can also be worked in its thickness, and one can make it visibly expressive in the quantity, solidity and material quality of what is placed there. Layers of pigment, thick paint barely out of the tube and modelled by the painter's touch are techniques that have become familiar for at least a century. In recent decades, this idea has been taken further with the use of all sorts of surface materials, some of them improvised, such as sand, soil and bits of

objects (the New York painter Julian Schnabel quickly rose to fame encrusting bits of broken crockery on to the canvas).

The link between the physical presence of the materials and expression is felt so strongly that some have tried to create a cinematic equivalent. The painter and film-maker Patrick Bokanowski tries, in his films, consciously to escape what he regards as the curse of the photographic image: the fact that it *documents* something. The technique he employs to this end is to multiply the ways his images are 'materialised'. In *Déjeuner du matin,* for example, his strategies range from using non-perspectivist decor to placing semi-transparent substances in front of the lens, visibly demonstrating signs of manipulation.

Colour and plastic values. All theories of painting since the advent of abstract art and all theories of 'abstract' or 'painterly' cinema have stressed the expressive role of colour. Most twentieth-century artists interested in expressive visual effects have played with colour, from the thick black stripes of Soulages (which also incidentally play with the slight unevennesses produced by the brush-strokes) to the coloured orgy sequence of *Ivan the Terrible.* So it is even more surprising to have to report that a theory of colour is still almost totally lacking. This value, perhaps the single most important one for the painter, and surely the easiest to control, has only given rise to a metaphorical discourse. We see musical metaphors (presumed equivalences between certain colours and certain sounds) giving rise to fanciful systems. We hear of physiological metaphors, the best-known one deriving from notions of temperature (red is 'hot', blue is 'cold', and so on). We have also had symbolic metaphors which take up, sometimes unconsciously, ancient parallels (red for blood, gold for power, deep blue for the heavens, and so on). All these, and others, have been continually copied and combined by plastic artists, from Kandinsky's lectures to the Bauhaus to Eisenstein's essays on montage. These approaches are not without interest, but they cannot be called theories, not even embryonic ones.

Forms as such. The catalogue of forms is infinite, and a theory of forms is even less developed than that of colour. Klee's or Kandinsky's thoughts on the line and its adventures are fascinating, but depend on fictions (lines which 'dawdle', lines which are 'in a hurry', 'unbalanced' lines and so forth). There remains the practice of art, which has shown that forms, elementary or complex, have been considered as important expressive elements. As for cinema, the inexhaustible Eisenstein wished to include 'graphic contrast' among the many parameters which determine the relation of one shot to the next in one of his early theories of montage. But it is in painting that we find the widest range of such techniques, from the geometric works of Feininger or Krupka, to Sonia Delaunay or Vasarely, from Sam Francis's mouldings to Jackson Pollock's 'drippings', from Hartung's scratches to the 'savagery' of André Masson, from Tachism to *art informel,* and so on. It is impossible here to attempt even the sketchiest typology, except perhaps to distinguish between 'intrinsic expressiveness', which would argue that the tri-

Figure 36 Cinematographic means of expression: the frame and grey monochrome. Alain Resnais' Hiroshima mon amour *(1959) with its filled frame and grainy skin textures; Yasujiro Ozu's* Late Spring *(1949) with a frame emptied of human presence and mineral textures.*

angle, more pointed than the circle, would be felt as more aggressive (one finds this hypothesis in Kandinsky, but also in Arnheim, Gombrich and Eisenstein, to keep to authors already cited), and 'extrinsic expressiveness', which would derive from the trace of the painter's gesture and would keep a dynamic link with it. Thus the same sinuous line can be carefully drawn (as with Kandinsky) or thrown angrily on to the canvas (as with Masson), each conveying a relatively different expressive quality. Stan Brakhage made a similar argument for the shakiness of his camera movements, claiming they were a direct expression of his physical being.

II.2.2 Style

Although the list of expressive elements may not be very long, it is clear that they can be combined in an almost infinite number of ways and that a rational theory of expression based on its basic elements is still a long way off, mainly because expression is never absolute. It is always supplemented by an ensemble of conventions, in the common-sense meaning of the term, of what is acceptable, normal or extraordinary, in short, by a *style*. This concept is by no means as simple as it appears, and depends on two semi-contradictory realities:

- that of the individual – 'style is the man' – It is in this sense that Roland Barthes, in *Writing Degree Zero*, opposes the individual level of style to that of writing; it is also the sense in which much everyday language uses the term;
- that of the group – this would be a period style or that of an art movement or school, such as the Baroque, Louis XIV or the followers of Ingres.

These two definitions are not incompatible. Individual style only translates choices made by an individual in reference to a style in the second sense, even if an individual modifies the group style somewhat. The Gothic style was thus reappropriated during the 19th century. Looking back, one sees less a growth of individual neo-Gothic styles than a group style, such as that of the Pre-Raphaelites. In this century, a more fluid style akin to the drawings of children has been championed by artists as different as Klee and Dubuffet: but although we could describe one or the other's style 'child-like', the styles are also marked by the schools to which the artists belonged, the Bauhaus and *art brut* respectively.

But whichever definition one adopts, style is still defined by a number of choices, not only regarding materials and forms, but also of representational, figurational elements, that is to say, the choices that make up the *mise en scène*. It is precisely because style affects *everything* about the work that it is so hard to define. As for its expressive power, it stems from the simple principle that style is most expressive when it is new. This is true for individual styles, and the search for innovation, for

218

feeling, has been among the overtly acknowledged goals of art since the 19th century. Christian Boltanski put it well: 'The goal of painting is emotion, and the unexpected is what excites it.' This may even be more true of group styles, which only define themselves in opposition to what went before: Neo-classicism is a reply to Rococo, Romanticism to Classicism, and so on.

These examples also repeat themes from our previous topic, since style also defines itself in relation to raw materials, to preferences for particular forms and colours, and so on. But it is most often the elements of *mise en scène* which have been the key to the definition of styles. For instance, take the example of light. A whole history could be written of the representation of light in painting, from its depiction in Italian thirteenth- and fourteenth-century paintings as golden, to early-twentieth-century efforts to depict electric light and the Futurists' efforts to render splashes of luminous particles, each one separately. This history would touch on the different ways of representing light as 'material' and as colour, from yellowish (Raphael) to bluish tones (Constable), white or red ones. It would bear the mark of successive conceptions of what light is: rays, waves, atmosphere. Above all, such a history would show the variations in the *mise en scène* of lighting from Caravaggio's and Rembrandt's chiaroscuro, where light denotes important areas, to the 'luminous' painters from Velasquez to Vermeer, for whom light bathes objects, envelops them and links them one to another. At each stage of this history, the style of representing light brings with it a sense of the ensemble. If Rembrandt's light poking holes into the shadows is dramatically expressive, Constable's clouded landscapes are atmospherically expressive.

Photography, cinema and even video have also had their styles of light. This is obvious in the case of 'mainstream' cinema, where lighting has its own technical specialist, the director of photography, also called the lighting cameraman or cinematographer, that most highly paid and highly regarded of technicians (many directors would envy the reputation of Nestor Almendros). In mainstream cinema, light is created to order. Styles of cinematic lighting have been diverse, and some cinematographers and directors have had their own personal lighting styles. Josef von Sternberg, who played both roles, is a case in point. To convey claustrophobia and growing madness as required by a script, Sternberg's penultimate film, *The Saga of Anatahan,* depends equally on oppressive decor, a very extrovert direction of the actors and a constant division of the image into lace- or trellis-like patterns of light and dark, creating a cagework which encloses and devours the characters. Even more so than in painting, cinematic lighting evokes the expressiveness of the image because films consist of light-images. Cinema does not simply represent light, it is made of it (*see* Chapter 3, §III.1).

Another example is the close-up. The close-up was mentioned earlier (*see* Chapter 3, §I.1.4) to illustrate the separation of plastic space from the viewer's space, and we noted that it was quickly recognised as one

of cinema's strongest expressive devices. We should add that there have been different styles of close-up. The human face was the first object favoured with close-ups and a film-maker like D. W. Griffith, for example, always used it to stress the facial miming of emotion in moments of high drama. From the 20s onwards, the European 'art cinema' sought to extend this technique to endow *objects* with expressiveness. When Béla Balázs spoke of 'physiognomy', he was thinking not just of faces, but also of landscapes, still-lifes, close-ups of *things*. Defending the close-up, Jean Epstein's famous book, *Bonjour cinéma*, juxtaposes tears flowing from an eye with a telephone, the expression conveyed by a mouth with a ladies' watch, and so on. If the close-up seemed to exhaust all its expressive possibilities during the 20s, Dreyer's *Jeanne d'Arc* was in a way its apotheosis. But many film-makers since then have used it to great effect, either to make a particular point emphatically (think of the close-up of Kane's mouth moaning 'Rosebud' at the beginning of Welles's film), or in more systematic ways: Sergio Leone, for example, is the master of using the close-up in conjunction with the wide screen. However, there is no need to dwell on such examples since the whole of art history teams with them. One last word on the means of expression, though: in his book *Cinema: The Movement-Image*, Gilles Deleuze categorises images of the human face as ('*image-affection*', or rather, affect-images). Images of disconnected, empty spaces preyed upon by light, shadow and colour, he calls 'any-space-whatever' or 'indifferent' space.' In film, the *image-affection* is that in which expression has an invasive, overwhelming, exclusive nature. As for 'any-space-whatever', it is that of the canvas, the screen, the image: the plastic space from which the viewer is always separated. What Deleuze points out about the cinema, and it could be applied to images in all their incarnations, is the expressive importance, the expressive potential inherent in an image's elements *prior* to their *mise en forme*, to their being shaped (when these elements are still indifferent and unspecified).

II.2.3 The Distortion Effect

The greater a style's novelty, the greater its chance of being regarded as expressive. This principle holds for expression in general, and it is one of the more frequent variants of the *formal* definition of style: the expressive work is that which is striking, which looks like nothing else known, which is innovative, which is plainly and obviously inventive. Formal innovation has always occurred in the history of art by the creation of a break in any given stylistic context. We are all familiar with this feature in the history of art. Anyone can recall the successive scandals created when Impressionism, Fauvism and Cubism successively ruptured an established stylistic tradition. Monet's *Impression, soleil levant,* which gave its title to a movement, was certainly considered a particularly expressive work in that it offered a radically new solution to the question of how light at daybreak should be represented. Monet in particular insisted on the diffusion of light in the air. In the same way,

*Figure 37 Deformation: In this drawing by Eisenstein (*The Capture of the Peon, *a sketch for an episode of* ¡Que Viva Mexico!, *1931), as in the photography by William Klein (*Revolver, *1954), it is the disproportion between foreground and background and the exaggerated perspective which provoke the effect of distortion.*

the first Cubist compositions were said to express more accurately a certain 'objective' quality of their models, and so on.

What we are trying to emphasise here is an almost universal link between innovation and distortion. The expressive work is very often the one which surprises by its formal freshness at the cost of appearing distorted. The very idea of distortion is, of course, suspect, since it can only occur in relation to a supposedly legitimate form. In an absolute sense, distortion cannot exist at all. Nowadays, we are used to finding some interest in just about any representational or non-representational convention, so there is no need to repeat the accusations which have been brought against just about every style considered a little too 'strong': that is to say, that it 'distorted' something (expectations mostly). Since the beginning of the 16th century, Michelangelo has been reproached for the unaccustomed intensity of his violence, his *terribilitá*. The idea of distortion, on the other hand, is interesting if one avoids its normative overtones. Certain styles distort images systematically in relation to a realist depiction of the visible. The notion of some absolute objectivity in representation has been abundantly criticised, and we have no intention of turning about-face now. The point is rather to look at works which have concerned themselves with the *meaning* and the *direction* of these distortions. In studies of 'primitive' arts (such as Jan Deregowski's), trying to explain the 'lateral' representational style of the North American Indians, or the enormous graphic simplifications encountered in certain African images, such forms are considered in relation to grand symbolic schemata. Following Deregowski's thesis, more or less, these are ex-

221

pressive distortions established, and rigidly maintained, by conventions of expression. They violate visual objectivity in order to include interpretations of the visible in their representations. Distorting styles are always schematising styles.

On the other hand, at the root of what is regarded as a distortion, is always a sort of localised over-enlargement or exaggeration of some aspect of the image: a visual effect which gives the image expressiveness. Impressionists distorted the academic painters' sense of visual reality because they exaggerated the effects of light; Fauvists did the same with colour, and both immediately acquired an extra measure of expressiveness. Around 1910, the notion of *art nègre* transformed an Ashanti terracotta statuette or a Baul mask from a primitive fetish into a powerfully expressive art work. Both exaggerate, in very stylised ways, certain physiognomic features. The exaggerated effects of montage which silent film occasionally over-used were a severe distortion of documentary reality, but, for a while, they were an inexhaustible source of expressiveness.

It may well be that, basically, expressiveness springs from distortion. But our survey of distortion-effects has also, yet again, pointed out that there are two aspects to expressiveness:

- an historical aspect, linked to the rise and fall of styles, their wasting away, their gradual movement, their accents, their transformation and their distortions relative to one another;
- an ahistorical aspect, because some elements, some contrasts, some values, seem to keep their expressive power whatever their deployment in history. Gombrich gives an oft-cited, enlightening and amusing example: 'ping' and 'pong'. Dozens of studies undertaken in different contexts show that these two almost meaningless words are felt to contrast one another on the level of expressiveness. 'Ping' is sharper, colder, bluer and so on; while 'pong' is rounder, warmer, redder, etc. However one takes that example, it stands for the existence of some sort of universal expressiveness (of which we could select other examples, from facial expressions to make-up).

II.3 The Example of Expressionism
It is worth devoting some space to the discussion of expression since it has sparked so many important debates in aesthetics, particularly in this century. These days, it goes without saying that an image is expressive, even that it is made to be precisely that. Moreover, we all have a more or less standard, 'spontaneous' idea of what expressiveness might be, a kind of cross between a subjective theory and a formal one: we consider an image to be expressive when it expresses its author by means of some sort of 'shock of the new'. This catch-all notion did not drop out of the blue: for the most part, it arose in the context of the development of one of the major artistic movements of the early 20th century: *Expressionism*. The usage and the definition of the term itself, and even more so of the

222

adjective 'Expressionist', have increasingly extended their scope over the years, and here we will simply try to sketch the contours of that semantic field while at the same time touching on some examples of *expressive* images.

II.3.1 Expressionism as an Art Movement

The critic and art historian Wilhelm Worringer who wrote, among other works, *Abstraktion und Einfühlung* (*see* Chapter 2, §III.2.2) coined the term 'Expressionism' in 1911 to distinguish a group of works shown in Berlin, notably by the Fauves (Derain, Dufy, Braque and Marquet), which he opposed to Impressionism. From the outset, the label became immensely popular and was applied to poetry (before 1914), to theatre (after 1918) and to the cinema (after *The Cabinet of Dr Caligari*, 1919). In 1921 Yvan Goll described the success of the term Expressionism as 'a state of mind which in the intellectual sphere has infected everything like an epidemic, not just poetry but also prose, not just painting but also architecture, theatre, music, and science, universities and educational policy'. The impression we have, some seventy years later, is that an entire generation of German artists and intellectuals from 1920 or so were Expressionists and nothing else.

This impression is only partly justifiable. Few of the artists in question failed to be affected by the movement in some way, even if they rejected it, as did Fritz Lang and Bertolt Brecht (after his first two plays). Long after the end of the Expressionist 'school' in the 30s, German intellectuals exiled in Moscow still considered the debates concerning the nature of Expressionism to be very important in directly ideological terms: was it a revolutionary movement or did it facilitate the rise of Nazism? This was the famous *Expressionismus-Debatte* in which Brecht, Lukács, Feuchtwanger, Herwarth Walden, Ernst Bloch, Béla Balázs and many others participated.[2] Note that for the Germans themselves, it was literary, poetic, and theatrical Expressionism which was the issue insofar as it tackled philosophical themes of utopia and hope.[3] These themes are evidently more difficult to convey in the plastic arts. To remain with painting, Expressionism had a real and long-lasting influence. Matisse's 1908 *Catéchisme fauviste* states: 'What I am seeking above all is expression . . . I cannot distinguish between the feeling I have of life and the way in which I translate it.' This is an Expressionist claim if ever there was one. After the 1911 Berlin Secession exhibition, Expressionism was given a more theoretical formulation by major critics such as Worringer, Walden and Hermann Bahr. Expressionism, then, is opposed to its predecessors, Impressionism and Naturalism/Realism, as an art of interior need rather than of exterior reality, of self-projection rather than imitation of nature. But soon the term came to encompass all the important trends of the decade, putting them all in the same bag. In a 1914 lampoon, Bahr sticks the Expressionist label on Matisse, Braque, the Fauves, the Blaue Reiter group (Klee, Kandinsky, Fanz Marc), Die Brücke (Nolde, Schmidt-Rottluf), the Futurists and the

Figure 38 Expressionism and cinema: the prototype (The Cabinet of Dr Caligari *by Robert Wiene, 1929) and the pastiche* (Pierrot lunaire, *Shaffy Workshop, 1988).*

early Cubist Picasso, and for good measure he throws in Negro and Gothic art as well.

This imperialism of Expressionism reached its apogee after the First World War when there were furtive dreams of an Expressionist architecture and above all of an Expressionist cinema. *Caligari* was, as we know, a premeditated coup designed by the clever producer Erich Pommer to cash in on the movement's fame. It succeeded beyond his dreams, and many films with fantastic or mythic content and decor came to be labelled 'Expressionist', either through a genuine confusion between their visual overload and the principles of the painters' movement, or because it made for a cheap advertising slogan. In 1926 Rudolf Kurtz published his little book *Expressionism and Cinema* in which he threw in such films as *Genuine* and *Raskolnikov* (made to exploit the success of *Caligari*), as well as the abstract films of Ruttmann and Fernand Léger's *Ballet méchanique*.

In short, terminological confusion reigned. After the Second World War, Lotte Eisner's book *The Haunted Screen* did not help matters. Easy to misread, Eisner's work seemed to say (but does not) that all of the German cinema of the 20s stood under the sign of Expressionism. Around 1960 a still current myth sprang up labelling as 'German Expressionist cinema' films as diverse as *Caligari*, Fritz Lang's *Metropolis* and *Mabuse*, all the way to the works of F. W. Murnau. This is not the appropriate place for the exposition of a detailed critique. Suffice it to say that, like any myth, it has had interesting symbolic effects and even beneficial ones. But it has only a remote relation to being an accurate account of history. The Expressionist movement only had one incarnation in the visual arts, and that was in painting (and a little in sculpture), before 1914. It was the champion of formal and subjective expression, and it is in relation to these aims that we shall outline its principles.

II.3.2 Expressionism as Style

Expressionism can be characterised by three basic features:

The refusal of imitation. 'In Expressionism ... representation is no longer what is represented. The actual, concrete representation is merely an invitation to grasp what is represented. In a way, what is represented begins only beyond the canvas, beyond the play, beyond the poem' (Herbert Kuhn, 1919). Earlier we noted that the loss of the optic reference, and even of the representational reference, is doubtless the key event of the recent history of the image. What the Expressionist ideology adds is precisely this notion of something *beyond* representation. If the image begins where the simple function of representation ends, it only has interest, that is to say, existence, inasmuch as it relates to this beyond. The Expressionist refusal of representation is not negative in nature, but a desire to go further, to let the image reach a representation of the invisible, the ineffable, the transcendent. From this point of view, Expressionism is the direct heir to those aesthetic movements of the 19th century from Romanticism to Symbolism. They had prepared

painters and the public for the idea that painting could use the figurative to convey the world of the divine (as with Caspar David Friedrich), the world of dreams and nightmares (as with Füssli), the world of fantasy (Odilon Redon) or that of myth (Böcklin).

The exacerbation of subjectivity. 'We must create reality ourselves. The meaning of an object is to be found beyond its appearance. . . . One must give a pure, unaltered reflection of the image of the world. And this can only be found in ourselves' (Casimir Edschmid, 1918). This is perhaps the most important point: through this somewhat naive subjectivist creed, Expressionism fixed a concept of expression as a whole which is still very influential. A study of one minor field such as comic strips (minor in the institutional sense) would be very enlightening in this context. Comic-strip art, especially in some of its most skilful products, quickly adopted Expressionist forms (helped from 1906 on by such moonlighters as Lionel Feininger). Its stunning growth in the 70s was facilitated by the then fashionable notion that 'personal fantasy' self-evidently needed and deserved to be expressed, and by the limitless value ascribed to subjectivity, believed to be all the richer the more it was promoted as 'personal' (evidenced by the bizarrely megalomaniac oeuvre of Phillipe Druillet).

The importance attached to materials. Here, every reader will be reminded of the received wisdom that Expressionism is the art of applied contrasts, of the broken and tilted line, of pure colour thrown onto the canvas in defiance of naturalism. This cliché is not entirely false and these views, linked more to the materials than to form, were indeed held by Expressionists of good standing such as Kirchner, and especially by Ludwig Meidner. It is this received wisdom which allows some careless critics to apply the 'Expressionist' tag to Hollywood's *film noir*, with its stark contrasts of black and white, or much of the above-mentioned comic-strip art, which is *noir* in its own peculiar way. But this is a very simplified notion of Expressionism, one almost never expressed either by the artists or the critics of the period. In 1919 Wilhelm Hausenstein characterised Expressionism by the disappearance of categories such as light, atmosphere, tone and nuance, the end of the 'joyful cult of *Stimmung* [atmosphere]'. In exchange, he affirmed the 'object-hood' of things and enthused over simple forms and dynamism. For him, Expressionism was the art of the 'centric' (contrasted with the 'acentricity' of Impressionism), of essentiality, of symmetry, of the static. This confident and adventurous affirmation is translated in plastic terms into an extremely structured, almost geometric aspect.

Hausenstein's text and others of his time may seem vague, since it is very difficult to give a list of characteristically Expressionist forms. The dangers of classifications are only too clear in all the slapdash versions of Expressionism doing the rounds. So, it bears repeating that despite Expressionism's cult of strong shapes and its ideological commitment to avant-garde abstraction, it is more often characterised by a short-circuiting of form, by a so-called 'direct' relation between materials and

feeling, even among artists whose approach most resembles pure abstraction. 'Cold calculation; blobs of paint spontaneously bounding forth, precise mathematical constructions (overt or hidden), mute or screaming drawings, meticulous finishing touches, from trumpet blasts and pianissimo tones of colour, large, peaceful, heavy; fragmented surfaces. Isn't this the form? Isn't this the way?' asks Kandinsky in 1910. Yet to this deliberately mixed-up list he adds:

> Souls in torment, suffering and searching, deeply wounded by the collision between the spiritual and the material. To find what is alive among the living and 'still(ed)' life (*nature morte*). Consolation found in the way the world appears, outside and inside. The idea of joy. The call. To speak what is secret through secrets. Isn't that the content?

One could not put it better: Expressionism does not have one single form. It bends forms to its double desire to express: to express both the soul and the world as one. As Hausenstein put it: 'Painter and object face each other. Both open up together, folding back their outer envelopes like wings to fuse their naked interiors.'

Excess. This additional term (only the first three are needed to define Expressionism) is not given simply to try to be exhaustive, but rather to isolate the core of what it is about Expressionism that still fascinates us. The Expressionists fought against what seemed to them a too-peaceful object-oriented way of painting. They sought to unleash the expressive power of materials and form to produce vision, to produce the most arbitrary and highly idiosyncratic interpretations. It is surely this excess, this unleashing, which must have seemed so attractive to those who later sought to match it. Expressionism indissolubly yoked artistic expression to emotion, in all its brutality and inalienability. In this sense, we are all still a little Expressionistic.

III. The Auratic Image

III.1 The Artistic Aura

III.1.1 What Is a Work of Art?

In the first two sections of this chapter, we have drawn attention to two major currents in twentieth-century art, the question of abstraction and that of the image's expressiveness. However, in doing so, we have tended to put the cart before the horse, since we have assumed that the basic question of what constitutes an image's artistic value has been settled and is generally known and accepted. On a day-to-day level, we may all have an idea of what is, or is not, art. But the precise definition of this quality, the limits of its domain, elude us. In fact, one of the more frequent experiences is that of feeling disturbed by shifts and changes in its terms of reference.

There have been many ways of defining art, each corresponding to a more or less hegemonic dominance of one particular ideology over

others. Academicism, for instance, is a purely ideological epiphenome-
non which holds that the art of painting resides in two essential values:

- Art relates to spiritual values, giving the viewer access to them, and
 the artist's duty is to cultivate those values. In the 19th century, the
 values are those deemed to be embodied by an eternal and largely
 imaginary Classical Greece: beauty, harmony, equilibrium, and so on.
 Conversely, art cannot and does not have any utilitarian value, nor
 can it be basely materialistic. Consequently, art must take care to
 avoid any direct reference to the contemporary world. Hence the
 Academy's condemnation of early Realist painters in France;
- Art is the privileged domain where 'formal perfection' is to be re-
 alised. The artist is one who is able, after showing he or she can mas-
 ter form and is a technical virtuoso (the avowed goal of the Prix de
 Rome competition), to go beyond virtuosity and put it to work in the
 search for formal perfection. The origins of this idea of perfection are
 to be found in an idealised understanding of the 'classical' art of
 antiquity.

Similarly, the Renaissance's notion of art can be summarised in
terms of two defining characteristics:

- The love of technical virtuosity; but it is a virtuosity which does not
 need to be dissimulated since it is the site and the sign of the artist's
 continuous experimentation, a process in which he or she should take
 great pride;
- The link between art and science, the latter being understood as syn-
 onymous with what we now call philosophy (although a certain
 amount of vagueness is allowed for in this overlap between science
 and philosophy). Painting is deemed to be a discovery of the world,
 of its laws, of its deepest meanings. Painting is a form of thought.

One could catalogue as many ideas of art as there are epochs and so-
cieties, but such a catalogue would reveal two key features:

Arbitrariness. what is missing from all such implicitly or explicitly
coded definitions of art is the idea of their own *relativity*. This is hardly
surprising since this is what ideologies do: they hide, even from them-
selves, in order to make us believe that it is dealing in basic universal
laws. From this point of view, remembering that we, too, are not exempt
from ideological prejudice, reflection about art has made some headway
in realising the relativism of all definitions of art. If today there is a
dominant ideology of art, it is probably what we have called the insti-
tutional definition: a work of art is that which is socially recognised as
such (at least by the art world), whatever the supposed intrinsic quali-
ties of the object in question may be. This is a concept visitors to any
museum of modern art confront daily, as they find themselves looking,
sometimes rather bemusedly, at art works such as a pile of coal, a heap

Figure 39 The Art of Painting: Renaissance and Academicism. Above, Sebastiano del Piombo's The Death of Adonis *(1512); below, Jean-Léon Gérôme's* The Cock Fight *(1846).*

of rotting apples, a cluster of television sets, in short, the 'any old thing' cited approvingly by Thierry de Duve (1989).

The foundational act which inaugurated this slightly cynical attitude was performed by Marcel Duchamp when he installed his ready-mades in the gallery: if a urinal or a bottle-rack can be considered works of art, it is because they have been exhibited in galleries (and now museums); they have been noticed as traces of thought, as artistic gestures, and as soon as a signature has been affixed to them, they can be linked to an artist. No one has gone beyond Duchamp in this regard. De Duve showed that, today, art as a whole is defined by institutions exhibiting it or presiding over that exhibition (leaving aside the awkward fact that these institutions at the same time define and try to impose eminently variable standards of acceptability).

Aura. On the other hand, although definitions of art have proliferated, they all have something in common. This 'something', which we could call the specific nature of artistic activity, is hard to define. At root it is a question of observing that in almost all societies which have known any artistic development, art is given a special value which endows its products with an unusual nature, a kind of prestige, an aura.

The word 'aura' literally denotes the luminous, more or less supernatural, emanation which is said to emanate from certain persons or objects. The metaphor is clear: if a work of art has an aura, that is because it radiates, emits, particular vibrations and cannot be seen as just an ordinary object. This is such a widespread view, one so inscribed in all definitions of art, that we shall only note that contrary to what one might think at first, the institutional definition has by no means abolished the aura of the work of art. Far from it: aura has simply changed its nature, as it has done across the centuries. Byzantine icons had a supernatural aura as a result of their religious function. A Poussin painting derives its aura from the recognised superiority of the painter's talent (also called 'genius').[4] Today's work exhibited in a gallery or museum derives its power from the very fact of its exhibition, which consecrates the work (while at the same time bestowing an exchange value from which art is now inseparable).

As art now appears as a social institution, it follows that it is historically extremely variable. Institutions confer the *auratic* status that defines a work of art to particular material productions, many of them being images. It is worth stressing that, even though the definitions of what an institution is also varies historically and despite the arbitrary forms art has taken, its existence is itself certainly not arbitrary, as is shown by the fact that art has existed in almost all known societies. Art responds to a social need originally linked to a religious need, to the sacred. It has always been linked to a wish to overcome the human condition, to gain access to experience or knowledge of the transcendent.

III.1.2 Mechanical Reproduction and the Loss of Aura
The concept of 'aura' which has been used here to describe the classic

attribute of a work of art was coined by Walter Benjamin. It is worth recalling the thesis of his famous article 'The Work of Art in the Age of Mechanical Reproduction' (1935). Like many of his contemporaries, Benjamin was struck by the proliferation of images, particularly of machine-made and mechanically reproduced images, of which newspaper photographs were the prototype. Against the argument of nineteenth-century critics, for whom the important phenomenon was the camera's role in the production of an image, for Benjamin the issue is reproduction: Is a work of art still a work of art when it is produced in series? And does not this multiplication, this mass reproduction, go hand in hand with a loss of aura, a disappearance of what had been the essence of art?

Benjamin answers in the affirmative: the invention of still photography not only created the means for instantaneous reproduction *ad infinitum*, but in doing so, the *cultural* importance of the work has been degraded in favour of its *exhibitory* value. His theme has been invoked and reworked by many writers. It has become almost banal to deplore how book illustrations, films and television, which daily reproduce thousands upon thousands of artistic images (and fewer and fewer original works), have had an unwelcome influence by making us insensitive to the aura of a work and have diminished our ability really to *see*. True enough, the proliferation of images and their accelerated rate of production have accustomed us only to see the most obvious characteristics at the expense of more subtle but essential traits. Looking at Dreyer's *Ordet* by the standards of modern American cinema, or Vermeer's paintings in terms of how they have been press-ganged into the service of advertising, leads inevitably to a misunderstanding, to an inability to see what is there.

But such readings of Benjamin's thesis are much too one-sided and travesty what Benjamin was saying, as has been demonstrated by Susan Buck-Morss.[5] On the one hand, those vulgarised readings of Benjamin forget that art in the age of mechanical reproduction has found other auratic values (which, of course, can always be contested: it is a question of appreciation). On the other hand, the concept of aura should not be understood as something that is unchanging. What won Michelangelo or Rembrandt the admiration of his contemporaries is not what defines their fame today, and works which we today invest with a strong aura (for example canvases by Vermeer or Georges de la Tour) were seen in their day as quite ordinary. Art in general has no meaning unless one accepts that works of art have an aura, but the nature of that aura and the works in which one recognises it, have kept changing for as long as art has existed. On the one hand, artistic aura has now become associated with institutions (and with the artist's signature), and, on the other hand, to 'historically important' works of the past. But there can be no doubt that this double definition will in turn be replaced in the future. In any case, it is worth no more nor less than those that have preceded it.

III.2 Aesthetics

III.2.1 From the Enjoyment of Images to a Science of Images

The artistic image has thus existed in all ages, and in all ages of recorded history it has provoked discussions and inquiries into its nature, its powers and its functions. This discourse is what we nowadays call *aesthetics*. Invented in the middle of the 18th century and derived from the Greek root *aisthesis* (perception or feeling), aesthetics first of all designates the feelings and emotions aroused by the work of art. This is no longer the dominant sense of the word, but it survives in some studies, notably those of a psychological bent which address the how and why of the specific pleasure[5] linked to looking at images (both artistic and non-artistic, but particularly the former because of the greater sensory and affective charge they are deemed to carry).

In a chapter of his monumental *Handbook of Perception* (1978), Irvin L. Child declares at the outset: 'The central problem of aesthetic theory is the following: why do people enjoy, or seem to enjoy, the act of perception itself?' Naturally, the author knows full well that it is the very existence of art which poses the question most clearly, but the 'aesthetic theories' he proposes are designed to account for aesthetic experiences of all kinds by concentrating expressly on 'the hedonistic value of the experience and acts of the viewer, or, as is often said, the hedonistic value which the perceived object or event is said to have due to the effect it has on the viewer'. In this approach we also find a useful schema for categorising theories of aesthetic pleasure(s), which, among other things, divides theories into the 'extrinsic' (in which pleasure is not assigned to perception itself but to something else), 'intrinsic' (pleasure is derived from features of the image, such as, for instance, harmonious proportions) and 'interactive' (pleasure is derived from the interaction between the image and characteristics of the viewer or his or her situation).

But very quickly aesthetics took on a quite different meaning and came to designate the study of the supposed source of the pleasurable feelings that works of art produce: beauty. In all its manifestations in the last two hundred years of art history, aesthetics is a theory of beauty. It is often said to be scientific, it often aims to prescribe artistic standards, and it almost always oscillates between objective and normative tendencies. Many of the great philosophers of the 19th century had their own aesthetic theories, whether they published them or not. Kant's distinction between sensing and understanding led him to privilege 'judgments of taste', locking his aesthetic theory into a problematic of beauty, creation and genius. Hegel, in the *Phenomenology of Spirit*, wanted to escape Kant's dubious theory of value-judgment. Hegel's aesthetics do not study beauty itself, but the function of art (which for Hegel is equal to that of religion or philosophy: a function of the self-discovery of the spirit).

Many aspects of these idealist philosophies are still with us. For instance, questions raised by Hegel find an echo in Sartre, and, in a

vulgarised form, these idealist notions still exert the most overt and direct influence on the current idea of art as 'creation'. However, two different currents within twentieth-century aesthetics have tended to start from different principles. These tendencies are known by the names of their respective founders: Aloïs Riegl and Benedetto Croce.

The Viennese art historian Riegl is today known for creating the concept of *'Kunstwollen'* ('artistic will'). If artists of a given historical period, especially in those periods which have traditionally been considered minor or decadent, produced the works they did, Riegl says, it is not because they could do no better. Rather, they had a consciously different artistic programme from their predecessors. An era of classicism may seem in our eyes to be 'better', to have created more accomplished and longer-lasting works, but, Riegl says, this is true only from our (illusory) point of view. Each epoch produces accomplished work, not in terms of *our* definition, but in terms of the *Kunstwollen* that inspires it. This relativist and historicist thesis influenced a whole generation of art historians. Panofsky is probably the one who drew the clearest lessons from Riegl: aesthetics is not a science of eternal and absolute beauty, but an evaluation of the equilibrium between an artistic project, a 'local' definition of art, and the products arising from that definition.

Benedetto Croce's project in his book *Estetica* (1902) is quite a different matter. Croce denies all the traditional oppositions, separating out and distinguishing between the arts of sight and of hearing, of space and of time, of stillness and of motion, asserting that there can indeed be a general theory of aesthetics, denying the very possibility of there being 'particular aesthetics'. A Crocean 'aesthetic' would then aim to be as inclusive as possible and would deal with painting and music alike. It could neither be a study of differing specific aesthetics which have existed in history, nor could it be an aesthetic in the normative sense. Croce wanted to found a general theory of symbols free of value judgments (indeed, he says that his aesthetics is closer to linguistics, or as one would say today, semiology). This absolutely ahistorical approach may seem inconvenient, but it has fuelled a major project of reflection on art which examines symbolism in works of art and the understanding we have of it (see our comments on Nelson Goodman in Chapter 4, §I.1.3 and on Richard Wollheim in §II.1 of the current chapter).

III.2.2 Aesthetic problems

As must have become evident from the above, aesthetics is neither a science, nor even a discipline. Yet it is still an active realm of wide-ranging studies, although much recent research on the image has become more specialised and can best be described as semiological or historical studies. At the same time, the approach has become more generalised, as, for instance, in Deleuze's work on a philosophy of cinema, which does despite everything include an aesthetic aspect. One of the most contentious points has been the notion that each art form has its own specificity. Are there or are there not particular aesthetic laws specific to

different socially and historically defined fields of artistic activity? Theorists do study 'deep' phenomena common to all artistic manifestations. An example would be, for instance, the study of the image in general, as we have tried to do in this book, but the appearance in the last two hundred years of new artistic practices based on the mechanical image (photography, cinema, video), has prompted renewed debates on specificity. We already noted how painting, faced with competition from photography in the field of optical precision, quickly moved to new grounds (*see* §III.2.1 above).

These debates have been taken up again in relation to cinema, first to get it accepted as one of the arts, and later, with even greater difficulty, to give it a specific definition as an art form. Riciotto Canudo's *L'Usine aux images* (1927) emphasised not only that the cinema was at least potentially an art form, but that (following his count of the six traditional arts) it was the seventh art. His idea of the cinema as a 'synthesis of the other arts' was much in favour, despite its absurdity if taken literally, and despite the difficulty of adapting aesthetic theory to a completely new form. The debate on the specificity of cinematic art has gone through several phases. First came the attempt to define silent film as distinct from theatre, to which it seemed related. We mentioned earlier such critics as Elie Faure who wished to identify a *cinéplastique* that would put cinema on the same footing with the noble art of painting. But many other definitions have been attempted. Some were based on musical analogies, however dubious (Abel Gance: 'Cinema is the music of light'). Others more simply saw cinema as a mutation of the minor art of pantomime (as many admirers of Charlie Chaplin did, notably Louis Delluc). Even though with the arrival of sound these potential definitions fell by the wayside, the desire to separate cinema from theatre did not disappear. It is interesting to note that it is in theatrical terms that the *Cahiers du cinéma* school and its followers (in the 50s in particular) defended and illustrated the notion of *mise en scène* (*see* Chapter 4, §II.3.2) to define a specifically cinematic aesthetic.

History has in a way repeated itself: a newborn 'video art' has sought to distinguish itself from previous forms, in this case from cinema in particular. If video art has had no difficulty demarcating itself institutionally as different from mainstream commercial cinema, it has had to be careful in marking its boundaries with, on the one hand, 'experimental' cinema, to which it is close in terms of audience, venue, and a great many stylistic and formal qualities, and, on the other, from broadcast television, especially its credit and advertising clips. It is in this necessary process of elaborating the terms of an art form's specificity that technical differences in how images are produced and projected have sometimes been mobilised. As noted earlier (*see* Chapter 3, §II.3.1) this may be less important than it appears.

Nevertheless, such debates on specificity have overshadowed other important questions. It is surprising, for example, how little attention has been paid to poetics in the Aristotelian sense, that is to say, to the

study of the creation, the construction of works. More precisely, the inattention of theoreticians is surprising, since many artists, particularly in this century, have written down their often fascinating ideas on the creative act and the poetry of images. We cited several painters at the beginning of this chapter, but there are equally rich seams to be mined in cinema. Great film-makers from Dreyer to Bergman and Tarkovksy have produced reflections on the creative aspects of film-making. The phenomenon is even more apparent in video art (as it was in experimental cinema) where the work is very often accompanied by long commentaries, manifestos and user's manuals (which, it must be said, are often part of the work itself, as is generally the case with much contemporary art). We should also note the poetics proposed in David Bordwell's studies of Dreyer and Ozu. Bordwell's film analyses are carried out through constant reference to the creation of films, explained mainly in terms of the particular formal and stylistic contexts of production in which the film-makers worked. Bordwell's poetics brings the creative process back to the circumstances in which films are made, with almost no reference to the artists' intentions. Distant cousins of Russian formalist theory of the 20s, Bordwell's studies unfortunately take the Hollywood production and narrative systems as the global norm and assess the poetics of other cinemas, anchored in and negotiating radically different historical tensions, in terms of their congruence with or deviation from that norm, thus erecting a notion of the viewer as conceived in contemporary American psychological disciplines as the standard. Nevertheless, Bordwell's analyses are very productive because of their extreme attention to details and despite the rather mechanistic nature of the stylistic systems he elaborates.

III.3 The Example of *Photogénie*

For the last hundred years, it has been especially the mechanical image which has provoked new aesthetic inquiry. Photography, the first major such mechanical image-making device, was initially thought of only as a gadget that automatically reproduced what the eye sees. It had difficulty in asserting that its images could be art. In this struggle, the idea of the photogenic (*photogénie*) played an important role, even more so when *photogenie* came to be extended beyond photography into cinema.

III.3.1 The Photogenic in Photography

The principle behind the invention of photography was that it reproduced the visible through the registration of traces of light impressions. Not long thereafter, people became aware that this recording, in optic terms approximating the image formed in the human eye, was in fact different, because it did something the eye cannot: it freezes a fleeting moment of the image (see the discussion of time in Chapter Three, §II and Chapter Four, §III). Consequently, photography gave access to a new way of seeing reality. This is the well-known theme of photographic

'revelation': the photograph lets us see what the naked eye cannot. As Kracauer said, it makes us see 'things normally not seen'.

The nineteenth-century English photographer Henry Peach Robinson wrote in 1896:

> Those who have had only a superficial knowledge of the possibilities of our art claim that the photographer is simply a mechanical realist who can himself add nothing to his product. At the same time, some of our critics, not without reason, go so far as to say that our images look nothing like nature. This betrays them, since if we can add untruth, we can idealise. But we go further and say that we can add truth to naked facts.

This extra ingredient is, literally, photogenic power, and one finds it mentioned throughout the whole foundation period of the art of photography, that is to say, until about 1930. It did take a long time before photography was admitted to the realm of the arts, even though it pursued artistic recognition in several different, even contradictory, directions. Around 1900 Pictorialists sought to produce photographic work that was visibly 'artistic', having recourse to retouching, scratching, printing on grainy surfaces to let the 'material' show through (as in the famous gum-bichromate process) and generally multiplying the manipulations of the image. This intriguing approach has returned periodically (notably in the 80s). Nevertheless, Pictorialism defined the expressiveness of photography in the very same terms of painting's traditional plastic values: materials, colour, artistic touch. Therefore, the principles of Pictorialism were contested tooth and nail by those photographers and critics who wanted to found the art of photography on what they called the 'essence' of photography: the unretouched recording of reality. According to Edward Weston (1965), 'People who would not think for a second of using a colander to get water from a well fail to see how crazy it is to use a camera to create a painting.'

There is no doubt that the realist trend has been dominant from the end of Camera Work's Pictorialist school (c. 1910) to the emergence of new manipulative tendencies in the 1970s and 80s. Yet the concept of photographic expressiveness has still not been agreed upon, far from it. Consider, for instance, the two admittedly diametrically opposed positions, which hold that:

- either the art of photography is the art of *mise en scène*, valorising the real, through skilful framing and lighting; and it is only through such technical mastery that photogeny becomes possible. Frank Roh (1929) stated:

> A photograph is not a simple imprint of nature, for it is a (mechanical) transformation of all colour values, even of depth of field, into a formal structure ... Is it enough just to master the tools of photography to become a good photographer? In no way: as in other fields of expression, one needs personality ... This constant individual quality is, as in the other arts, remarkably

236

durable and is enough to show that a good photograph is based on organisation and individuality.[6]

The photographer's art is to show nature in its best light, to draw out intentionally and wilfully its photogenic potential, that is, to express reality;

- or, on the contrary, the photographer should try to efface himself as much as possible, forget technical mastery and let the photograph simply 'happen' (*'advenir'* is the word used by Roland Barthes in his *Camera Lucida*) as though it is always a little miracle. A photograph should uncover something we have not noticed, and which we could not have noticed without it. This 'miraculous' definition is no doubt the more popular idea of the photogenic. This is what we mean when we say that someone is 'photogenic', in other words, that they are 'more beautiful' in a photograph than in person, that the photograph brings out a quality invisible in the flesh. Without going quite that far, many photographers have made such observations: in a successful shot, the photogenic is what touches us, what touches me (in that generalised *me* which changes according to each one's preference). With his notion of *punctum* Barthes has only formalised this definition by deliberately expressing it in a very subjective manner.

III.3.2 The Photogenic in Cinema
If the photogenic has not been easy to define in photography, it has unsurprisingly proved harder to do so in the cinema; there the definition is even more nebulous, even more unstable.

Of course, it was above all in the era of silent cinema that the photogenic potential of the medium was felt most strongly. Indeed, the word *'photogénie'* can be found in the writings of two French film-makers and critics of the 20s, Louis Delluc and Jean Epstein. Delluc initially took it to be the very core of cinematic art, calling one of the first major theoretical works on cinema *Photogénie* (1920):

> Our best films are sometimes very ugly, too laborious and artificial. How many times . . . has the best part of an evening in front of the screen been the newsreels, where a few seconds give such a strong impression that we feel them as artistic. One can hardly say the same of the dramatic feature . . . which follows. Few people understand the importance of *photogénie* and the rest do not know what it is. I would be delighted if one assumed a mysterious link between *photo* and *génie*. Alas! The public is not so stupid as to believe in that. No one will persuade it that a photo can surprise like a work of genius, for no one, as far as I know, believes it can be such a work.

Delluc clearly does not believe in the 'miracle' of photography. For him, photogeny is something that has to be worked for, with 'a maximum of elegance', to be sure. In other words, his definition of cinematic art is nothing more than the art of the director, the *'cinéaste'* (and it is

237

Figure 40 Photogénie *in cinema in the 80s: Philippe Garrel's* Liberté la nuit, *1983 (top); J. M. Straub and D. Huillet's* La Mort d'Empédocle, *1987 (bottom).*

Delluc, let us not forget, who invented the word and defined its use). His colleague Epstein (1921) took a less binary view. It is time that for him, too, photogeny was a rare commodity, defining an aesthetic which he defends and illustrates, notably in the use of slow-motion and the close-up, which are nowadays considered to be the most conspicuous stylistic marks of his films. Epstein doubtless also thought that the art of cinema belongs to the *cinéaste* and that photogeny is won or even earned, one might say. Yet, his writings reveal a more 'miraculous' notion, more like the idea of letting a photograph 'take itself', letting nature disclose itself:

> What is photogeny? I call photogenic all aspects of things, beings and souls which increase in moral quality through cinematographic reproduction. Any aspect which is not enlarged in this cinematographic reproduction is not photogenic, is not part of the cinematographic art.

One can see that this definition is less a definition of the photogenic (which he nowhere clearly defined) than a sometimes polemical defence of a certain type of film aesthetics. Epstein went on:

> I said a while ago that what is photogenic is that of which the moral value is amplified in cinegraphic reproduction. I now say that only the mobile aspects of the world, of things and of souls can have their moral value increased by cinegraphic reproduction ... Photogenic mobility is a mobility in the space-time system, mobility in both space and time. One can thus say that the photogenic aspect of an object is the outcome of its variations in space and time.

The aesthetic Epstein proposed may seem rather flat, insisting that the artistic specificity of film is in movement. In this respect, his essay (and others like it) seems more like special pleading than a true manifesto.[7]

The photogenic power of the cinema was elicited by most of the writers of the silent era, often without uttering the word itself. Photogeny was for a whole generation of critics and film-makers a sort of password corresponding to the *je-ne-sais-quoi* Diderot invoked to define painting. More recently, it has returned more or less surreptitiously in the writings of critics who have rediscovered silent films, such as in Claude Ollier's explanation of his fascination with the adventures of light in pre-war film, and André Fieschi, who together with Noël Burch and André Labarthe layed down the groundwork for a re-evaluation of the 'first wave' of French cinema. As far as recent film-making is concerned, developments have been less interesting. Photogeny has been made trite, and fixed in ready-made formulae. The considerable technical advances in film stock and lighting and the impressive skills of many directors of photography only too often serve merely to enhance rather hackneyed 'special effects'. Some film-makers are aware of this: Eric Rohmer has often lamented the passing of a visual and luminous style that was completely non-stereotypical; Jean-Marie Straub and Danielle Huillet have consciously tried to eliminate spurious visual

effects in order to let reality emerge from the image. In both the cases, photogeny has been made very discrete, colder than in Epstein's work, as if today, photogeny could only survive by its self-effacement.

III.4 Conclusion: The Pleasure of Images

As we have been considering the artistic qualities of images, we have stressed that images exist to be seen, consumed, appreciated and appropriated by a viewer in a particular institutional context, and that art is one such context among others. This consumption of images has its pleasurable side. It is perhaps not self-evident that this visual object we call an image, made for the eye, a 'cold' organ which senses at a distance, might create pleasure. Aesthetic theories that address the pleasure(s) we get from images have tended to seek the source of that pleasure outside perception: in the circumstances of our contemplation, in its motivation, or its effects. What the artistic image suggests is that the pleasure in the image cannot be separated from some aesthetic, albeit a rudimentary one, or at least from knowledge about art, about its production and its aims. We can say what we like about the *joie de vivre* emanating from Picasso's drawings in those dizzying and prolific series he completed in his final years, but it is clear that the pleasure we get from them is inseparable from the vaguer mental image we have of Picasso in the act of drawing, expressing his joy in creativity. Bonnard's canvases, images of happiness in painting *par excellence*, may owe their effects to the harmonious use of colour, to the oranges and blues. But they, too, cannot be divorced from an idea of serene, day-by-day creation. If Bonnard's brush technique is so effective, it is perhaps also because we know that he could come back to the same canvas year after year to alter some minute detail.

In short, the pleasure of images, the viewer's pleasure, must be linked to the pleasure assumed to have been enjoyed by the artist. This creative pleasure has taken countless forms. Between Rubens' creation of more than two thousand paintings in an unparalleled frenzy of virtuosity and skill and Leonardo's labours to finish perhaps a dozen in his whole life, there lies a vast gulf. Yet each was driven to paint by a desire which would not leave them alone (and all artists who have spoken of their art could endorse the title of André Masson's book *The Pleasure of Painting*). The fascination of works of art may have no other source, in our age at least. We are heirs to Romanticism, we feel the desire of the individual.

Images in general are often seen as a sort of extension of artistic images, and the pleasure we derive from them is of the same kind, even if we feel it in a different visual register (parodic, ironic, playful as in the images of advertising, for example). Even the documentary image, which we value for showing the world 'as it is', acquires the prestige accorded to creativity and the pleasure of invention. The great photographic and cinematic documentarists from Flaherty to Depardon are those who show us their look, their gaze, at the same time as showing us the world. However one may choose to understand it, the pleasure of

images is, in the last resort, the pleasure of having added another item to the objects in our world.

IV. A Civilization of Images?

In the introduction, we noted the social importance of images, their apparently infinite proliferation, their frenzied circulation, their hidden ideological meanings and their influence, in short, the importance of all that has given rise to what has this century been called 'a civilization of images' (the title of a 1969 book by Enrico Fulchignoni). Closing our panoramic view of the main problems pertaining to the visual image with an inquiry into the artistic image forces us to reconsider this idea. Certainly the last hundred years have seen an impressive increase and accumulation of images. We may sometimes even have the impression in our everyday lives that images have invaded us, that they represent an unstoppable flood. There is a widespread feeling that we really live in the era of the image, to the point where various prophets at regular intervals announce for better or worse the end of writing.

But this feeling (whether it thrills or dismays us) prevents us from realising that this proliferation of images is only an epiphenomenon of a deeper upheaval. Down the centuries and often from crisis to crisis, the status of images has changed: they have changed from *spiritual* into *visual* objects. The medieval image, and perhaps also that produced by more distant civilisation, was fundamentally different from today's, at least insofar as its visible aspect was not regarded as paramount. This was only an earthly, outward appearance, of little value compared to the supernatural and heavenly beings to which it gave access. In a culture where the paradigmatic image, indeed the very basis of any notion of an 'image', is the incarnation of God the Father in Jesus Christ, clearly much more is at stake than the visual appearance of images or the replication of the world: the ideological, intellectual and social roles of images were far more important than the way they might appear to our eyes. So, the real image revolution (if there was one) happened a long time ago, when images lost the transcendent power they used to have and were reduced to mere records, however expressive, of appearances. Nowadays, the massive multiplication of images may appear to signal a return of the image, but our civilisation remains, whether we like it or not, a civilisation of language.

Notes

1. See, for instance, Jean-Marie Floch (1986), where he aims to define photography as composition. Floch's polemic is against the theoretical tendency that defines photography in terms of being a trace.
2. See, for instance, Hans-Jürgen Schmitt(1973), and the collection of essays published in the *New Left Review* of September–October 1973, and collected in Ernst Bloch et al., *New Left Review: Aesthetics and Politics* (1977). The most informative analysis of the literary and ideological aspects of these debates remains Helga Gallas (1971).
3. For the history and the function of the notion of 'genius', see Peter Bürger's

essay 'Some Reflections upon the Historico-Sociological Explanation of the Aesthetics of Genius in the Eighteenth Century' [1984]. Bürger also provided the most insightful and far-reaching discussion of the institutional nature of definitions of art in his *Theory of the Avant-Garde* [1974]. For a lighter look at the notion of 'genius' in contemporary Italy, see Umberto Eco, 'The Italian Genius Industry' [1973].

4. It must be remembered that Benjamin's essay, literally translated, was called 'The Artwork in the Age of its Technological Reproducibility'. For an extended discussion of the essay's complex engagement with notions of vision, see Susan Buck-Morss, *The Dialectics of Seeing: Walter Benjamin and the Arcades Project* (1989); for the best recent discussions of Benjamin's essay, see Susan Buck-Morss, 'Aesthetics and Anaesthetics: Walter Benjamin's Artwork Essay Reconsidered' (1992) and Miriam Hansen, 'Benjamin, Cinema and Experience: The Blue Flower in the Land of Technology' (1987).

5. For a discussion of whether one can speak of 'a pleasure', in the singular, associated with looking at images, or whether, in fact, a whole array of pleasures is necessarily and always at play simultaneously, see Paul Willemen's 'Through the Glass Darkly: Cinephilia Reconsidered' (1994).

6. This quotation and others hereafter are from Alan Trachtenberg's collection *Classic Essays on Photography* (1980).

7. For a recent discussion of Epstein's and the French avant-garde's notion of *photogénie*, see Paul Willemen, 'Epstein and *Photogénie*', in *Looks and Frictions* (1994), pp. 124–33.

V. Bibliography

The Abstract Image

Arnheim, Rudolf, *The Power of the Center* (Berkeley, CA: University of California Press, 1981).

Ayfre, Amédée, *Dieu au cinéma* (Paris: P.U.F., 1953).

——, *Cinéma et foi chrétienne* (Paris: Fayard, 1960).

Duthuit, Georges, *Représentation et présence, premiers écrits et travaux (1923-1952)* (Paris: Flammarion, 1974).

Eisenstein, S. M., 'The Fourth Dimension in Cinema' [1929], *Selected Works: Writings: Volume 1, 1922-34* (London: BFI, 1988).

——, 'Organic Unity and Pathos' [1939], in *Nonindifferent Nature* (Cambridge: Cambridge University Press, 1987), pp. 10–37; for a shorter version, see *Notes of a Film Director* (London: Lawrence and Wishart, 1959), pp. 53–62.

Faure, Elie, 'La Cinéplastique' [1922], in *Fonction du cinéma* (Paris: Ed. d'Histoire et d'Art, 1953); see also Richard Abel (ed.), *French Film Theory and Criticism, Volume 1: 1907–29* (Princeton, NJ: Princeton University Press, 1988).

Floch, Jean-Marie, *Les Formes de l'empreinte* (Périgueux: Pierre Fanlac, 1986).

Focillon, Henri, *Vie des formes* [1943] (Paris: P.U.F., 1947).

Francastel, Pierre, *La Figure et le lieu: L'Ordre visuel du quattrocento* (Paris: Gallimard, 1967).

Ghyka, Matila, *Esthétique des proportions dans la nature et dans les arts* [1927] (Monaco: Ed. du Rocher, 1987).

Groupe μ, 'Iconique et plastique, sur un fondement de la rhétorique visuelle', in *Revue d'esthétique*, nos. 1–2 (Paris: U.G.C., coll. 10/18, 1979), pp. 173–92.

Kandinsky, Vassily, 'Point, Line and Surface' [1926], *Kandinsky: Complete Writings on Art*, (Thorndike: G. K. Hall and Co., 1982).

Klee, Paul, *Pedagogical Sketchbook* [1925] (London: Faber and Faber, 1968).

Léger, Fernand, *Functions of Painting* [1913–60] (London: Thames and Hudson, 1973).

Lhote, André, *Traités du paysage et de la figure* (Paris: Bernard Grasset, 1958).

Lyotard, Jean-François, *Discours Figure* (Paris: Klincksieck, 1971).

Maldiney, Henri, *Regard Parole Espace* (Paris: L'Age d'homme, 1973).

Merleau-Ponty, Maurice, 'Peinture et image animée' and 'Regards sur le rhytme', in *Esthétique et psychologie du cinéma*, vol. 1 (Paris: Ed. Universitaires, 1963).

Passeron, René, *L'Oeuvre picturale* (Paris: Vrin, 1962).

da Vinci, Leonardo, *Treatise on Painting*, 2 vols (Princeton, NJ: Princeton University Press, 1956).

The Expressive Image

Barthes, Roland, *Writing Degree Zero* [1953] (New York: Hill and Wang, 1968).

Balázs, Béla, *Der sichtbare Mensch, oder die Kultur des Films* [1924], in *Schriften zum Film*, vol. 1 (Munich: Hanser, 1982), pp. 45–143.

Bloch, Ernst, et al. (eds), *New Left Review. Aesthetics and Politics* (London: New Left Books, 1977).

Deleuze, Gilles, 'The Affection-Image', in *Cinema: The Movement-Image* [1983] (London: Athlone Press, 1986).

Deregowski, Jan, *Distortion in Art: The Eye and the Mind* (London: Routledge and Kegan Paul, 1984).

Duthuit, Georges, *Réprésentation et présence, premier écrits et travaux 1923–1952* Paris: Flammarion, 1974).

Eisner, Lotte, *The Haunted Screen* [1952] (London: Secker and Warburg, 1973).

Epstein, Jean, 'Bonjour Cinéma' [1921], in *Ecrits sur le cinéma*, vol. 1 (Paris: Seghers, 1971), pp. 71–104; see also *Afterimage* [London] no. 10, Autumn 1981.

Gallas, Helga, *Marxistische Literaturtheorie: Kontroversen im Bund proletarisch-revolutionärer Schriftsteller* (Berlin: Hermann Luchterhand Verlag, 1971).

Gombrich, Ernst H., *Art and Illusion: A Study in the Psychology of Pictorial Representation* [1959] (Princeton, NJ: Princeton University Press, 1961).

——, 'Action and Expression in Western Art' [1970], in *The Image and the Eye, Further Studies in the Psychology of Pictorial Representation* (Oxford: Phaidon, 1982).

Kurtz, Rudolf, *Expressionismus und Film* (Berlin: Lichtbildbühne, 1926).

Langer, Suzanne, *Feeling and Form* (New York: Charles Scribner's Sons, 1953).

Richard, Lionel (ed.), 'L'Expressionsime', in *Obliques* nos. 6–7, 1976.

Schmitt, Hans-Jürgen (ed.), *Die Expressionismusdebatte: Materialien zu einer marxistischen Realismuskonzeption* (Frankfurt am Main: Suhrkamp, 1973).

Sontag, Susan, *Against Interpretation* (New York: Dell, 1969).

Ropars-Wuillemier, Marie-Claire, *Le Texte divisé* (Paris: P.U.F., 1981).

Worringer, Wilhelm, *Abstraction and Empathy* [1913] (London: Routledge and Kegan Paul, 1953).

The Auratic Image

Andrew, Dudley, *Film in the Aura of Art* (Princeton, NJ: Princeton University Press, 1984).

Barthes, Roland, *Camera Lucida* (New York: Hill and Wang, 1980).

Benjamin, Walter, 'The Work of Art in the Age of Mechanical Reproduction' [1935], *Illuminations* (New York: Schocken Books, 1969).

Buck-Morss, Susan, *The Dialectics of Seeing: Walter Benjamin and the Arcades Project* (Cambridge, MA: MIT Press, 1989).

———, 'Aesthetics and Anaesthetics: Walter Benjamin's Artwork Essay Reconsidered', *October* no. 62, Fall 1992, pp. 3–41.

Bürger, Peter, 'Some Reflections upon the Historico-sociological Explanation of the Aesthetics of Genius in the Eighteenth Century' [1984], in *The Decline of Modernism* (London: Polity Press, 1992).

———, *Theory of the Avant-Garde* [1974] (Minneapolis, MI: University of Minnesota Press, 1984).

Canudo, Riciotto, *L'Usine aux images* (Geneva: Office Central d'Editions, 1927); see also 'The Birth of the Sixth Art', *Framework* no. 13, Autumn 1980; and Richard Abel (ed.), *French Film Theory and Criticism, Vol. 1: 1907–29* (Princeton, NJ: Princeton University Press, 1988).

Child, Irvin L., 'Aesthetic Theories', in *Handbook of Perception*, vol. 10 (New York: Academic Press, 1978), pp. 111–31.

Croce, Benedetto, *Aesthetic* [1902] (London: Peter Owen, 1953).

Danto, Arthur, *Transfiguration of the Commonplace* (Harvard University Press, 1981).

Delluc, Louis, *Photogénie* (1920), in *Ecrits cinématographiques*, vol. 1 (Paris: Cinémathèque Française, 1985).

Dreyer, Carl Theodor, *Dreyer in Double Reflection*, ed. D. Skoller (New York, Dutton, 1973).

Duve, Thierry de, *Au nom de l'art* (Paris: Ed. de Minuit, 1989).

Eco, Umberto, 'The Italian Genius Industry' [1973] in *Apocalypse Postponed* (London: BFI, 1994).

Epstein, Jean, 'Bonjour Cinéma' [1921], in *Ecrits sur le cinéma*, vol. 1 (Paris: Seghers, 1971).

Kracauer, Siegfried, *Theory of Film* (London: Oxford University Press, 1960).

Hansen, Miriam, 'Benjamin, Cinema and Experience: The Blue Flower in the Land of Technology', in *New German Critique* no. 40, Winter 1987.

Lories, Danielle (ed.), *Philosophie analytique et esthétique* (Paris: Méridiens-Klincksieck, 1988).

Masson, André, *Le Plaisir de peindre* (Nice: la Diane française, 1950).

Riegl, Aloïs, *Grammaire historique des arts plastiques* [1899] (Paris: Klincksieck, 1978).

Tarkovsky, Andrey, *Time Within Time: The Diaries, 1970–86* (London: Faber and Faber, 1994).

Trachtenberg, Alan, *Classic Essays on Photography* (New Haven: Leete's Island Books, 1980).

Willemen, Paul, '*Photogénie* and Epstein' [1982], in *Looks and Frictions* (London: BFI, 1994), pp. 124–33.

———, 'Through the Glass Darkly: Cinephilia Reconsidered', in *Looks and Frictions*, pp. 223–59.

Zurbrugg, Nicholas (ed.), 'Electronic Arts in Australia', special issue of *Continuum* vol. 8 no. 1, 1994.

A Civilisation of Images?

Fulchignoni, Enrico, *La Civilisation de l'image* (Paris: Payot, 1969).

Index

245

246

7188 112